U0076639

# 婚禮平面設計

## WEDDING STATIONERY DESIGN

夏洛特·弗斯戴克　編

李嬋　譯

北星圖書事業股份有限公司

# ♥ ♥ ♥ Contents ♥ ♥ ♥

## 目 錄

# ♥ ♥ ♥  Preface  ♥ ♥ ♥

## 前 言

A wedding is a very important day in a person's life. It is a day where two people join as one and marry in front of all their friends and family. And this particular day, no matter how humble or grand, is a significant day that many will remember forever. To the couple, this day is more than just a day they wed; it is a day where they get to show to the people in their world who they are as a couple and a way to show their love for each other. To a graphic designer however, a wedding day is essentially an event, one that is planned out perfectly to the minute detail. With this in mind, it is so critical that every element of that day tells a story about the couple's image to the family and friends attending. It is our job to set the scene, right from the beginning, with the wedding stationery.

As a graphic designer who works closely with clients to develop their brands and overall image, it is important to begin a project by seeing it from the eyes of the consumer, customer, client or in this case, the guest. And it is equally important to create something that will last a lifetime. Much like a client project, the design and build of an image for a couple's wedding takes a special amount of care. Care in understanding not only what they want or how they want to be portrayed, but also understanding who they are together as a unit.

From the perspective of a former bride, I personally know how crucial it is for the whole day to be perfect in every way. From the invitations, save-the-date cards, flowers, colour schemes, decorations, thank-you cards, signage on location, cake, dresses, venue, food and drink to the smallest visual elements on the day, it is so important that every element connects together and that each takes part in the theme of the event. And with this perspective comes an utmost understanding of the needs of clients such as these.

A wedding invitation is more than just a ticket that informs us where and when the event will occur. From the point of view of a designer, the primary job for an invitation is to be... inviting! When the package arrives in the mail, the guests receive a small taste of the couple and a teaser of the event to come.

I like to see wedding branding (and I'll call it that because it's much more

婚禮是一個人一生之中非常重要的一天。這一天，兩個人在所有親朋好友面前許下誓言，正式結合。而這特別的一天，不論是簡單樸素還是無比盛大，都會是很多人終生難忘的最有意義的一天。對新婚夫婦來說，這一天不僅僅是他們結婚的日子，更重要的是，在這一天，在他們生命中最重要的人們面前，首次展現兩人作為一對夫妻的關係，同時也展現他們對彼此的愛戀。然而，對平面設計師來說，婚禮首先是一場活動，一場需要精確策劃到每分每秒的活動。從這個意義上說，婚禮上的每個元素都應該讓出席婚禮的親朋好友看到這對新人的獨一無二。我們的任務就是用平面設計為新人打造量身訂製的婚禮。

作為平面設計師來說，我們要與委託客戶緊密合作，實現他們的設想和預期。所以，我們著手設計之前，一定要站在委託客戶的角度來看。在婚禮設計中，客戶往往也就是新人。而且，你的設計不應該只是應付任務而已，你的作品本身應該歷久彌新，讓人終生受用。跟其他類型的委託設計一樣，婚禮平面設計也需要設計師傾注大量的心血，不僅要理解新人要什麼或者是希望你如何展現他們的形象，而且要表現出他們兩人作為一對夫妻相結合的關係。

從新娘的角度上，我個人清楚地知道，一場各方面都完美無缺的婚禮對新娘來說有多麼重要。請柬、日期卡、花朵、色彩、飾品、感謝卡、標識、蛋糕、婚紗、場地、飲食乃至婚禮上最不起眼的視覺元素，所有的一切都要和諧統一，一致地表現出婚禮的主題。從這個角度上說，我們要清楚掌握委託客戶的要求，比如上述這些方面。

婚禮請柬可不僅僅是一張入場券，上面告訴你婚禮的時間和地點。從設計師的角度來看，婚禮請柬的首要目標就是－引人注目！賓客收到請柬的時候，彷彿看到新人的驚鴻一瞥，又像看了婚禮的精彩預告片，讓人滿心期待。

婚禮平面設計不僅僅是簡單的婚禮用品設計，我們更在設計中

than stationery) as a great space to be creative and do something that will standout and impress. Of course it's important to have this attitude with every project, but there is something quite fun about designing for a person as opposed to a business or company. It is a refreshing kind of project. It's the kind of project that can take many different forms; rules can be broken and ideas can be stretched. But the single most important part of wedding branding is presentation and execution. It's all about the details; the right paper stocks, colour coordination, embellishments, size, layout and printing techniques. And if you can get this right, the end result can truly stun.

A wedding invitation and the stationery for a wedding event is a particularly special project on which to work. It has a beautiful element of intimacy that as a designer you do not seem to come across with regular client work. It is a project that can sometimes lend itself to a great deal of creativity, as the project is mostly about the unique personalities of the clients. The colour palettes, paper textures, design elements, and special touches can certainly bring an invitation to life. It is something that may be kept; a very personal piece that connects only to those two people, something truly one of a kind.

As designers, we often feel honoured to design for a wedding. Maybe it is honourable as it takes a lot of faith from the bride and groom (but let's admit, mostly the bride), that the person who asked to design the invites will not ruin them. Or maybe due to the intimacy, as mentioned earlier, that happens when you design something that is so close and important to the client.

Designers love to excite those who have the privilege to receive our works. It is a wonderful feeling to deliver works that draw people beyond a particular event or brand into creative and unique narratives that expand and enhance the ideas portrayed. This is our greatest pleasure. And so with a project such as the design of a wedding brand, we have this wonderful opportunity to be part of creating lifelong memories.

Charlotte Fosdike

樹立婚禮或者新人的形象。在這個領域的設計中，我們可以充分發揮創造力，設計一些讓人印象深刻或者眼睛為之一亮的作品。當然，任何的設計我們都應該抱持這種態度，但是，相較於為公司企業做設計，為個人設計更會更親切有趣。這類設計更讓人充滿熱情。做這類設計，你可以有很多不同的手法，可以打破設計原則的規則，設計思路可以無限延展。但是，婚禮平面設計最重要的，就是設計思路的實施和最終效果的呈現。說到底，就是細節，比如：紙張的選擇、色彩的搭配、裝飾品的運用以及卡片的尺寸、頁面配置和印刷技術等。如果這些你都能做好，最終的效果真的會讓人驚嘆。

婚禮平面設計對設計師來說確實是一件很特別的工作。在這類設計中，有一種特別的親切感，那是你作為設計師在其他常規的委託設計工作中很難碰到的。這類設計有時本身就會激發你的創造力，因為每次設計針對的都是獨一無二的客戶。色彩、紙張、特別的裝飾等設計元素都能賦予婚禮請柬生命力。這樣的請柬是值得永久收藏的，是只與新郎新娘兩人相關的私人收藏，真正的獨一無二。

作為設計師，我們常常為設計婚禮而感到榮幸。也許這是因為婚禮寄託新郎與新娘的信念（但我得承認，主要是新娘），所以，找你設計這套卡片的人是如此珍視你的設計。或者，也許是因為前面提到的那種親切感，你的設計對委託客戶來說是如此的親切、如此的重要。

設計師喜歡讓委託我們設計的客戶眼睛為之一亮。希望透過創意的、獨一無二的設計把人們的視線吸引到我們表現的東西上來，那種感覺真是棒極了！這就是我們最大的快樂。藉由像婚禮平面設計這樣的機會，我們得以為人們創造終生難忘的回憶。

夏洛特・弗斯戴克

## 婚禮平面設計的內容

Marriage is about love and romance, and a romantic, unique and memorable wedding is one of the best witnesses to the love of the newlyweds. Here arises a sweet yet challenging task for graphic designers.

Wedding stationery design reveals the quality and delicacy of a well-planned wedding. The theme and style of a wedding could be embedded in all the wedding stationery. A good wedding stationery design is not only to provide necessary information to the guests, but more importantly, to impress them with exquisite designs showing that the newlyweds have meticulously paid attention to very detail by heart. A theme wedding with all stationery designed in a consistent style and with a unique identity would strongly individualise the new couple. Elaborate thank-you notes and small gifts on the wedding would be collectible for a beautiful memory.

However, wedding stationery design, as an important part in a perfect wedding, is often neglected by the newlyweds. When it comes to wedding stationery, it is always simply understood as invitation card design. They will carefully select invitation cards for their wedding or even design a special one by themselves, but various elements other than cards are always ignored. Apart from invitation cards, a high-standard wedding comprises save-the-date cards, route maps, wedding books, wedding programmes, cards with guests' names and table names or numbers, seating arrangements design, RSVP cards, table cards, menus, thank-you cards, etc. All of these play a significant role in a successful wedding.

### Save-the-Date Cards

When the date and venue have been decided, you may send save-the-date cards to your guests. When receiving such a card, a relative or friend will share with the newlyweds their delight and happiness and most importantly, he or she can adjust his or her schedule to save the date for attending the wedding. Save-the-date cards usually are single-paged, with simple words to indicate names of the newlyweds and the wedding date. For out-of-town guests, recommended places to stay can be added. (Fig. 1.1-1.4)

Compared with invitations, save-the-date cards are not that formal and indispensable, but in the following circumstances, a save-the-date card is necessary:

·For guests whom the newlyweds really hope to see in their wedding, or for guests of particular significance for the newlyweds;
·For out-of-town or even oversea guests;
·For guests usually working busy, constantly on business trips or in special professions;
·For weddings on weekdays, so that guests can ask for leave in their work in advance;
·For weddings during holidays or festivals, because some guests might have travel plans and save-the-date cards would remind them to adjust the schedule.

It's better to send save-the-date cards six months before the wedding, in order to give enough time for guests to arrange their schedule. Nowadays with the network medium, making an E-card would be a good choice, being hip and environmentally friendly.

### 日期卡

婚姻是令人嚮往的，而婚禮是見證愛情的最佳方式，因此舉辦一場獨特又令人難忘的婚禮對於人來說尤為重要。

婚禮平面設計是一場婚禮精緻品質的呈現，婚禮主題的設計以及風格的展現都可以透過它所展出來。婚禮平面設計可以將眾多關於本場婚禮的資訊清晰地傳遞給賓客，精心的設計可以給賓留下美好的印象，表現出新人在細節之處的用心，與婚禮主題相呼應的設計風格，可以凸顯新的獨特個性，製作出精美的感謝卡以及婚禮答謝品皆值得人們收藏。

但如今，婚禮平面設計作為一場完美婚禮的重要元素卻往往會被新人所輕視。提起婚禮中的平設計，人們通常將其簡單理解為"婚禮請柬"，而且都會為了自己的婚禮精心挑選甚至專門設一款精緻的請柬，但是對於其他一些元素的關注遠不及請柬。一場高規格的婚禮除了精美的請外，還包括了日期卡、路線圖、簽到簿、流程卡、領位卡、座位表、回覆卡、桌號牌、菜單、謝卡等，它們在婚禮的整個過程中同樣扮演著不可忽視的角色。

新人在婚禮日期和場地確定以後，就可以給遠方的賓客寄送日期卡。這樣做的目的既可以在第時間同親友分享自己的喜悅心情，又可以讓賓客在自己的行程表上把這個日期空出來。日期卡般使用單頁的卡片，措辭比較輕鬆，只要註明婚禮的日期以及雙方新人的名字就可以了，對於地的賓客，也可以備註上推薦的住宿地點。( 見圖 1.1~ 圖 1.4 )

日期卡相對請柬沒有那麼正式，但對於以下情況則必須要使用日期卡：
· 新人非常希望到場或對新人來說具有特殊意義的重要賓客
· 路途遙遠 ( 在外地或外國 ) 的親朋好友
· 工作比較繁忙，需要經常出差或特殊職業的賓客
· 在工作日舉辦婚禮的新人需要寄送日期卡，可以方便賓客提早安排請假時間以便出席婚禮
· 在重要的節假日舉辦婚禮的新人也建議寄送日期卡，很多賓客可能會在節假日安排外出旅行日期卡可以提醒他們預留出時間

寄出日期卡的時間最好在婚禮前的 6 個月，以便給賓客留出充足的時間安排檔期，如今，網路介非常便捷，選擇製作電子日期卡也不失為時尚又環保的辦法。

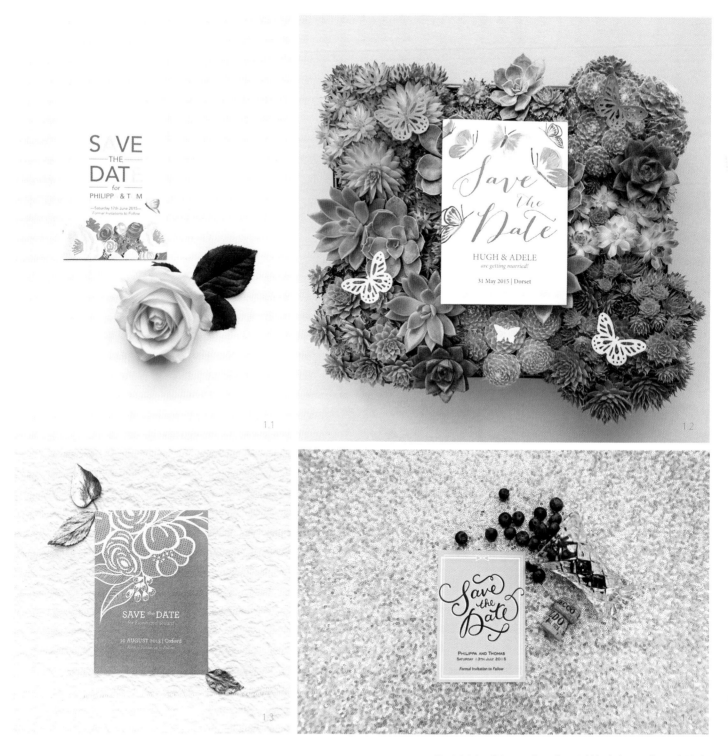

Fig. 1.1-1.4 : All four projects from British design studio BerinMade
圖 1.1 ~ 圖 1.4 這四個設計均來自英國設計工作室 "貝林製造"

## Invitation Cards

For the following formal invitation, invitation cards shall be sent to guests six to eight weeks before the wedding. Since there may be changes to the guests list, it is recommended to prepare some extra invitation cards. Usually an invitation card goes with a RSVP card and a route map, all put in a matching envelop to send to the guest.

Information on the invitation card shall include: guest name, newlyweds' names, as well as date, accurate time and venue of the wedding. If the wedding ceremony and party are held in separate places, specific time and venues shall be clearly noted. RSVPs are cards that the guests return to the newlyweds replying that he or she can or cannot attend, and in the latter case a reason is expected. It is important for the newlyweds to have the final number of attendants. Lastly, a route map can be added to the invitation card, including the main roads and car parks near the wedding venue and perhaps some special notes. It shows care and concern for the guest, who otherwise might miss the wedding due to lack of directions to the destination. (Fig. 1.5-1.6)

## Attendance Books

Attendance books are an indispensable part in a wedding. Besides traditional handwritten ones, now we have new, avant-garde ways, such as by fingerprints and by cards. It would be a memorable gift for the newlyweds to have a painting with the fingerprints of all the guests. Compared with conventional attendance books, such a fingerprints painting is so creative and original, a unique piece of artwork whose aesthetics is totally determined by the creativity of the guests. (Fig. 1.7-1.8)

## Wedding Programmes

Designed to tell guests order and time of events on the wedding. For a wedding that has ceremony and banquet held at the same venue, a wedding programmes card is not that important; but sometimes there would be performances before the ceremony, or a firework show or party after the wedding, then a card with information about specific programmes is necessary.

Apart from opening & ending time and venue of each event, such a card could give clear indications about more details, for example the background music of each programme so that the guest can have proper interaction with the newlyweds. If the ceremony is held in a special venue, the do's and don'ts could be indicated, if any. Wedding programmes cards could be placed at the reception for convenience of guests, be them single-paged cards, folding brochures or in any interesting form. (Fig. 1.9-1.10)

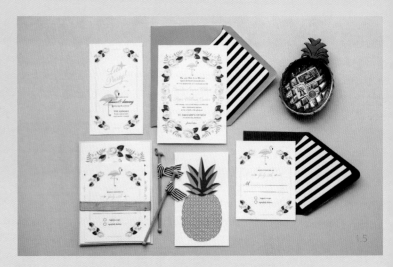

### 請柬

婚禮請柬是正式地向賓客進行邀約，一般於婚禮前 6 ～ 8 周寄送給賓客。因為賓客名單的數量可能存在不穩定性，所以建議多準備一些以備用。請柬一般分為三個部分：邀請卡、回覆卡（RSVP）以及行車路線圖，三個卡片需裝進配套的信封寄送給賓客。

在邀請卡上需要標明賓客姓名、新人姓名、婚禮具體日期、時間、地點等資訊，如果儀式和婚宴場地分開，還要分別註明儀式及婚宴的時間、地點。回覆卡是賓客對新人的邀請所做出的回覆資訊，能夠出席或不能出席以及不能出席的原因都要標明後寄還給新人，以便新人統計最後出席的賓客人數。此外，婚禮請柬中還可以附上婚禮地點的地圖或行車路線圖、停車資訊以及注意事項等，既可表現出新人對賓客的尊重與關心，又可大大避免賓客因為找不到目的地而錯失婚禮。（見圖1.5、圖1.6）

### 簽到簿

簽到簿是婚禮中必不可少的元素，除了傳統的手寫簽名外，現在也有很多時尚的簽到方式，如指紋簽到、卡片簽到等。在婚禮現場的每位賓客留下獨一無二的指紋，這是多麼獨特的祝福！和傳統來賓簽到冊相比，指紋簽到極具創意，簽到畫的美觀程度完全靠現場賓客去發揮，是一份由賓客為新人打造的獨一無二的藝術品，非常有紀念的意義。（見圖1.7、圖1.8）

### 流程卡

流程卡的主要內容是為賓客詳細說明婚禮的主要流程及時間安排。對儀式和婚宴一起舉辦的婚禮來說，流程卡不是特別重要。但有些新人會在婚禮儀式前舉辦文藝演出，或者在婚禮結束後還要舉辦煙火表演和慶祝派對，這時流程卡就很需要了。

流程卡上除了必須要寫明每場儀式開始及結束的時間和地點外，也可註明主要儀式的配樂，方便賓客與新人互動。如果在特殊地點舉辦婚禮，還可以列出注意事項，增加新人與賓客之間的親切度。流程卡一般會放置在婚禮的簽到處，可以是單頁卡片、折疊小冊子或者其他有趣的形式。（見圖1.9～圖1.10）

Fig. 1.5: Invitation cards in contemporary style, by U.S. studio Papermade Design

Fig. 1.6: Invitation card with RSVP and route map, by British design studio jollybureau

Fig. 1.7: Fingerprints painting, sourced from http://www.lovewith.me/

Fig. 1.8: Attendance cards, by Canadian designer Kay Kent. Every guest puts his or her card into the mesh, completing a big heart of love and wish. Such a special way would be impressive for guests, and at the same time produce a memorable gift for the newlyweds.

Fig. 1.9: A romantic programmes card by U.S. design studio Olive & Emerald, specially designed with a bag of colourful round pieces of paper. It is indicated that when the bride and groom walk by, the guest is expected to open the bag and scatter the pieces of paper in the air. Such interactive experiences would make for a playful and delightful wedding.

Fig. 1.10: Programmes cards in the form of a fun, practical and convenient for an outdoor wedding in summer, by British design studio Belinda Love Lee

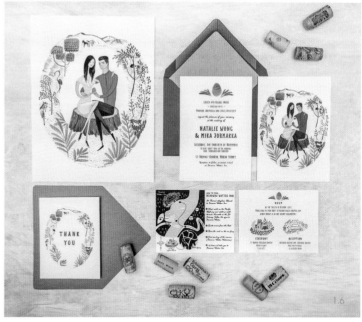

圖 1.5 現代風格請柬，來自美國設計公司 "紙質設計"

圖 1.6 婚禮地圖設計，來自英國設計公司 "喬莉設計"

圖 1.7 兩位新人正在自己的簽到簿上留下自己的指紋，來自網站 http://www.lovewith.me/

圖 1.8 卡片簽到簿，來自加拿大設計師凱·肯特，每位賓客線上網中插入自己的名牌，最後匯成一個充滿愛和祝福的大心形，既可以給賓客留下深刻的印象，又是賓客送給新人的特殊禮物，具有紀念價值。

圖 1.9 來自美國奧利弗 & 埃默拉爾德設計工作室的浪漫婚禮流程卡，在這張特別的流程卡裡附贈了裝滿彩色小圓紙片的袋子，並特別註明了婚禮儀式時當新郎和新娘從賓客身邊走過，請賓客打開小袋子，並把裡面的紙花撒向空中。讓每位賓客都能參與其中，增添了婚禮的互動性與趣味性。

圖 1.10 做成了扇子的水彩花朵流程卡，在夏季舉辦的室外婚禮上會讓賓客感覺實用又貼心，來自英國設計工作室 BLL

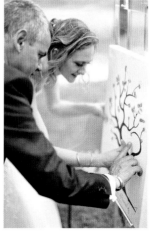

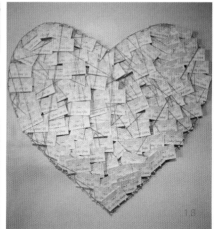

## Table Names or Numbers

A card with the name of the guest, and on the back with the name or number of the table which he or she is expected to sit at. In the wedding, such cards are usually placed at the reception, so that every guest would get one with which he or she can easily find the right table. It could be a traditional simple card, or designed in an interesting way. (Fig. 1.11-1.13)

## Seating Arrangements

Seating arrangements should be clearly shown with guests' names and table numbers, placed in a conspicuous location, usually at the reception or at the entrance of the wedding venue, with simple design and a large size for the convenience of the guest. (Fig. 1.14-1.16)

## Table Cards

These are cards placed on tables with numbers or names to help guests find their seats. Tables could be simply numbered, or given botanical names or names of different places, according to the theme of the wedding. (Fig. 1.17-1.19)

## Menus

Menus are usually placed at the centre of the table together with table cards. In Western weddings every guest often gets a menu placed in his or her plate, while in the East the menu would likely be placed at the entrance of the banquet hall. (Fig. 1.20-1.22)

## Thank-You Notes

A thank-you note is necessary in any wedding regardless of the styles or themes. Usually the new couple would have a tight schedule on the wedding day, and thus some guests might be underserved. In this case, a thank-you card can smooth things over. After experiencing a memorable wedding, the guest could receive a card with thanks from the newlyweds. Such cards could be printed with the same words, or custom-made for each guest. You don't need beautiful words but heart-felt thanks expressed sincerely. Usually they are small cards put in the guest's plates, or sometimes made in funny forms as special gifts for the guests. (Fig. 1.23-1.25)

## 領位卡

領位卡的主要內容是賓客的姓名，並在背面標明他的桌號。在婚禮時，領位卡一般也會放置在婚禮的簽到處，每一位賓客在入座前都會透過自己的領位卡順利找到自己的座位。領位卡可以是傳統的小卡片，也可以做得很有趣。（見圖1.11~1.13）

## 座位表

座位表的主要內容是所有的桌號名稱及每桌賓客的名字。座位表通常會擺放在婚禮現場比較顯眼的位置，一般在簽到處附近或者婚宴現場的入口處，設計方式簡單明瞭，體積較大，以供賓客能夠快速找到自己的座位。（見圖1.14~圖1.16）

## 桌號牌

桌號牌的主要內容是桌號名稱，主要目的是為了說明賓客快速找到自己的座席。桌號名稱可以用傳統的數字表示，有時為了增添趣味性和創意性也可以用植物名稱或地區名稱代替，具體可根據婚禮主題而定。（見圖1.17、圖1.18）

## 菜單

菜單的主要內容就是本次宴席的菜目表，一般會印製出來和桌號牌一同放在每桌的中間；西式婚禮的婚宴一般會為每位賓客製作一張放置在餐盤中；而有的則會統一標示在明顯的地方，擺放在宴會廳的入口處。（見圖1.19、圖1.21）

## 感謝卡

不管是哪種風格的婚禮，為賓客贈送一張感謝卡都是必不可少的。新人在婚禮當天行程安排非常緊湊，有對個別賓客照顧不周是不可避免的，一張感謝卡則可以幫助新人向每一位賓客致謝。賓客在欣賞完一場美好難忘的婚禮之後，還能感受到新人良好的涵養。感謝卡上的內容可以統一印製，也可以由新人為每位賓客訂製，用詞不需要華麗，但感情一定要真摯。感謝卡一般製作成小卡片放置於賓客的餐盤中，而有的則會精心製作成有趣的樣子，送給賓客做紀念。（見圖1.22~圖1.24）

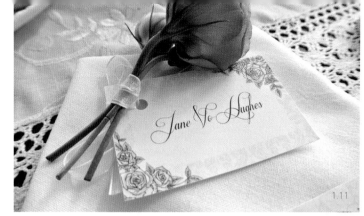

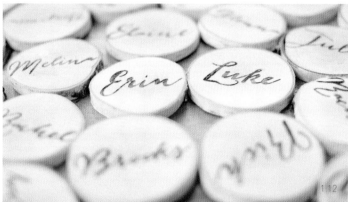

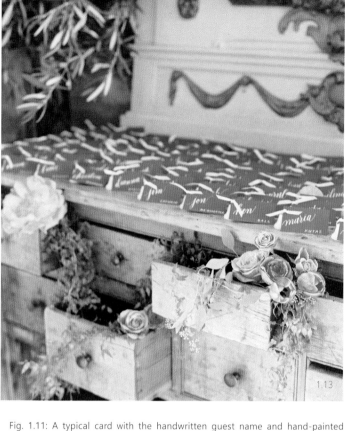

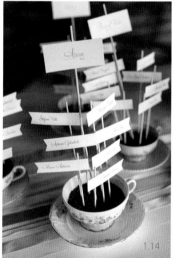

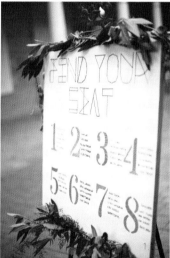

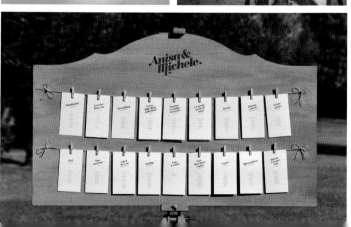

Fig. 1.11: A typical card with the handwritten guest name and hand-painted flowers, by British designer Carole Chevalier

Fig. 1.12: Special cards in wood, each engraved with the name of the guest and table number on the back, by U.S. design studio Caliber Creative

Fig. 1.13: Green cards neatly placed on the reception desk, by U.S. design studio MaeMae Paperie

Fig. 1.14: A special design showing seating arrangements with sticks and cups, by Italian design studio CUTandPASTE-lab

Fig. 1.15: Seating arrangements board by U.S. design studio October Ink, with big numbers and pink colour – theme colour of the wedding, placed at the entry of the banquet hall

Fig. 1.16: Seating arrangements board simulating musical notation, for a music-themed wedding by Italian designer Giorgia Smiraglia

圖 1.11 經典卡片式領位卡，手繪的花朵和手寫字體都凸顯了該婚禮的浪漫主題，來自英國設計師卡羅爾·希瓦利埃。

圖 1.12 木質的圓形領位卡，新人專門為自己的婚禮特製的領位卡，每個領位卡上都刻上賓客的名字，卡片背面是賓客的桌號，來自美國的卡勒伯創意工作室。

圖 1.13 綠色的田園風格領位卡整齊地排列在簽到臺上，來自美國設計工作室"梅梅紙質設計"。

圖 1.14 這個特殊的座位表來自義大利"剪貼設計工作室"，設計師將座次名稱和賓客名字做成小竹籤插進茶杯中，一目瞭然。

圖 1.15 該設計來自美國設計工作室"十月墨"，該座位表使用了醒目的字體和配合主題的豔粉色，並且放置在宴會廳的入口處。

圖 1.16 該設計來自義大利設計師喬琪亞·斯密哥利亞，這是一場音樂主題的婚禮，設計師將座位表用小夾子固定在兩條線上，就像五線譜上跳動的音符。

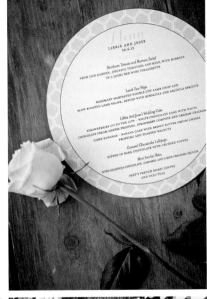

Fig. 1.17: Table card with big number for easy communication by Canadian designer Kay Kent

Fig. 1.18: Table card put on a card stick, with romantic typeface and floral pattern echoing the theme of the wedding, by U.S. designer Brittany Von Lanken

Fig. 1.19: Menu printed on a round card with the same style as the wedding, by U.S. design studio Good on Paper

Fig. 1.20: Menus placed in the plate of each guest in a romantic pink wedding, by U.S. design studio Legacy Loft

Fig. 1.21: Menu written on a black door reclined on an old tree, for an outdoor rural-style wedding, by French design studio Monsieur + Madame

圖 1.17 該設計來自加拿大設計師凱·肯特，該桌號牌使用了傳統的數字來表示，字體設計粗大醒目，有著提示作用。

圖 1.18 該設計來自美國設計師布列塔尼·范蘭肯，該桌號牌使用了浪漫的字體配合周圍的清秀花紋，放置在高高的卡托上，既凸顯了婚禮的主題，又清晰醒目。

圖 1.19 該設計來自美國的設計工作室"紙上好設計"，該功能表印製在圓形的卡片上，採用與婚禮主題統一的風格。

圖 1.20 該設計來自美國設計工作室"傳說中的閣樓"，這是一場以粉色為主題色彩的浪漫婚禮，設計師為每位賓客準備了粉色的菜單並放在他們的餐盤中。

圖 1.21 該設計來自法國設計工作室"先生＋太太"，這是一場室外田園風格婚禮，設計師將功能表的內容寫在黑板上，並將黑板立於宴會場地旁邊的大樹旁，表達了新人熱愛自然、回歸自然的特點。

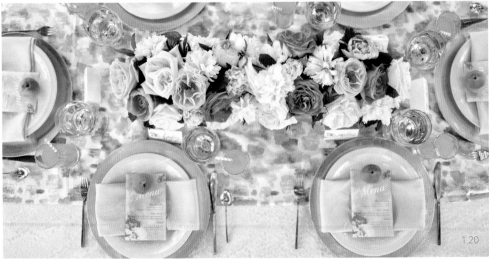

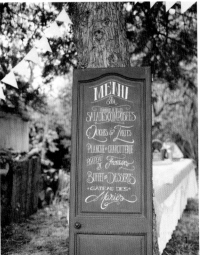

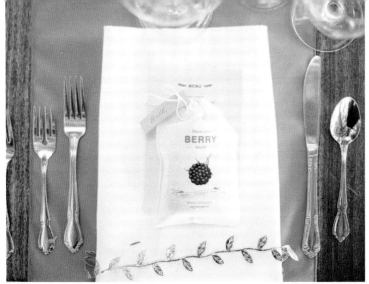

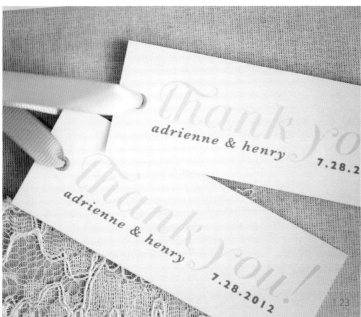

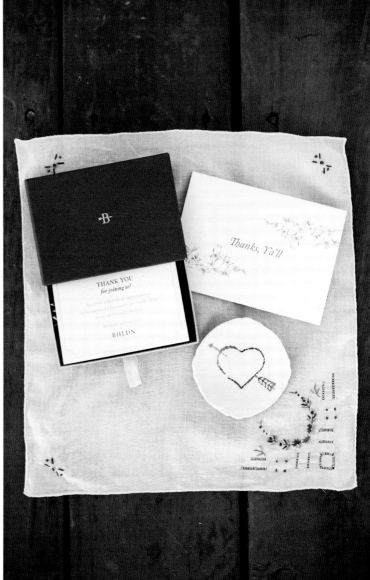

Fig. 1.22: Thank-you note combined with a gift by U.S. designer Lisa Mishima, for a plant-themed wedding. Thanks words are printed on a small fabric bag full of gifts made of berries.

Fig. 1.23: Thank-you notes designed in the form of a bookmark for guests to keep as souvenirs, by U.S. design studio Papermade Design

Fig. 1.24: Thank-you note with a gift, a hand-embroidered handkerchief, to be put into a well-designed paper bag, by U.S. design studio Olive & Emerald

圖 1.22 該設計來自美國設計師麗莎·三島，這是一場以植物為主題的婚禮，設計師將感謝卡與回贈禮物相結合，以漿果為主題的感謝詞印製在麻質的禮袋上，裡面裝滿了用漿果製作的禮物回贈給賓客，既呈現了這場婚禮的主題，又充分表現了新人對賓客的感激之情。

圖 1.23 該設計來自美國設計公司 "紙質設計"，設計師將該感謝卡設計成書籤的形式，賓客可以保留下來作為紀念。

圖 1.24 該設計來自美國奧利弗 & 埃默拉爾德設計工作室，設計師將感謝卡連同新人送給賓客的手繡手帕一起裝進精心設計的紙袋中。

## 婚禮平面的設計元素

In the above components of wedding design, some key design elements are involved. The wedding's theme, style, colour scheme, guests and their cultural backgrounds should all be taken into account when doing the wedding stationery design, including design elements such as logo, colour, pattern, illustration and text.

### Custom Logo

A custom logo is the basic element of wedding stationery. It is the symbol of the wedding, and would be used throughout in all pieces of the wedding stationery. A good logo would impress the guests, as the soul of the wedding.

Usually the logo would consist of the names (full names or initials) of the bride and groom, as well as the wedding date. To add interest, some interesting and creative logos can be created, such as cartoon characters of the bride and groom, or special designs with wedding photos, hobbies of the newlyweds, or a symbol that can represent the wedding best. Here are some rules of thumb concerning wedding logo design: design with minimal complication; create simple logos because they're easier to remember; avoid overmuch colours (single colour recommended); last but not least, the logo should be distinctive and best demonstrate the features of the newlyweds. (Fig. 2.1-2.8)

### Colour Scheme

Colour, as the most direct visual language, is a vital part in a successful wedding. In wedding stationery design, first you have to be clear about the dominant style and theme colour of the wedding, and then choose colours that are consistent with the main tone. Secondly, get to know about the guests, especially their cultural backgrounds, and use colours that would be easily accepted by the audience. Thirdly, preference of the newlyweds should be considered to produce personalised wedding stationery. Lastly, time and venue of the wedding are also decisive factors in your stationery design because the chosen colours should match up with the surroundings. Generally speaking, golden and silver colours communicate luxury and wealth, and are preferred in stationery design for classical weddings. Purple is romantic and mysterious, pink feels soft and tender, and beige is a mild, warm colour. These three colours are suitable as the main colour palette in romantic weddings. Yellow and orange are colours of harvest and vigour, and are preferred in country-style weddings.

Green is the symbol of life and vitality and is perfect for a nature-themed wedding. It is worth mentioning that it's better to have less than three colours used, and very intense colours should be avoided as much as possible. In practice of your stationery design, always take the style and features of the wedding into consideration and at the same time follow principal laws of colour scheme design. (Fig. 2.9-2.11)

在列出了婚禮平面設計所包含的主要內容後，還需要明確婚禮平面的設計元素。整場婚禮的主題風格、主要色調、賓客的成員構成以及文化背景決定了婚禮平面的主題風格。而這種獨特風格則表現在它的設計元素上，也就是每對新人專屬的標識（LOGO）、色彩、圖案、插畫以及文字。

### 訂製的標識

婚禮訂製標識是每套婚禮平面設計的基礎，作為兩位新人的標誌，應用到婚禮的各個地方，是整場婚禮的靈魂。婚禮訂製標識既是新人形象的代表，又能讓賓客加深對本場婚禮的印象。

婚禮標識一般由兩位新人的名字及婚禮日期等元素組成，可以使用兩人名字的全稱也可以使用首字母代替。有時為了增添婚禮的趣味性，也會使用一些具有趣味性、創意性的婚禮標識，比如具有新人特徵的卡通形象、兩人的婚紗照、兩人共同的愛好、呈現婚禮主題的某種圖形等。不過，婚禮標識在設計時需要注意幾個問題：設計不宜太複雜，最好簡單方便記憶；顏色不宜過多，建議使用單色設計；最關鍵的還是要設計鮮明，展現出兩人的特點。（見圖2.1~ 圖2.8）

### 專屬的色彩

色彩作為最直接的視覺語言，對一場完美的婚禮是相當重要的因素。在進行婚禮平面設計的色彩設計時，首先，要明確整場婚禮的整體風格和主要色調，使得婚禮平面與整場婚禮風格統一。其次，要弄清參與婚禮的賓客成員構成及文化背景，使得婚禮平面的色彩易於被大眾接受。再次，應充分考慮到新人的特徵及喜好，使得婚禮平面的色彩具有鮮明的個人特徵。最後，應考慮到婚禮的舉辦時間和舉辦場地，使得婚禮平面的色彩與周圍環境相融合。一般來說，金色、銀色是奢華和富貴的顏色，經典風格的婚禮適合選擇金色、銀色作為婚禮平面的主色調。紫色浪漫又神秘，粉色柔美又嬌豔，米色柔和又溫暖，浪漫風格的婚禮適合選擇紫色、粉色和米色作為婚禮平面的主色調。黃色和橙色象徵著生命與收穫，鄉村風格的婚禮適合選擇黃色和橙色作為婚禮平面的主色調。綠色代表著生命和健康，是大自然的顏色，田園風格的婚禮適合選擇綠色作為婚禮平面的主色調。但需要注意的是，婚禮平面的色彩不要超過三種，並儘量不使用過於激烈的顏色。在具體設計時不僅要考慮到該場婚禮的風格特點，還要嚴格遵守色彩搭配的基本原則。（見圖2.9~ 圖2.11）

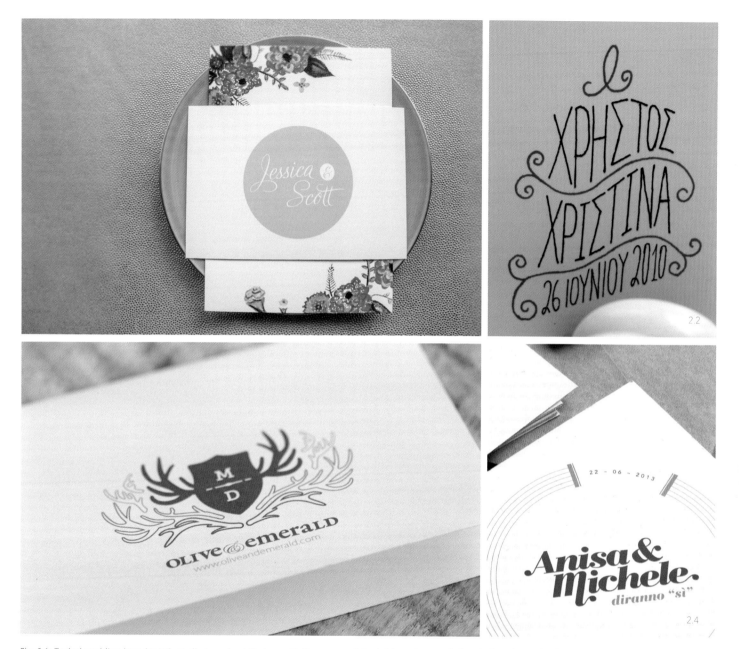

Fig. 2.1: Typical wedding logo by U.S. studio Lauraland Design, with the names of the bride and groom in handwritten form, simple yet romantic

Fig. 2.2: Logo design for an ocean-themed wedding by Greek design studio FIIL, with playful blue curves representing waves of the ocean, combined with the names of the newlyweds in a dynamic way

Fig. 2.3: Logo design for a wedding in medieval style by U.S. design studio Olive & Emerald, in which the main colour is sage green, the colour of moss, and a medieval element – antlers – is added

Fig. 2.4: Logo design for a music-themed wedding by Italian designer Giorgia Smiraglia, in which the names are designed with musical elements such as note and staff

圖 2.1 該設計來自美國的蘿拉藍德設計工作室，這是一款最常見的婚禮標識，設計師將兩位新人的名字用手寫體的方式呈現出來，簡潔浪漫，符合該場婚禮的主題。

圖 2.2 該設計來自希臘設計公司 "菲兒"，這是一場以海洋為主題的婚禮，設計師加入了藍色的曲線代表大海的波浪，兩人的名字設計成浪花上下起伏，具有律動感。

圖 2.3 該設計來自美國奧利弗 & 埃默拉爾德設計工作室，這是一場中世紀風格婚禮，整場婚禮的主題色是代表苔蘚的灰綠色，設計師為了凸顯主題，特意在具有兩人名字縮寫的標識上加入了代表中世紀風格的麋鹿角。

圖 2.4 該設計來自義大利設計師喬琪亞·斯密哥利亞，這是一場音樂主題婚禮，設計師在兩人的名字中增加了音符的元素，並且在四周加入了五線譜作為裝飾，凸顯了婚禮的主題。

Fig. 2.5: Logo design for a farm-themed wedding by Hong Kong-based studio Kalo Make Art. The new couple hope to have a farm of their own in the near future. They both love animals, particularly pigs, so images of lovely pigs are used in the logo, which did impress the guests greatly!

Fig. 2.6: Logo design by Spanish design studio El Calotipo, with a wedding photo specially treated and names of the newlyweds in a romantic typeface

Fig. 2.7: Logo with illustration of the bride and groom, by Italian designer Mara Colombo

Fig. 2.8: Logo design for a gay wedding by Canadian designer Michael De Pippo, with cartoon characters revealing their romantic story: falling in love at first sight...

Fig. 2.9.1-2.9.2: Colour scheme for a romantic wedding by U.S. design studio Legacy Loft, with pink chosen as the theme colour of the whole wedding as well as of the stationery, completing a tender and intimate context with distinct female characteristics. To use similar colours with the main tone is a safe choice.

Fig. 2.10.1-2.10.2: A rural wedding held in a grove, with green nature as the background, by U.S. design studio Olive & Emerald. Contrastively bright orange is chosen as the theme colour of the stationery. Complementary colours help get rid of the otherwise tedious atmosphere and add interest to the wedding.

Fig. 2.11.1-2.11.2: Colour scheme with rich and bright hues adding vigour and vitality to the wedding, by UK-based studio NatsukiOtani Illustration

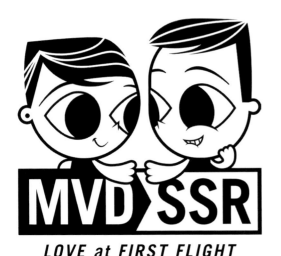

圖 2.5 該設計來自中國香港的卡洛藝術創作工作室，這是一場農場主題的婚禮，兩位新人的願望就是在不久的將來能有一個屬於自己的農場。他們兩個都很喜歡動物，特別是豬，所以設計師特意將他們的婚禮標識設計成一對可愛的恩愛小豬，特點鮮明，給賓客留下了深刻的印象。

圖 2.6 該設計來自西班牙埃爾·卡魯蒂伯設計工作室，設計師將兩位新人照片做特殊處理，並且加入了新人的名字作為婚禮的標識。

圖 2.7 該設計來自義大利設計師馬拉·可倫坡，設計師抓住了兩位新人的特點，將兩位新人的形象用插畫的形式表現出來，讓人印象深刻。

圖 2.8 該設計來自加拿大設計師邁克爾·德·皮波，這是一場同性婚禮，設計師將兩位新人以一對四目相望的卡通人物插畫表現出來，凸顯了兩位新人一見鍾情的浪漫戀愛史。

圖 2.9.1、圖 2.9.2 該設計來自美國設計工作室"傳說中的閣樓"，這是一場浪漫風格婚禮，婚禮平面與整場婚禮都選擇了相同的粉色調，顯得柔嫩而又溫馨，具有明顯的女性特徵。與婚禮主色調相近的顏色是穩定保守的選擇。

圖 2.10.1、圖 2.10.2 該設計來自美國奧利弗＆埃默拉爾德設計工作室，這是在一片小樹林中舉辦的田園風格婚禮，背景是大自然的綠色，而設計師卻選擇了鮮明的橘黃色作為婚禮平面的主色調。選擇互補色能夠消除沉悶的氣氛，使婚禮環境更加悠然。

圖 2.11.1、圖 2.11.2 該設計來自英國大谷夏樹插畫設計工作室，設計師選擇了五彩繽紛的漸層作為該設計的主色調，大膽的配色將簡單的背景襯托得更有趣味性。

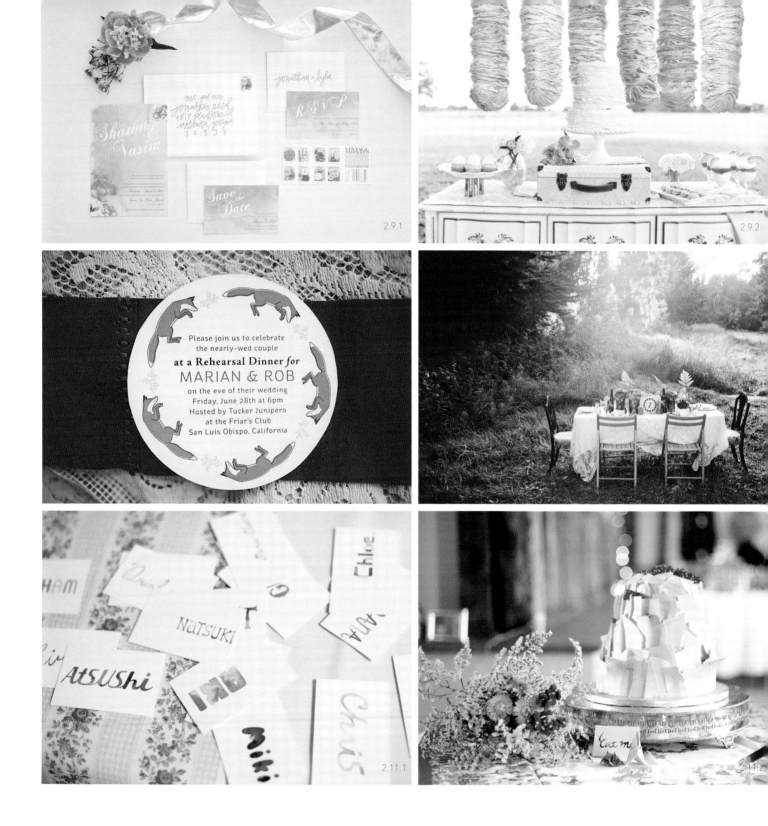

2.9.1

2.9.2

Please join us to celebrate
the nearly-wed couple
**at a Rehearsal Dinner** *for*
MARIAN & ROB
on the eve of their wedding
Friday, June 28th at 6pm
Hosted by Tucker Junipero
at the Friar's Club
San Luis Obispo, California

2.11.1

## Fine Pattern

Patterns are an important decorative element in graphic art. In wedding stationery design, proper use of patterns can enrich a wedding and impress the guests with beautiful graphics. Commonly used patterns in wedding design include basic patterns, frame patterns and repetitive patterns, with floral images or figures, printed or handwritten. What's worth mentioning is that the pattern should be chosen according to the style of the wedding. (Fig. 2.12-2.13)

## Interesting Illustration

Illustrations can go with the text as a decorative or explanatory element, adding appeal and interest to the wedding. In wedding stationery, illustrations frequently used include character illustrations, animal illustrations and scenery illustrations. Character illustrations mainly feature the bride and groom, highlighting their typical facial expressions and gestures. Animal illustrations usually are cartoons of the newlyweds' favourite animals. Scenery illustrations would feature typical landscapes at the location of the wedding venue, sometimes designed as a simple map for the guests' convenience. Exaggeration and personification are common approaches in such illustrations. Character illustrations are often exaggerated figures of the bride and groom, with their typical features highlighted. Animal illustrations usually have cartoon animals personified with their own unique features. Besides, try to make things interesting and show creativity of the newlyweds. An interesting wedding with playful, distinct visual language is likely to impress the guests and make the wedding memorable. (Fig. 2.14-2.16)

## Brief Text

Texts are a necessary ingredient and the most informative part in wedding stationery. The arrangement of texts is a decisive factor in creating a clear visual image for guests. Words should be brief and designed based on the style of the wedding.

Texts can be printed or handwritten. An invitation card with handwritten words can be distinctive and show the newlyweds' respect for the guest, but the words should be clear and tidy for easy reading. No matter printed or handwritten, names of the guests should be correctly spelled. (Fig. 2.17-2.19)

## 精美的圖案

圖案是具有裝飾性和藝術性的平面元素，在婚禮平面設計中，合理地運用圖案會使整場婚禮更有意境，給賓客強烈的感染力。在婚禮平面設計中經常出現的圖案一般有單獨紋樣、適合紋樣以及連續紋樣，圖案的題材一般為植物圖案、花卉圖案以及人物圖案，在表現方式上通常以印刷和手繪為主。需要注意的是選擇圖案的標準一定要以整場婚禮的風格為主要依據。（見圖2.12、圖2.13）

## 趣味的插圖

插圖也是插畫，在婚禮平面設計中加入合適的插圖，不僅可以對文字內容做出形象的說明，還可以加強作品的感染力和趣味性。在婚禮平面設計中，經常用到的插圖一般有人物插圖、動物插圖以及風景插圖。其中人物插圖主要以兩位新人為主要素材，透過抓住新人的臉部特徵、肢體動作來表現出新人的特點。動物插圖是以動物的卡通形象為主要素材，一般選用新人喜愛的動物，並賦予其人的感情色彩。風景插圖是以婚禮舉辦地的風景作為主要素材，有時可以設計成地圖或行車線路圖的形式。在表現手法上，一般採用誇張、擬人、趣味的表現手法。其中誇張手法是要極力誇大形象的特點，目的是使形象更凸顯、更鮮明、更具有典型性。在動物插圖的表現上通常使用擬人的手法讓插圖顯得妙趣橫生，使形象更具有鮮明的個性，從角色的人性化創作過程中，把平凡轉化為神奇。在設計婚禮平面設計時，還會經常運用到趣味的表現手法，既可以反映出設計的內容，又可以看出新人的創造力和修養，設計師將大家熟悉的事物，經過巧妙的色彩構圖，既給賓客留下一種嶄新奇特的視覺印象，又能產生輕鬆愉快的趣味性，使人讚嘆令人回味。（見圖2.14~ 圖2.16）

## 醒目的文字

文字是婚禮平面設計的重要組成部分，在婚禮平面設計中，文字是最為重要的構成元素，其主要功能是向賓客傳達新人的意圖和婚禮資訊。要達到這一目的，給賓客清晰的視覺形象，文字設計排列的好壞直接影響最終版面的視覺效果。婚禮平面設計的文字設計應避免繁雜凌亂，並且要符合整場婚禮的風格特徵，不能與婚禮相脫離。

在婚禮平面設計設計中，文字設計一般採用印刷和手寫兩種形式。但需要注意的是，手寫文字雖然能夠更加凸顯特色，顯示新人的誠意，但書寫時一定要工整美觀，切勿潦草。不管是印刷還是手寫，都要正確書寫賓客的名字及婚禮資訊，做到無誤是對出席賓客最基本的尊重。（見圖2.17~ 圖2.19）

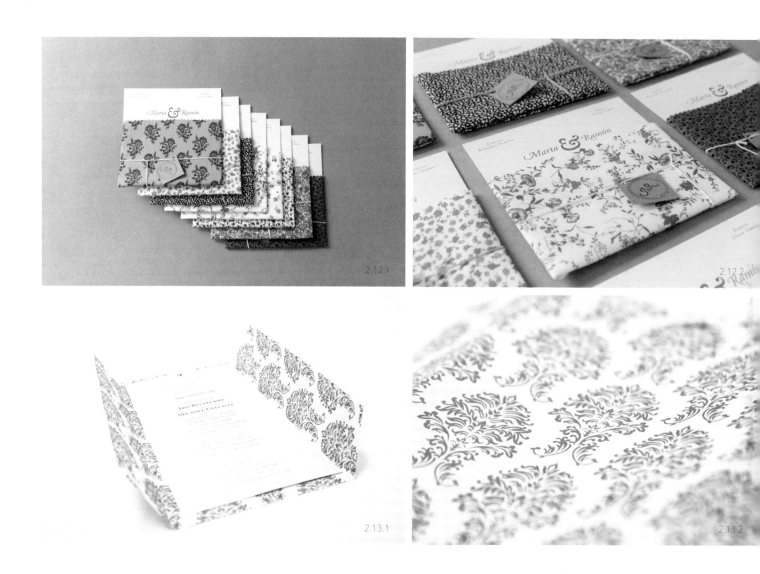

Fig. 2.12.1-2.12.2: Invitation cards for newlyweds who love nature very much, with various floral patterns and wrapped in cloth with the same style, by Spanish designer Carlos Robledo Puertas

Fig. 2.13.1-2.13.2: Fine floral pattern for a classical-style wedding, by New Zealand designer Michiel Reuvecamp

圖 2.12.1、圖 2.12.2 該設計來自西班牙設計師卡洛斯‧羅夫萊多‧普埃爾塔斯，這是一場田園風格婚禮，設計師依新人喜愛植物的特點，設計了一套帶有各種植物圖案的婚禮請柬，每套請柬都放在不同圖案的布藝袋子中，不僅匠心獨運且值得人們收藏。

圖 2.13.1~2.13.3 該設計來自新西蘭設計師米希爾‧羅夫坎普，這是一場經典風格婚禮，設計師在婚禮平面設計中加入了適合整場婚禮風格的植物紋樣，看起來十分精美。

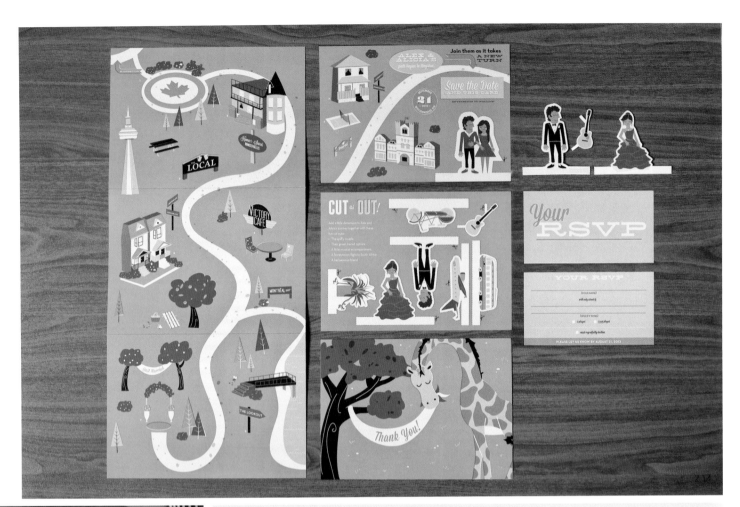

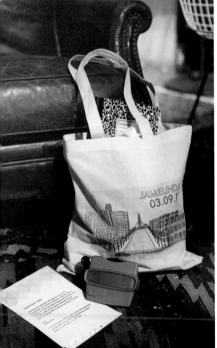

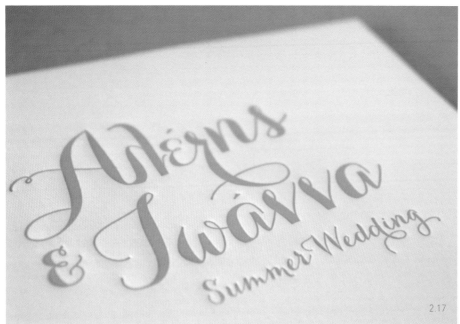

Fig. 2.14: Wedding stationery with cartoons of the bride and groom, wedding schedule, as well as the map, making things easy and interesting and completing a wedding full of vigour, by August Studios based in Canada

Fig. 2.15: Hand bag as a gift for the guest, printed with an illustration of Los Angeles, the city where the wedding takes place, by U.S. design studio 'Bash, Please'

Fig. 2.16: Wedding stationery by German designer Jono Garrett with his team. The newlyweds asked friends and family to draw illustrations and use them in their invitation cards and dishes. These illustrations have special meaning for the new couple.

Fig. 2.17: Names of the newlyweds in handwritten form by Greek design studio FIIL. The blue letters brought a breeze to the summer wedding.

Fig. 2.18: Invitation card in a DIY wedding in which all elements are designed with illustrations by U.S. design studio Jolly Edition. Names of the newlyweds are handwritten with distinctive letters.

Fig. 2.19: Invitation card by Spanish design studio mubien for a young couple who prefer modern-style wedding stationery with futuristic prints

圖 2.14 該設計來自加拿大八月設計工作室，設計師用卡通趣味性的方式將兩位新人的形象以及婚禮當天的流程和地圖表現出來，簡單易懂且色彩鮮明，顯得這個婚禮生氣勃勃，富有活力。

圖 2.15 該設計來自美國設計工作室 "請重擊"，設計師將兩人的婚禮舉辦在洛杉磯用插圖的形式表現出來，並且印在手提袋上作為給賓客的回贈禮，令人印象深刻。

圖 2.16 該設計來自德國的設計師約諾·加勒特等，新人特意邀請了自己的親朋好友繪製了不同的插圖，並且將其運用到自己的婚禮請柬及盤子上，這些插圖對新人具有特殊的意義。

圖 2.17 該設計來自希臘設計公司 "菲兒"，這是一場夏季婚禮，設計師將新人們的名字設計成清新的藍色手寫字體，就像夏天的一縷清風，讓人備感清涼。

圖 2.18 該設計來自美國喬利設計工作室，這是一場 DIY 婚禮，所有的婚禮平面設計設計都由 "喬利設計" 以插畫的形式表現出來，該公司還專門為兩位新人手寫了他們的婚禮請柬，字體簡潔清秀，凸顯了新人的特點。

圖 2.19 該設計來自西班牙穆必恩設計工作室，這是一場現代風格的婚禮，這對年輕的新人設計了一套非常時尚的婚禮平面設計，所有的字體都採用現代印刷字體，顯得設計感十足。

## 婚禮平面的設計手法

### Feature of the Newlyweds

Every wedding is unique, and the wedding stationery should be based on the feature of the new couple, including their dispositions, personalities and hobbies, which should be taken into account when choosing a style for the wedding. For instance, newlyweds who are big kids at heart prefer cartoon style; a couple with some petit bourgeoisie sentiments would like an exquisite and elegant wedding; newlyweds who love rock and roll are likely to choose the mysterious Gothic style; retro-styled weddings are suitable for a low-key and nostalgic couple; while rural style would be perfect for people who love being close to nature. Moreover, occupations of the new couple can be a decisive factor. For example, a math teacher might use geometrical elements in his wedding stationery; designers prefer artistic weddings; and farmers could have images of farm animals in their wedding. In a word, the feature of the new couple is what makes their wedding distinctive and should be considered seriously in stationery design so that guests would be impressed and left with a good memory. (Fig. 3.1-3.2)

### Aspirations & Gratitude of the Newlyweds

A wedding is a solemn ceremony on which we have wishful vows between the bride and groom, gratitude of the newlyweds towards their parents, blessings from friends and family… A good wedding stationery design should not only fully display to the guests the intimate love between the new couple, but also express their aspirations and gratitude to the guests. Sometimes the new couple would make DIY gifts for guests, inexpensive but unique, with deep sincerity and thus worth being cherished. (Fig. 3.3-3.4)

### 新人特徵的表述

每一場婚禮都是獨一無二的，婚禮平面設計也必須要考慮新人的特點及喜好，不同的新人應該呈現出不同的風格。例如童心未泯的新人們適合選擇卡通風格，小資情調的新人們適合選擇清新風格，喜歡搖滾樂的新人適合選擇妖媚氣質濃重的哥特風格，低調懷舊的新人們適合選擇復古風格，喜歡親近大自然的新人們則可以選擇田園風格等等。當然，在設計婚禮平面設計項目時，還可考慮雙方新人的職業。數學老師的婚禮可以加入平面幾何的元素，而設計師的婚禮可以設計得更具藝術特色，農場主人的婚禮則可以加入農場動物的元素。總之，為賓客奉上一套能夠準確表達新人特徵的婚禮平面設計，既可以給親朋好友一份驚喜，也給大家留下很多美好的回憶。（見圖3.1、圖3.2）

### 新人情感的表述

婚禮是一個莊重的儀式，在婚禮上有幸福的誓言，有對父母的感恩，有親朋好友的祝福，可以說婚禮本身就是各種感情的表現。一個成功的婚禮平面設計案例，不僅要向賓客表達出兩位新人之間的親密愛情，更要向賓客表達出兩位新人的感謝之情、純真的友情以及深厚的親情。有的新人選擇親手製作禮物回贈給賓客，純手工製作成就了它的獨一無二，可能東西並不貴重，但卻能夠讓賓客感受到新人的真誠和滿滿的愛心，值得一輩子去珍藏。（見圖3.3、圖3.4）

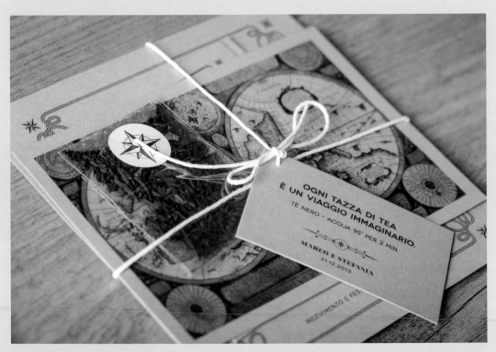

Fig. 3.1: Paper goods for a couple who love travelling very much, with compass, map and nautical symbols, by Italian design studio caratterino

圖 3.1 該設計來自義大利卡特里諾設計工作室，這對新人非常喜歡旅行，設計師利用指南針、地圖及航海標誌等元素為他們量身設計了這套作品，清晰地向賓客傳達了兩位新人的特點。

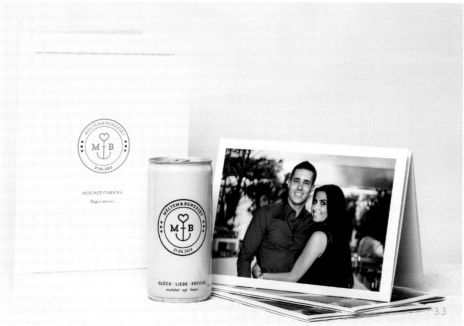
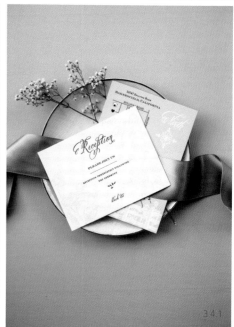
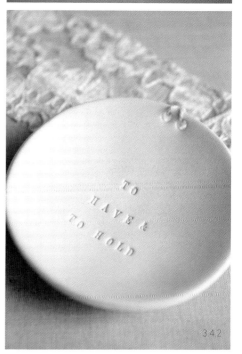

Fig. 3.2.1-3.2.3: Stationery for a wedding with strong Chinese style, by U.S. design studio Atelier Isabey. The new couple are both fans of China, and Chinese elements can be found everywhere: special buttons in the Chinese dress cheongsam, Chinese seals, window lattices in ancient Chinese architecture... Thanks to contemporary techniques of surface printing and laser cutting, these elements can impress the guests with both modern exquisiteness and the aesthetics of antiquity.

Fig. 3.3: Wedding stationery by German design studio K.GREBE, for a couple to demonstrate three aspirations: luck, success and love, graphically symbolised by star, diamond and heart. An intimate photo was printed on the invitation to highlight the most precious one – love.

Fig. 3.4.1-3.4.2: Wedding stationery by U.S. studio Papermade Design, including reception card and map, together with a silk ribbon and handmade pottery dish, given to the guest with heartfelt gratitude and respect from the new couple

圖 3.2.1- 圖 3.2.3 該設計來自美國伊薩貝設計工作室，這是一場具有中國特色的浪漫風格婚禮。從這幾張圖片中不難看出這對新人是個中國迷。設計師運用了旗袍的盤扣、中國的印章以及中式的窗櫺來表現中國文化的主題，凸板印刷加上了鐳射切割技術，使整件作品精緻美觀，給人留下很深刻的印象。

圖 3.3 該設計來自德國格雷貝設計工作室，這對新人要向人們展示他們的三個願望：幸運、成功與愛情，設計師特意用星星、鑽石和心來代表這三個願望，並且在他們的婚禮請柬上印上了兩人的親密合照，向人們表達了他們珍貴的愛情。

圖 3.4.1-3.4.2 該設計來自美國設計公司 "紙質設計"　設計師特意將這套婚禮平面設計項目用絲帶綁在手工製作的小陶盤上和婚禮請柬一起贈送給賓客，同時配上了表示感謝的小卡片，既表現了新人在細節之處的用心，同時又表現了對賓客的尊重，讓人感覺溫暖又貼心。

## 婚禮平面的製作工藝

Wedding stationery is the media to share information of the wedding with the guests, and the quality of the media is important for the success of a wedding. Apart from design approaches, good techniques for production will improve quality of the stationery and enhance easy communication. For graphic designers, when choosing certain techniques, it is necessary to keep the style of the wedding in mind. The following paragraphs will introduce some commonly used techniques.

### Sketches

Nothing can make a wedding more special than sketches drawn by the newlyweds themselves! What's more, in this way they can participate in the wedding preparation and enjoy the happy process. Before drawing, you should have an idea about your creation, including the contents and approaches. You may sketch an intimate moment, or beautiful landscape of the wedding venue, or something special between you two. The style and colour scheme of the wedding can be decisive in choosing the tone of your sketches. For example, for a romantic wedding, light pink, lavender and beige would be appropriate, while in a modern wedding, clean, pure colour will feel fashionable. Finally, you could scan the sketches into your computer and make subtle modifications. Apart from pencil sketches, watercolours can be a good choice, which can easily recall relaxed and happy time in early spring and midsummer, and therefore is perfect for weddings in refreshing, rural or romantic styles. The light colours are likely to enhance sweetness and romance of your wedding. Pencil sketches would be suitable for modern-style weddings, with simple portrait sketches directly printed on pieces of wedding stationery revealing the artistic taste of the new couple. (Fig. 4.1-4.3)

### Embossing

Embossing is an artistic technique that creates a pattern on a material such as paper, metal, fabric, leather, or wood. The pattern can be raised or in relief, depending on how it is embossed. There are two ways to emboss: dry embossing and heat embossing. Nowadays the technique has gained its popularity in wedding stationery design. Both dry and heat embossing techniques can be used for such projects, depending on how the artist wants the finished piece to look. This technique will create unique raised designs that cannot be replicated, contributing to delicate and elegant details in your wedding stationery. (Fig. 4.4-4.6)

婚禮平面作為婚禮資訊的重要因素分享給認識的每一位親朋好友。然而，想要擁有一場完美的婚禮，婚禮平面設計的製作工藝同樣重要。巧妙的工藝不僅僅是為內容穿件華麗的外衣，而且是在為新人和賓客之間的交流加分。對設計師而言，在選擇某種製作工藝時，一定要以整場婚禮的風格為主要依據。下面介紹幾種常見的製作工藝。

### 手繪

如果新人想要一場獨一無二的婚禮，又想真正地參與其中並且享受到婚禮帶來的幸福感，不妨為自己手繪一套專屬的婚禮平面作品吧。在繪製前，首先要考慮到創意、構圖等問題，繪製的內容可以是兩人的照片，可以是結婚場地優美的風景，也可以是兩人的定情物件。其次要考慮到婚禮的風格及整體配色，浪漫的婚禮適合淡粉色、淡紫色和米黃色，現代的婚禮適合時尚的純色。最後可以將繪製的最終圖形掃描進電腦裡進行最後的調整和修改。繪畫的形式可以是水彩也可以是素描。水彩總是讓人們想起心曠神怡的初春和盛夏，清新風格、田園風格及浪漫風格的婚禮用水彩這樣柔軟的色調來繪製，是再好不過的選擇了。輕柔素雅的顏色相互融合在一起，能給整場婚禮製造出無限的甜蜜和浪漫。寫實的現代風格婚禮比較適合用鉛筆素描來繪製，淡雅樸素的素描頭像可以直接印製在婚禮平面作品上，與傳統模式的作品相比，既溫馨甜蜜又展現了新人的藝術氣息。（見圖4.1～圖4.3）

### 凹凸

凹凸工藝又稱"凹凸印刷"，該工藝最大的特色是不用油墨，而是使用預製好的雕刻模型，透過機械壓力作用使紙張表面形成高於或低於紙張平面的立體效果。如今，這種印刷工藝已經越來越多地運用到婚禮平面設計中，並且在傳統設計上增加了更多的新技術，字體的印跡更深，不僅看得清楚還能用觸覺感受出來，使整個作品溫柔雅致又不失精美。（見圖4.4～圖4.6）

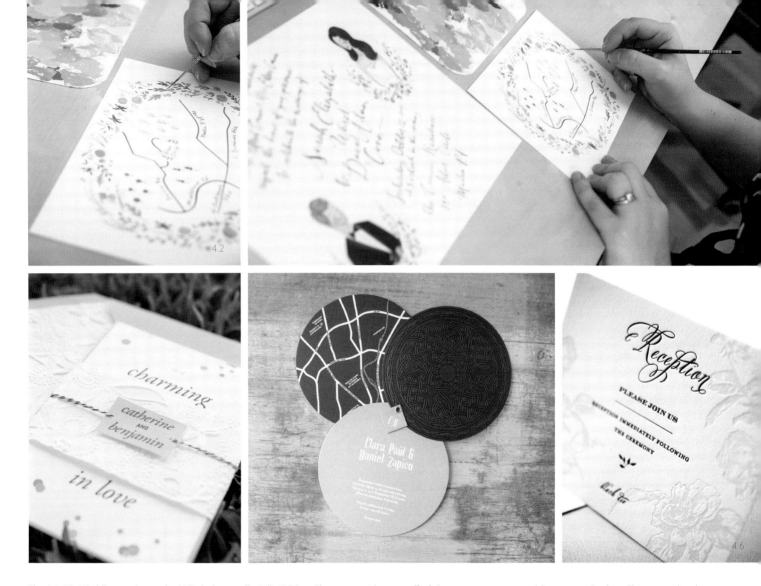

Fig. 4.1-4.3: Wedding stationery by U.S. design studio Jolly Edition. The new couple are staff of the same restaurant, and love comes in time. They wanted to have a memorable travelling wedding. The stationery was custom designed based on wedding pictures, daily photos and special items provided by the couple. The white background, lovely sketches and beautiful illustrations with pleasing colours and forms all together complete a really memorable wedding experience.

Fig. 4.4: Paper goods by U.S. studio Llorente Design, inspired by fashion brand Kate Spade. Laces in Kate Spade bags are replaced by embossed paper, completing an avant-garde yet romantic wedding.

Fig. 4.5: Wedding stationery for a musician couple, by Spanish design studio El Calotipo. The cards are designed mimicking vintage vinyl records, added with elements of Baroque music which the new couple loves. Embossing technique is employed to enhance the retro sense.

Fig. 4.6: Reception card for a classical-style wedding by U.S. studio Papermade Design. Floral patterns are embossed on the card.

圖 4.1- 圖 4.3 該設計來自美國喬利設計工作室。兩位新人在同一家餐廳工作，日久生情，他們想要舉辦一場難忘的旅行婚禮，該設計公司根據新人提供的婚紗照、日常照以及兩人的定情物等各種資料，繪製了這套別有一番風味的婚禮平面作品。白色的背景、漂亮的插畫手繪圖案、顏色和形式都讓人心情愉快，如此獨特和用心的設計應該會留給主人和賓客一輩子美好的回憶。

圖 4.4 該設計來自美國洛倫特設計工作室。著名時尚品牌凱特·絲蓓是設計的主要靈感來源，設計師將凱特·絲蓓皮包中的蕾絲花邊，用帶有凹凸工藝的紙來代替，整套作品現代大膽，同時又不失浪漫特色。

圖 4.5 該設計來自西班牙埃爾·卡魯蒂伯設計工作室。這是為一對音樂人所做的婚禮平面設計，整個設計像一張音樂黑膠片，配上這對新人喜歡的具有巴羅克音樂風格的元素，用凹凸的工藝展現出來，不僅具有濃厚的個人特色，還為人們展示了美妙音樂的感染力。

圖 4.6 該設計來自美國設計公司"紙質設計"。這是一場經典風格婚禮，設計師將美麗的花朵用凹凸的方式展現在作品上，十分精美又有立體感。

### 3D

The 3D technique that is often applied in book design is now becoming popular in wedding stationery, especially for invitation cards. A 3D card is usually complicated in design, but when the guest opens it, it brings a big surprise! Moreover, 3D invitations can display the whole scene of the wedding venue, and thus can be convenient and helpful for guests. (Fig. 4.7-4.8)

### Metal Arts

Metal arts made by metal plates with specially treated surfaces can be applied as decorations in wedding stationery. The solid material ensures that such decorations would stand the test of time, and this is particularly meaningful for a wedding as a symbol of everlasting love and happiness. The special texture of metal would add a sense of nobility to the wedding. (Fig. 4.9-4.10)

### Hollowing Out

Paper or cards can be laser engraved to produce a hollowed-out structure. Such a technique would bring out both a classical air and a stylish atmosphere. Tradition and modernity are thus perfectly combined into one. (Fig. 4/11-4.12)

### Fabrics

The texture of fabrics particularly recalls a Zen atmosphere and the charm of the Oriental. Generally speaking, fabrics is a compatible element as any material or item can be combined with fabrics to produce any style desired, be it refreshing, natural, elegant, gorgeous, romantic or sentimental. Fabrics can be graceful with particular colours and qualities, adding exquisite details to the wedding. (Fig. 4.13)

### 立體

人們經常見到書籍中的立體工藝，現在也越來越多地運用到婚禮平面設計中，多用於婚禮請柬設計。立體的婚禮請柬設計複雜，在打開的瞬間會讓賓客感受到濃濃的設計感與空間時尚感，能夠顯現出新人的品味。立體請柬的優勢在於可以快速地展現婚禮舉辦場地的全景，讓賓客對婚禮場地一目瞭然、清晰可見。（見圖4.7、圖4.8）

### 金屬雕花

金屬雕花板表面是經特殊圖層處理過的優質彩色浮雕金屬板，因其材料的優勢可以長久保持美觀，同時代表著對新人天長地久的祝福之意。金屬的質感為婚禮的整體形象設計增添了高貴的氣質。（見圖4.9、圖4.10）

### 鏤空

鏤空工藝又叫鐳射雕刻，代表著雕刻的技藝，外表的完整與內部的通透形成鮮明的對照。這種通透、柔美的質感既經典又具有時尚的氣息，顯現出新人溫馨浪漫的性格特點。（見圖4.11、圖4.12）

### 布藝

布藝的質感更多的表現出東方禪意的韻味，表現出新人睿智含蓄的人格魅力。與布藝材質搭配清新自然、典雅華麗、情調浪漫，因為材質本身的包容特性讓它跟很多不同風格的物件都可以搭配，而且會有完全不同的感覺。布料的色彩和質感也從細節上彰顯著高貴典雅的氣質。（見圖4.13）

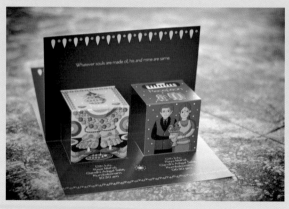

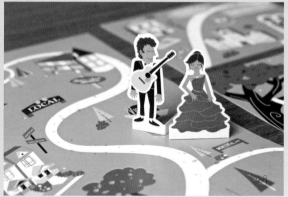

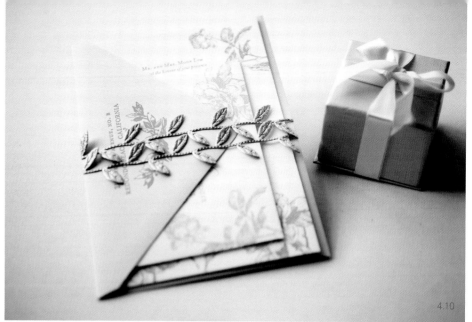

Fig. 4.7: 3D card for a traditional wedding in South India, by Indian design firm Atma Studios. The new couple and their parents appear in three-dimensional images, following the Indian tradition in a modern way.

Fig. 4.8: Cartoon map with images of the new couple standing three-dimensionally, playful and funny, by Canadian design firm August Studios. The guests would expect an interesting wedding!

Fig. 4.9: Floral metal arts as decoration for a small vintage box, delicate and lively, by U.S. design studio Gourmet Invitations

Fig. 4.10: Foliage metal arts combined with rose patterns on the cards completing a romantic contrast, by U.S. studio Papermade Design

Fig. 4.11: The intricate hollowed-out structure greatly enriched the design creating a 3D effect, by U.S. design studio Atelier Isabey.

Fig. 4.12: Paper goods with a typical Chinese element, window lattice, using techniques of hollowing out and 3D, also by Atelier Isabey

Fig. 4.13: Invitation envelop made of linen, simple yet revealing a retro style, by FIIL

圖 4.7 該設計來自印度阿特馬設計工作室。這是一場具有濃郁民族氣息的南印度傳統婚禮，在該設計中設計師運用了立體的工藝將兩位新人及其父母生動地表現出來，也表現了印度婚禮的特色。

圖 4.8 該設計來自加拿大八月設計工作室，設計師將整個婚禮舉辦場地設計成一張卡通風格的地圖，而兩位新人立於地圖上，簡單的設計使整個作品顯得生動有趣。用這樣一款婚禮平面設計作品，一定會讓收到的賓客眼睛為之一亮，更加期待參加這場婚禮。

圖 4.9 該設計來自美國設計公司 "美味請柬"。金屬雕花作為裝飾物放置在復古的盒子上，顯得十分精緻生動。

圖 4.10 該設計來自美國設計公司 "紙質設計"。柔美的玫瑰印花圖案配合金屬的葉子外環，別出心裁的設計使整個作品十分浪漫精美，使人過目不忘。

圖 4.11 該設計來自美國伊薩貝設計工作室。精美的鏤空藝術的運用，使整個作品富有層次，增添了立體感。

圖 4.12 該設計來自伊薩貝設計工作室。該設計向人們展示了濃厚的中國文化，傳統的窗櫺用鏤空和立體的工藝展現出來，凸顯了該場婚禮的特點。

圖 4.13 該設計來自希臘設計公司 "菲兒"。設計師選用亞麻布作為婚禮請柬的信封，展現出這場婚禮質樸、復古的風格。創新而簡潔的設計受到賓客的好評。

# ♥♥♥ Styles & Case Studies ♥♥♥

## 婚禮平面的設計風格及案例

The wedding is one of the most important occasions in one's life, and everyone deserves a personalised and unique wedding. People of different nationalities, ethnic backgrounds and faiths prefer weddings in different styles, such as vintage, ocean, romantic, classic, rural and modern styles. In the following part of case studies you can find wedding stationery designs for these styles.

婚禮是我們人生中最重要的時刻，每個人都想舉辦一場屬於自己的個性化婚禮，不同國家、不同民族、不同信仰的人所舉辦的婚禮風格都有所不同。比較常見的風格有：復古風格、海洋風格、浪漫風格、經典風格、田園風格以及現代風格。在以下的案例中，將為大家詳細介紹在這幾種風格中，婚禮平面設計的具體應用情況。

# LAUREN & CHRISTOPHER 勞倫與克里斯多夫婚禮平面設計

Design agency: Papermade Design
Designer: Elaine Chou
Photographer: Erin J. Saldana Photography
Client: Lauren & Christopher
Country: USA

機構："紙質設計"公司
設計師：伊萊恩‧周
攝影師：愛琳 J.薩爾達納攝影公司
委託客戶：勞倫、克里斯多夫
國家：美國

For Papermade Design, these were one of the sweetest couples to work with. Lauren and Christopher shared a love for books and Lauren included a quote on the invitation and each of the coordinating pieces. The design was vintage-inspired and had a border reminiscent of old book designs with a monogram that included a dipped feather pen illustration. Colours were soft-muted in subtle golds and greys. The designers finished off the suite with a dark-gold wax seal.

對"紙質設計"公司來說，勞倫和克里斯多夫是他們的委託客戶裡面最甜蜜的一對夫婦了。兩人都熱愛讀書，婚禮請柬以及其他相關設計上引用的文字是勞倫提出的。這套平面設計採用復古風格，卡片邊緣的設計模仿古書的形式，利用兩人名字的首字母組合設計成 LOGO 標誌，還畫上一支羽毛筆。色彩上以柔和的金色和灰色為主，最後的封蠟採用暗金色。

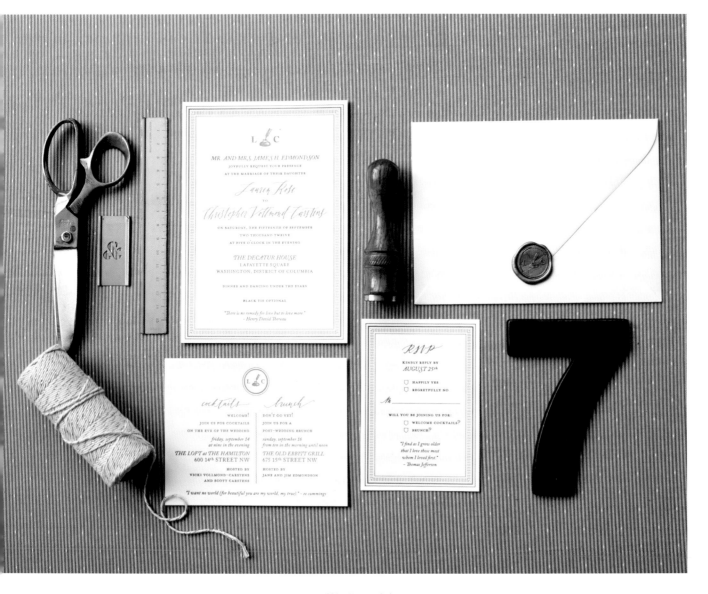

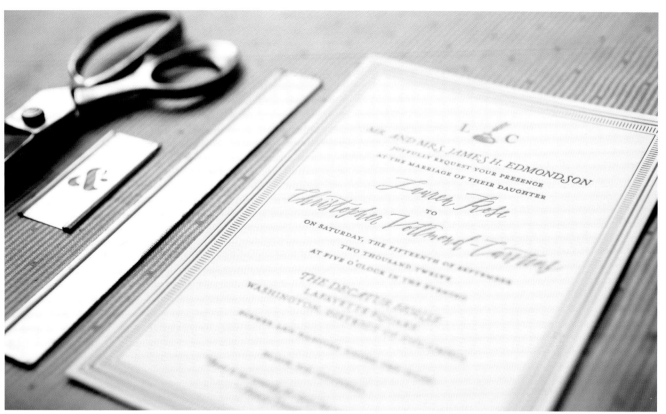

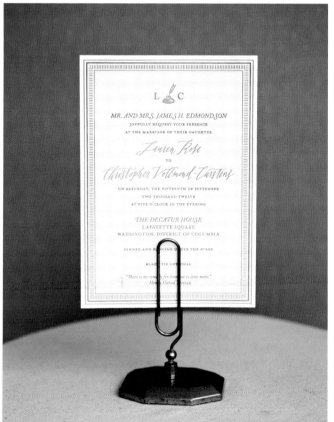

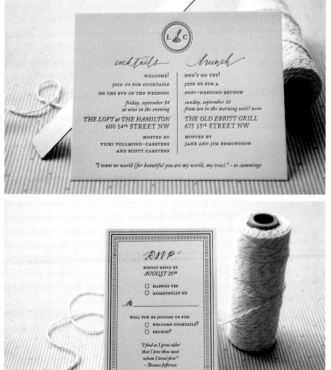

# PRIDE & PREJUDICE ＂傲慢與偏見＂婚禮平面設計

Design agency: caratterino
Designer: Ara Marsili
Photographer: Cinzia Bruschini
Country: Italy

設計機構：卡拉特里諾設計工作室
設計師：阿拉·瑪律西利
攝影師：欽齊亞·布魯斯奇尼
國家：義大利

Vintage wedding stationery based on Pride and Prejudice novel's theme. The designer wanted to recreate the romantic but also fervent atmosphere of the novel, where female characters contended for men's love and proudly struggled with it. So the stationary is a mix of letter, postcards and old pictures on Amalfi paper, wrapped by silk ribbon.

這是一套復古風格的婚禮平面設計，主題圍繞著小說《傲慢與偏見》。設計師想要重現小說中浪漫又熾熱的愛情氛圍，即女性角色為得到男士的愛而奮力競爭，同時又驕傲地與男士鬥爭。所以這套平面設計彙集了信件、明信片和古老的相片等形式，採用阿馬爾菲紙（Amalfi），並用絲帶裝飾。

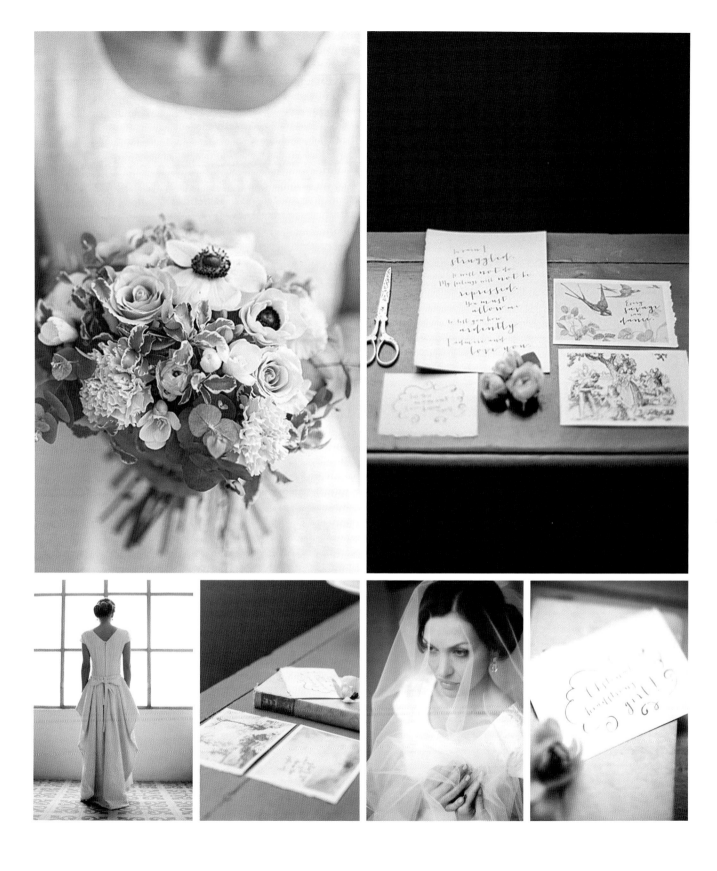

# VINTAGE TRAVEL SUITE 復古旅行婚禮平面設計

Design agency: caratterino
Designer: Ara Marsili
Photographer: Aberrazioni Cromatiche Studio
Country: Italy

設計機構：卡拉特里諾設計工作室
設計師：阿拉‧瑪律西利
攝影師：埃博拉基奧尼‧克洛馬蒂什工作室
國家：義大利

This wedding stationery is inspired by a couple who adores travelling. The designer used a kraft colour card, printed with compass, nautical elements and old maps. In the envelope, he also put a little tea bag, as a symbol of imaginary travels.

這對新人熱愛旅行，所以這套婚禮平面設計就以旅行為主題。設計師採用了牛皮紙顏色的卡片，上面印上指南針、古老地圖等各種與航海有關的元素。信封上繪製了一個小茶包，作為旅行的象徵。

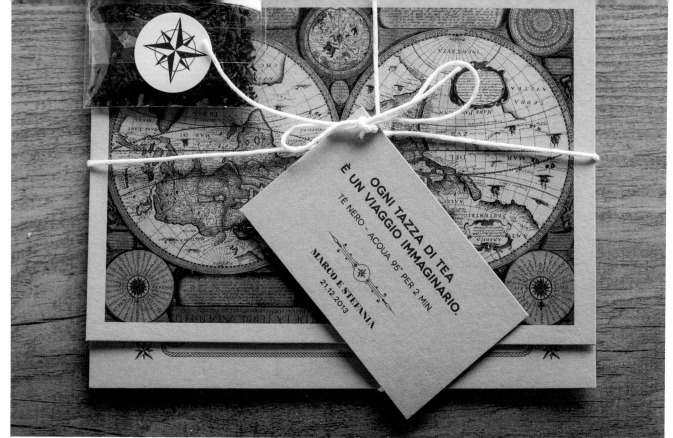

OGNI TAZZA DI TEA
È UN VIAGGIO IMMAGINARIO.

TÈ NERO - ACQUA 95° PER 2 MIN.

MARCO E STEFANIA
21.12.2013

Forneria Toffe

# AUDREY & RYAN

**奧德莉與賴安婚禮平面設計**

Design agency: Papermade Design
Designer: Elaine Chou
Photographer: Erin J. Saldana Photography
Client: Audrey & Ryan
Country: USA

設計機構："紙質設計"公司
設計師：伊萊恩·周
攝影師：愛琳 J. 薩爾達納攝影公司
委託客戶：奧德莉、賴安
國家：美國

This event included very bold decor such as white antler chandeliers. The designer used bright pops of blues, oranges and yellows with patterned accents. The playful motif and wording was key for this fancy, but not-at-all stuffy affair.

這場婚禮應用了非常大膽的裝飾元素，比如白色的鹿角吊燈。設計師採用了明亮的流行色，包括藍色、橘色和黃色等，並凸顯了裝飾圖案的使用。婚禮的主題和請柬的措辭都非常輕鬆幽默，奠定了這場婚禮的氛圍－趣味而不沉悶。

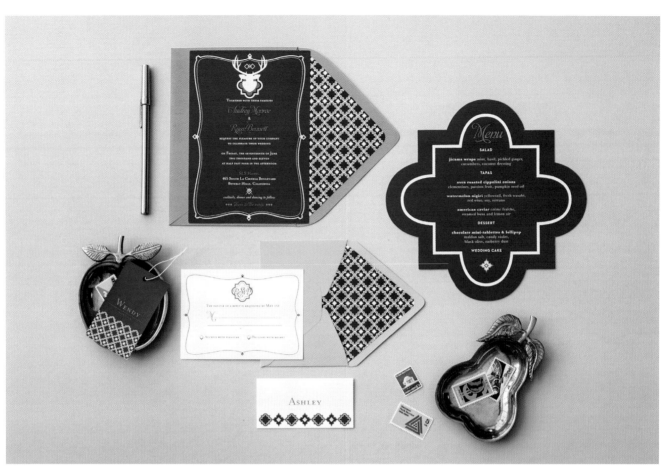

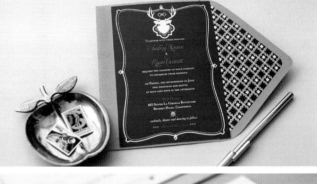

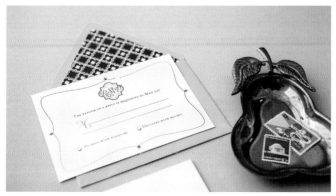

## GET HITCHED

### "幸福牽手" 婚禮平面設計

Design agency: Charlotte Fosdike
Photographer: Charlotte Fosdike
Client: Mark & Charlotte
Country: UK

設計機構：夏洛特·弗斯戴克設計工作室
攝影師：夏洛特·弗斯戴克設計工作室
委託客戶：馬克·夏洛特
國家：英國

Get Hitched was a unique project to design, as the clientele was the designer herself and her fiancé. She wanted their wedding invitations to be something that would deliver the essence of what they are as a couple. Both highly adventurous people – they love travelling, discovering new foods, and exploring the world with all of their senses. So she created an invitation that would give their guests a small taste of them as a couple.

"幸福牽手" 是一套很特別的設計，因為委託客戶是設計師自己和她的未婚夫。設計師想要他們的婚禮請柬傳達出兩人作為夫婦的特徵－兩個都是非常喜歡探險的人，熱愛旅行，喜歡發現新的美味，用一切感官去體驗世界。所以這款請柬的設計向賓客傳遞出夫婦二人的共同愛好和品味。

## DEAR STEPHEN AND REBEKAH JONES

Here is a gift of spices that will give you a taste of who we are together. We've chosen seven of our favourite flavours - those with which we've cooked, those that we've enjoyed whiffing and those that remind us of times we've spent together. As you probably know, we're rather adventurous people; we love to travel, eat new foods and meet new people.

WHEN WE'RE TOGETHER, WE'LL SOMETIMES COMPARE EACH OTHER TO SPICE. MARK SAYS HOT AND DELIGHTFUL. CHARLOTTE SAYS FULL OF FLAVOUR AND AMAZING ADVENTURES.

We both love that exoticness that the first taste delivers, as well as the mysterious ride that the spice takes us on as it matures in our palette - be it a slow sweetening, a stimulating burn or a surprising softening of tang which eases the bitterness of the food. We think that it can represent our journey together, past to present to future, saturating our lives in colour, variety and adventure. With this little box, you can have a taste of our perspective. Go on, we dare you to give some of these a go, they are pretty tasty, *especially with food.*

So, to help celebrate our passion for each other and our certain spice to life, Boyd and Annie Heidenreich, together with Bill and Joanne Fosdike, would like to invite you to our wedding.

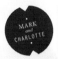

MARK *and* CHARLOTTE

CEREMONY
Time: 3pm
Place: Circle
of Oaks, corner
of Victoria Street
and John Avenue
Gumeracha

RECEPTION
Time: 5.30pm
Place: Gumeracha
Town Hall on 38
Albert Street

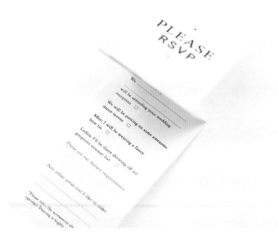

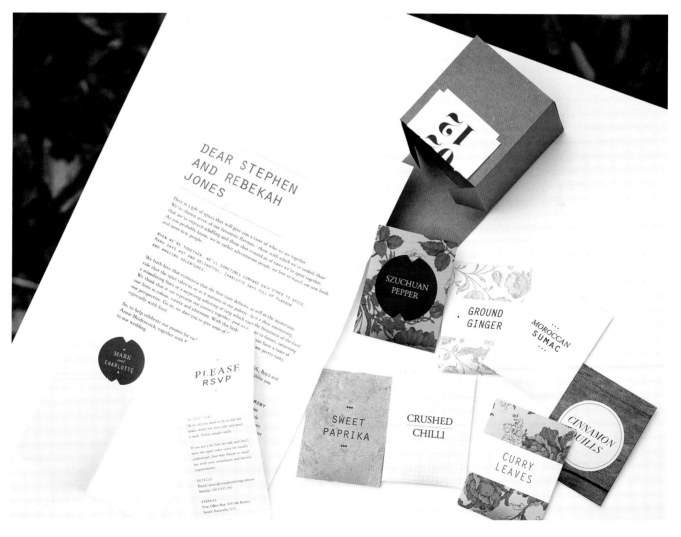

# CRISTINA & DAVID 克莉絲蒂娜與大衛婚禮平面設計

Design agency: El Calotipo Printing Studio
Photographer: El Calotipo Printing Studio
Client: Cristina & David
Country: Spain

設計機構：埃爾‧卡魯蒂伯設計工作室
攝影師：埃爾‧卡魯蒂伯設計工作室
委託客戶：克莉絲蒂娜、大衛
國家：西班牙

These are the wedding invitations of Cristina and David which El Calotipo designed thinking of the place where it was going to be celebrated: the Pyrenees. They tried to design them so that they'd have certain similarity with such a fabulous settlement, playing with wild motives and using materials to provide some warmth to them. The designers used cardboard as the main material and decorated the invitations with artisanal seal and a piece of a cord. This cord would keep the invitation and the plan together, preventing the attendees from arriving getting lost at any important places of celebration. In the following photos you can see the final result of this 100% Calotipo style invitation.

克莉絲蒂娜和大衛的婚禮請柬設計，以婚禮的舉辦地〝比利牛斯山〞為設計出發點。設計師力爭使這套設計與這一非同凡響的地點相匹配，呈現出某些共同點。設計採用了大自然的主題，並在材料的選用上儘量賦予其溫暖的感覺。主要材料採用硬紙板，並以手工藝印章和一截細繩來裝飾婚禮請柬。細繩將請柬和地圖綁在一起，避免賓客不小心遺失而導致錯過任何重要的婚禮活動。從圖片中可以看出，這套婚禮請柬設計是百分之百卡魯蒂伯風格的。

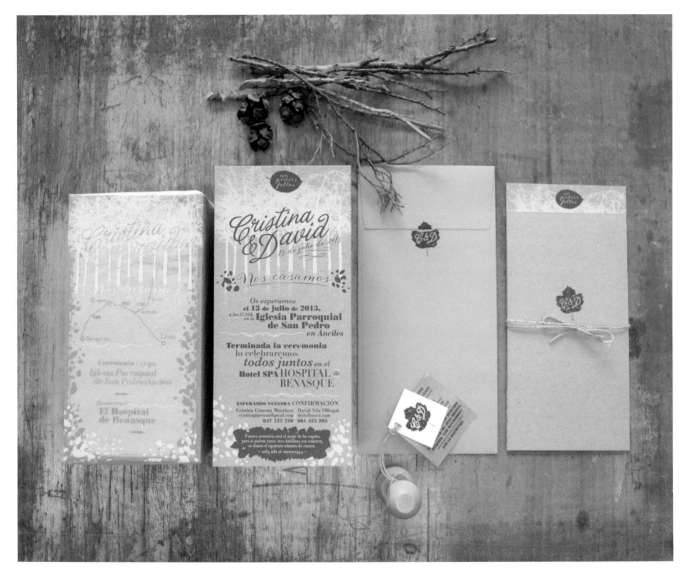

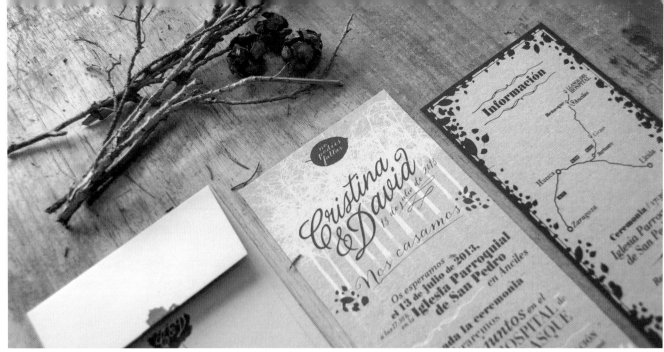

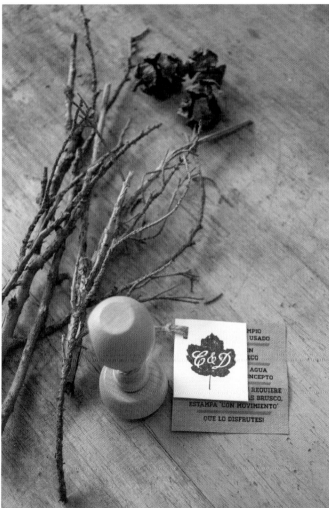

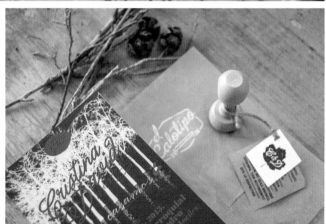

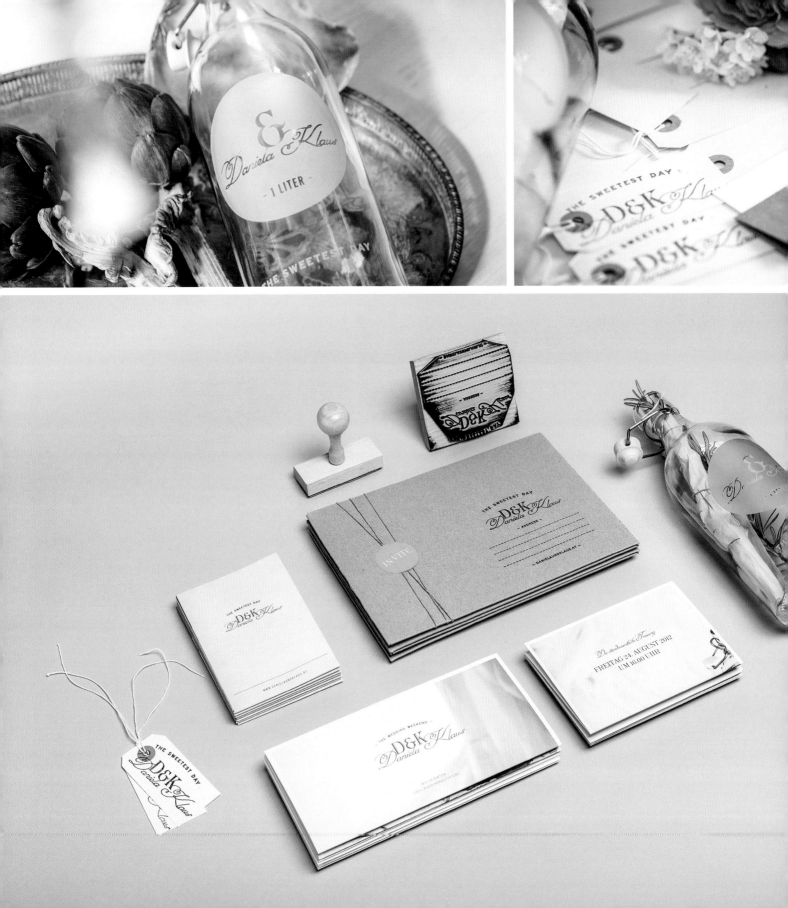

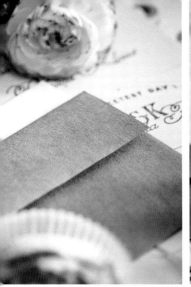

# D&K WEDDING
## D&K 婚禮平面設計

Design agency: Bureau Rabensteiner
Designer: Mike Rabensteiner & Isabella Meischberger
Photographer: Mike Rabensteiner
Client: Klaus Ehrenfried
Country: Austria

設計機構：哈本斯坦納設計工作室
設計師：麥克·哈本斯坦納、伊莎貝拉·邁施貝格爾
攝影師：麥克·哈本斯坦納
委託客戶：克勞斯·艾仁弗裡德
國家：奧地利

'Shabby chic with a squeeze of lemon'. This is the stationary design for a beautiful wedding on Mallorca, including the photography of the still life used for it. It was a "first" for Bureau Rabensteiner and they enjoyed doing it.

這是在西班牙東部的馬略卡島上舉辦的一場浪漫婚禮，平面設計主打 "新懷舊" 風格帶一點兒 "檸檬味的小清新"。設計師大膽採用靜物畫的形式，這對哈本斯坦納設計工作室來說尚屬首次，設計師也享受其中。

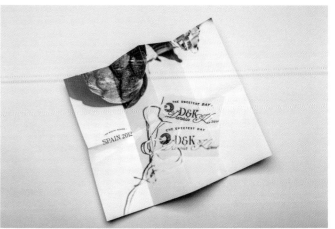

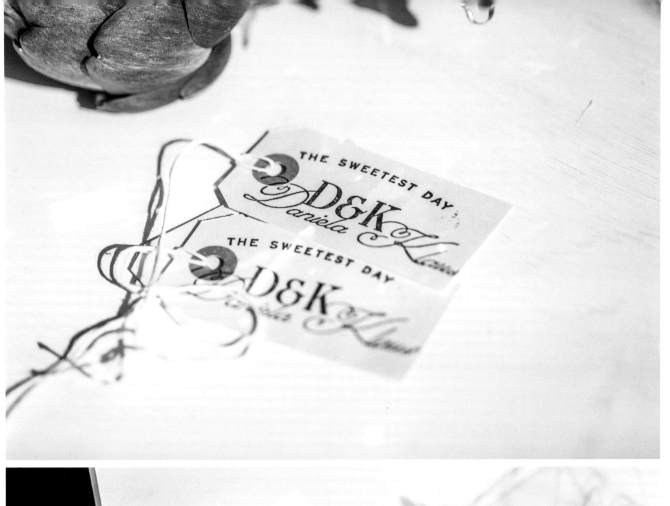

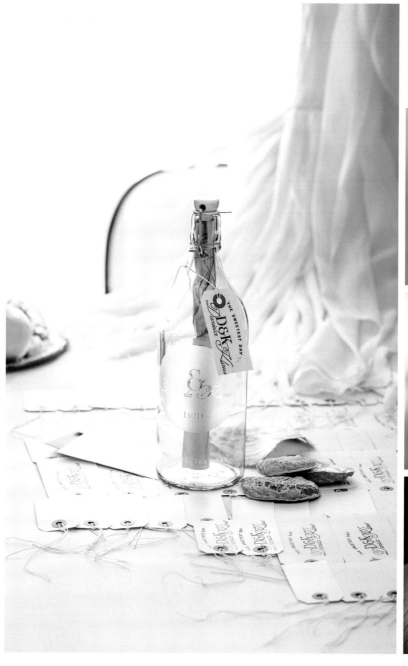

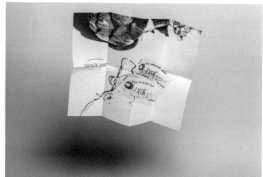

# VINTAGE WEDDING IN THE SOUTH OF FRANCE

## 法國南部復古婚禮平面設計

Design agency: Monsieur + Madame
Designer: Maeva & Cedric Dendoune
Photographer: Anne-Claire Brun
Client: Rachel & Fabien Christin
Country: France

設計機構："先生＋太太"設計工作室
設計師：瑪伊瓦・丹杜納、塞德里克・丹杜納
攝影師：安-克雷爾・布朗
委託客戶：蕾切爾・克裡斯汀、法比安・克裡斯汀
國家：法國

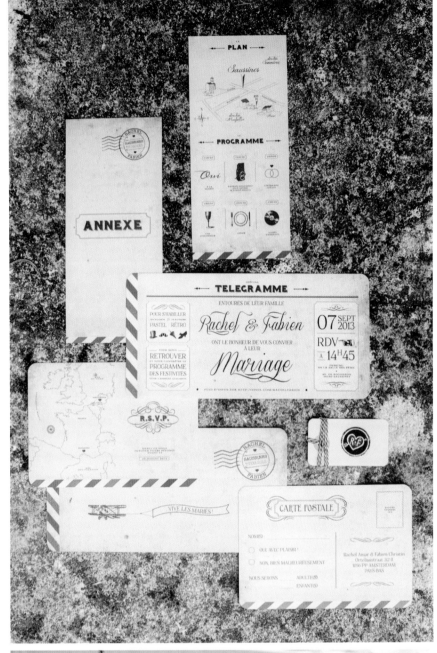

Rachel and Fabien asked Monsieur + Madame to create a vintage atmosphere for their wedding. They wanted something like a garden party from the 1920s, back a century earlier with a big outdoor banquet and cute antique details. The designers started with the airmail stationary and created all the graphic design in every detail of the decoration. It was a magical day!

蕾切爾和法比安邀請"先生＋太太"設計工作室為他們的婚禮打造浪漫的復古氛圍。他們想要 20 世紀 20 年代"遊園會"（露天招待會）的感覺，重現一個世紀前的浪漫場景，包括大型戶外宴會以及復古風格的各種細節設計 設計師以航空郵件的形式為設計出發點，對整套婚禮平面設計的每個細節都精益求精，鑄就了一場神奇的婚禮！

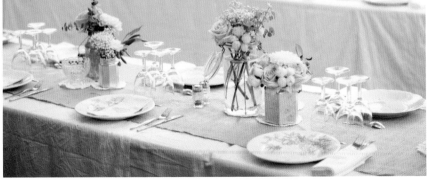

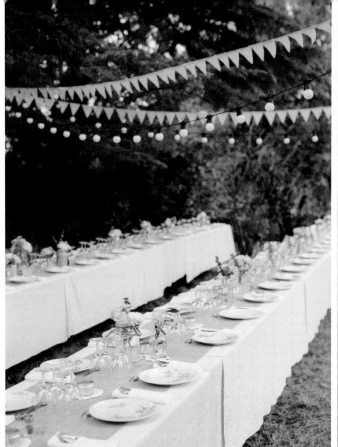

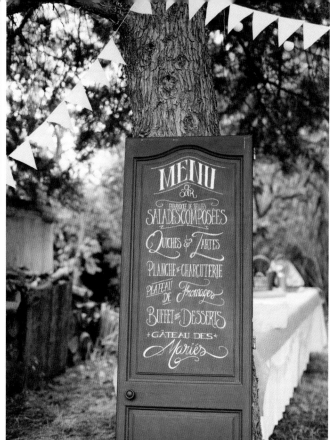

MENU
CE SOIR

TRANCHE DE SELLES
SALADES COMPOSÉES

Quiches & Tartes

PLANCHE DE CHARCUTERIE

PLATEAU DE Fromages

Buffet DES DESSERTS

GÂTEAU DES
Mariés

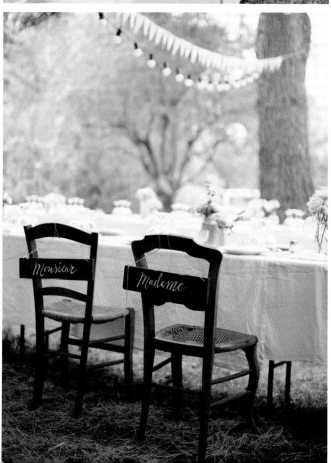

Monsieur     Madame

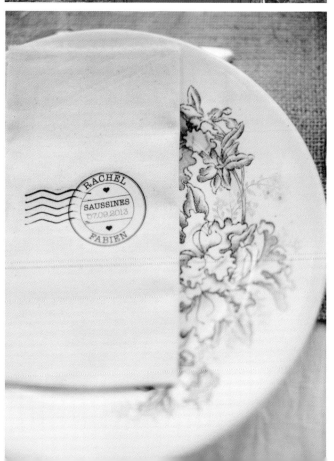

RACHEL
SAUSSINES
07.09.2013
FABIEN

# VINTAGE MEXICAN-INSPIRED
# WEDDING 墨西哥復古風格婚禮平面設計

Design agency: If So INKlined Calligraphy and Design
Designer: Jen Maton
Photographer: Jen Fariello
Client: Stephanie & John
Country: USA

設計機構：墨線設計工作室
設計師：珍‧梅頓
攝影師：珍‧法列洛
委託客戶：斯蒂芬妮、約翰
國家：美國

This wedding was a 'vintage Mexican fiesta' aesthetic with a 'running' presence. Stephanie and John were both professional runners and wanted to make sure to incorporate their passion for running. Save-the-Dates were actual race bibs, and flags were used throughout, even as their wedding invitation.

這場婚禮表現了十足的墨西哥復古風格，以"跑步"為主題。兩位新人斯蒂芬妮和約翰都是職業跑步運動員，希望將他們對跑步的熱情表現在婚禮中。日期卡模仿運動員衣服上的號牌。另外，設計中還廣泛使用運動賽場上旗幟的形式，甚至婚禮請柬都是旗幟的造型。

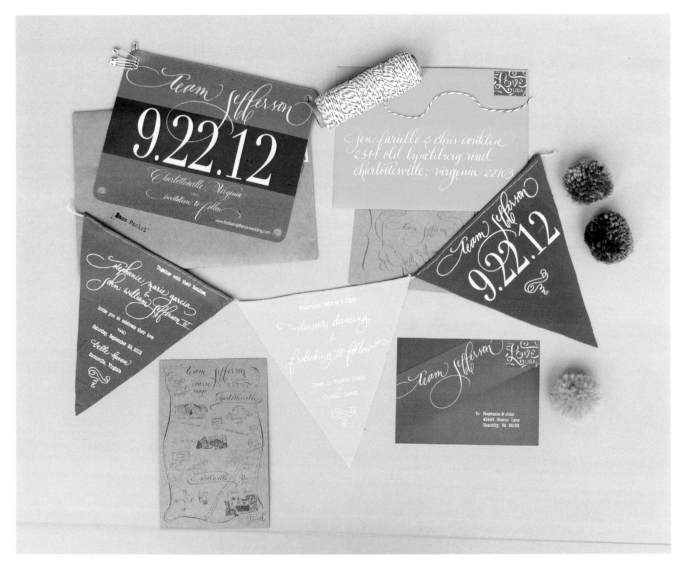

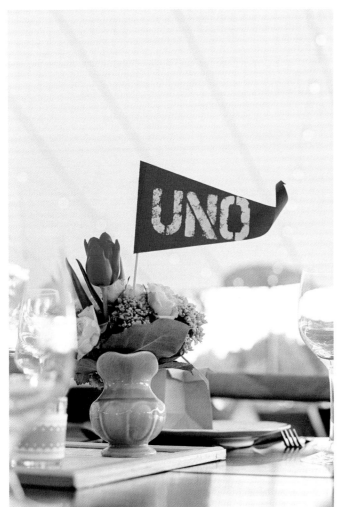

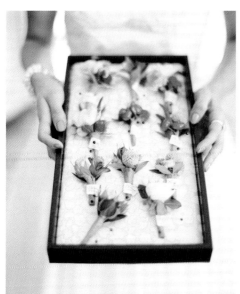

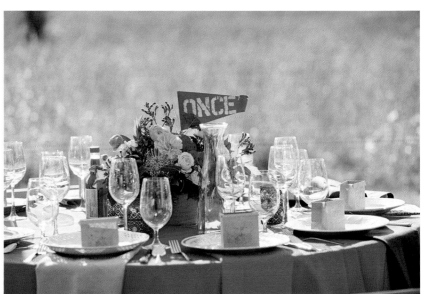

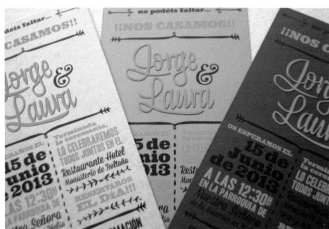
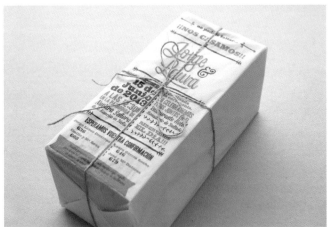

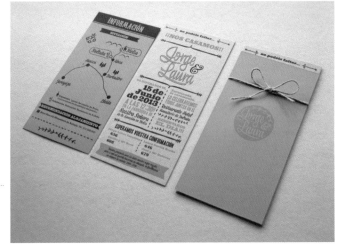

# JORGE & LAURA 豪爾赫與蘿拉婚禮平面設計

Design agency: El Calotipo Printing Studio
Photographer: El Calotipo Printing Studio
Client: Jorge & Laura
Country: Spain

設計機構：埃爾・卡魯蒂伯設計工作室
攝影師：埃爾・卡魯蒂伯設計工作室
委託客戶：豪爾赫・蘿拉
國家：西班牙

Laura and Jorge came from Barcelona to order wedding invitations and they also brought a lot of ideas how to focus on their design: printed on cardboard with combined fonts, the format would be lengthened and the entire look combined with a vintage air. El Calotipo started with the design full of clear ideas and came up with the image they wanted, of course, after all the necessary changes that entire image work leads to. This is the result of the work for Laura and Jorge's invitations: silkscreen printed in two colours, with an informational plan, branded Calotipo-style and black envelopes contrasting with the colour of the invitation.

蘿拉和豪爾赫從巴賽隆納專程趕來預定婚禮請柬，並且提出了很多設計思路，包括：採用硬紙板、多種字體相結合印刷，請柬規格加長，整體表現出復古風格。埃爾・卡魯蒂伯設計工作室就從這些清晰的設計思路開始展開了設計，並最終達到了客戶想要的效果，當然，是在做過無數必要的修改之後。這裡展示的就是蘿拉與豪爾赫婚禮請柬設計的成果，請柬採用雙色絲網印刷，配一張行程圖，黑色的信封是卡魯蒂伯的典型風格，與請柬的顏色形成鮮明對比。

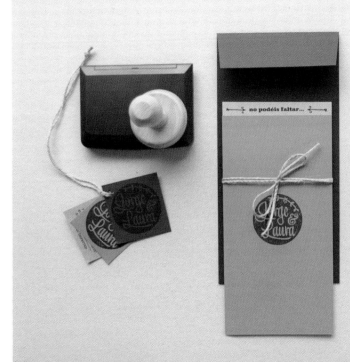
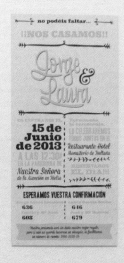
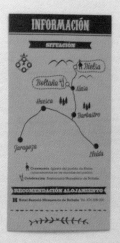
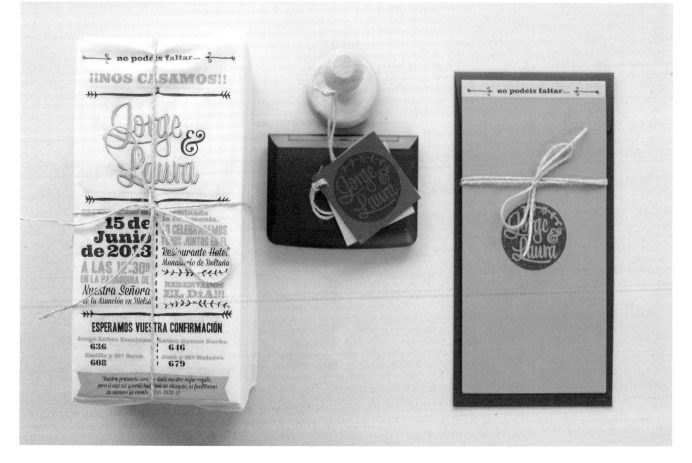

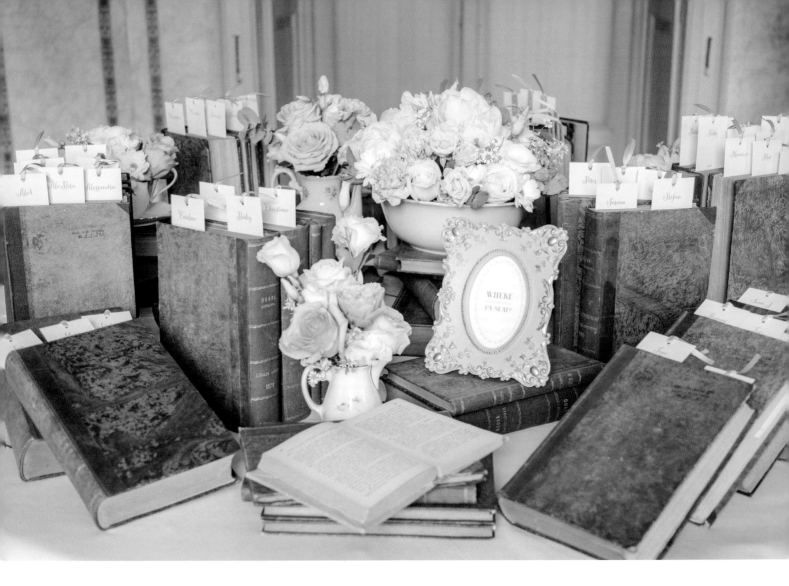

# LITERARY IN LOVE SUITE

### "愛情文學" 婚禮平面設計

Design agency: CUTandPASTE-lab
Photographer: Innocenti Studio
Client: Francesca & Torsten
Country: Italy

設計機構：剪貼設計工作室
攝影師：純真工作室
委託客戶：法蘭西斯卡、托爾斯騰
國家：義大利

Books and words was the theme chosen to celebrate a very sentimental event of love and friendship that even words could not fully express. According to that invite was more of a story than an official invite to the wedding; escort cards were bookmarks with famous quotes from famous writers chosen personally for their friends and family and each table was named with a font.

這場婚禮選擇用書籍與文學作為主題，表現兩位新人用文字已經無法充分表達的深情厚誼。因此，婚禮請柬就要與普通的正式請柬不同，需要別具深意。附帶的小卡片做成書籤的形式，上面有知名作家的名言金句，都是新人為每一位親朋好友親自挑選的。此外，每桌都用一種字體來命名。

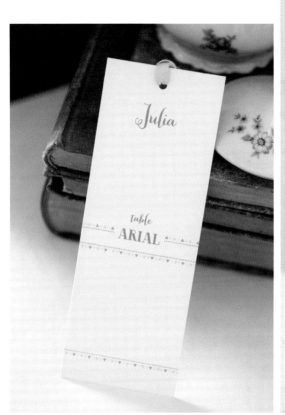

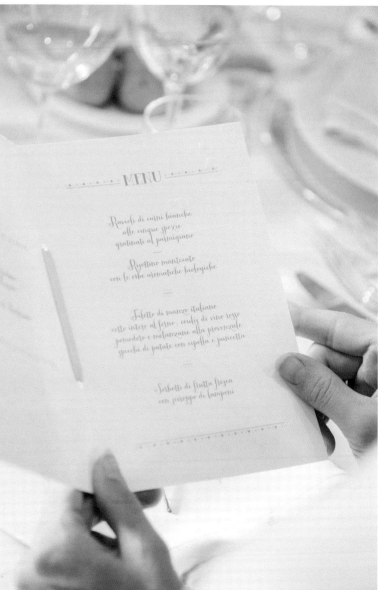

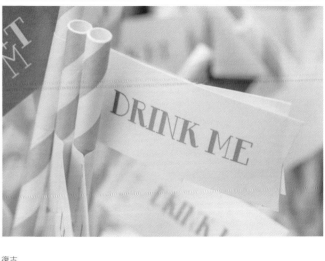

# VINTAGE AIR MAIL SUITE 復古航空郵政婚禮平面設計

Design agency: Jen Simpson Design
Designer: Jen Simpson
Photographer: Ashley Bee Photography
Country: USA

設計機構：珍・辛普森設計工作室
設計師：珍・辛普森
攝影師：艾希莉・比攝影公司
國家：美國

Come travel the world with me! This invitation was inspired by vintage air mail and telegrams. It is perfect for a travel-themed wedding.

來跟我一起周遊世界吧！這套婚禮平面的設計靈感來自古老的航空郵件和電報，對於一場以旅行為主題的婚禮來說是再適合不過了。

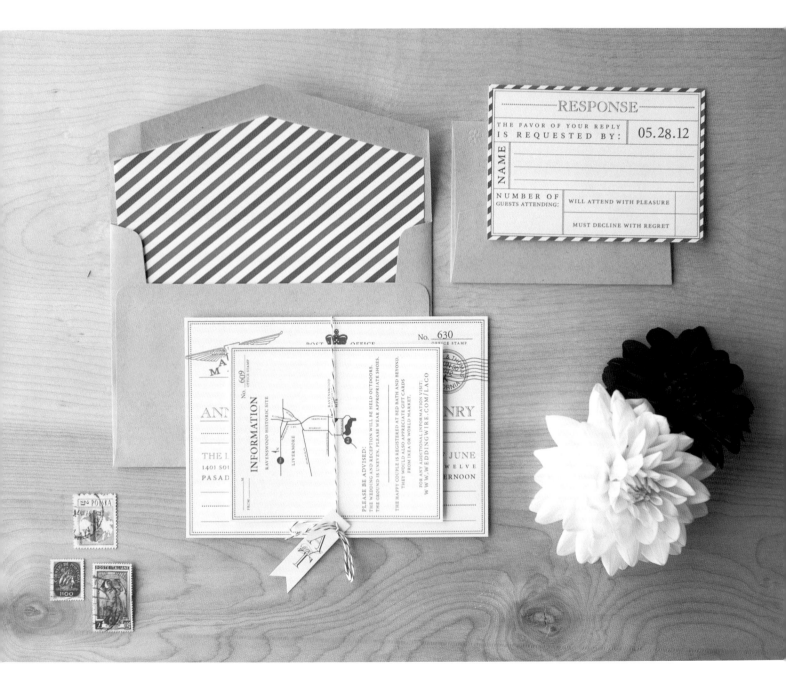

# MODERN RETRO PUNCH CARD 打孔卡式婚禮平面設計

Design agency: Jen Simpson Design
Designer: Jen Simpson
Photographer: Ashley Bee Photography
Country: USA

設計機構：珍·辛普森設計工作室
設計師：珍·辛普森
攝影師：艾希莉·比攝影公司
國家：美國

This invitation has a unique look with its punch card style date and fun quirky typography. It has a vintage modern feel from the retro 50s and 60s that shows off a fun introduction to its guests.

這套婚禮平面設計選擇了獨特的打孔卡形式，日期以打孔的方式出現，印刷格式也輕鬆別致。整套設計表現出一種現代的復古風，重現了 20 世紀、50 年代和 60 年代的感覺，將資訊以一種趣味的方式向賓客呈現。

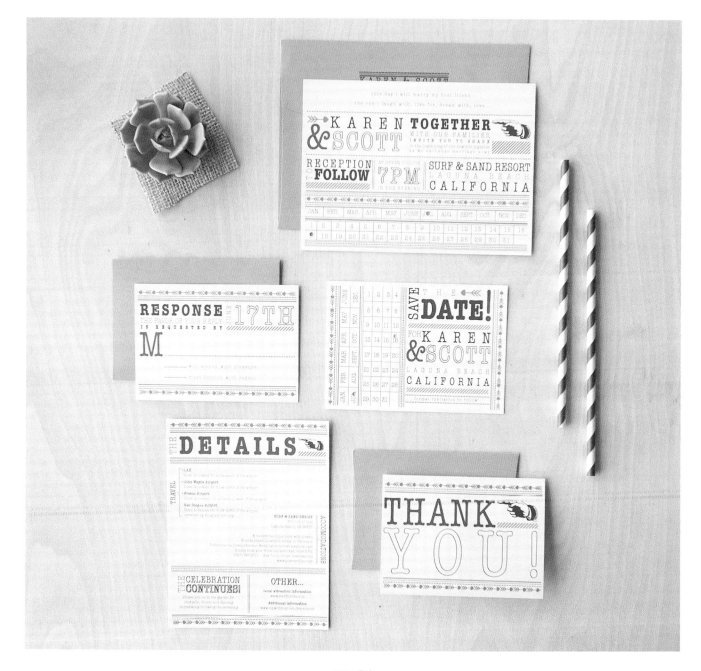

# SHABBY CROWN SUITE "懷舊皇冠" 婚禮平面設計

Design agency: CUTandPASTE-lab
Photographer: Michela Zucchini
Client: Melissa & Nicola
Country: Italy

設計機構：剪貼設計工作室
攝影師：米凱拉・祖基尼
委託客戶：梅麗莎、尼古拉
國家：義大利

Kraft and yellow was the colour palette chosen by the bride and groom for their special day. This solar shabby mood was underlined in all the stationery elements created, using wood and laser cutting from the invitation to the fan, from the ceremony programme to the escort card display.

牛皮紙色和黃色是新郎和新娘為他們特別的日子選定的色彩。這種陽光、溫暖又懷舊的感覺貫穿了婚禮平面設計的每個元素，從請束到摺扇，從流程卡到配套的系列卡片。材料上使用了木材，應用的技術主要是鐳射切割。

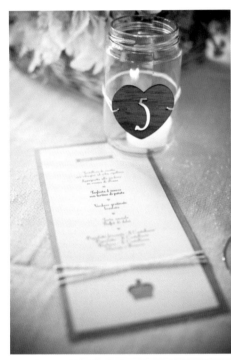

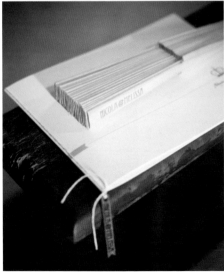

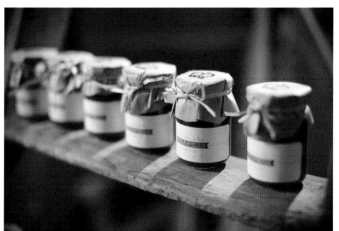

# TAHOE SUITE 太浩湖婚禮平面設計

Design agency: Olive & Emerald
Photographer: Bret Cole Photography
Client: Bret Cole Workshops
Country: USA

設計機構：奧利弗 & 埃默拉爾德設計工作室
攝影師：佈雷特·科爾攝影公司
委託客戶：佈雷特·科爾工作室
國家：美國

Inspired by the rustic environment of Lake Tahoe and infused with a little mid-century modern flair, the Tahoe Suite showcases complimentary organic shapes and bold patterns. The mid-century feeling is made stronger with a colour palette of moss, orange and grey, reminiscent of the era gone by.

這套婚禮平面設計的靈感來自美國太浩湖（Lake Tahoe）的原始自然景觀，並融入了一絲中世紀的摩登風情。整套設計凸顯了有機的形態和大膽的圖案。中世紀的感覺透過採用苔蘚綠、橘色和灰色等顏色得到進一步加強，凸顯了對那個逝去的年代的悵然追憶。

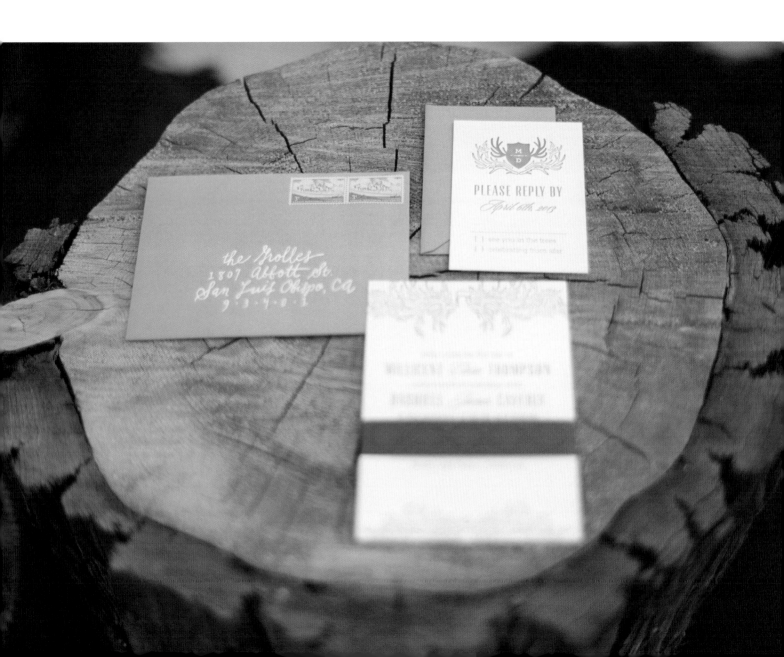

OLIVE & emerald
www.oliveandemerald.com

MILLIE
loves
DASH

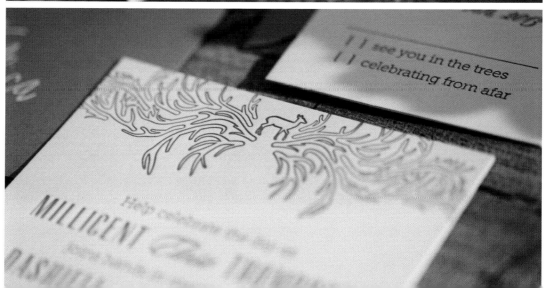

[ ] see you in the trees
[ ] celebrating from afar

MILLICENT

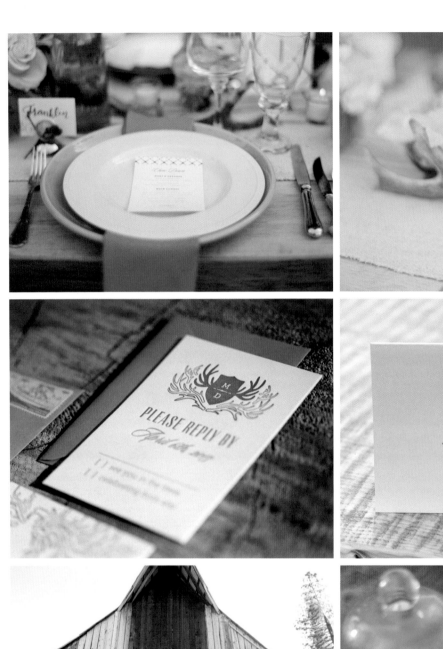
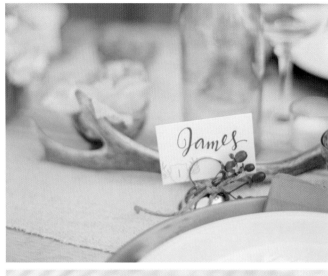

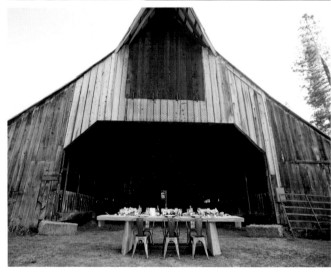

Help celebrate the day as
MILLICENT *Eloise* THOMPSON
joins hands in marriage with
DASHIELL *James* CAVERLY
in the presence of family and friends
Saturday, the fourth of May
two thousand and twelve
at half past four in the afternoon
North Lake Tahoe, California

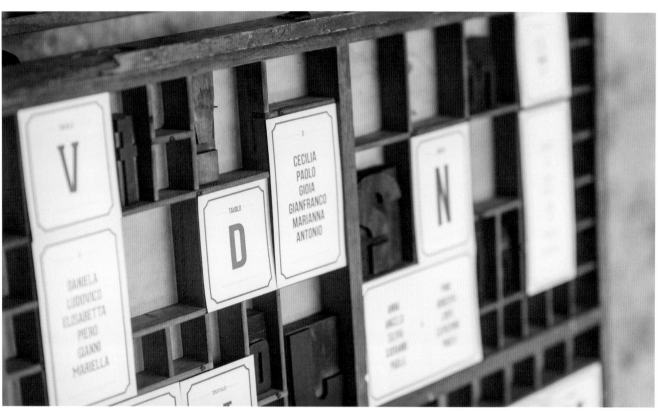

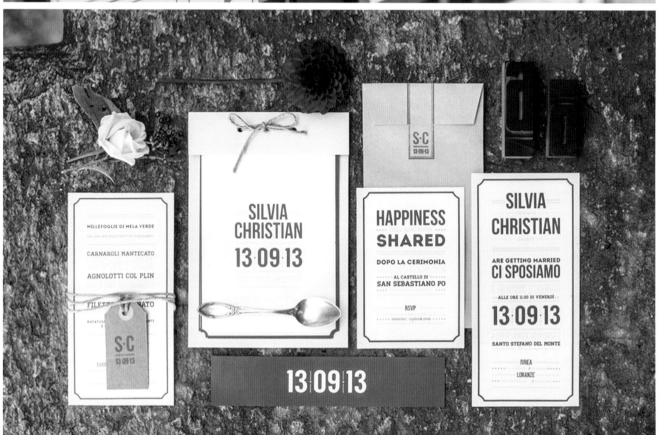

# USA TYPO SUITE

## 美國活版印刷婚禮平面設計

Design agency: CUTandPASTE-lab
Photographer: giuli&giordi
Client: Silvia & Christian
Country: Italy

設計機構：剪貼設計工作室
攝影師：g&g 工作室
委託客戶：西爾維婭、克利斯蒂安
國家：義大利

Simple, ironic and fresh, with a vintage touch. The
colours chosen were red and blue, colours that the
couple loves, which were also capable of paying
tribute to the American origins of Chris. All the
elements of the wedding suites have been created
keeping in mind the two main themes: breakfast and
typography.

簡單、獨特而清新，同時具備一絲復古風情。選用的
色彩是新婚夫婦最愛的紅色和藍色，另外也能表現出
新郎克利斯蒂安的美國籍身份。整套婚禮平面設計的
所有元素都貫穿了兩大主題－早餐與活版印刷。

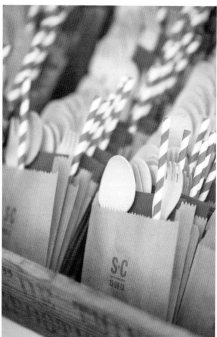
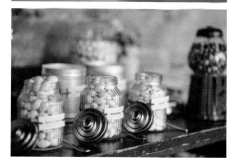
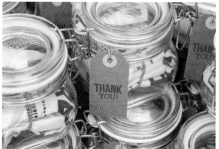

# LOVE AT FIRST FLIGHT "飛機場的一見鍾情" 婚禮平面設計

Design agency: Michael De Pippo
Designer: Michael De Pippo
Photographer: Toy Piano & Riley Stewart
Client: Michael De Pippo & Shaun Robinson
Country: Canada

設計機構：邁克爾‧德‧皮波設計工作室
設計師：邁克爾‧德‧皮波
攝影師：托伊‧皮亞諾‧賴利‧斯圖爾特
委託客戶：邁克爾‧德‧皮波、肖恩‧羅賓遜
國家：加拿大

A special project created for the wedding of the designer himself and his lover. The theme of the wedding was 'Love at First Flight' due to the fact that they met each other at the Toronto Pearson Airport on Christmas Eve. They planned and designed the entire wedding themselves with the help of a few friends and family. The result was a unique, very DIY-chic, and memorable event.

這是設計師為自己的婚禮所做的設計。婚禮的主題是"飛機場的一見鍾情"，因為兩位新人是耶誕節前夕在多倫多皮爾遜國際機場浪漫邂逅的。整場婚禮在幾位親朋好友的幫助下由他們自己策劃並設計。婚禮呈現獨一無二的 DIY 風格，令人難忘。

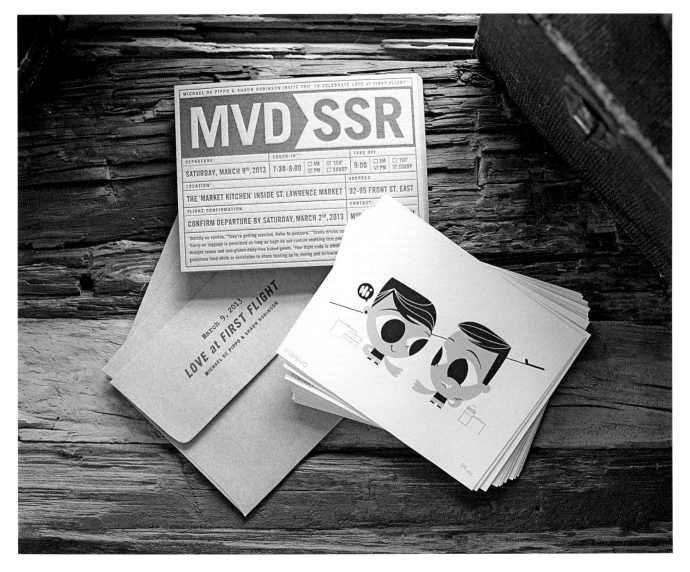

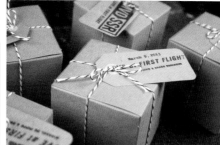

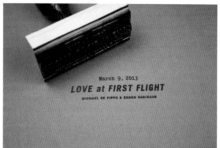

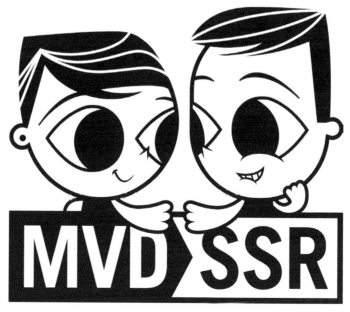

LOVE at FIRST FLIGHT

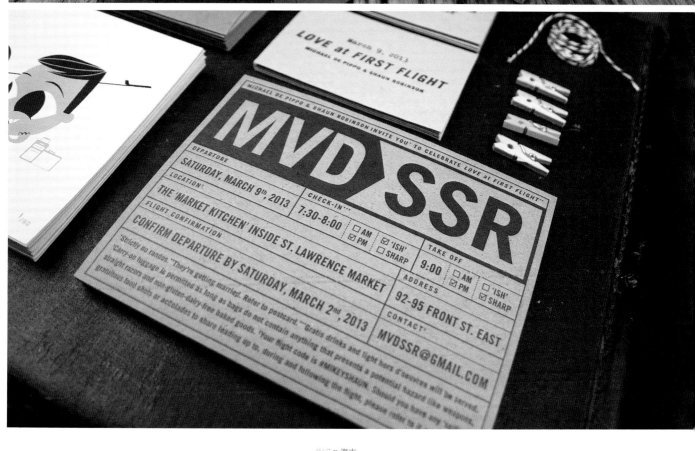

# ESTHER & KIKO

**埃絲特與基科婚禮平面設計**

Design agency: El Calotipo
Photographer: El Calotipo
Client: Esther & Kiko
Country: Spain

設計機構：埃爾‧卡魯蒂伯設計工作室
攝影師：埃爾‧卡魯蒂伯設計工作室
委託客戶：埃絲特、基科
國家：西班牙

Esther and Kiko got married three months ago and they were going to celebrate their different wedding party in two months with their family and friends. For this occasion they asked El Calotipo to make the invitations, giving the artists complete freedom in the design with the premise that they would be merry, to avoid that seriousness of the ordinary invitation cards. They wanted their invitation cards to reflect their personalities, so the artists used bright colours and some funny photos which were made when they were going out of the court on the day of their wedding. El Calotipo manufactured handmade envelopes, as the size of the card was a bit unconventional, and a personalised stamp. Esther and Kiko were delighted with the result and the artists were even more!

埃絲特和基科三個月前結婚，想在兩個月後邀請親朋好友舉辦一場不一樣的婚禮。他們找到埃爾‧卡魯蒂伯設計工作室來設計請束，並賦予設計師充分的自由，前提只有一點：請束要表現出歡樂的氛圍，避免普通婚禮請束的那種嚴肅和正式感。另外，他們還想讓請束表現出新人的特徵，所以設計師選擇了輕快的色彩以及一些有趣的照片（是他們從法院登記完出來時拍的照片）。信封是手工製作的，因為請束的規格跟普通請束不同，此外還增加了獨特的個性化封印。埃絲特和基科對設計結果非常滿意，設計師也樂在其中！

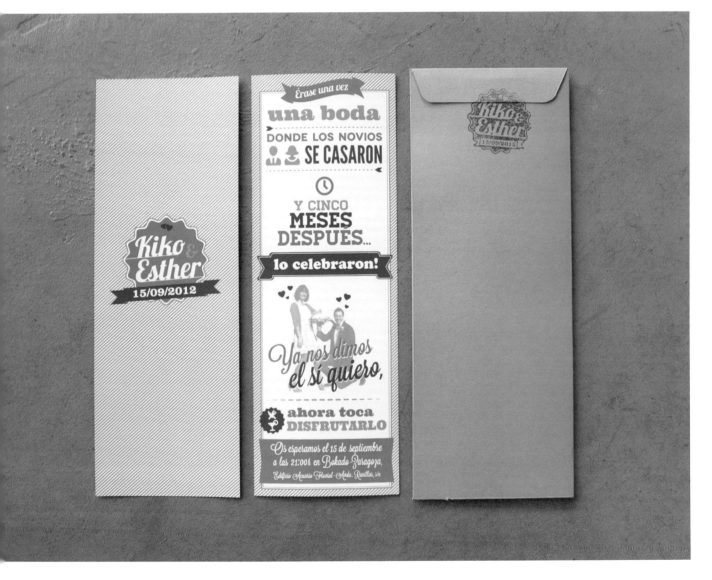

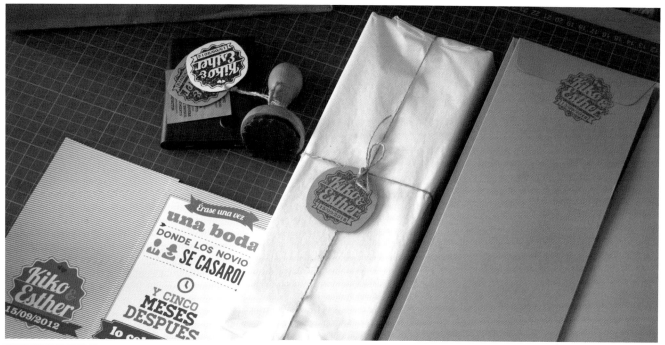

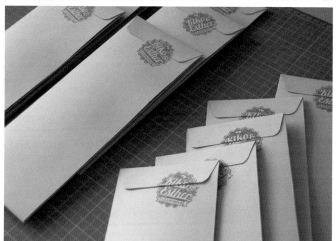

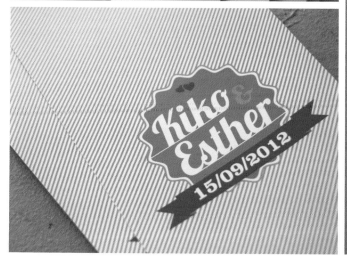

# MIDSUMMER NIGHT'S DREAM "仲夏夜之夢" 婚禮平面設計

Design agency: Greg Coulton Design & Illustration
Designer: Greg Coulton
Photographer: Greg Coulton & Luis Holden
Client: Greg & Rebecca Coulton
Country: UK

設計機構：葛列格‧庫爾頓設計工作室
設計師：葛列格‧庫爾頓
攝影師：葛列格‧庫爾頓、路易士‧霍爾登
委託客戶：葛列格‧庫爾頓、麗蓓嘉‧庫爾頓
國家：英國

With the wedding ceremony taking place in the stunning grounds of 'Chaucer Barn' in Norfolk, England, the concept of nature and its beautiful forms was the outstanding choice. Drawing inspiration from 'Alice in Wonderland' and 'A Midsummer Night's Dream' (the ceremony itself taking place on the Summer Solstice) the design evolved to become a secret garden, immersing and enveloping the bride and groom's simple, elegant monogram with love and romance. The elaborate illustration features an owl which represents the groom. The name 'Greg' comes from the Latin 'Gregorius', meaning 'to be awake' or 'to be watchful'. The bride is depicted by a fox, 'Fox' being her maiden name. The flowers that encircle the illustration are drawn directly from the flora found within the grounds of the wedding venue itself, but also represent the happy couple being surrounded by and engulfed in, the love and best wishes from their close friends and family assembled all together to celebrate the joyous occasion. The master 'G&R' design was completely hand-drawn.

這場婚禮的舉辦地點非同凡響，是英格蘭東部的諾福克郡著名的"喬叟莊園"，所以用當地美麗的自然風景作為設計理念自然成為最佳選擇。設計師從《愛麗絲夢遊仙境》和《仲夏夜之夢》當中汲取靈感（典禮就選在夏至那天舉行），將婚禮設計成"秘密花園"的風格。新郎和新娘名字首字母組成的組合圖案"G & R"充滿愛意和浪漫。插畫設計中有隻貓頭鷹是代表新郎，因為新郎的名字"葛列格"（Greg）源於拉丁文"Gregorius"，意思是"警醒"或"保持警惕"；新娘則用狐狸的形象來代表，因為新娘的娘家姓為"福克斯"（Fox）意為"狐狸"。插畫四周的花朵圖案是按照婚禮舉辦場地附近的花卉來繪製的，同時也代表著一對新人在這喜慶的日子裡幸福地沉浸在親朋好友的愛與祝福中。"G & R"字母組合完全手繪而成。

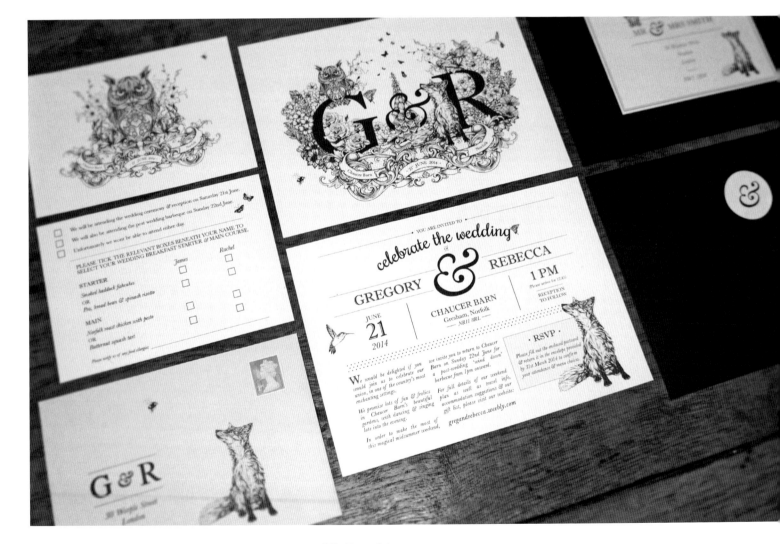

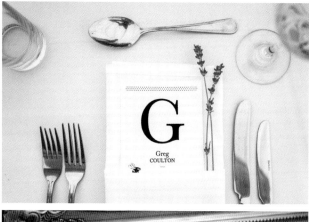

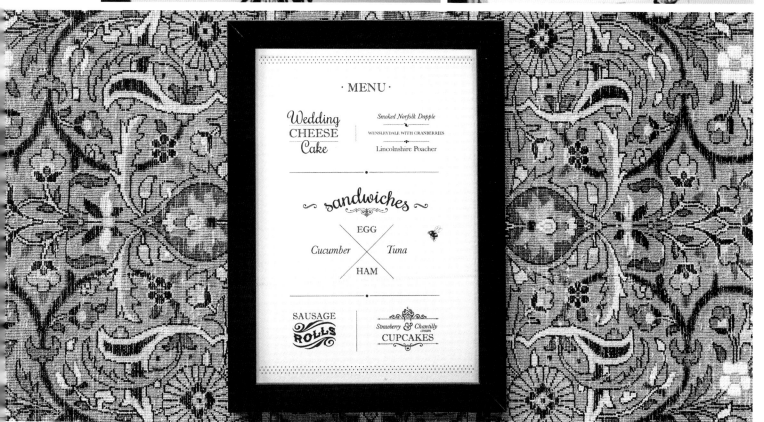

# J&K WEDDING

## J&K 婚禮平面設計

Designer: Jan Baca
Photographer: Jan Baca
Country: Slovakia

設計師：簡・巴卡
攝影師：簡・巴卡
國家：斯洛伐克

Logo, invitations and stationery set created for the designer's own wedding day. Invitations were written on old cutting plotter with ink pen to achieve handwritten effect even in bigger quantity. Then all cards (ca. 70 pcs) were hand-finished carefully. Papers used: White Laid 300 gsm, SH Recycling 160 gsm (brown/grey), 300 gsm (brown/brown) and matching envelopes. All supplied by Europapier.

這是斯洛伐克設計師簡・巴卡為自己的婚禮所做的平面設計。利用刻字機和墨水筆，大量的請柬也能營造出手寫的效果。所有的卡片最終都經過手工的仔細修飾。所用紙張：300 磅白色直紋紙、160 磅 SH 回收紙（棕色／灰色）和 300 磅（棕色／棕色），此外還有配套的信封。所有紙張都由紙品供應商 Europapier 提供。

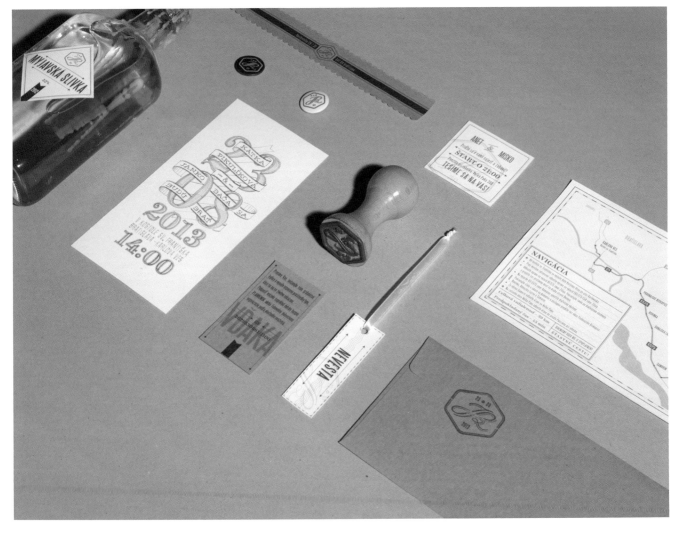

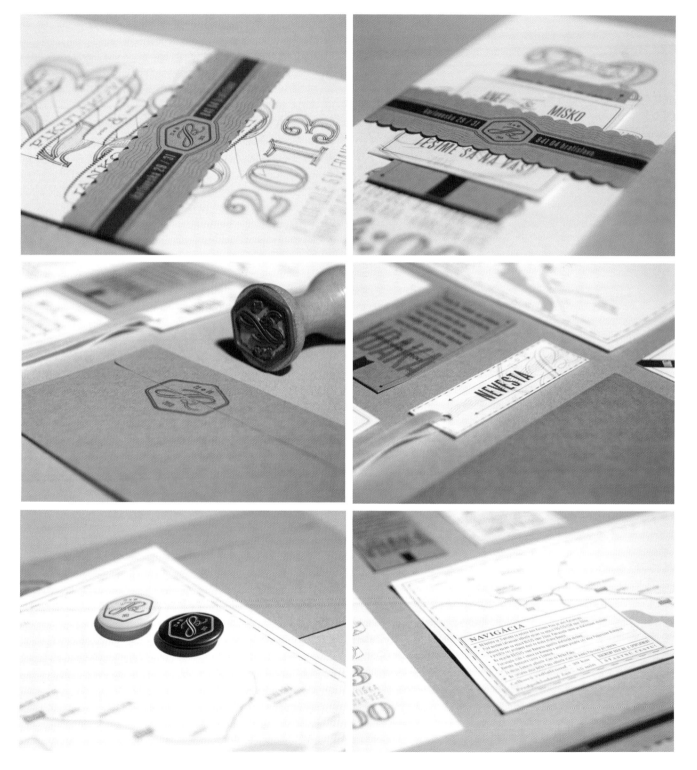

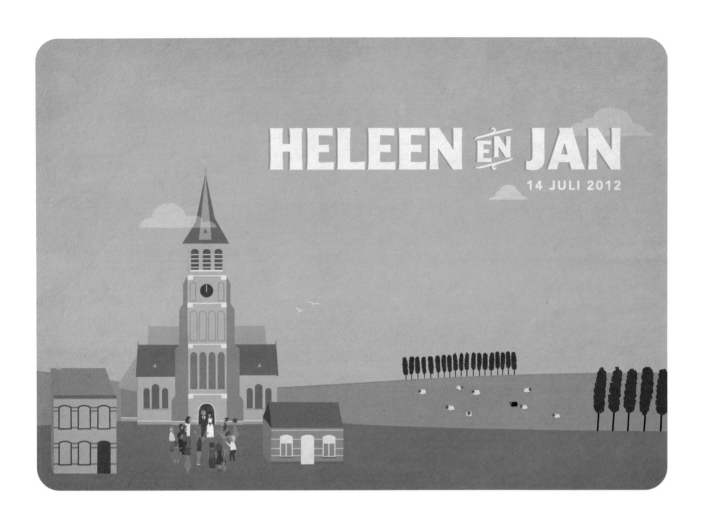

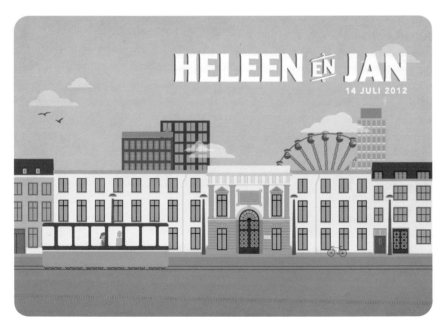

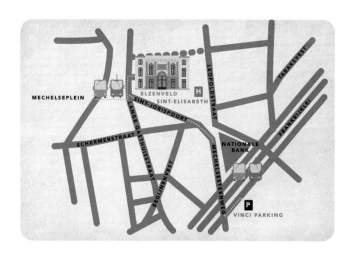

ZATERDAG 14 JULI 2012 - 19U00
GRAAG BEVESTIGEN VOOR 23 JUNI 2012

HELEEN & JAN NODIGEN

ZAAL ELZENVELD
LANGE GASTHUISSTRAAT 45
ANTWERPEN

GRAAG UIT OP HUN AVONDFEEST

JANENHELEENTROUWEN@GMAIL.COM
GSM HELEEN 0494 652 503 - GSM JAN 0476 617 932

# HELEEN & JAN 海倫與簡婚禮平面設計

Design agency: Babs Raedschelders
Photographer: Babs Raedschelders
Client: Heleen & Jan
Country: Belgium

設計機構．巴布思‧雷薩德斯設計工作室
攝影師：巴布思‧雷薩德斯設計工作室
委託客戶：海倫、簡
國家：比利時

Heleen and Jan lived in Brussels but got married in a cute litte church at the Flemish countryside. Afterwards they gave a great wedding party in a beautiful old building in the centre of Antwerp.

海倫和簡住在布魯塞爾，但婚禮選在佛蘭德鄉村的一座漂亮的小教堂裡舉行。典禮過後他們在安特衛普市中心的一棟美麗而古老的建築內舉行了盛大的婚禮派對。

# INGE & BERT 英奇與伯特婚禮平面設計

Design agency: Babs Raedschelders　設計機構：巴布思·雷薩德斯設計工作室
Photographer: Babs Raedschelders　攝影師：巴布思·雷薩德斯設計工作室
Client: Inge & Bert　委託客戶：英奇、伯特
Country: Belgium　國家：比利時

This wedding invitation is a map of Flanders, illustrated with the couple's favourite places, memories and holiday destinations. It's like a small travel guide for the guests full of tips and tricks. Babs Raedschelders designed an invitation, a booklet and a menu. The titles were: Map of Life for Good Marriage, Book for a Good Marriage and Recipe for a Good Marriage. On the big day all guests received homemade jam or homemade elderberry Gin as a little 'Thank You' present. Instead of a guestbook Inge and Bert asked the artist to design four different post cards. Each of them contains a personal question: 'Which holiday destination would you recommend?', 'What will you always remember of this wedding day?', 'What's your favourite memory that involves the bride or groom?' and 'What is your wedding wish for this newly married couple?'

這款婚禮請柬設計成了佛蘭德地圖，包括新人最喜歡的地方、有著難忘回憶的地方以及旅遊度假勝地。整張請柬就像一份旅遊指南一樣，給賓客各種貼心的建議和提醒。設計內容包括請柬、小冊子和功能表，分別命名為"良緣地圖"、"良緣之書"和"良緣菜譜"。婚禮當天所有賓客都收到了一份自製果醬或自製杜松子酒作為表示感謝的小禮物。英奇和伯特不想要普通的賓客留言板，而是讓設計師設計了四款明信片，每張明信片上有一個問題，分別是："你推薦哪個度假勝地？""這場婚禮讓你最難忘的是什麼？""你跟新娘或新郎有什麼難忘的回憶？""你對這對新人的新婚祝福是什麼？"

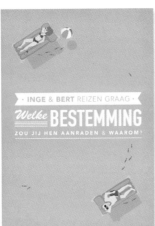
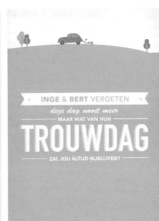
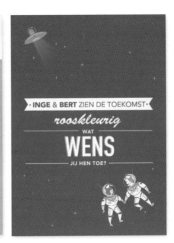

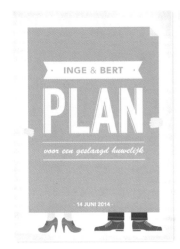
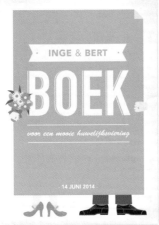
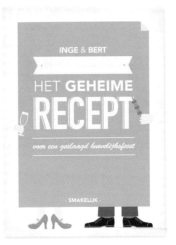

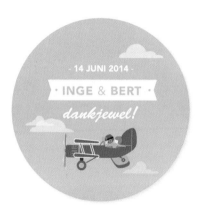

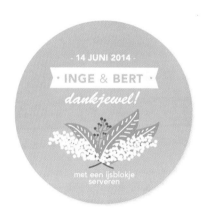

duidelijkheid: hun buitenverblijf bestaat uit nylon, stokjes en een paar piketten.

- Dé zee met stadjes Deauville en Honfleur en de D-daystranden. Het binnenland met de ciderroutes langs kleine wegjes met hoge hagen.

- Panier de fromage/saucisson: een gigantisch mand vol kaas of worst. Het is niet de bedoeling dat je ze volledig leegvreet. Gebruik het bijgeleverde Opinel-mes om stukjes af te snijden en geef de overschot terug. Probeer hierbij calvados of pommeau van Pierre Huet.

- Calvados Pierre Huet: Avenue des Tilleuls 5, Cambremer

## 17. *Marokko*

Topvakantiebestemming waar élke taxi een Mercedes uit de jaren stillekes is.

- Marokko daagt al je zintuigen uit met de geur van leerlooierijen, de kleuren van verse kruiden, de broeierige zomerhitte, de oproep voor het gebed (om 6u 's morgens!) en de heerlijke smaken van de Marokkaanse keuken.

- Pastilla: bladerdeegpakketjes met vreemd klinkende, maar heerlijk smakende vullingen (bvb. lamsgehakt met kaneel). Probeer ook de tajine met kabeljauw en venkel.

- Hoe lekker het lokale eten ook is, het kan zo zijn gevolgen hebben voor gevoelige Europese darmen.

## 18. USA

Deze bestemming staat al jaren op het verlanglijstje van Bert en Inge en is nu bekroond met de titel: huwelijksreis.

- Het gezicht van Inge als ze de Grand Canyon ziet en het gedartel van Bert tussen de sequoiabomen.

## 19. Damme

Hier wordt geregeld een openluchtboekenmarkt gehouden. Bert en Inge zoeken hier af en toe boeken om hun boekenkast verder vol te stouwen. Zoek je een bepaald boek? Misschien kan je het uitlenen in hun groeiende bibliotheek?

## 20. DE PLOEG

Het stamcafé uit de studententijd van Bert en Inge. Een doorsnee bruin café met snookertafel, vogelpik en de gebruikelijke selectie bieren en frisdrank. Het bijzondere zit hem in het volk dat er over de vloer komt. Je zit er gegarandeerd in goed gezelschap. Moet het meer zijn?

## 21. Merelbeke

Hier kan je Bert op werkdagen aantreffen. Soms op het veld, soms in het labo en soms achter zijn computer. Eén ding is zeker: he's sciencing as fast as he can!

## 22. BRUSSEL

Op citytrip in eigen land!

- Een concert in de Ancienne Belgique, de antiekwinkels en het brocante marktje in de Marollen, het Belgisch stripmuseum (ontworpen door Horta!) en last but not least, het "Boterhammen in het park"-festival tijdens de laatste week van de zomervakantie.

- De buurt rond de Grote Markt is zeker en vast ook de moeite waard om te bekijken, maar de meeste cafeetjes hier, zijn echte toeristenvallen.

- Ancienne Belgique: Anspachlaan 110 Boterhammen in park: Warandepark Belgisch stripmuseum: Zandstraat 20

## 23. GUY'S NAAICENTRUM

Het Walhalla van de naaibenodigdheden. Zoek je een grappig stofje, een kleurige draad of een volautomatische naaimachine? Guy zoekt het voor jou uit met zijn ongebreideld enthousiasme!

- Roodkruisstraat 98, Hamme

## 24. SPORT *feesten*

Eén van de vele KLJ-activiteiten waar je Inge en Bert steevast kon aantreffen tijdens de voorbije zomers. Informeer bij uw lokale bruid of bruidegom naar hun favoriete KLJ-momenten. Ze kunnen eindeloos vertellen over sportfeesten, kampavonturen, over activiteiten en cursussen!

- Het Landjuweel: tweejaarlijkse hoogdag van de KLJ-sportwerking.

- Niet te missen   Let op!
- Moet je proeven   Adres

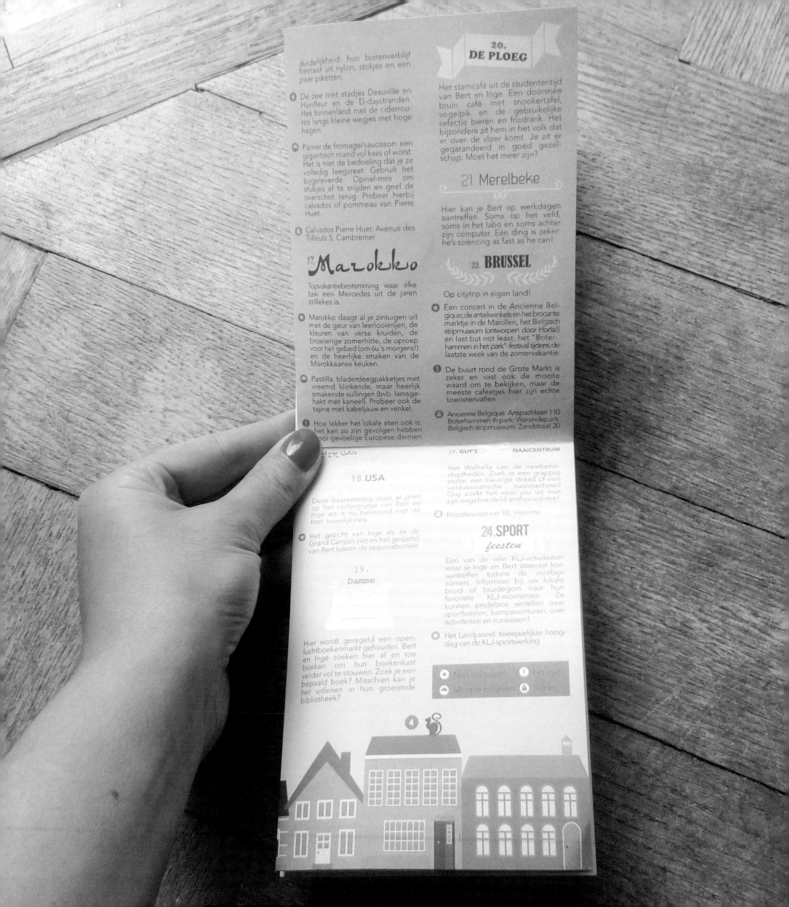

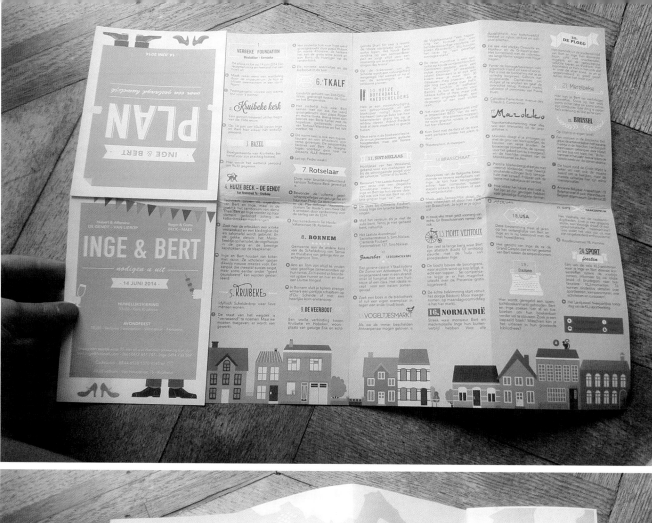

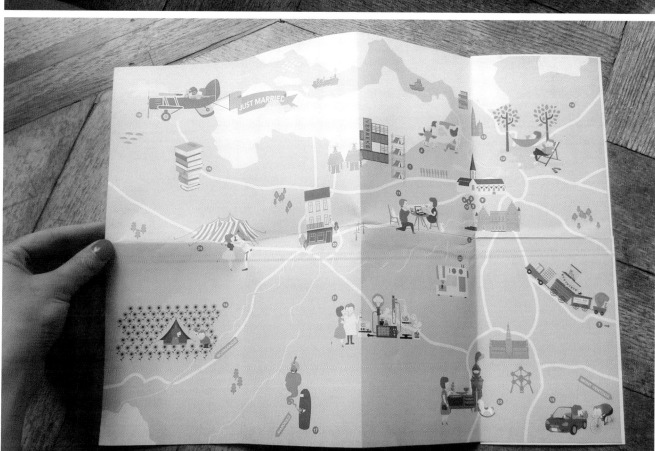

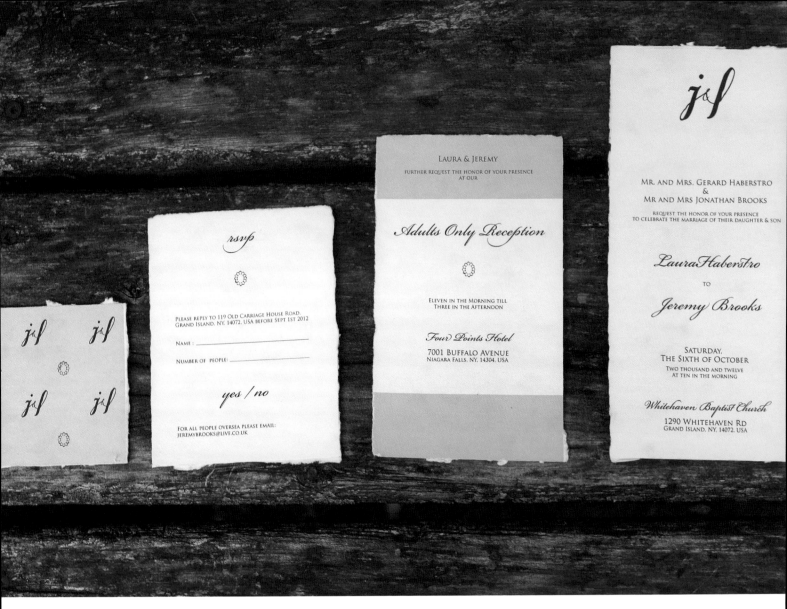

# JEREMY & LAURA
### 傑瑞米與蘿拉婚禮平面設計

Design agency: Belinda Love Lee　設計機構：比琳達設計工作室
Photographer: Belinda Love Lee　攝影師：比琳達設計工作室
Client: Jeremy & Laura Brooks　委託客戶：傑瑞米·布魯克斯、蘿拉·布魯克斯
Country: UK　國家：英國

The pattern designed for this invite was inspired by the bride's engagement ring. The ring given to her was a hand-me-down previously worn by her fiance's mom! It's such a beautiful story in itself, that it needed to be replicated on these invites.

這張婚禮請柬的設計靈感來自新娘的訂婚戒指。這是枚家傳戒指，之前戴在新娘未婚夫媽媽的手上。所以，設計師決定在請柬中出現這枚有故事的戒指。

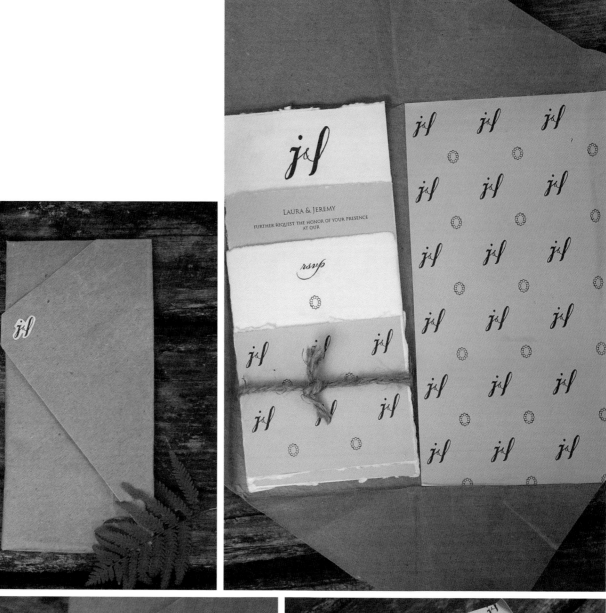

# KATHARINA & JAN 卡塔琳娜與揚婚禮平面設計

Design agency: Pretty in Print
Designer: Ann Gancarczyk
Photographer: Ann Gancarczyk
Client: Katharina & Jan
Country: Germany

設計機構："漂亮印刷"設計工作室
設計師：安‧甘卡爾齊克
攝影師：安‧甘卡爾齊克
委託客戶：卡塔琳娜、揚
國家：德國

For this formal wedding, the artist created custom logos and an invitation design that highlighted the locations of the events that were to take place over Katharina and Jan's wedding weekend. Each location had its own logo and there was a main composite version as well. The logos incorporated hand-drawn lines, which counter balanced the sleekness of the overall design elegantly. The couple and the guests were delighted with the design, since it added such a personal touch to the wedding.

這是一場非常正式的婚禮，設計師打造了訂製的 LOGO 標識以及請柬的設計，請柬上有典禮後安排的各種活動的場所，每個場地都設計了一個標識，此外還有一張彙集了所有標識的卡片，一目瞭然。標識採用手工繪製，與整體設計的精美印刷形成對比。新人及賓客對設計結果都非常滿意，因為這套設計為婚禮增添了個性化的色彩。

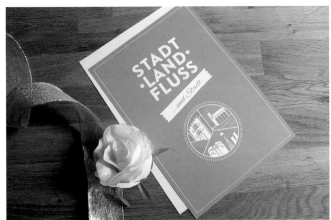

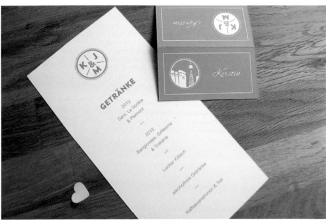

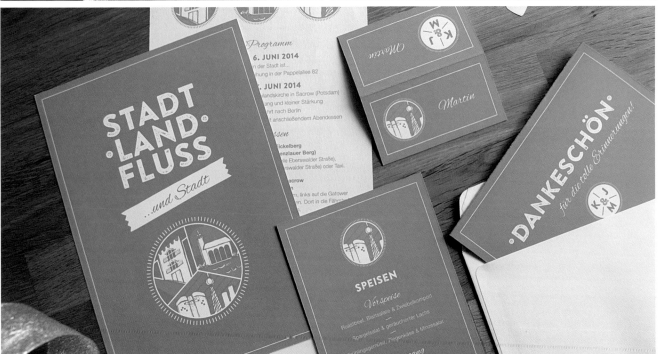

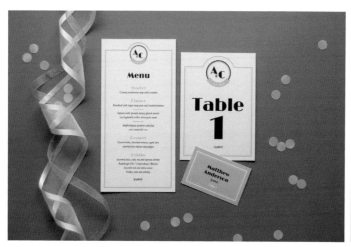

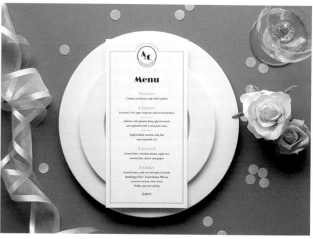

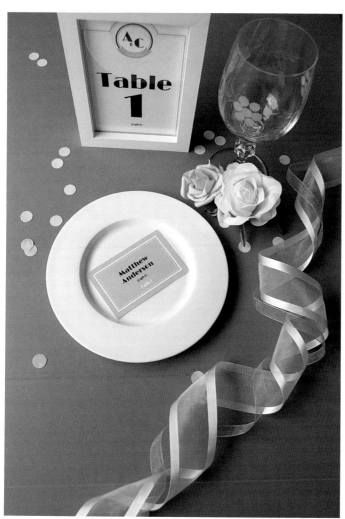

# JAZZ AGE WEDDING
## "爵士時代" 婚禮平面設計

Design agency: Pretty in Print 　　設計機構："漂亮印刷" 設計工作室
Designer: Ann Gancarczyk 　　　　設計師：安·甘卡爾齊克
Photographer: Ann Gancarczyk 　　攝影師：安·甘卡爾齊克
Country: Germany 　　　　　　　　國家：德國

This collection of vintage styled wedding paper goods draws inspiration from the 1920s and all of its charm and elegance. When creating these designs the artist tried to keep the look refined and classy throughout, varying the design only slightly for each product. Each item in this collection has a monogram with the couple's initials and wedding date, which ties them all together.

這套復古風格的婚禮平面設計，靈感來自 20 世紀 20 年代的典雅潮流。在創作的過程中，設計師特別注意讓整套設計看上去古典、精緻，而每張卡片細節上又略有不同。每張卡片上都有新人名字的字首字母組合圖案以及婚禮日期，讓所有卡片組成整體的一套。

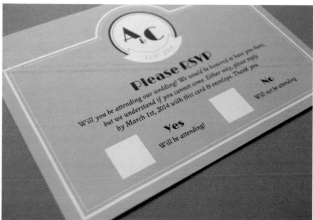

First kiss as a married couple:
14u00 · O.L.Vr.Hemelvaartkerk · Bassevelde

Design agency: Pretty in Print
Designer: Ann Gancarczyk
Photographer: Ann Gancarczyk
Client: Katharina & Jan
Country: Germany

# LEEN & RUBEN

## 利恩與魯本婚禮平面設計

........................................................

Design agency: Babs Raedschelders
Photographer: Babs Raedschelders
Client: Leen & Ruben
Country: Belgium

設計機構：巴布思‧雷薩德斯設計工作室
攝影師：巴布思‧雷薩德斯設計工作室
委託客戶：利恩、魯本
國家：比利時

Stationery design for a retro-styled wedding full of American vintage elements of the 1950's. The artist created illustrations of the newly married couple with an orange background, and an image of the bride in yellowish tone, completing an interesting yet reminiscent wedding.

這是一場復古風格的婚禮，整套設計充滿了 20 世紀 50 年代美國風格的復古元素。設計師繪製了趣味性的插圖，將兩位新人的特徵表現得淋漓盡致，紅色的背景加上懷舊的黃色圖形，使整場婚禮顯得活潑又有生氣，令人印象深刻。

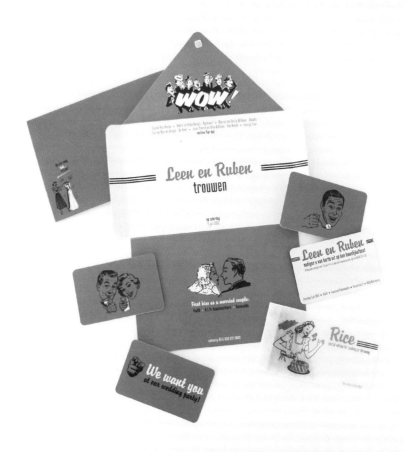

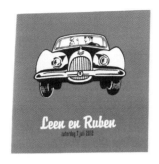

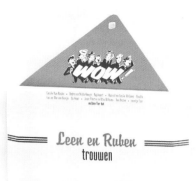

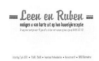

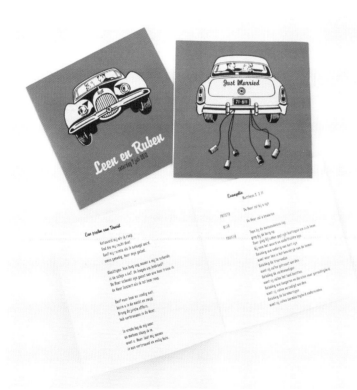

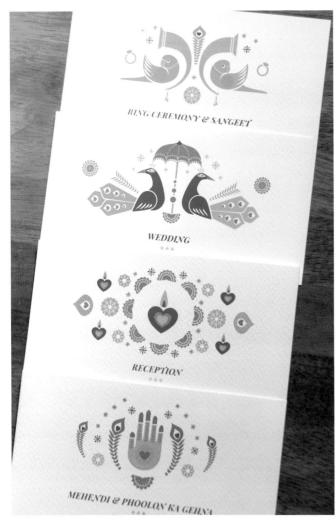

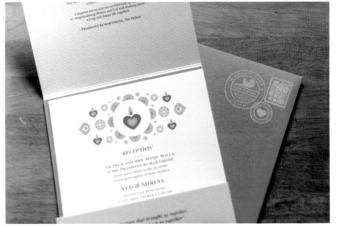

# RANGEELA ["COLOURFUL"]

**繽紛色彩婚禮平面設計**

Design agency: Studio Kohl
Designer: Mira Malhotra
Photographer: Mira Malhotra
Client: Shreya Ghose
Country: India

設計機構：科爾設計工作室
設計師：米拉・瑪律霍特拉
攝影師：米拉・瑪律霍特拉
委託客戶：施萊亞・高斯
國家：印度

A colourful and vibrant Indian card that still keeps it elegant. Bearing motifs of a henna covered hand, peacocks, parrots, tutaris (indian horn) and diyas (indian lamps), this invitation was made for a couple who loves to have fun. The envelope continues the concept as traditional motifs are interpreted as rubber stamp designs in mango yellow on bright pink paper.

為一場印度婚禮設計的色彩繽紛、充滿生機而又不失典雅莊重的請柬。這對新婚夫婦熱情開朗，所以卡片上選擇了許多生動活潑的圖案，有帶指甲花的手、孔雀、鸚鵡、印度號角和油燈等。裝請柬的信封也延續了同樣的風格，以橡皮圖章的方式繪製出印度傳統元素，芒果黃的圖章蓋在豔粉色的信封上，分外搶眼。

# ANNA & ADAM 安娜與亞當婚禮平面設計

Designer: Raminta Vas
Photographer: Raminta Vas
Client: Anna Spenser & Adam Walker
Country: UK

設計師：拉敏塔・瓦斯
攝影師：拉敏塔・瓦斯
委託客戶：安娜・斯賓塞、亞當・沃克
國家：英國

The design brief was to create an elegant wedding invitation which had a vintage, handmade feel. In order to achieve this, the artist included an elegant script typeface in her design and created some vintage style illustrations, such as ribbons, doves, roses. The wedding invite was accompanied with a RSVP card and a dark brown, vintage style envelope.

設計要求是要讓婚禮請柬傳達出復古的手工製作感覺。為了實現這一目標，設計師採用了兩種現代的字體（Bebas Neue 和 Gothic 720 BT）並與復古風格的插畫相結合，如絲帶和玫瑰的圖案。寫著新人名字的心形圖案採用了粉色，因為這種顏色象徵著溫暖與愛。

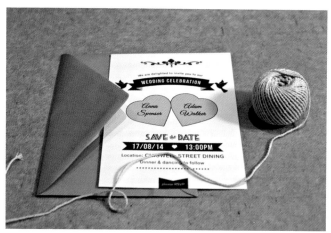

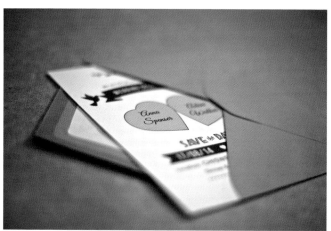

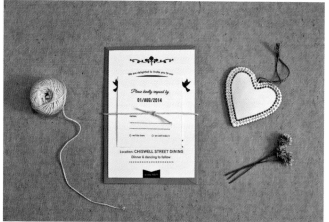

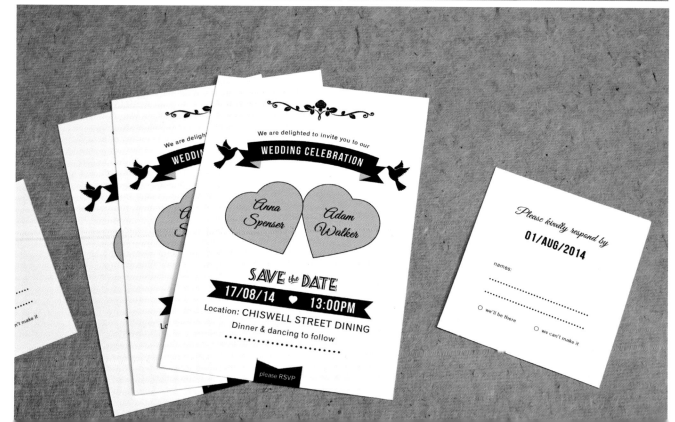

# ENCHANTED LOVE WEDDING 魔法奇緣婚禮平面設計

Design agency: Pretty in Print
Designer: Ann Gancarczyk
Photographer: Ann Gancarczyk
Country: Germany

設計機構："漂亮印刷"設計工作室
設計師：安·甘卡爾齊克
攝影師：安·甘卡爾齊克
國家：德國

For this collection the artist wanted to create the perfect combination of rustic and charming. She combined lovely script fonts and charming graphic elements, such as the cupid's heart combined with the couple's initials. The idea was that these elements could be repeated throughout the wedding as stamps, stickers or any decoration elements. The warm hues of yellow and orange are the perfect choice for a summer and fall wedding.

這套婚禮平面設計想要實現淳樸與魅力的完美結合。設計師將可愛的手寫字母和漂亮的平面元素相結合，比如丘比特之心結合新人名字的首字母縮寫。設計初衷是讓這些元素在婚禮上形成統一的風格，以印章、貼紙或者任何其他裝飾元素的形式出現。黃色和橘色營造出溫暖的色調，對於一場夏末秋初的婚禮來說再適合不過了。

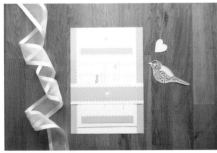

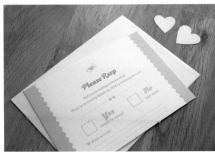

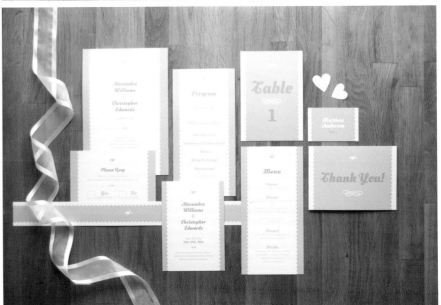

# RESHMA & DEEP 瑞詩瑪與迪普婚禮平面設計

Design agency: CECI New York　　設計機構：紐約 CECI 設計工作室
Client: Reshma & Deep　　　　　　委託客戶：瑞詩瑪、迪普
Country: USA　　　　　　　　　　國家：美國

The stunning Reshma Shetty, a star on the hit show 'Royal Pains', is of Indian descent. Naturally, she wanted her wedding invitations to mirror her rich background. The designers were glad to rise to the challenge, creating a custom painting for her invite that included details such as gorgeous pink lotus flowers, henna-inspired embellishment and the word 'Om' in the centre. It is literally a work of art! All of her accessories, like menus and programmes, were designed to match.

在熱播電視劇《欲海醫心》中星光閃耀的著名女演員瑞詩瑪‧謝蒂擁有印度血統，所以她希望她的婚禮請柬能夠表現出她豐富的種族背景。設計師為此專門打造了複雜的拼貼畫，裡面的元素包括粉色的荷花、指甲花以及正中央的 "Om" 字樣。這幅拼貼畫本身就是　件藝術品。另外，所有的配套設計，包括功能表和流程卡等，都延續了相同的風格。

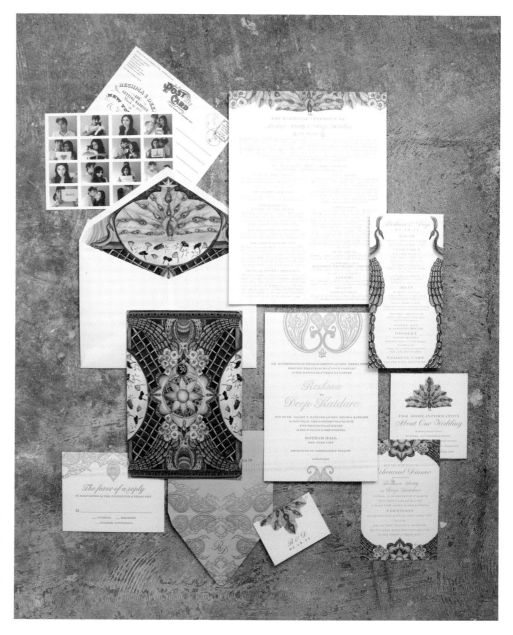

# PAPER GOODS & CALLIGRAPHY 婚禮卡片及書法設計

Design agency: JenHuangArt
Photographer:
JenHuangPhoto
Country: USA

設計機構：黃珍設計工作室
攝影師：黃珍攝影工作室
國家：美國

The use of sealing wax in the paper goods brought out a traditional touch. The unique calligraphy as well as the selection of paper reveals the new couple's preference for vintage style and love for nature. Tender pink is combined with elegant colours of grey and white, creating a classical, low-key colour scheme.

設計師在設計中融入了傳統火漆的元素。另外，手寫書法與紙張的選擇都表現了這對新婚夫婦的復古情懷和對自然的喜愛。柔軟的粉色色調與淡雅的灰、白色相結合，這一經典的顏色搭配低調地展示了設計的魅力。

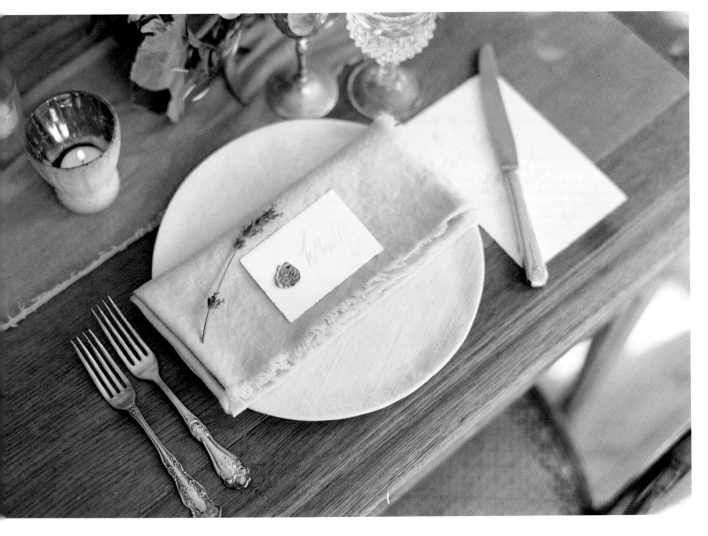

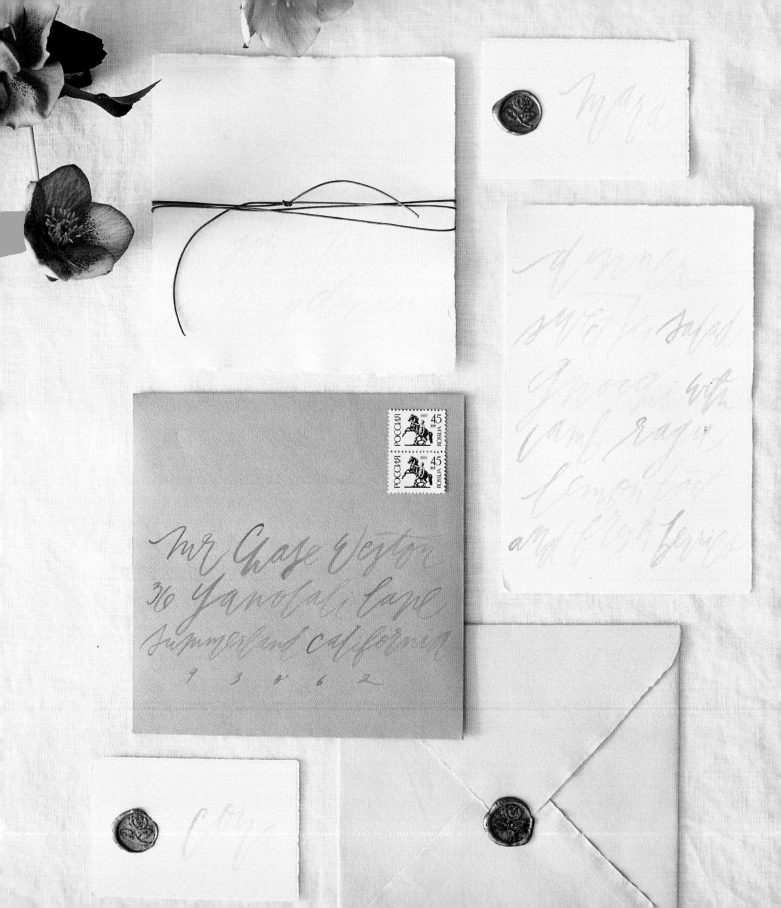

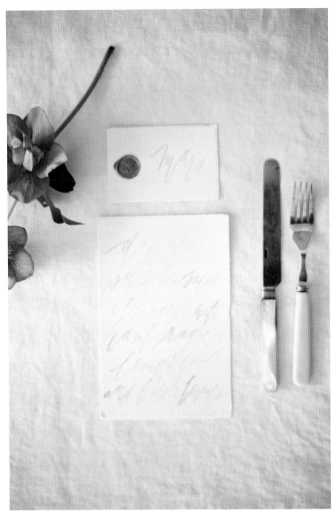

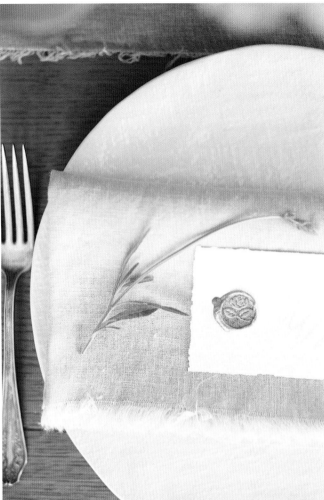

# WINTER
# WONDERLAND

## "冬日仙境" 婚禮平面設計

Design agency: Lauraland Design
Designer: Laura King
Photographer: Tess Polivka Photography
Country: USA

設計機構：蘿拉蘭德設計工作室
設計師：蘿拉·金
攝影師：苔絲·波利夫卡攝影工作室
國家：美國

Frolic and play in this winter wonderland! This invitation invites guests to a wedding engagement dinner hosted in the majestic mountains of Colorado. Laura King incorporated an illustrated woodland flora and fauna pattern into the design complete with elk antlers! Simplicity and texture are perfect for this woodland fête.

這場婚禮的宴會訂於科羅拉多山上舉行，這份請柬邀請賓客來到 "冬日仙境" 盡情嬉戲！設計師在請柬的設計中融入了各種林地花草的圖案，另外還加上了鹿角的形象。簡潔又極具質感，對一場林地婚宴來說最為合適。

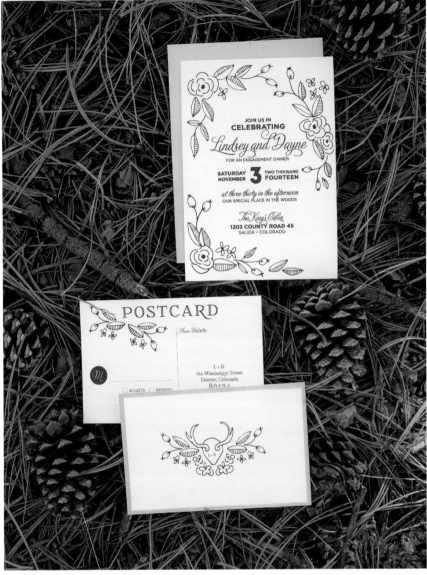

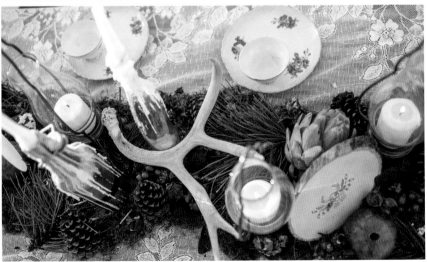

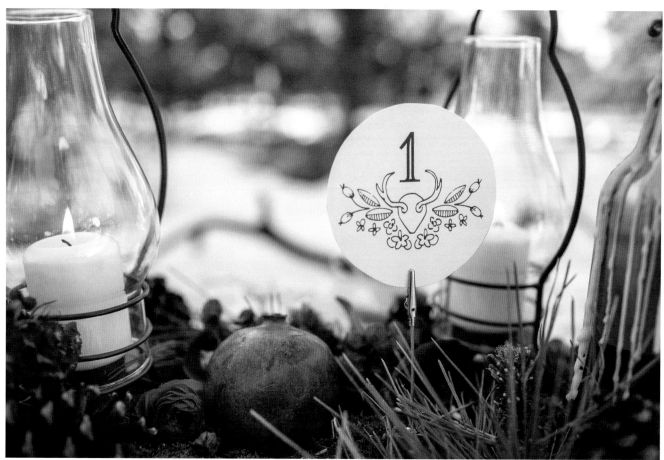

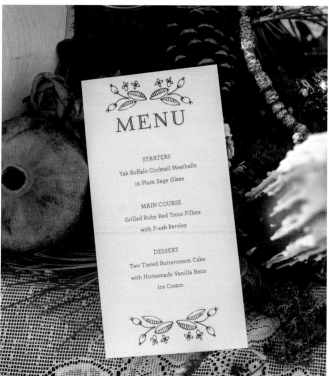

MENU

STARTERS
Yak Buffalo Cocktail Meatballs
in Plum Sage Glaze

MAIN COURSE
Grilled Ruby Red Trout Fillets
with Fresh Parsley

DESSERT
Two Tiered Buttercream Cake
with Homemade Vanilla Bean
Ice Cream

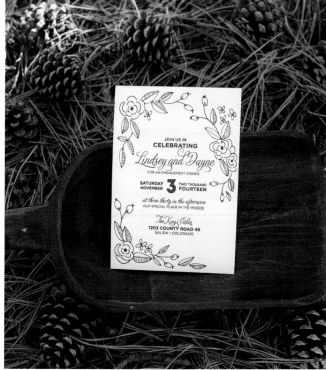

JOIN US IN
CELEBRATING
Lindsey and Dayne
FOR AN ENGAGEMENT DINNER

SATURDAY   3   TWO THOUSAND
NOVEMBER       FOURTEEN

at three thirty in the afternoon
OUR SPECIAL PLACE IN THE WOODS

The King's Cabin
1203 COUNTY ROAD 45
SALIDA • COLORADO

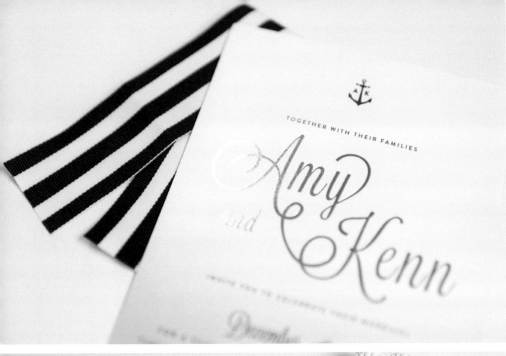

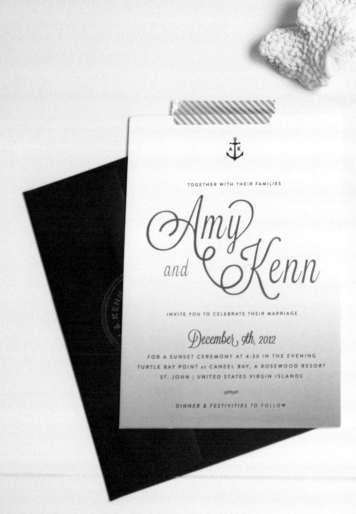

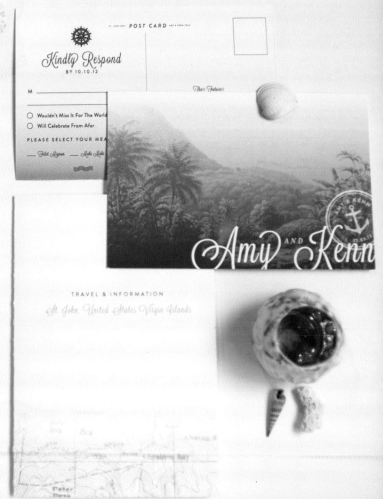

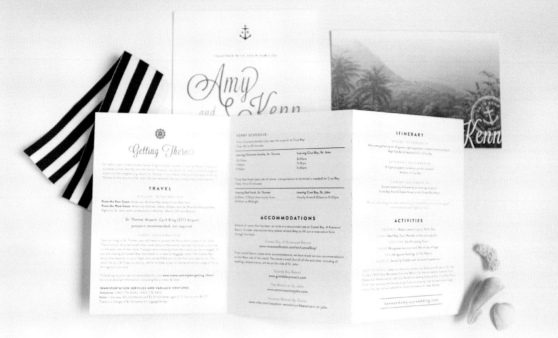

# AMY & KENN
## 艾米與科恩婚禮平面設計

........................................................

Design agency: Carina Skrobecki Design
Designer: Carina Skrobecki
Photographer: Carina Skrobecki Photography
Client: Amy Fritz & Kenn Volz
Country: USA

設計機構：凱芮納·斯可羅賓基設計工作室
設計師：凱芮納·斯可羅賓基
攝影師：凱芮納·斯可羅賓基攝影工作室
委託客戶：艾米·弗裡茨、科恩·沃爾茲
國家：美國

This suite is a mix of both digital printing and gold foiling. The artists created an ombre effect on all the pieces (to cue the sunsets in St. John) to tie them together and an anchor monogram was used on other printed materials as well as on a rubber stamp that sealed the envelopes.

這套婚禮平面設計結合了數位印刷和燙金工藝。設計師讓所有的卡片都呈現出漸變色的效果，象徵著婚禮的舉辦場地〝美國聖約翰島〞落日的餘暉。同時，所有設計也都形成統一的風格。新人名字首字母的組合圖案印在所有印刷品上，封印信封的橡皮圖章也是相同圖案。

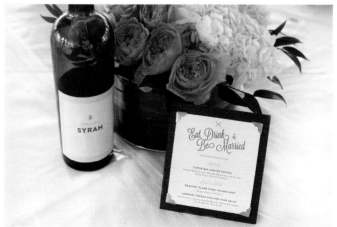

# CRYSTAL & AARON 克麗斯特爾與亞倫婚禮平面設計

Design agency: Papermade Design
Designer: Elaine Chou
Photographer: Erin J. Saldana Photography
Client: Crystal & Aaron
Country: USA

設計機構："紙質設計"公司
設計師：伊萊恩‧周
攝影師：愛琳 J. 薩爾達納攝影公司
委託客戶：克麗斯特爾、亞倫
國家：美國

Nautical inspired design has always been one of the designer's favourites. This one has a modern twist with peach watercoloured backdrop and whimsical hand-lettering. Vintage nautical imagery along with gold handwritten calligraphy for contrast is used. The dark navy envelopes with wide striped liners added a fresh update to a classic theme.

這位設計師一向偏愛航海風格的設計。這套婚禮平面設計以粉色水彩為背景，手寫字母別具一格，呈現出清新的現代感。設計師採用了一系列復古風格的航海標識，而文字則是燙金的手寫字母，兩者形成鮮明對比。深藍色的信封（海軍藍），再配上寬寬的條紋綁帶，為這一古典的主題增添了一絲現代的氣息。

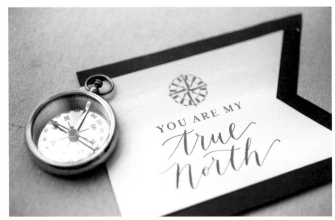

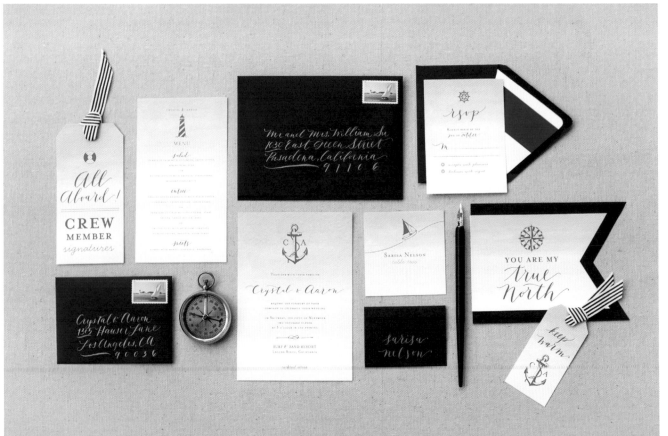

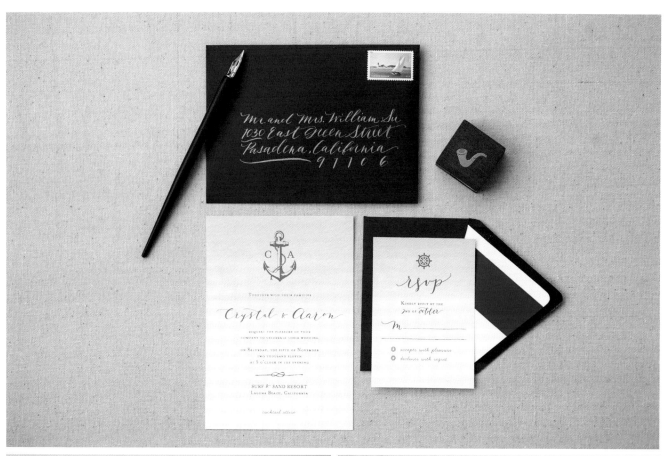

# MEGHAN & ANDREW 梅根與安德魯婚禮平面設計

Design agency: Papermade Design
Designer: Elaine Chou
Photographer: Erin J. Saldana Photography
Client: Meghan & Andrew
Country: USA

設計機構："紙質設計"公司
設計師：伊萊恩‧周
攝影師：愛琳 J.薩爾達納攝影公司
委託客戶：梅根、安德魯
國家：美國

This handsome couple had their summer wedding by the ocean. Their wedding was draped with beautiful white orchids and included soft-blue linen tables. Their invitations came in a kraft-brown box with letter-pressed cards with blue-edge colouring. A tiny glass capsule with their initials decorated the elegant suite.

這對璧人選在海邊舉行浪漫的夏日婚禮。婚禮現場撒滿白色的蘭花，桌布是淡藍色的亞麻布。婚禮請柬裝在棕色的牛皮紙盒子裡，請柬上的文字是壓印上去的並且有藍色鑲邊。請柬盒上附有一枚小巧的玻璃膠囊作為裝飾物，並有兩個字母，是新人名字的首字母縮寫。

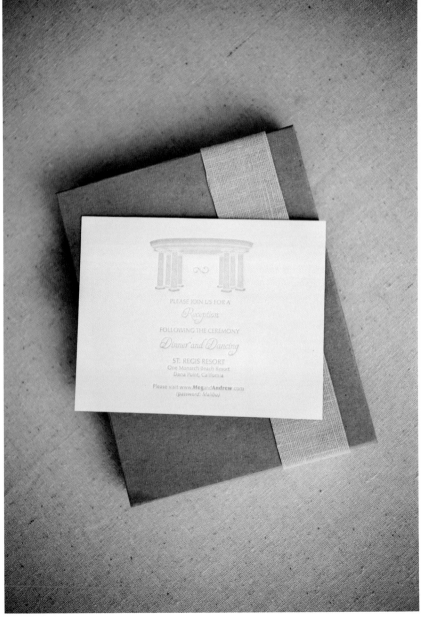

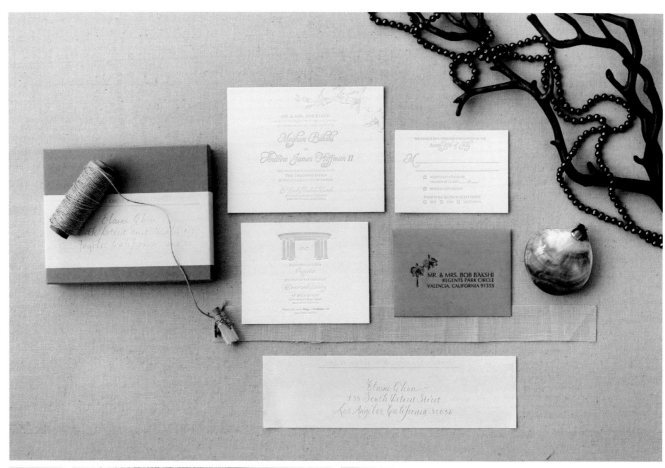

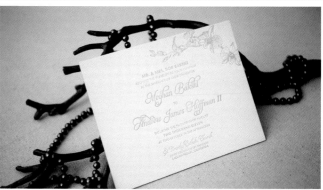

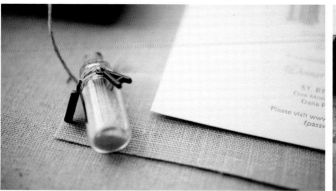

# DANIELA & DAVID 丹妮拉與大衛婚禮平面設計

Designer: David Espinosa & Daniela Rivano
Photographer: Fernanda Pineda, Hanz Rippe & Antonio Aperador
Client: David Espinosa & Daniela Rivano
Country: Colombia

設計師：大衛‧埃斯皮諾薩、丹妮拉‧裡瓦諾
攝影師：費爾南達‧皮內達、漢茨、裡珀、安東尼奧‧阿佩拉多
委託客戶：大衛‧埃斯皮諾薩、丹妮拉‧裡瓦諾
國家：哥倫比亞

When Daniela and David decided to get married, they didn't know how wonderful it would be. They think that the fact of making everything by themselves was the best for their relationship. The main concept was 'You complete me'. Then, their hairstyles and their initials were the key for the project. They created two logos, inspired by things they love most: sea and music in records. The embroidered napkins, the tableclothes and the snow-in-water ball as souvenirs were a great idea from Daniela. David made some handmade wood signs for the signaling, the animated gifs and all the graphics.

這對新人都是設計師，當兩人決定結婚的時候，他們還不知道親自動手創作自己的婚禮平面設計會是如此的美妙！他們只是覺得由自己來設計婚禮上的每件用品會非常有意義。設計理念是 "你使我完整"，兩人的名字和頭像都巧妙融為一體。兩人打造了兩款 LOGO 標誌，設計靈感來自他們的最愛－大海和音樂。繡花餐巾紙、桌布和水晶球（送給賓客的紀念品）是丹妮拉設計的，大衛負責手工製作的木質標識、動畫短片以及其他平面設計。

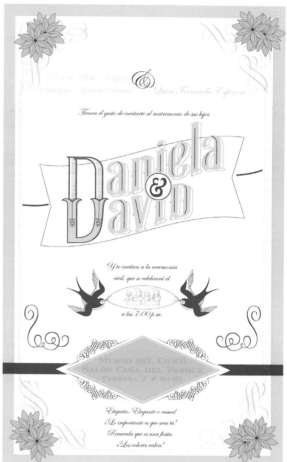

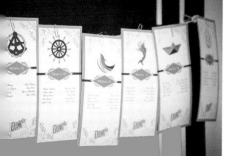

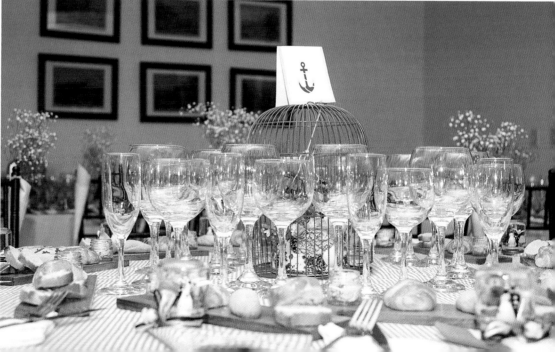

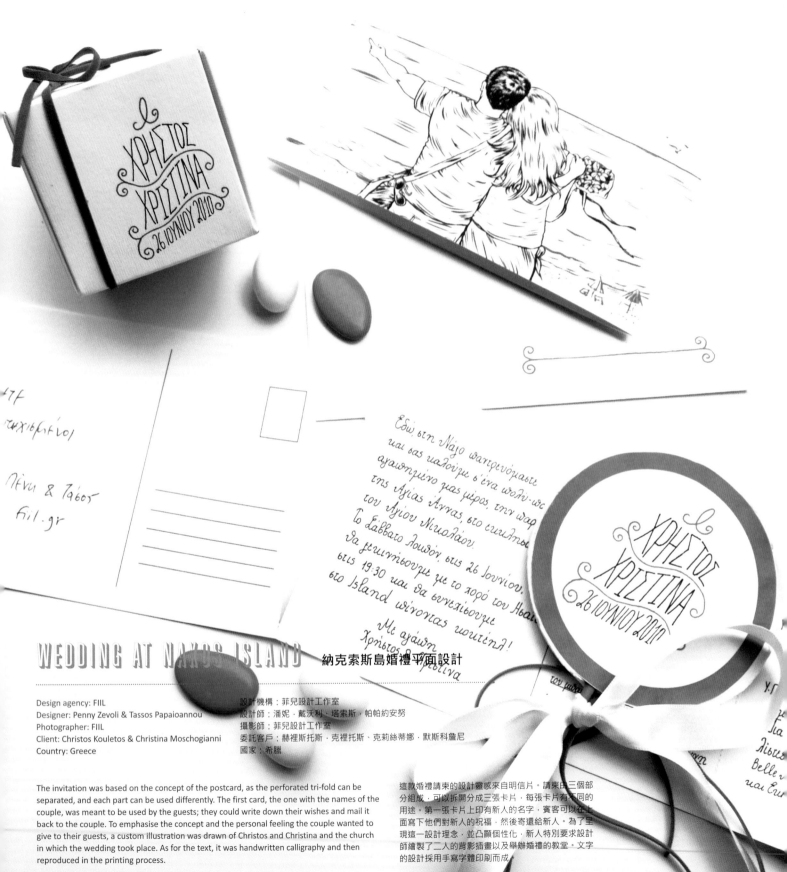

# WEDDING AT NAXOS ISLAND 納克索斯島婚禮平面設計

Design agency: FIIL
Designer: Penny Zevoli & Tassos Papaioannou
Photographer: FIIL
Client: Christos Kouletos & Christina Moschogianni
Country: Greece

設計機構：菲兒設計工作室
設計師：潘妮・戴沃利・塔索斯・帕帕約安努
攝影師：菲兒設計工作室
委託客戶：赫裡斯托斯・克裡托斯・克莉絲蒂娜・默斯科詹尼
國家：希臘

The invitation was based on the concept of the postcard, as the perforated tri-fold can be separated, and each part can be used differently. The first card, the one with the names of the couple, was meant to be used by the guests; they could write down their wishes and mail it back to the couple. To emphasise the concept and the personal feeling the couple wanted to give to their guests, a custom illustration was drawn of Christos and Christina and the church in which the wedding took place. As for the text, it was handwritten calligraphy and then reproduced in the printing process.

這款婚禮請束的設計靈感來自明信片。請束由三個部分組成，可以拆開分成三張卡片，每張卡片有不同的用途。第一張卡片上印有新人的名字，賓客可以在上面寫下他們對新人的祝福，然後寄還給新人。為了呈現這一設計理念，並凸顯個性化，新人特別要求設計師繪製了二人的背影插畫以及舉辦婚禮的教堂。文字的設計採用手寫字體印刷而成。

# TANIA & ABEL 塔妮婭與亞伯婚禮平面設計

Design agency: CECI New York
Client: Tania & Abel
Country: USA

設計機構：紐約 CECI 設計工作室
委託客戶：塔妮婭、亞伯
國家：美國

With a wonderful fairy-tale wedding overlooking the Pacific Ocean in Carmel, California, Tania and Abel's wedding was full of lush peonies and whimsical details, including a commemorative intimate painting of their wedding story and all their loves. Little personal touches were drawn in a chic storybook style – shopping and her dogs for her, his motorcycle and golf clubs for him. The lining presents the breathtaking view of the ocean adorned by their silhouettes. Finished with pewter and soft blush inks for the perfect balance.

塔妮婭和亞伯的婚禮是奇妙的童話風格，地點選在加利福尼亞州毗鄰太平洋的卡梅爾小鎮。請柬的設計大量採用牡丹花以及各種奇思妙想，包括描繪兩人婚禮現場的一幅紀念畫。新人的特徵以故事書的形式巧妙表現出來，愛購物的新娘牽著寵物狗，新郎則有摩托車和高爾夫球杆。信封內層呈現出令人歎為觀止的海景，並用新人的剪影作為裝飾。最後用白蠟與柔和的緋紅色油墨營造出完美的效果。

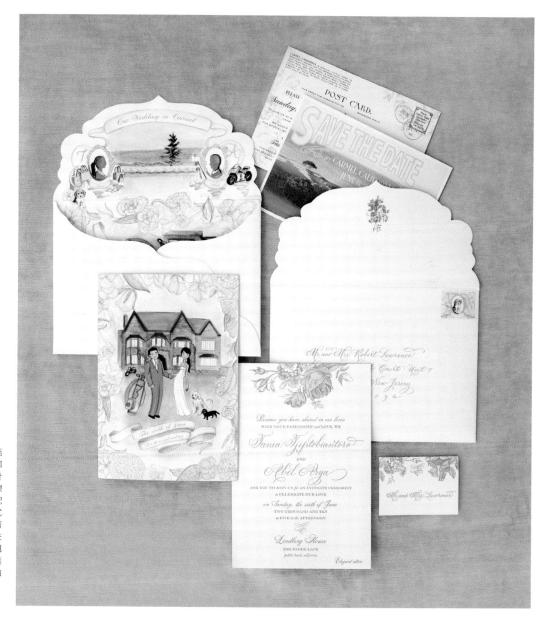

# DEIRDRE & BENNY

## 迪爾德麗與本尼婚禮平面設計

Design agency: CECI New York
Client: Deirdre & Benny
Country: USA

設計機構：紐約 CECI 設計工作室
委託客戶：迪爾德麗、本尼
國家：美國

With a modern beach wedding, this design had to capture the essence of the Hamptons. Rolling dunes, sea grass, photography of the ocean all beckon guests to come away for a relaxing weekend. The cover is a custom illustration of an artistic interpretation of waves or natural wood grain. Invitation is an eight-page ultra luxe booklet lined with 100% bamboo-woven paper complete with a pocket in the back cover to hold RSVP set.

這是一場現代風格的海灘婚禮，地點選在美國度假勝地漢普頓斯，所以平面設計要抓住當地風景的精髓。起伏的山丘、奇異的海草以及海景的攝影仿佛在召喚著賓客，跳脫開繁忙的日常生活，來此享受一個輕鬆的週末吧！請柬信封上是專門繪製的海浪和木紋圖案。請柬是一本 8 頁的小冊子，盡顯奢華品味，鑲有一張淺色的 100% 竹編襯紙。背面有個裝有回覆套卡小口袋。

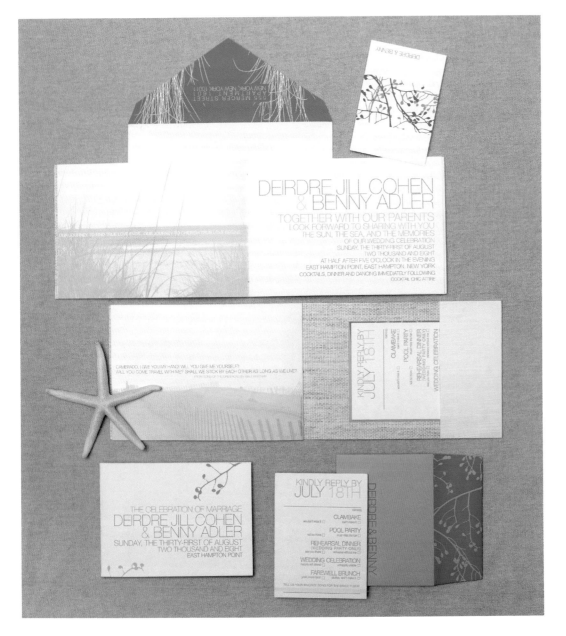

# FRENCH MEDITERRANEAN WEDDING 法式地中海風情婚禮平面設計

Design agency: Pretty in Print
Designer: Ann Gancarczyk
Photographer: Ann Gancarczyk
Client: Love Circus
Country: Germany

設計機構："漂亮印刷"設計工作室
設計師：安‧甘卡爾齊克
攝影師：安‧甘卡爾齊克
委託客戶："愛情馬戲團"
國家：德國

This collection of paper goods was commissioned by a team of wedding planners in Berlin, Love Circus, for a styled photo shoot. The theme was a French Mediterranean wedding and the designs are elegant in their simplicity, with a lovely warm taupe on cream paper. The designer chose calligraphic fonts and hand-drawn olive branches to give these designs a rustic chic look. The olive oil wedding favours are her favourite, as they make very practical and beautiful gifts.

這套婚禮平面設計受柏林婚禮策劃團隊"愛情馬戲團"委託。婚禮的主題是法式地中海風情，設計上簡約而又典雅，採用乳色紙和溫暖而別致的灰褐色色調。設計師選擇了手寫字體和手繪的橄欖枝，賦予這套卡片一種純樸自然的氣息。這位設計師偏愛使用橄欖油作為婚宴的禮品，美觀又實用。

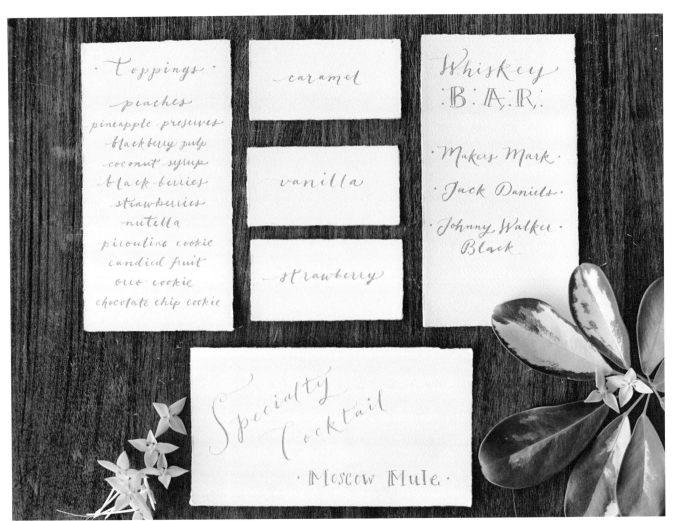

· Toppings ·

peaches
pineapple preserves
blackberry pulp
coconut syrup
black berries
strawberries
nutella
pirouline cookie
candied fruit
oreo cookie
chocolate chip cookie

caramel

vanilla

strawberry

Whiskey
:B:A:R:

· Makers Mark ·

· Jack Daniels ·

· Johnny Walker
Black ·

Specialty
Cocktail

· Moscow Mule ·

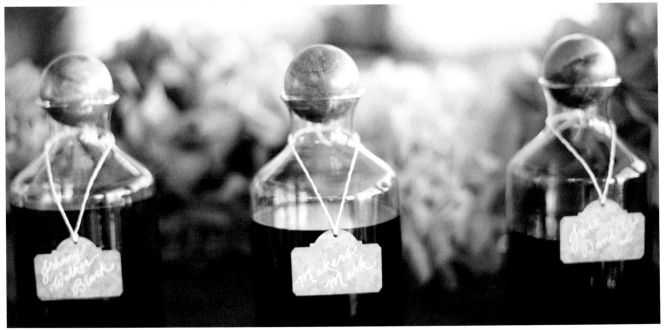

# SIERRA & MICHAEL

## 謝拉與邁克爾婚禮平面設計

Design agency: Paperfinger &
JenHuangArt (Watercolour Menu)
Photographer: JenHuangPhoto
Client: Sierra & Michael
Country: USA

設計機構："紙手指"設計工作室、
黃珍設計工作室（水彩功能表）
攝影師：黃珍攝影工作室
委託客戶：謝拉、邁克爾
國家：美國

The wedding features green leaves and bright-coloured
flowers, with an exotic air of the island. The designers
chose hand-drawn illustrations and watercolour, in a
light and elegant tone that matches up with the style
of the wedding. The invitation suite features torn-edge
paper, naturally bringing out a rustic feeling.

謝拉和邁克爾的婚禮由綠葉襯托的鮮豔花朵所裝飾，海
島的氣息撲面而來。設計師選擇了手繪和水彩的繪畫方
式來設計婚禮上的平面元素，清新淡雅的色彩迎合了婚
禮的主題。卡片的設計採用了簡單撕邊的白色紙張，凸
顯自然的主題。

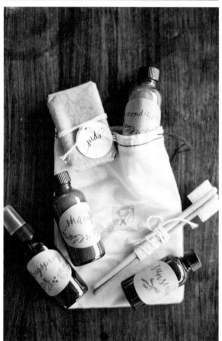

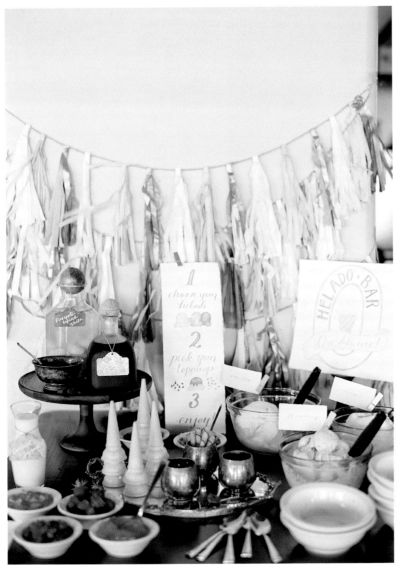

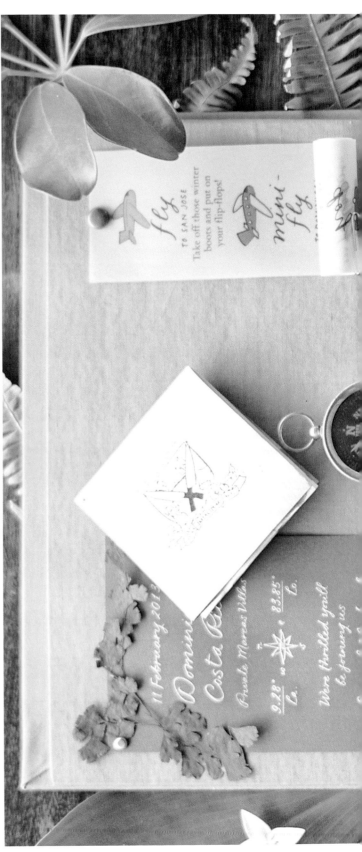

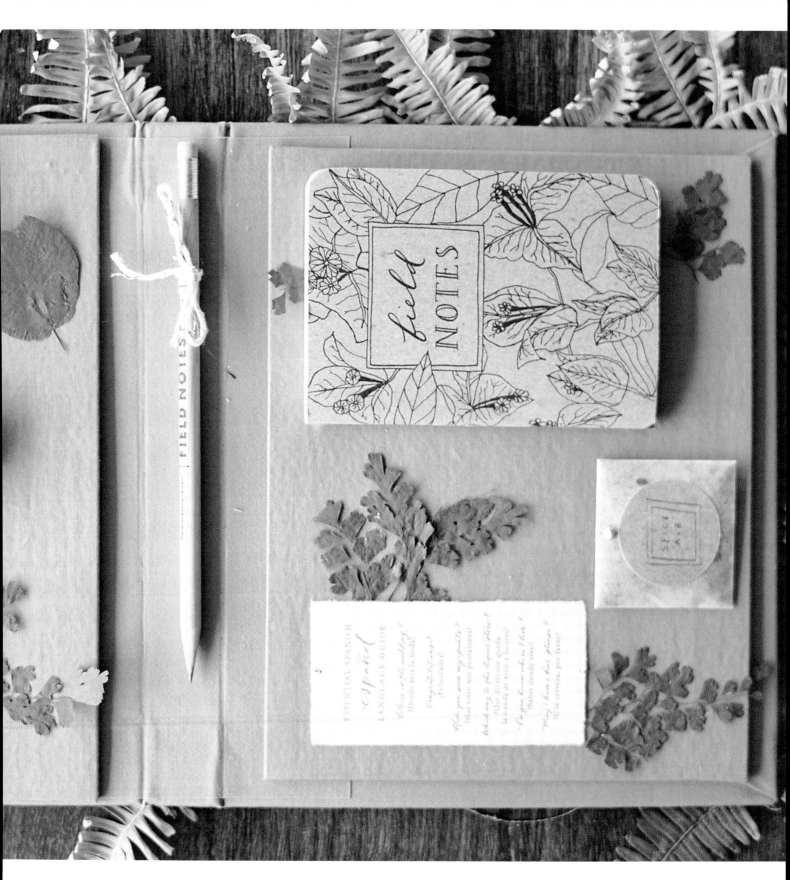

# ALICIA & JOEL
## 艾麗西婭與喬爾婚禮平面設計

Design agency: Papermade Design
Designer: Elaine Chou
Photographer: Erin J. Saldana Photography
Client: Alicia & Joel
Country: USA

設計機構："紙質設計"公司
設計師：伊萊恩·周
攝影師：愛琳 J. 薩爾達納攝影公司
委託客戶：艾麗西婭、喬爾
國家：美國

This design had Victorian-inspired accents such as the detailed border and vintage floral imagery. The artists used a modern, cursive typeface with many flourishes to add a playful flair to the paper goods. The colours were monochromatic which was a sophisticated balance to the whimsical flourishes. The soft, floral references helped describe the outdoor spring wedding hosted in the open fields.

這套婚禮平面設計以維多利亞風格為特色，如卡片邊緣的精緻花紋和復古的花卉圖案。設計師選用了一種帶有手寫體風格的現代字體，又增加了繁複的花式設計，使文字顯得更加靈動。整套卡片為單色，簡單大方，避免過於複雜的字體產生令人眼花撩亂的感覺。這是一場春季戶外婚禮，所以使用花草圖案可謂恰到好處。

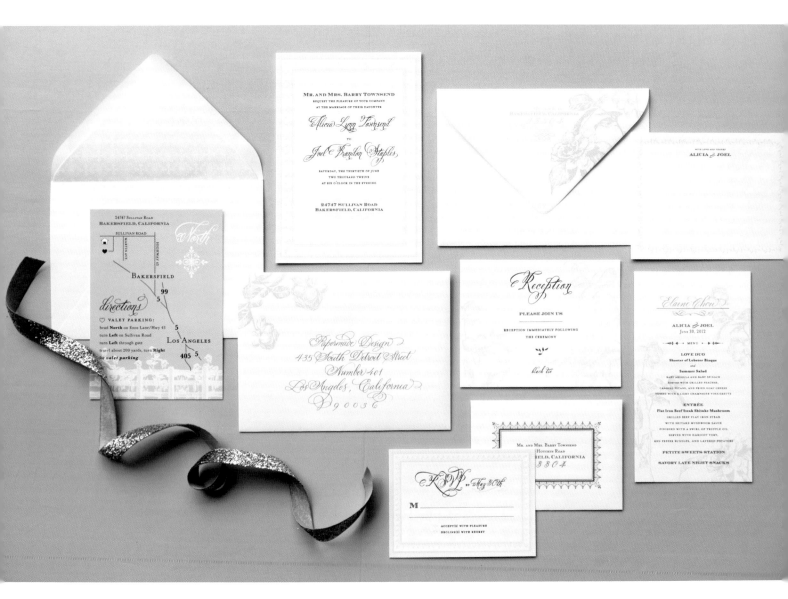

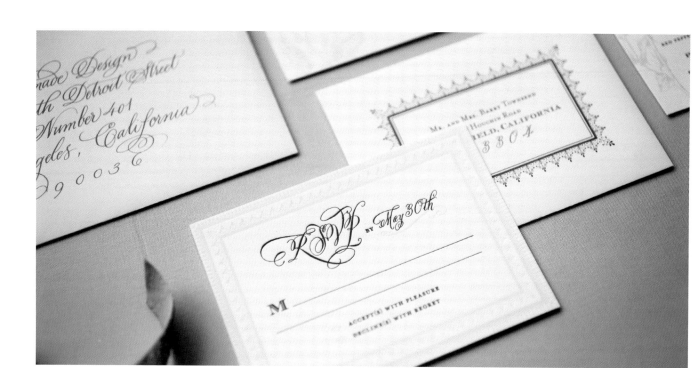

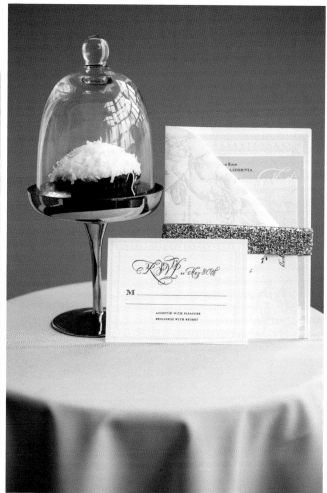

# VANITY FAIR

## "名利場" 婚禮平面設計

Design agency: caratterino
Designer: Ara Marsili
Photographer: Cinzia Bruschini
Country: Italy

設計機構：卡拉特里諾設計工作室
設計師：阿拉‧瑪律西利
攝影師：欽齊亞‧布魯斯奇尼
國家：義大利

Inspired by the novel Vanity Fair, this stationery is a precious mix of cotton paper printed cards, decorated by gold ink and thread details. Handwritten vintage linen textiles were used as placeholder.

這套婚禮平面設計的靈感來自小說《名利場》。設計內容包括一套精美的棉纖維紙印刷卡片，以金色油墨和螺紋圖案裝飾。預留位置的布條是復古風格的亞麻織物，上面有手寫的名字。

AUGUST THE 25ᵀᴴ 2013

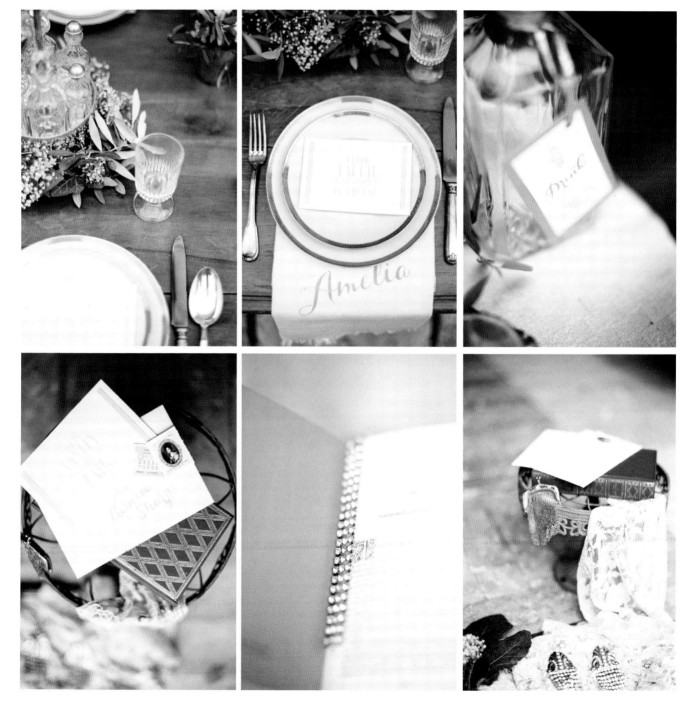

# JOSH & BRITTANY 喬希與布列塔妮婚禮平面設計

Designer: Brittany Von Lanken
Photographer: Jessica Barley
Client: Brittany Von Lanken
Country: USA

設計師：布列塔妮‧范蘭肯
攝影師：潔西嘉‧巴厘
委託客戶：布列塔妮‧范蘭肯
國家：美國

Brittany Von Lanken is a graphic designer from Illinois. She has always loved art and pursued her degree in the graphic arts. When her husband proposed to her, she knew she wanted an artsy wedding, filled with her own designs to give it a personal touch. Everything you see in the photos is designed by herself. For the invitations and programmes, she watercoloured the flowers, then hand drew the black floral design on her computer. Design is such an important part of her life and it is her passion, so she wanted that to be very apparent in her wedding. She had so much fun designing everything, from the invites to the centre pieces. Her husband Josh has supported her art, and he enjoyed the designs she did for their wedding just as much as the guests and the bride did!

布列塔妮是來自伊利諾州的平面設計師，從小熱愛藝術，畢業於平面設計專業。當喬希向布列塔妮求婚的時候，新娘就決定舉辦一場充滿藝術氣息的婚禮，婚禮上的一切設計都由自己親自操刀，表現出個人特色。我們在圖片中看到的一切都是布列塔妮設計的。婚禮請柬和流程卡上的花卉是她用水彩畫的，黑色的花卉圖案是在電腦上手繪的。對於布列塔妮來說，設計已經成為生命中的重要部分，她為之傾注了全部熱情，所以希望在她的婚禮上能夠傳達出這一點。婚禮上的各項用品，從請柬到餐桌中央的擺飾，設計過程她都享受其中。喬希一直非常支持布列塔妮的藝術創作，他也像布列塔妮和婚禮來賓一樣喜愛她的設計！

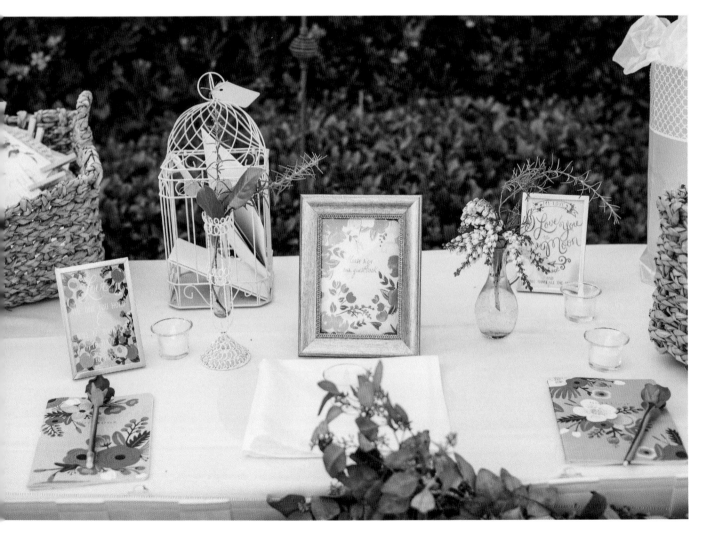

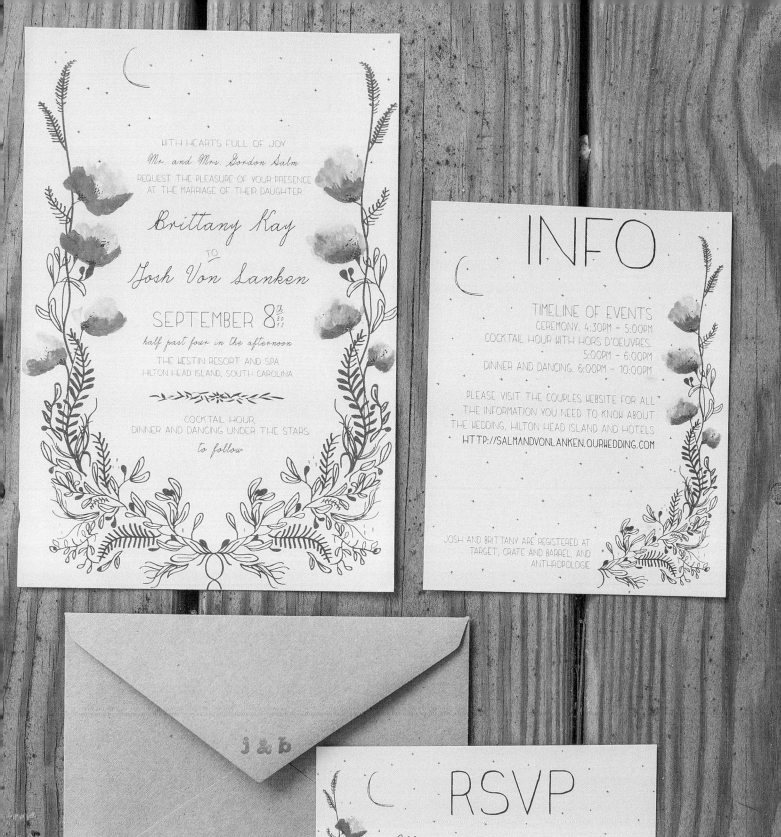

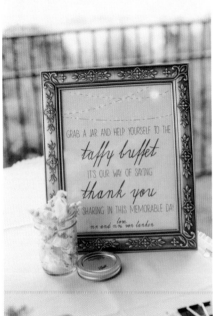

GRAB A JAR AND HELP YOURSELF TO THE

*taffy buffet*

IT'S OUR WAY OF SAYING

*thank you*

FOR SHARING IN THIS MEMORABLE DAY

love,
mr. and mrs. von lanken

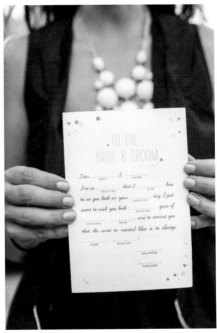

TO THE
BRIDE & GROOM

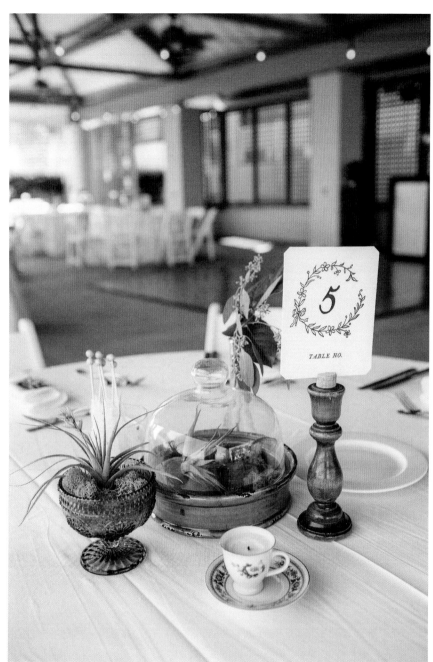
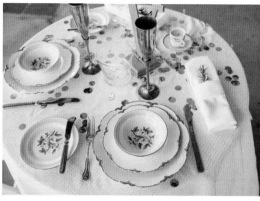
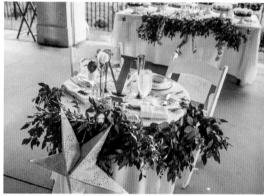
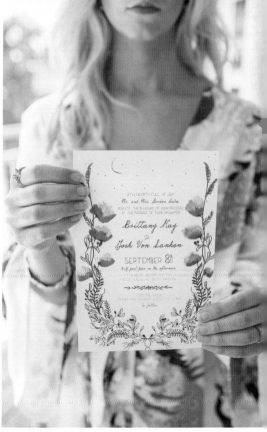

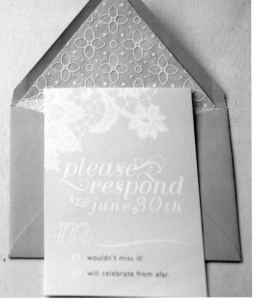

**menu**

*first course*
Squash ravioli served with sage brown butter
and persimmons

*second course*
Seared Halibut, toasted red peppers,
Dodoni feta, roasted potatoes, herbs,
lemon honey dressing

*third course*
Apricot panna cotta, apricot compote,
vanilla yogurt, sweet and sour apricot foam,
pistachio dust

Freshly brewed coffee and a selection of teas

*please respond*
by june 30th

M

○ wouldn't miss it!
○ will celebrate from afar.

*elaine*
2

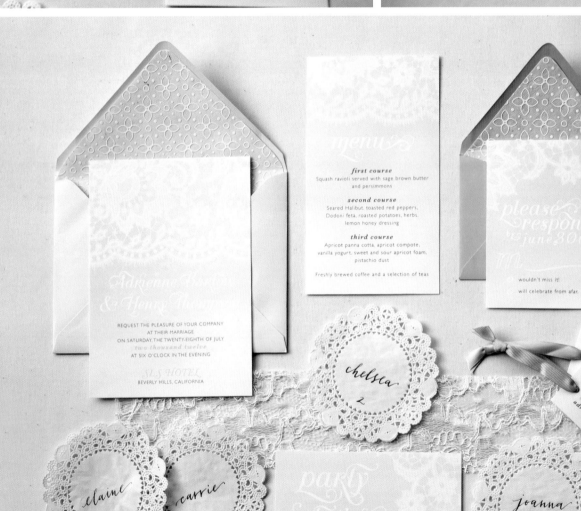

**menu**

*first course*
Squash ravioli served with sage brown butter
and persimmons

*second course*
Seared Halibut, toasted red peppers,
Dodoni feta, roasted potatoes, herbs,
lemon honey dressing

*third course*
Apricot panna cotta, apricot compote,
vanilla yogurt, sweet and sour apricot foam,
pistachio dust

Freshly brewed coffee and a selection of teas

*please respond*
by june 30th

M

○ wouldn't miss it!
○ will celebrate from afar.

Adrienne Horton
& Henry Thompson

REQUEST THE PLEASURE OF YOUR COMPANY
AT THEIR MARRIAGE
ON SATURDAY, THE TWENTY-EIGHTH OF JULY
*two thousand twelve*
AT SIX O'CLOCK IN THE EVENING

SLS HOTEL
BEVERLY HILLS, CALIFORNIA

*chelsea*
2

*elaine*
2

*carrie*
1

*party into the night*

JOIN US
*saturday evening*
midnight until dawn

SLS HOTEL
*presidential suite*

*joanna*
2

*Thanks*
adrienne & henry
7.28.12

# ADRIENNE & HENRY

## 艾德麗安與亨利婚禮平面設計

Design agency: Papermade Design
Designer: Elaine Chou
Photographer: Erin J. Saldana Photography
Client: Adrienne & Henry
Country: USA

設計機構："紙質設計"公司
設計師：伊萊恩·周
攝影師：愛琳 J. 薩爾達納攝影公司
委託客戶：艾德麗安、亨利
國家：美國

This event took note from the runway with soft-ombre pastels and lace/eyelet-inspired textures. Doilies were hand-dyed and finished with calligraphy to serve as place cards. A light rainbow palette with lace silhouette was used for the backdrop for the invitation cards.

這套婚禮平面設計以柔和的漸變色蠟筆畫為特色，呈現出獨特的質感，靈感來自蕾絲和孔眼。小型裝飾桌布是手工染色的，上面有手寫體的文字，作為桌號牌的作用。清淺的繽紛色調搭配蕾絲圖案，用作婚禮請束的背景。

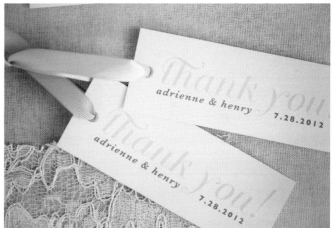

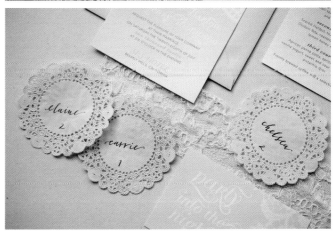

# ERIN & LUKE

**艾琳與盧克婚禮平面設計**

Design agency: Caliber Creative
Designer: Maxim Barkhatov
Photographer: Caliber Creative
Client: Erin & Luke Shellenberger
Country: USA

設計機構：卡利伯創意工作室
設計師：馬克沁·巴克哈托夫
攝影師：卡利伯創意工作室
委託客戶：愛琳·舍倫柏格、盧克·舍倫柏格
國家：美國

As a wedding gift, Caliber designed the entire suite of aspen-inspired materials needed for the big day: a screen-printed three-part invitation on balsa wood and corresponding envelope, menu, custom wine bottle and screen-printed box as a thank-you gift for guests and personalised programme.

卡利伯創意工作室打造這套婚禮平面設計，作為送給新人的禮物。設計以獨特的材質為特色，靈感來自白楊樹。婚禮請柬包括三張卡片，裝在軟木盒子裡，盒蓋上採用絲網印刷技術。此外還有配套的信封、菜單和個性化流程卡。專門製作的酒瓶和絲網印刷的木盒是送給賓客的禮品。

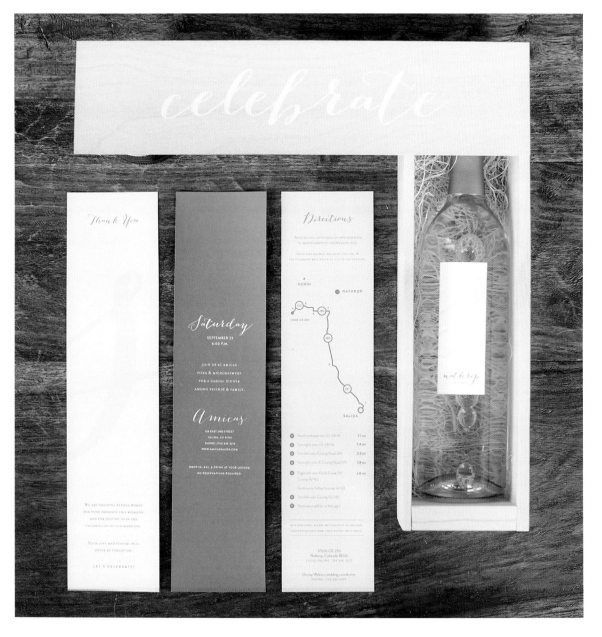

ERIN HUDSON FLETCHER
&
DAVID LUKE SHELLENBERGER
09.23.12

ERIN HUDSON FLETCHER
&
DAVID LUKE SHELLENBERGER
09.23.12

*menu*

HORS D'OEUVRES

LOCAL FARM BRUSCHETTA

COLORADO CHEESE AND FRUIT BOARD

*greens*

AUTUMN GREENS

*colorado sliders*

NATURAL RANGE CHICKEN CORDON BLEU

HUTCHINSON RANCH GRASS-FED SLIDER

COLORADO PORK TENDERLOIN WITH
CILANTRO & LIME

APPLEWOOD SMOKED BACON & BLUE
CHEESE STUFFED BEEF SLIDER

*side*

FARM FRESH SWEET POTATO FRIES

*children's palate*

FIVE CHEESE MACARONI

*To:* Whitney
& Noah

FORT WORTH, TX

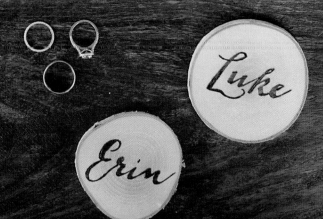

Luke

Erin

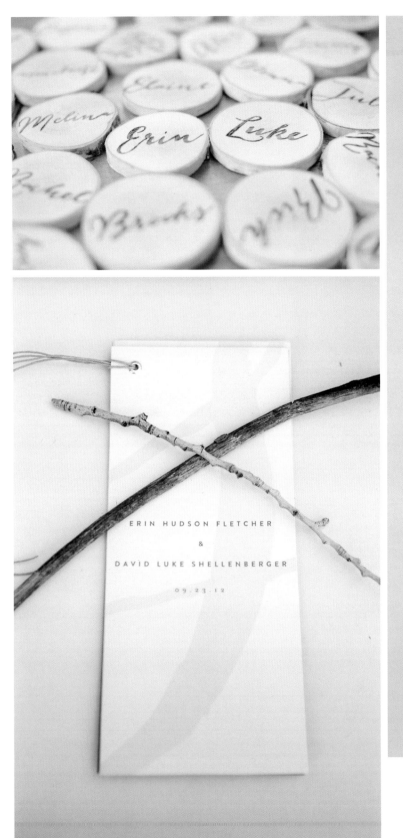

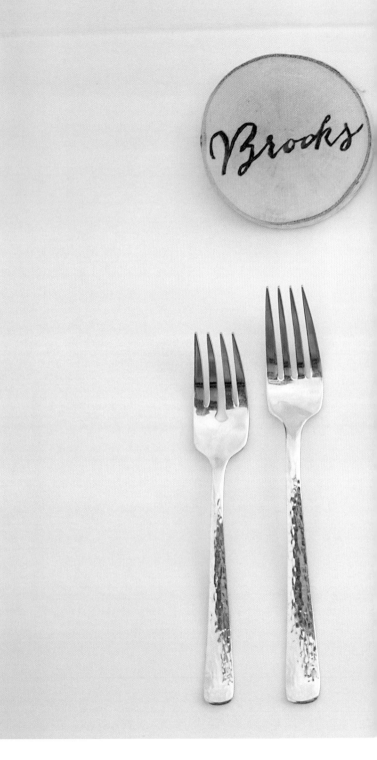

## menu

### Hors D'Oeuvres

PALISADE PEACHES WITH GOAT CHEESE MOUSSE.
PALISADE, COLORADO, PEACHES WRAPPED IN A CANDY-SMOKED,
ALL NATURAL BACON, TOPPED WITH A LOCAL GOAT CHEESE CHEVRE
MOUSSE AND FARM FRESH CHIVES

### Local Farm Bruschetta

FRESH SALIDA BAKERY TOASTED BREADS, ERIN'S GEOTHERMAL
GREENHOUSE TOMATOES, BASIL & LOCAL COLORADO SOFT CHEESE,
TOPPED WITH AGED BALSAMIC VINEGAR AND HONEY TRUFFLE OIL

### Colorado Cheese and Fruit Board

JUMPIN' GOOD GOAT DAIRY AND HAYSTACK FARMS SELECTION OF
NATURAL GOAT CHEESES, ROCKING W SOFT CHEESES & FRESH ORGANIC
VARIETY OF NATURAL FRUITS & BERRIES OF COLORADO WITH LOCALLY
MADE SOURDOUGH AND FRESH BREADS

## greens

### Autumn Greens

FRESH PICKED FRISEE & COLON ORCHARD APPLE SALAD WITH DRIED
WESTERN SLOPE CHERRIES, AND WALNUTS, TOPPED WITH COLORADO
APPLE CIDER VINAIGRETTE

## colorado sliders

### Natural Range Chicken Cordon Bleu

BOULDER POULTRY ALL NATURAL CHICKEN BREAST GRILLED WITH
FRESH ORGANIC LOCAL HERBS, TOPPED WITH ALL NATURAL SMOKED
HAM & ROCKING W SWISS CHEESE, DRIZZLED WITH A FRESH MADE
LEMON AND BASIL SAUCE

### Hutchinson Ranch Grass-Fed Slider

HUTCHINSON RANCH NATURALLY RAISED GRASS-FED BEEF
TENDERLOIN, WITH ERIN'S GEOTHERMAL GREENHOUSE TOMATOES,
CARAMELIZED ONIONS & MELTED LOCAL SWISS AND PROVOLONE

### Colorado Pork Tenderloin with Cilantro & Lime

NATURAL RANGE PORK TENDERLOIN, GRILLED TO PERFECTION,
BATHED IN CARAMELIZED ONIONS AND A DRIZZLE OF CILANTRO
AND LIME MAYO

### Applewood Smoked Bacon & Blue Cheese Stuffed Beef Slider

ALL NATURAL GRASS-FED BEEF TENDERLOIN ROLLED IN SMOKED
COLORADO BACON, STUFFED WITH SCANGA BLUE CHEESE, TOPPED
WITH SAUTEED ONIONS, FRESH HERBS AND ERIN'S CHERRY TOMATOES

## side

### Farm Fresh Sweet Potato Fries

LOCAL, MANDOLINE-CUT SWEET POTATOES FRIED IN
RENDERED DUCK FAT THEN SPRINKLED WITH COARSE SALT
AND FRESHLY-GROUND PEPPER

## children's palate

### Five Cheese Macaroni

ALL NATURAL MACARONI PASTA, BATHED IN A SELECTION OF FIVE
LOCAL CHEESES, TOPPED WITH BOULDER COUNTY BREAST
OF CHICKEN & FRESH HERBS

A SPECIAL THANK YOU TO WILD ALTITUDE ORGANIC CATERING
SALIDA, COLORADO
WWW.AWILDALTITUDE.COM

# CLYDE SUITE 克萊德婚禮平面設計

Design agency: Olive & Emerald
Photographer: Cameron Ingalls Photography
Client: Greengate Ranch & Vineyard
Country: USA

設計機構：奧利弗 & 埃默拉爾德設計工作室
攝影師：卡梅倫‧英戈爾斯攝影工作室
委託客戶：綠門農場與葡萄園
國家：美國

In an effort to style a wedding that rose above the typical clichés, the Clyde Suite took cues from equine elegance, inspired by the rustic romance seen in the designs of Ralph Lauren. A neutral colour palette was livened by the addition of classic script and cutting-edge details.

這套婚禮平面設計旨在跳脫常規，賦予這場婚禮自身獨有的風格。設計圍繞駿馬的形象展開，靈感來自國際著名服裝品牌拉夫‧勞倫設計中的"田園浪漫"氣息。復古的手寫字體和前衛的細節設計讓中性的色調煥發光彩，有畫龍點睛的作用。

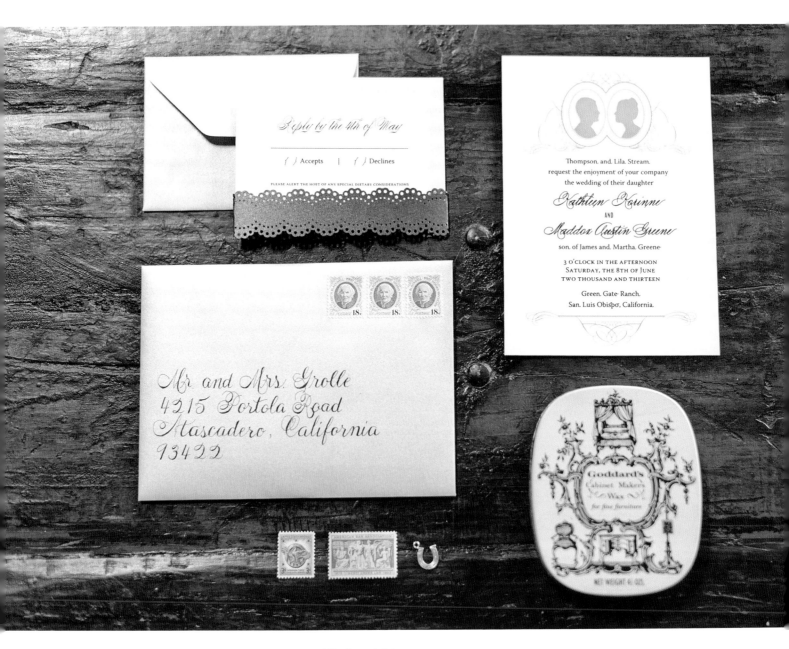

Kathleen & Maddox
are about to get

*Hitched!*

SAN LUIS OBISPO, CALIFORNIA
JUNE 8TH, 2013

Please mark your calendars
so you can join in the festivities.

MORE INFO AT
WWW.K·M·WEDDING·2013.COM

PLEASE SEND TO:

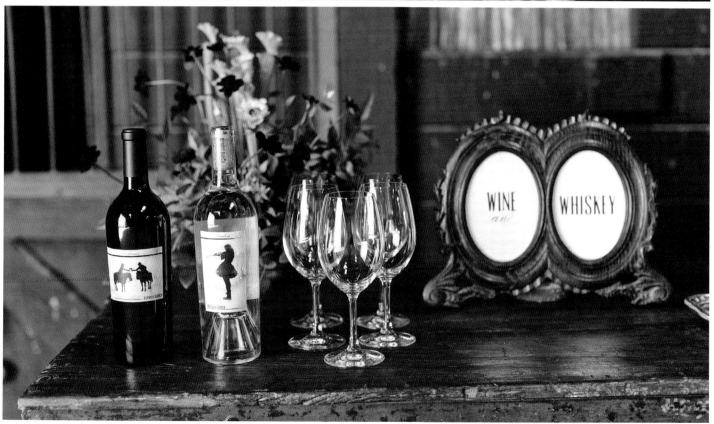

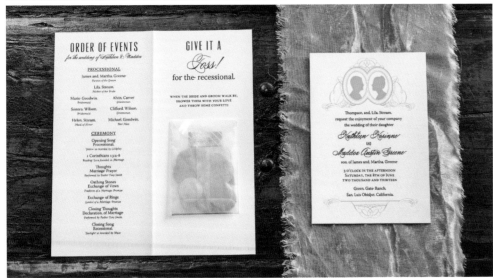

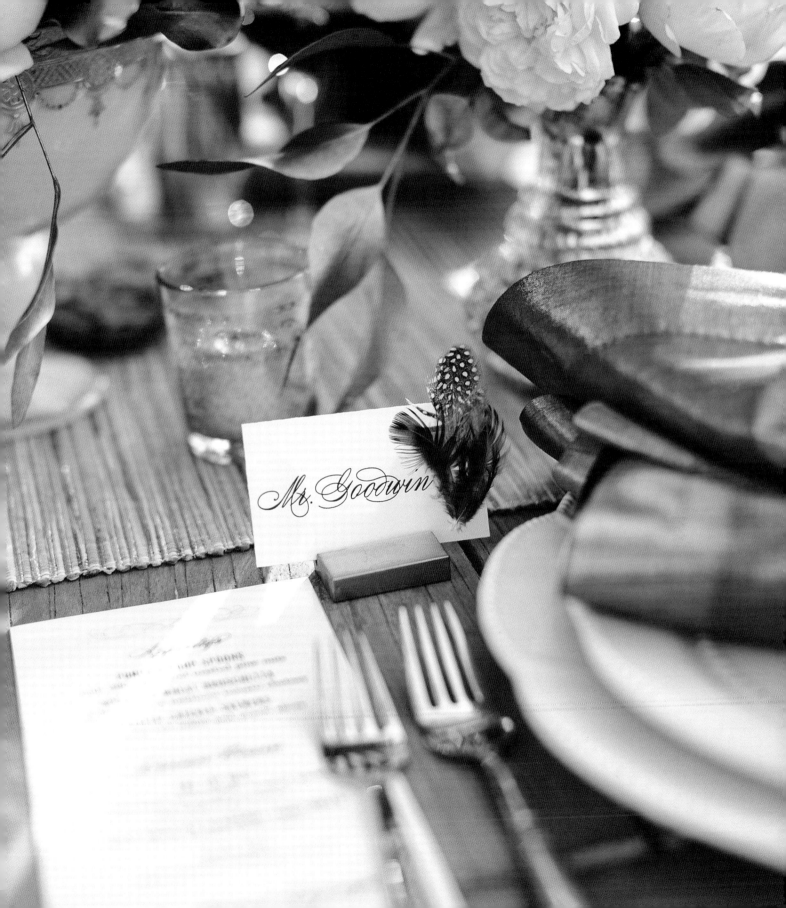

# CONFETTI WEDDING

## 五彩紙花婚禮平面設計

Design agency: Jen Simpson Design
Designer: Jen Simpson
Photographer: Ashley Bee Photography
Country: USA

設計機構：珍‧辛普森設計工作室
設計師：珍‧辛普森
攝影師：艾希莉‧比攝影公司
國家：美國

Start your wedding of with confetti! Let everyone know you are having a wonderful jubilee filled with modern elegance and confetti!

用五彩紙花來為你的婚禮開場吧！讓每個人都知道，你正沉浸在巨大的歡樂與幸福中，而營造出這福幸氛圍，除了現代高雅的設計，當然就是五彩紙花了！

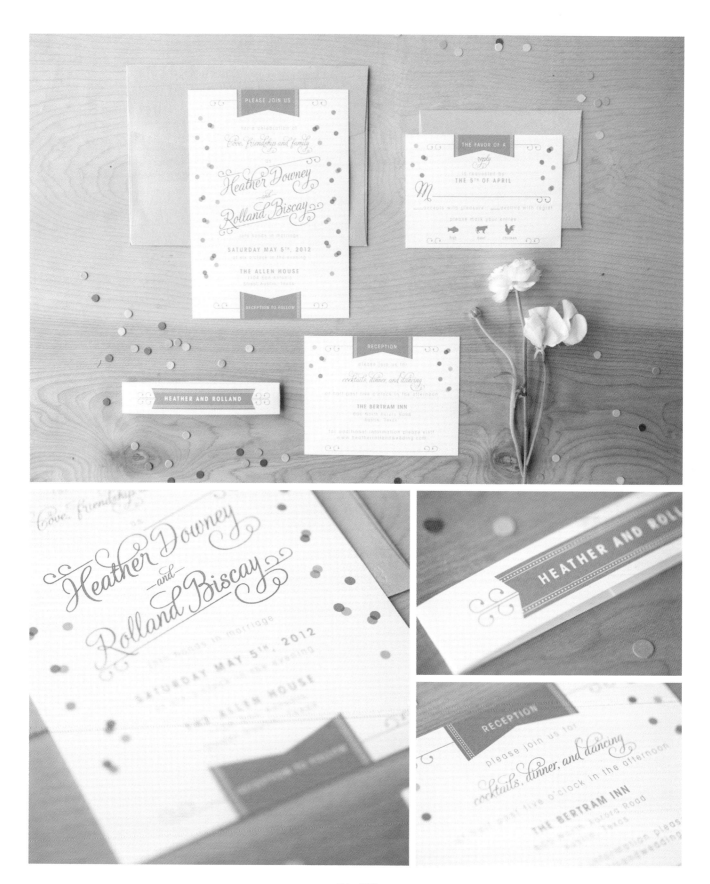

# ELO & FER 埃羅與費爾婚禮平面設計

Design agency: El Calotipo Printing Studio
Photographer: El Calotipo Printing Studio
Client: Elo & Fer
Country: Spain

設計機構：埃爾‧卡魯蒂伯設計工作室
攝影師：埃爾‧卡魯蒂伯設計工作室
委託客戶：埃羅、費爾
國家：西班牙

Elo and Fer came to El Calotipo Printing Studio with their minds made to have sunflowers on their wedding invitations. The designers came to that idea carefully trying to create cheerful, colourful and full-of-life invitations, playing around with different fonts and nature elements to make their invitations reflect not only the ceremony itself but also a family party.

埃羅和費爾找到埃爾‧卡魯蒂伯設計工作室的時候，已經決定要在他們的婚禮請束上出現向日葵的形象。設計師透過精心的設計，既實現了他們的願望，又讓請束呈現出喜慶、繽紛的色彩，充滿生機。請束採用多種字體和大自然的元素，旨在表現出婚禮舉辦場地的特點，同時也營造出家庭大聚會的歡樂氛圍。

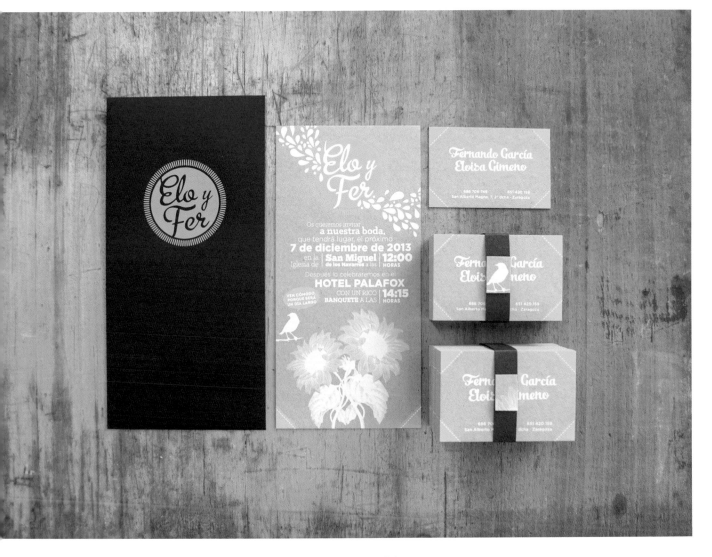

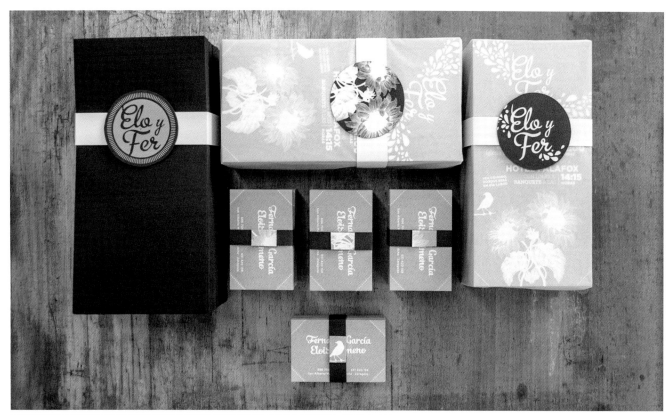

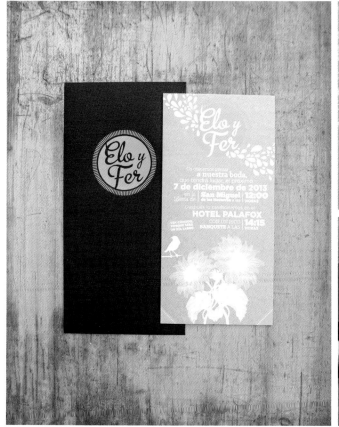

# FIONA & KAI

### 菲奧娜與卡伊婚禮平面設計

Design agency: Anna Katharina Jansen | Illustration
Designer: Anna Katharina Jansen
Photographer: Anna Katharina Jansen
Client: Fiona & Kai
Country: Germany

設計機構：安娜‧卡塔琳娜‧揚森平面設計工作室
設計師：安娜‧卡塔琳娜‧揚森
攝影師：安娜‧卡塔琳娜‧揚森
委託客戶：菲奧娜、卡伊
國家：德國

Wedding invitation for Fiona and Kai. They wanted the artist to design a simple but happy theme for their wedding stationery, so she worked with a clear lettering and a lovely – not too kitschy – floral pattern. Fiona originally is from Scotland, so some invitations were designed in German and some in English.

本案是為菲奧娜和卡伊所做的婚禮請柬設計。這對新人希望他們的請柬既簡單又能表現出歡樂的主題，所以設計師採用了清晰的拼寫和可愛的花卉圖案（可愛而不庸俗）。菲奧娜來自蘇格蘭，所以有些請柬設計成英語，有些是德語。

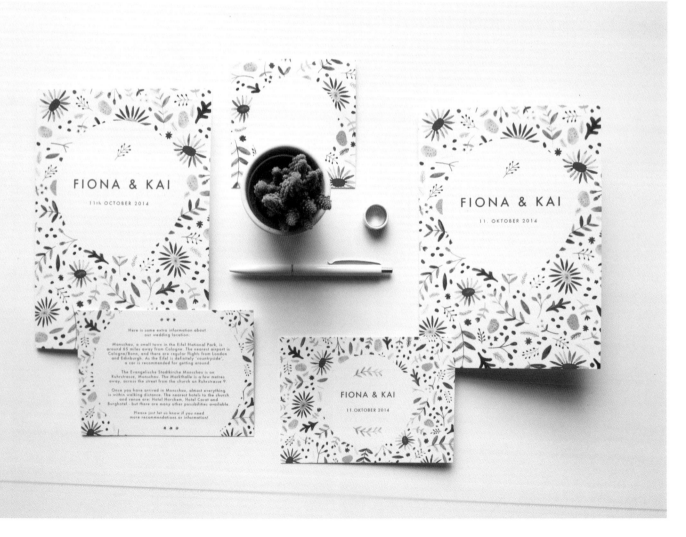

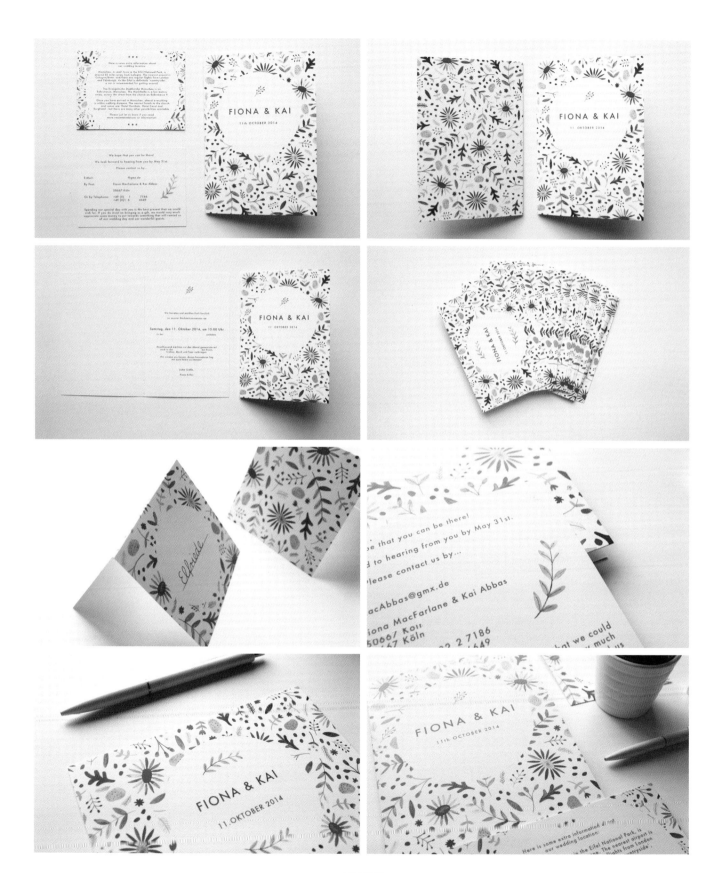

 "我願意！" 婚禮平面設計

Design agency: studiofrau
Designer: Karoline Frau
Photographer: Karoline Frau & malaika fotografie
Client: Judith & Rolf Liebfried
Country: Germany

設計機構：弗勞設計工作室
設計師：卡羅利妮‧弗勞
攝影師：卡羅利妮‧弗勞、瑪萊卡攝影工作室
委託客戶：裴蒂絲‧利布弗裡德、羅爾夫‧利布弗裡德
國家：德國

'Wir sagen JAAA' or 'we say YEEES' is the theme of this wedding paper. Two little birds, one the bride, the other the groom, are printed on invitation, menu, etc. Little symbols like hearts, stars and cloverleafs complete the design, which appears in a very special colour, matching the flowers and table decoration. Special is also the pattern generated out of the little birds, which was used as a wrapping paper for the presents.

"我願意！"這就是這套婚禮平面設計的主題。婚禮請柬、菜單以及其他各處印有兩隻小鳥，一隻代表新娘，一隻代表新郎。設計中還使用了心形、星星和四葉草等符號。請柬呈現出一種非常特別的色彩，跟婚禮上的花卉和桌上的裝飾相搭配。值得一提的是，圖案的設計也源自小鳥的圖形，出現在給賓客包裝禮品用的包裝紙上。

»LIEBE IST DAS WUNDERBARE GEFÜHL NACH DEN STERNEN GREIFEN

ZU KÖNNEN, OHNE SICH DABEI AUF ZEHENSPITZEN STELLEN ZU MÜSSEN«

KLARA LÖWENSTEIN

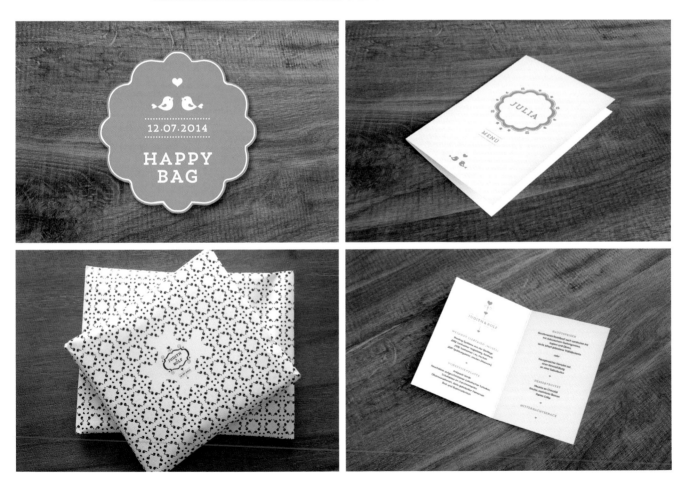

# PAULA & BRYAN 寶拉與布萊恩婚禮平面設計

Design agency: Belinda Love Lee
Photographer: Belinda Love Lee
Client: Paula & Bryan Lee
Country: UK

設計機構：比琳達設計工作室
攝影師：比琳達設計工作室
委託客戶：寶拉‧李、布萊恩‧李
國家：英國

The invites were inspired by the location itself as Paula and Bryan got married on a vineyard. The designer hand illustrated the vines and flowers using Gauche and watercolour, and then paired it alongside some fancy hand lettering to make it really unique and individual to them. The envelopes themselves were penned by the bride herself to give it a personal touch for each guest. The programmes were designed to not only be pretty but also functional, as handles were added to them making them into fans for the hot day occasion.

這套婚禮請柬的設計靈感來自婚禮舉辦場地，寶拉和布萊恩選在一個葡萄園裡舉行婚禮。設計師利用 Gauche 軟體和水彩的技法，手繪了藤蔓和花卉的圖案，然後搭配了一些詭異的手寫體字母，形成了這對新人獨一無二的請柬。請柬信封由新娘親筆書寫，表示對每位賓客的敬意。婚禮流程卡不僅美觀大方，而且非常實用，卡片上附帶把手，可以當扇子使用，非常適合這場夏日婚禮。

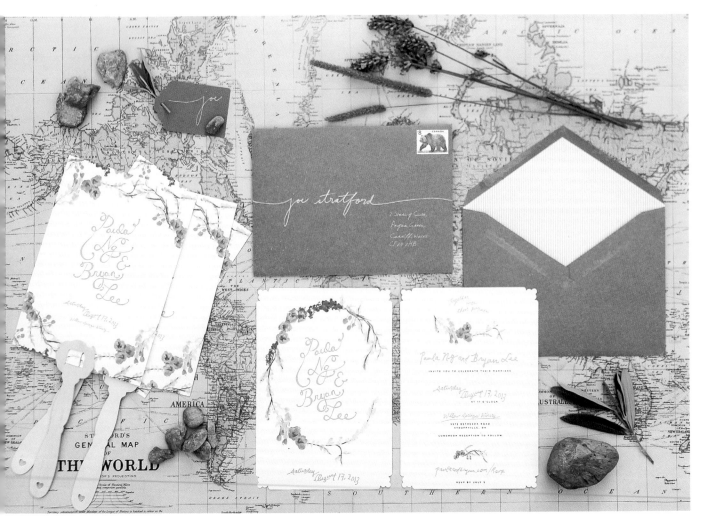

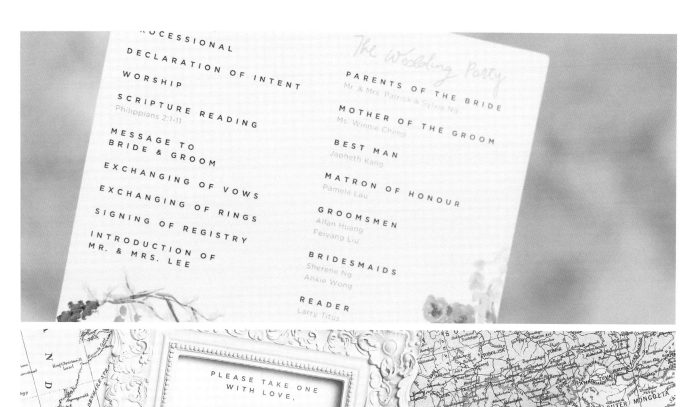

PROCESSIONAL

DECLARATION OF INTENT

WORSHIP

SCRIPTURE READING
Philippians 2:1-11

MESSAGE TO
BRIDE & GROOM

EXCHANGING OF VOWS

EXCHANGING OF RINGS

SIGNING OF REGISTRY

INTRODUCTION OF
MR. & MRS. LEE

*The Wedding Party*

PARENTS OF THE BRIDE
Mr & Mrs Patrick & Sylvia Ng

MOTHER OF THE GROOM
Ms Winnie Cheng

BEST MAN
Japheth Kang

MATRON OF HONOUR
Pamela Lau

GROOMSMEN
Allan Huang
Feiyang Liu

BRIDESMAIDS
Sherene Ng
Ankie Wong

READER
Larry Titus

PLEASE TAKE ONE
WITH LOVE,

*Mr. and
Mrs.
Lee*

*Joe*

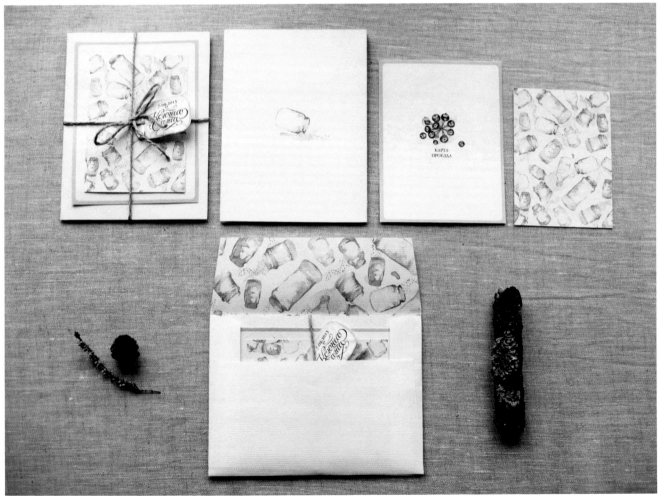

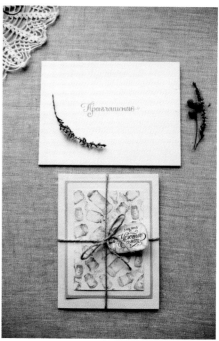

# WEDDING IN GRANNY'S GARDEN

## "外婆花園裡的婚禮" 平面設計

Design agency: murmuration.ua
Designer: Oksana Karpova
Photographer: Oksana Nazarchuk
Country: Ukraine

設計機構：嗚嗚設計工作室
設計師：奧克沙那・卡爾波娃
攝影師：奧克沙那・納紮楚克
國家：烏克蘭

The wedding invitation set was created to support the main colours of the celebration, as well as the main theme – 'a wedding party in the granny's garden'. The set consists of: an invitation (three-turn postcard), a road map, a business card of the wedding coordinator, a tag with a logo, an envelope and a chocolate box. Graphic tools: ball pen and watercolours.

這套婚禮請柬的設計旨在與這場婚禮的主色調相一致，同時契合婚禮的主題 "外婆花園裡的婚禮"。這套設計包括：請柬（一張三折的明信片）、路線圖、婚禮籌辦人的名片、帶LOGO 標識的標籤、信封以及巧克力盒子。平面設計中用到的工具包括圓珠筆和水彩。

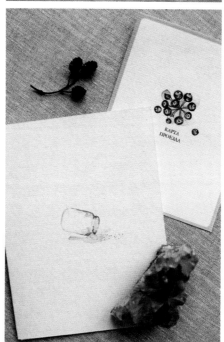
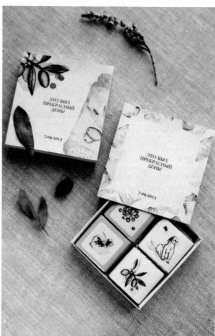

# FLY AWAY WITH ME

## "隨我飛去" 主題婚禮平面設計

Design agency: Legacy Loft
Designer: Lauren Black
Photographer: Ingrid Carney at Molliner Photography
Country: USA

設計機構： "傳說中的閣樓" 設計工作室
設計師：勞倫·布萊克
攝影師：英格麗·卡尼（莫利納攝影公司）
國家：美國

Fresh florals and whimsical watercolours make this outdoor wedding perfect for summer! The 'Fly Away with Me' theme invites guests to get swept away with bright colours, gold accents, serene watercolours and fun embellishments, and who could forget the hot air balloon getaway!

清新的花卉圖案和夢幻的水彩效果讓這場浪漫的夏日戶外婚禮堪稱完美！婚禮主題是 "隨我飛去" ，寓意是讓賓客與新人一起，乘上熱氣球，沉浸在鮮豔的色彩、金閃閃的裝飾、清澈的水彩和妙趣橫生的裝飾中。誰會忘記這歡樂的場景呢！

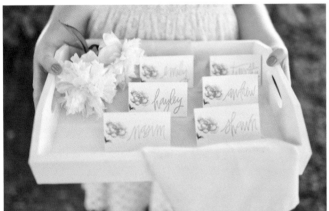

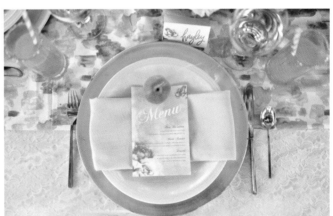

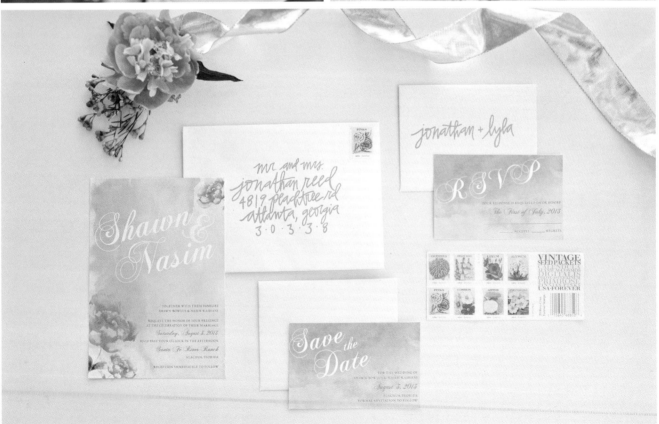

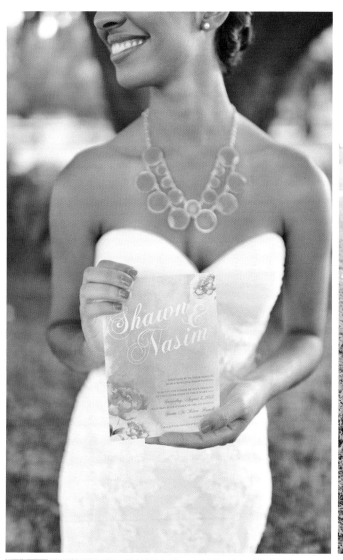

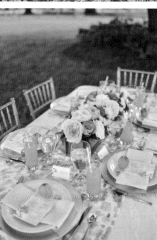

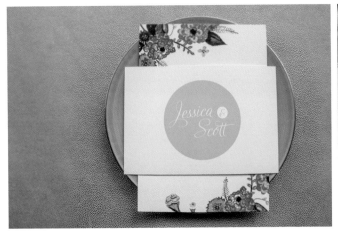
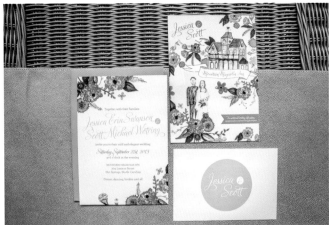
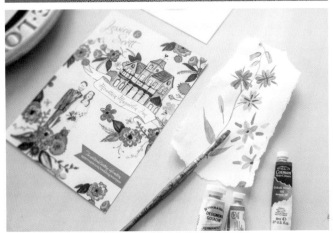
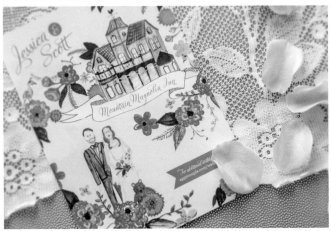

# MAGNOLIA MOUNTAIN
# WEDDING 木蘭山婚禮平面設計

Design agency: Lauraland Design
Designer: Laura King
Photographer: Laura King
Country: USA

設計機構：蘿拉蘭德設計工作室
設計師：蘿拉・金
攝影師：蘿拉・金
國家：美國

Commissioned by the bride to paint invitations that embraced the beautifully restored Victorian estate venue and a floral palette that was meaningful to the couple. This custom hand-painted wedding invitation was created to be romantic, meaningful, and most importantly, a true representation of the married couple to be!

新娘委託蘿拉蘭德設計工作室繪製婚禮請柬，並要求請柬上要包括他們為這次婚禮而佈置的一棟維多利亞風格的建築場地，此外，繪製的花卉也是新娘指定的，這些花卉對這對新人有著特別的意義。這款專門設計的請柬由手工繪製而成，既浪漫又意義非凡，同時最重要的是上面還繪製了新婚夫婦的形象，象徵了他們未來幸福美滿的生活！

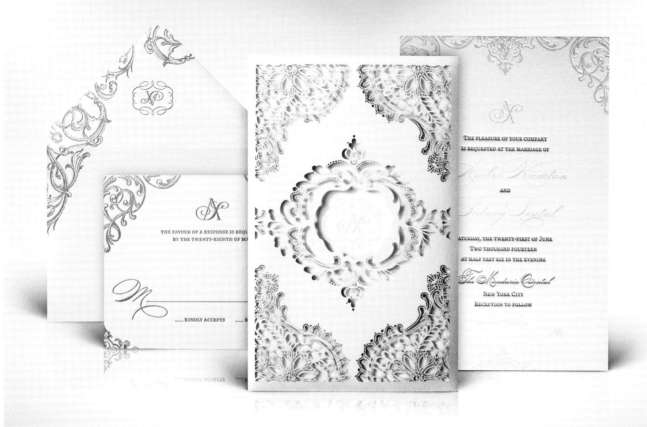

# AMBER & SIDNEY

## 安布林與西德尼婚禮平面設計

Design agency: Atelier Isabey
Designer: Margot Hallac & Steve Hallac
Photographer: Atelier Isabey
Client: Amber & Sidney
Country: USA

設計機構：伊薩貝設計工作室
設計師：瑪戈特‧哈拉克、史蒂夫‧哈拉克
攝影師：伊薩貝設計工作室
委託客戶：安布林、西德尼
國家：美國

For a white wedding with a modern twist, Atelier Isabey were tasked with creating an invitation that made a bold statement without using any colours but white and silver. By layering different shades and textures of white from matte, to shimmery, to pearlescent and iridescent, they created an invitation that was memorable and true to the style and feel of the couple's vision. The invitation is housed within a laser-cut sleeve showcasing a lace motif with a central window made to highlight the custom monogram created just for them.

這是一場現代風格的婚禮，主色調為白色。伊薩貝設計工作室受邀設計婚禮請束。設計師非常大膽，除了白色和銀色之外沒有使用任何其他色彩。請束上的白色呈現出不同的層次和質感，有的地方粗糙，有的地方微微發亮，有的地方有著珍珠般的光芒，還有的地方帶螢光。這樣一款請束會給人留下深刻的印象，同時也實現了新婚夫婦對請束的設想和要求。請束裝在鐳射切割的信封裡，信封採用蕾絲圖案，中央開窗，能夠看到為這對新人專門設計的名字首字母組成的組合圖案。

# ROMANTIC WATERCOLOUR 浪漫水彩婚禮平面設計

Design agency: Suze Studio Design
Photographer: BiancoAntico Wedding Planner
Client: BiancoAntico Wedding Planner - For Mariele and Aymeric
Country: Italy

設計機構：蘇士設計工作室
攝影師：比安科．安蒂科婚禮策劃工作室
委託客戶：比安科．安蒂科婚禮策劃工作室（新人：瑪麗勒、艾默里克）
國家：義大利

A delicate wreath with flowers and leaves is the symbol designed for the wedding of Mariele and Aymeric, in the stunning Italian countryside. Round corners, soft colours and calligraphic fonts are the key details. The wedding suite is bilingual and includes: invitation with venue map, RSVP and guest information cards, ceremony booklet, seating chart, menu, monogram stickers, favours tags and more.

花朵和葉片構成的精緻花環就是為瑪麗勒和艾默里克的婚禮設計的象徵符號。這場婚禮在風景如畫的義大利鄉村舉行。柔和的圓角、淡雅的色彩以及手寫的字體都是這款請柬設計的關鍵細節。這套婚禮平面設計是雙語的，內容包括：請柬（附路線圖）、回覆卡、賓客資訊卡、典禮小冊子、座位表、菜單、新人名字首字母組合圖案的貼紙、禮品標籤等。

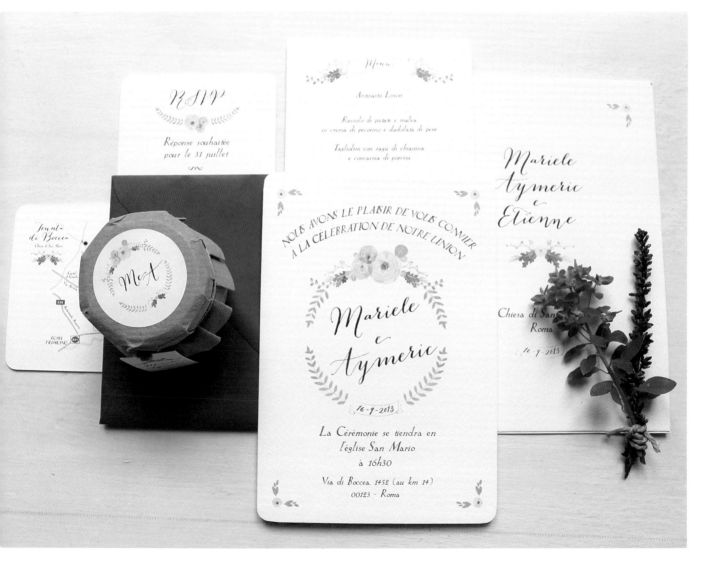

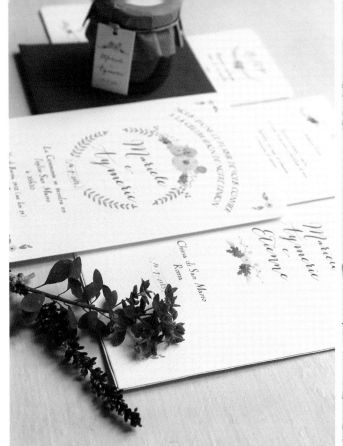

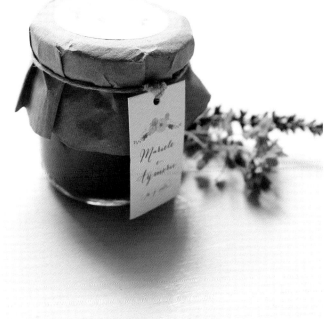

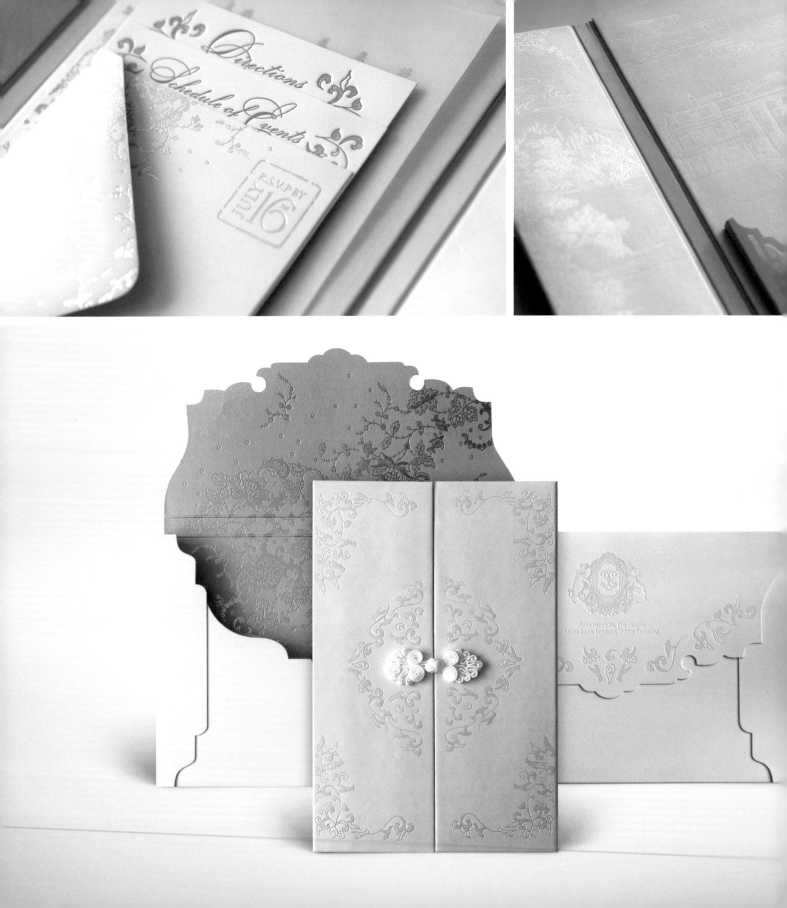

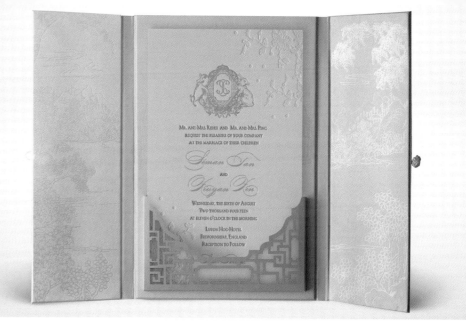

# SIMAN & XIUYAN

## 希曼與秀妍婚禮平面設計

Design agency: Atelier Isabey　　　設計機構：伊薩貝設計工作室
Designer: Margot Hallac & Steve Hallac　　　設計師：瑪戈特‧哈拉克、史蒂夫‧哈拉克
Photographer: Atelier Isabey　　　攝影師：伊薩貝設計工作室
Client: Siman & Xiuyan　　　委託客戶：希曼、秀妍
Country: USA　　　國家：美國

The artists at Atelier Isabey were excited when Siman came to them looking to create a wedding invitation that captured a feeling of elegant romance while also incorporated Chinese culture and heritage. They were very averse to designing anything that was cliché or expected, so the artists hand illustrated their location, a gorgeous estate in England, but in a traditional Qing Dynasty style. Throughout the invitations, the designers incorporated reinterpretations of Chinese historical motifs (from the laser-cut latticework pockets, to an elegant cheongsam closure on the cover) in letterpress and a one-of-a-kind, custom mother of pearl foil.

希曼找到伊薩貝設計工作室設計婚禮請柬，希望既能有浪漫、典雅的感覺，同時又包括中國傳統文化的元素。這激發了設計師的創作熱情，因為千篇一律的設計已經令他們厭煩了！設計師手繪了婚禮的舉辦地－英格蘭的一座華麗建築，同時又表現出古典的清代中國風。婚禮請柬包括多種中國元素，比如鐳射切割的信封（模仿中式格子窗）和封面（模仿旗袍），並有凹凸效果，還有一顆獨一無二的珠母貝。

# COURTNEY & MATT

**考特妮與馬特婚禮平面設計**

Design agency: Atelier Isabey
Designer: Margot Hallac & Steve Hallac
Photographer: Atelier Isabey
Client: Courtney & Matt
Country: USA

設計機構：伊薩貝設計工作室
設計師：瑪戈特‧哈拉克‧史蒂夫‧哈拉克
攝影師：伊薩貝設計工作室
委託客戶：考特妮‧馬特
國家：美國

When Atelier Isabey were tasked with creating a wedding invitation inspired by the hit series *Game of Thrones* as well as Shakespeare's *A Midsummer Night's Dream*, they decided to create an invitation that would have both dramatic flair and romanticism. The invitation is nested inside of a navy laser-cut sleeve hinting at a lush, overgrown forest through which a custom-designed coat of arms is revealed. The suite was accented with letterpress and gold foil on all cards and came with a custom-designed mini itinerary booklet.

這對新人邀請伊薩貝設計工作室設計婚禮請柬，要求從熱播劇《權力的遊戲》和莎士比亞名劇《仲夏夜之夢》當中汲取靈感。設計師決定讓這款請柬既能吸引眼球，又能呈現出浪漫情懷。請柬裝在鐳射切割的海軍藍信封裡，中央的鏤空處是一片茂密的森林，森林中隱約現出一枚盾徽，也是為這場婚禮專門設計的。凹凸印刷的效果加上燙金工藝，讓這套卡片更顯別致。與卡片配套的還有一本專門設計的迷你旅程路線圖。

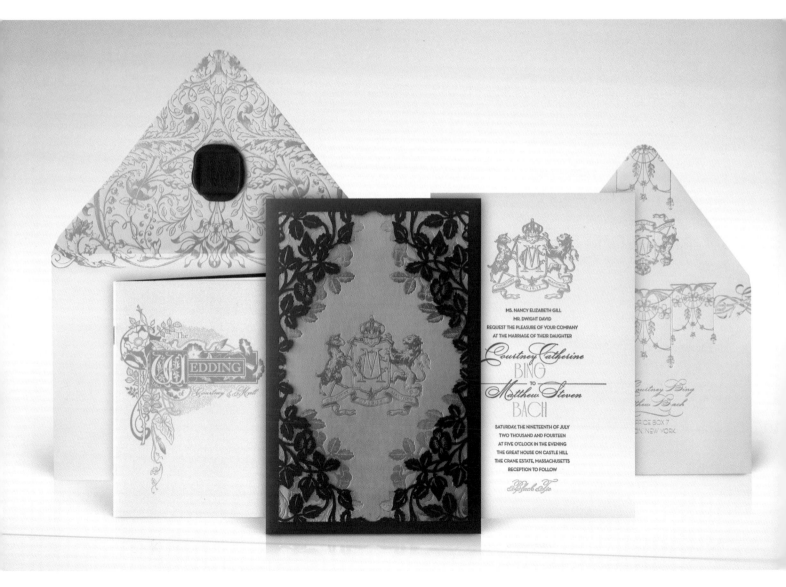

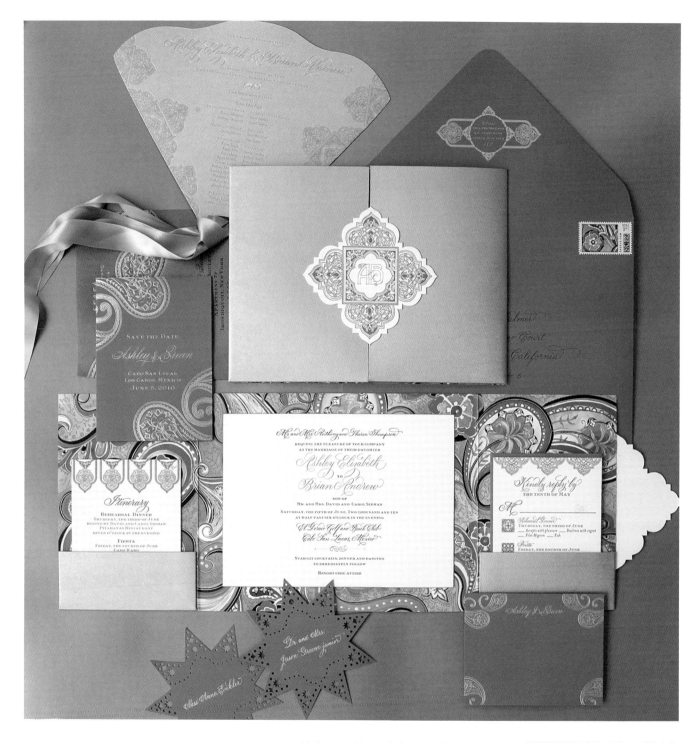

# ASHLEY & BRIAN

## 艾希莉與布萊恩婚禮平面設計

Design agency: CECI New York
Client: Ashley & Brian
Country: USA

設計機構：紐約 CECI 設計工作室
委託客戶：艾希莉，布萊恩
國家：美國

Mexico meets Morocco in this spectacular invitation suite. The invitation centres on a hand-painted swirl of hot pink and orange paisleys, accented in gold and black. To add an overall exotic vibe, the artists included Moroccan-style embellishments throughout, from the main envelope to the reply card. The bright and exotic vibe carries over to the matching accessories, complete with bright pink laser-cut stars and an elegant fan programme.

當墨西哥邂逅摩洛哥，會擦出怎樣的火花呢？在這套婚禮平面設計中，設計師手繪了由桃紅色和橘色組成的複雜渦紋圖案，輔之以金色和黑色作為點綴。為了增加異國風情的感覺，特別加入了摩洛哥風格的裝飾，整套卡片中都能找到摩洛哥元素，從卡信封到回覆卡，這種色調叫媚的異國風情也延續到了請柬套卡的配套附件中，包括鐳射切割的豔粉色星形卡和典雅大方的扇形流程卡。

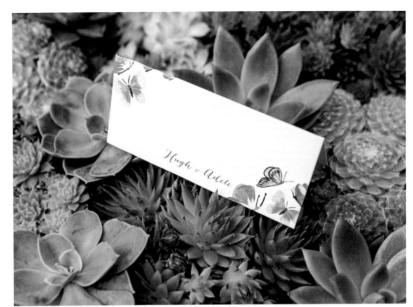

# BUTTERFLY SUITE

**蝴蝶婚禮平面設計**

Design agency: BerinMade
Designer: Erin Hung
Photographer: BerinMade
Country: UK

設計機構：貝林設計工作室
設計師：艾琳・洪
攝影師：貝林設計工作室
國家：英國

The Butterfly Suite is inspired by taxidermy, and features a cascade of butterflies forming a decorative frame around the invitation. Perfect for weddings that are down to earth and nature-inspired.

蝴蝶婚禮套卡的設計受到標本剝制術的啟發，利用蝴蝶形成請柬卡片的裝飾框架。這套平面設計非常適合親近自然的、田園風格的婚禮。

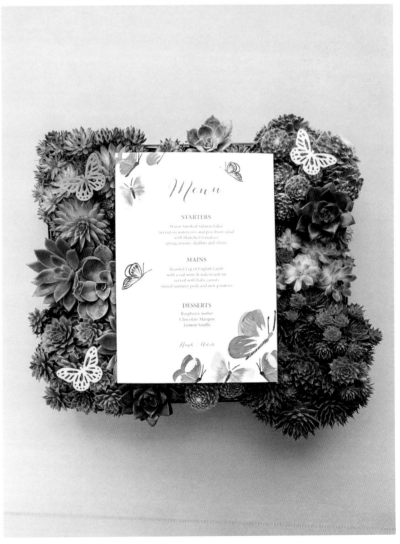

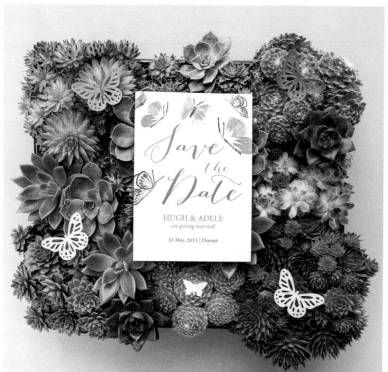

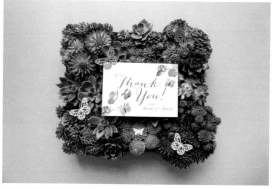

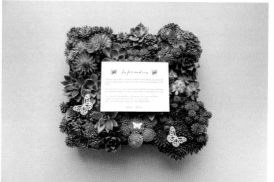

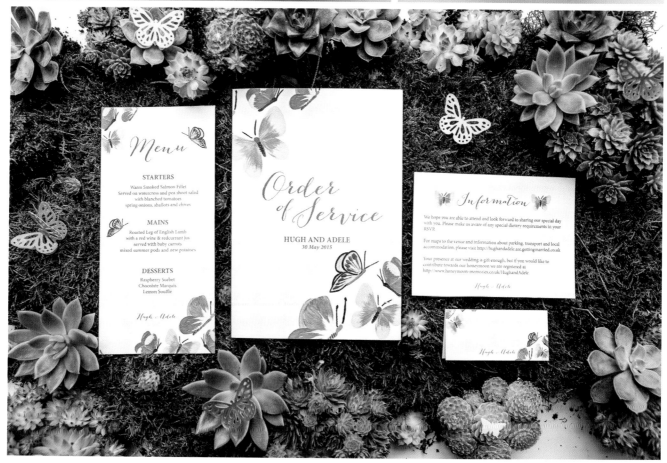

## CHAPIN SUITE　花體字婚禮平面設計

Design agency: BerinMade　　設計機構：貝林設計工作室
Designer: Erin Hung　　　　　設計師：艾琳・洪
Photographer: BerinMade　　　攝影師：貝林設計工作室
Country: UK　　　　　　　　國家：英國

The Chapin Suite is inspired by the modern day ballerina in its pale pastel palette, and elegant twirls in the lettering. Each piece includes black dramatic lettering to add a sense of the dramatic and is perfect for those ballroom affairs.

這套花體字婚禮套卡呈現出淡淡的色彩，高貴典雅，一如舞臺上的芭蕾舞演員。文字設計成考究的花體。每張卡片上都有黑色的花體字，婉轉飄逸，非常搶眼，尤其適合舞會的場合。

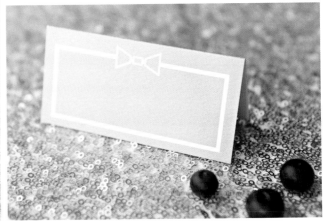

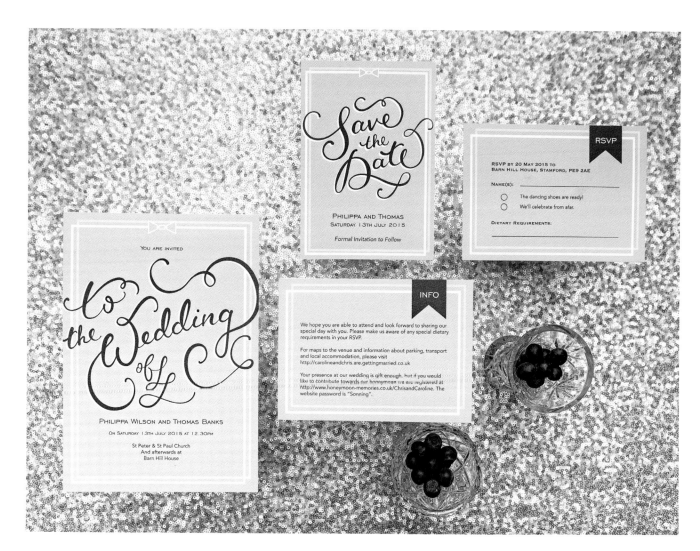

# FLORAL LACE SUITE 蕾絲花卉婚禮平面設計

Design agency: BerinMade
Designer: Erin Hung
Photographer: BerinMade
Country: UK

設計機構：貝林設計工作室
設計師：艾琳·洪
攝影師：貝林設計工作室
國家：英國

Grown-up, girly, and everything beautiful in between. Nude tones overlaid by bridal floral lace designs, reminiscent of delicate hand-made French lace that adorned royal garments. The lace cutouts bring a feminine, old world charm, combining with a modern typeface to create a clean understated suite. Perfect for the vintage bride.

既有成熟的女性美又有少女的純真，能夠兩者兼顧的非蕾絲莫屬。這套卡片設計以肌色為底色，上面覆蓋蕾絲花卉的圖案，使人想起宮廷服飾上精緻的法式手工蕾絲花邊。蕾絲紋樣傳遞出一種女性獨有的美與復古的美感，搭配現代的字體，形成了這套簡潔、低調的婚禮套卡，非常適合偏愛復古風格的新娘。

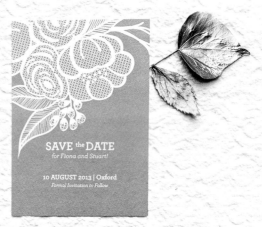

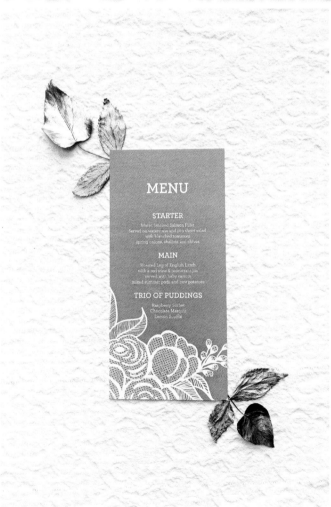

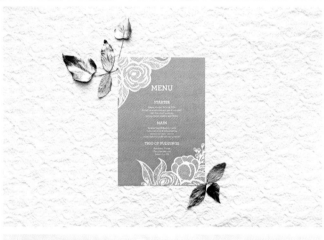

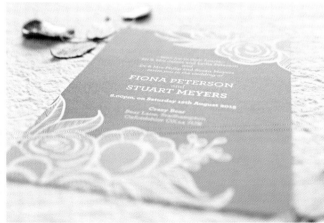

# NATALIE & MIKA 娜塔莉與米卡婚禮平面設計

Design agency: Jolly Edition　　設計機構：喬利設計工作室
Photographer: Sarah Mooney　　攝影師：薩拉‧穆尼
Client: Natalie & Mika　　委託客戶：娜塔莉、米卡
Country: USA　　國家：美國

After a sunset horse ride in the Namibian desert, surrounded by the open plains and red sand dunes, Mika gave Natalie a wooden egg which he carved himself. Around the base of the egg is an opening with a hinge. Inside is an engagement ring. Natalie said yes.

在夕陽的餘暉下，在納米比亞沙漠中縱馬馳騁後，周圍是一望無際的平原和火紅的沙丘，就在此時此地，米卡拿出一枚木頭蛋給娜塔莉，那是他自己雕刻的。木頭蛋底部可以打開，裡面是一枚訂婚戒指。娜塔莉接受了求婚。這套婚禮平面設計就源於這段浪漫的求婚故事。

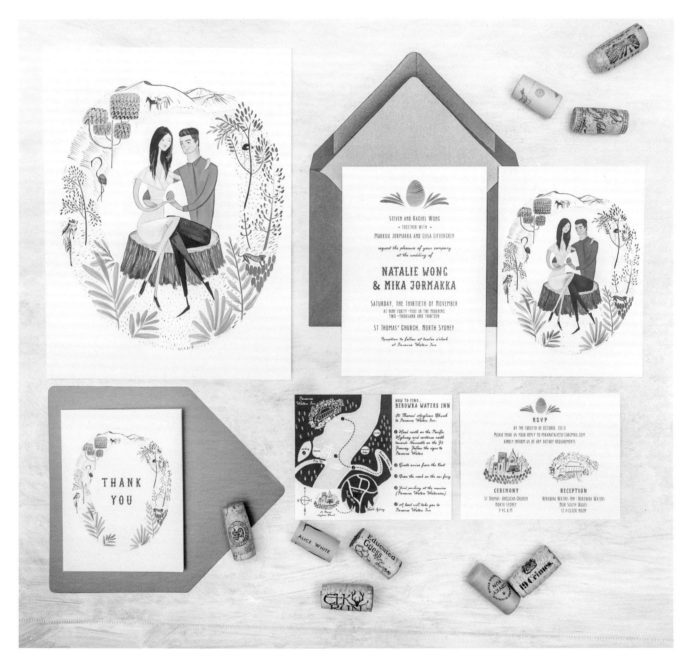

# RONIT & MATTHEW 羅妮特與馬修婚禮平面設計

Design agency: CECI New York
Client: Ronit & Matthew
Country: USA

設計機構：紐約 CECI 設計工作室
委託客戶：羅妮特、馬修
國家：美國

Inspired by their favourite pattern from a pillow in their home, Ronit brought this to the designer, unsure if it was a 'good idea'. The artist always believes that you can find inspiration in anything! Featuring lime greens and peacock blues for the save-the-dates then transitioning into purples and charcoals for the invitations and accessories. Keeping the design elements the same, the colour shift only made the effect more intriguing. The vellum overlay in Hebrew slipped in for those guests who didn't speak English. All finished with an elegant laser-cut belly band!

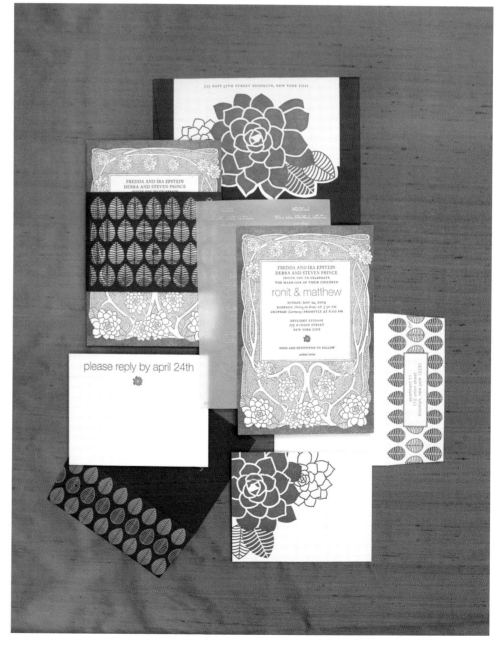

羅妮特非常喜歡家裡一隻枕頭上的圖案，她找到紐約 CECI 設計工作室的時候帶來了這一圖案，並表示她不確定這是否是個"好主意"。剛好這位設計師一貫認為設計靈感可以來自任何東西。於是便有了這套婚禮平面設計。日期卡以石灰綠和孔雀藍為主色，而請柬以及配套卡片則為紫色和炭灰色。設計元素不變，利用色彩的轉變，營造出更加引人入勝的效果。牛皮紙上書寫的是希伯來文，也裝入請柬信封中，這是為不會說英語的賓客準備的。鏤空的綁帶採用鐳射切割技術，使整套設計更顯高雅。

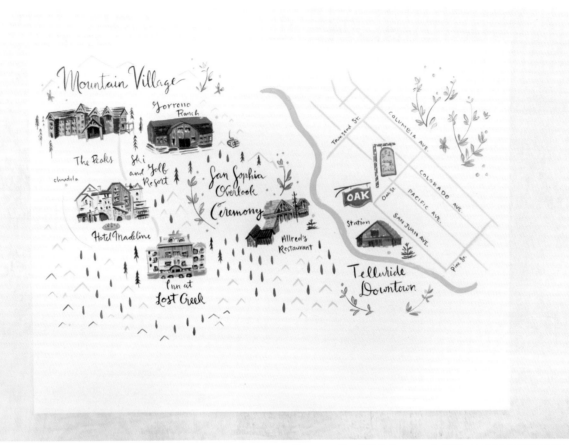

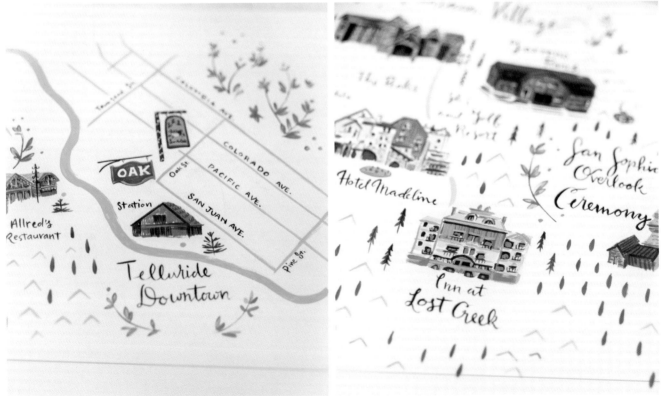

# PIPPIN & ALEX

## 皮萍與亞曆克斯婚禮平面設計

Design agency: Jolly Edition
Photographer: Sarah Mooney
Client: Pippin & Alex
Country: USA

設計機構：喬利設計工作室
攝影師：薩拉‧穆尼
委託客戶：皮萍、亞曆克斯
國家：美國

Pippin and Alex met at a mutual friends' wedding. Sparks flew and they found themselves marrying at their favourite ski resort in the mountains of Telluride, Colorado.

皮萍和亞曆克斯是在他們共同朋友的婚禮上浪漫邂逅的。兩人隨即碰撞出愛的火花，不久就喜結連理，婚禮地點選在兩人最愛的科羅拉多滑雪勝地特萊瑞德小鎮。

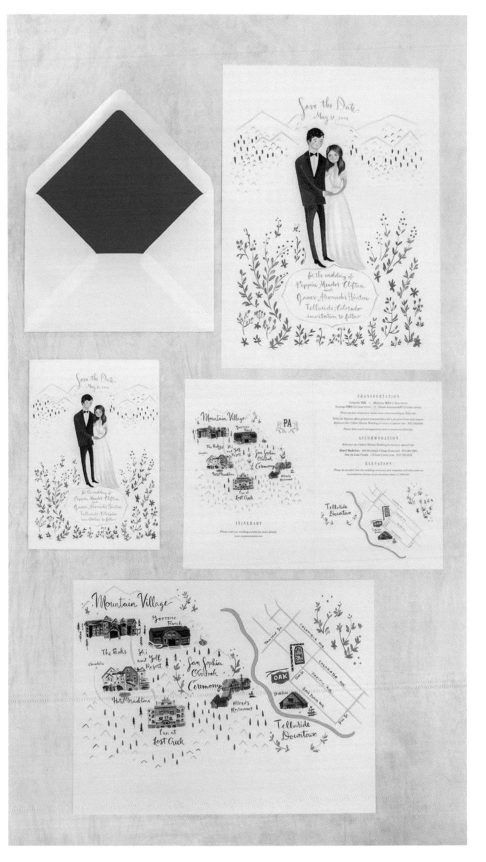

# VINTAGE LUXE SUITE　復古奢華婚禮平面設計

Design agency: Jen Simpson Design
Designer: Jen Simpson
Photographer: Ashley Bee Photography
Country: USA

設計機構：珍・辛普森設計工作室
設計師：珍・辛普森
攝影師：艾希莉・比攝影公司
國家：美國

A vintage invitation that is sure to inspire your guests! Late 1900 French flourishes mix with a detailed vintage pattern to create a luxurious, must-have invitation suite.

這套復古風格的婚禮請柬必定會讓您的賓客眼睛為之一亮！20世紀末奢華的法式紋樣，搭配精緻、繁複的復古圖案，形成了這套品味非凡的婚禮套卡，絕對值得擁有！

# ART DECO 裝飾藝術風格婚禮平面設計

Design agency: Jen Simpson Design
Designer: Jen Simpson
Photographer: Ashley Bee Photography
Country: USA

設計機構：珍‧辛普森設計工作室
設計師：珍‧辛普森
攝影師：艾希莉‧比攝影公司
國家：美國

This invitation is a gorgeous take on the Art Deco style. Printed in a beautiful antique gold ink with sophisticated glam tone. The hard lines of a geometric frame compliment a luxe fan pattern printed on the back.

這款婚禮請柬的設計成功借鑒了裝飾藝術風格（Art Deco）。印刷採用金色油墨，彰顯古典與高雅，搭配繁複的圖案設計，極具魅力。請柬正面幾何框架的線條非常硬朗，與背面複雜的扇形圖案帶來眼花撩亂的感覺不同。

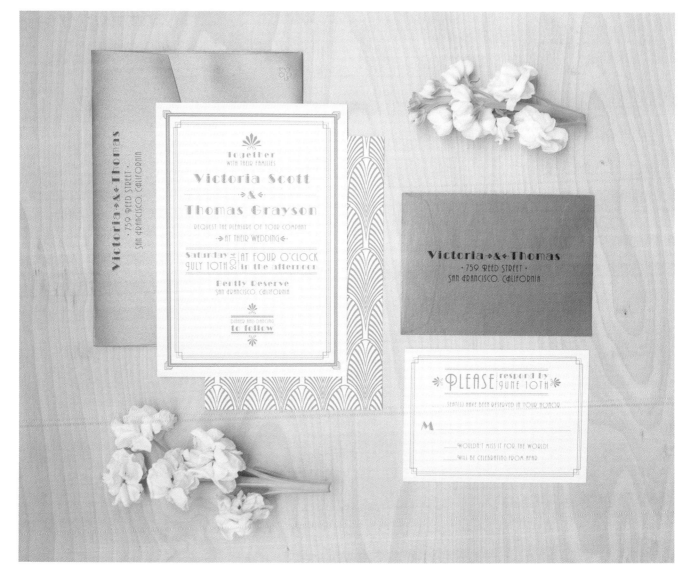

# DENISE & RUSSELL 丹妮絲與拉塞爾婚禮平面設計

Design agency: Papermade Design
Designer: Elaine Chou
Photographer: Erin J. Saldana Photography
Client: Denise & Russell
Country: USA

設計機構："紙質設計"公司
設計師：伊萊恩・周
攝影師：愛琳 J.薩爾達納攝影公司
委託客戶：丹妮絲、拉塞爾
國家：美國

This playful couple wanted hand-illustrated elements with a whimsical touch, so the artists created hand-lettered names with illustrations of their wedding bands and a custom map. They used a black/gold patterned liner to contrast the simplistic invitations.

這對新人活潑開朗，他們希望設計元素由手工繪製，同時要給人一種不同尋常的感覺。於是設計師設計並手繪了兩人名字的拼寫，巧妙利用了兩人結婚戒指的形象。此外還設計了一張路線圖。信封的內層採用黑色和金色組合而成的圖案，避免請柬過於簡約單調。

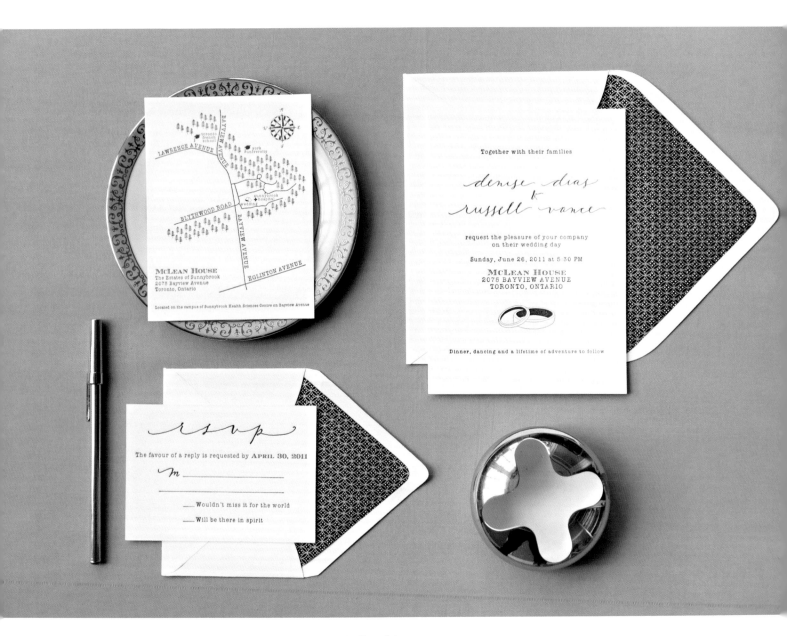

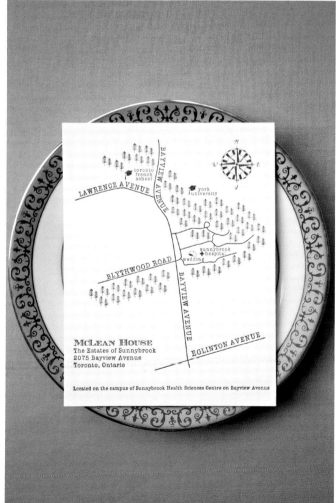

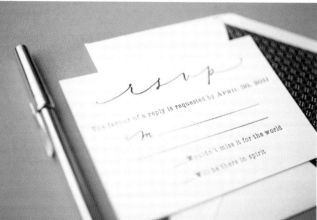

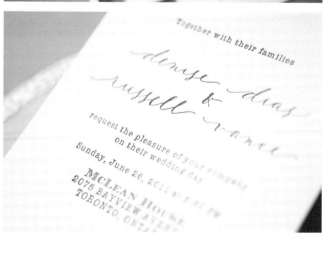

# BROGAN & MARC 布羅根與馬克婚禮平面設計

Design agency: Atelier Isabey　　　　設計機構：伊薩貝設計工作室
Designer: Margot Hallac & Steve Hallac　設計師：瑪戈特‧哈拉克、史蒂夫‧哈拉克
Photographer: Atelier Isabey　　　　攝影師：伊薩貝設計工作室
Client: Brogan & Marc　　　　　　　委託客戶：布羅根、馬克
Country: USA　　　　　　　　　　　國家：美國

Atelier Isabey took Art Deco styling to the next level with this high fashion inspired black and gold wedding invitation. Printed in dazzling gold foil on thick black stock, this invitation is evocative of a dramatic piece of costume jewellery or couture accessory, a look that truly embodies the vision the couple were looking to achieve.

這款以黑色和金色為主色調的婚禮請柬，其設計靈感來自高級時裝。伊薩貝設計工作室由此將裝飾藝術風格（Art Deco）帶到了一個新高度。閃閃耀目的燙金文字印在厚厚的黑色紙板上，讓這款請柬更像是一件閃亮的首飾或服裝配飾，而這正是這對新婚夫婦想要營造的效果。

# CATHERINE & WILLIAM 凱薩琳與威廉姆婚禮平面設計

Design agency: CECI New York
Client: Catherine & William
Country: USA

設計機構：紐約 CECI 設計工作室
委託客戶：凱薩琳、威廉姆
國家：美國

In honour of what's being called The Wedding of the Decade, CECI New York have designed their take on the royal wedding invitation. The artist loves creating crests for her clients, and a special one is made for Will and Kate. She chose a navy blue for the elegant script and a sky blue for the envelopes, topping things off with gold-foil monogram. To add a romantic feel, the artist brought in lush, English-garden style flowers to the lining of the envelope. Totally fit for a princess, don't you think?

為紀念結婚十周年，凱薩琳與威廉姆決定舉辦一場皇室風格的婚禮，並邀請紐約 CECI 設計工作室來做平面設計。這位設計師一向喜歡為客戶設計皇冠，此次也不例外。設計師選用海軍藍來書寫典雅的字母，而信封則採用天藍色，夫婦兩人名字的首字母組合圖案則用燙金工藝，畫龍點睛。為了營造浪漫的感覺，信封內層特地使用了英式花園風格的茂盛花卉圖案。簡直是公主的婚禮請柬，不是嗎？

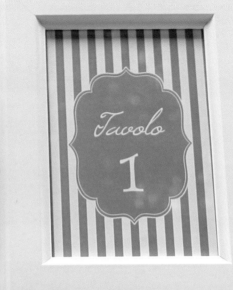

Menu

Tavolo

1

COME RAGGIUNGERE IL

*Santuario della Madonna della Luce*

ALL'USCITA MARSCIANO-COLLEPEPE DELLA E45, SEGUITE LA S.P. 383.
ALLA PRIMA ROTATORIA VOLTATE A SINISTRA PER VIA LENIN.
SEGUITE LE INDICAZIONI FINO A COLLELUNGO.

FINITA LA CERIMONIA VI ASPETTIAMO
PER FESTEGGIARE INSIEME AL

*Castello di Civitella di Conti*

RIPERCORRETE VIA LENIN E SEGUITE LE INDICAZIONI PER CIVITELLA

Menu

RISOTTO CON FONDUTA DI PECORINO
E MILLEPUNTI DI PISTACCHI GRIGLIATI
AL BALSAMICO

LASAGNETTA DI FARINA DI FARRO
CON FARAONA E TARTUFO

VITELLINA
ROSMARINO
RADICCHIO STUFATO

SUIRE:

BUFFET DI DOLCI

M & C

M & C

*Maria Elena & Claudio Maradi*

SONO LIETI DI ANNUNCIARE IL LORO Matrimonio

LA CERIMONIA SI SVOLGERÀ IL GIORNO
7 settembre 2013
ORE 17:00
SANTUARIO DELLA MADONNA DELLA LUCE
COLLELUNGO

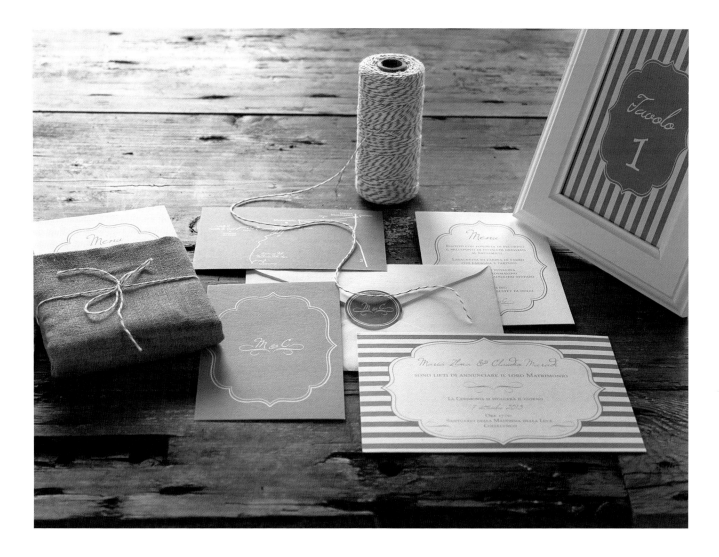

# CHIC IN WHITE AND GREY

## 別致灰白婚禮平面設計

Design agency: Suze Studio Design
Photographer: BiancoAntico
Client: BiancoAntico Wedding Planner - For Maria and Claudio
Country: Italy

設計機構：蘇士設計工作室
攝影師：比安科‧安蒂科婚禮策劃工作室
委託客戶：比安科‧安蒂科婚禮策劃工作室（新人：瑪麗亞、克勞迪奧）
國家：義大利

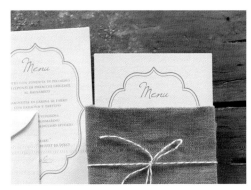

A simple yet so elegant colour palette for Maria and Claudio, stripes and curves, an informal handwritten font combined with a classic one... Stationery for a wedding in the scenario of a dreamy castle in Italy. The wedding suite includes: invitation with venue map, monogram stickers as envelope seals, ceremony booklet, seating chart, menu, favours tags and more.

瑪麗亞和克勞迪奧的婚禮請柬採用灰白的配色，簡約而典雅。直線和曲線相搭配，搭配以手寫體字母，盡顯古典風範。這場婚禮在義大利的一座夢幻的城堡中舉行。平面設計的內容包括：請柬（附路線圖）、新人名字首字母組合圖案的貼紙（作為信封的封條）、典禮小冊子、座位表、菜單、禮品標籤等。

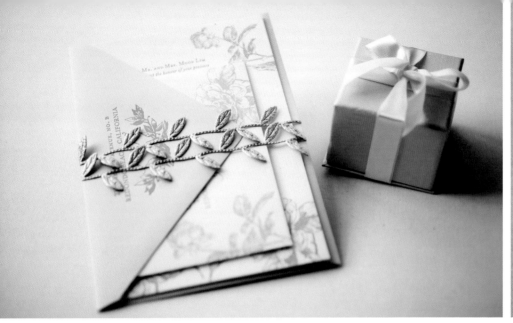

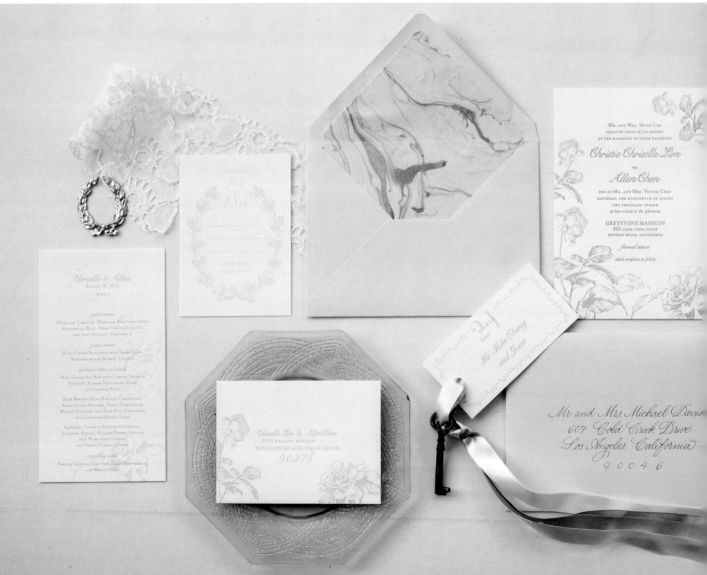

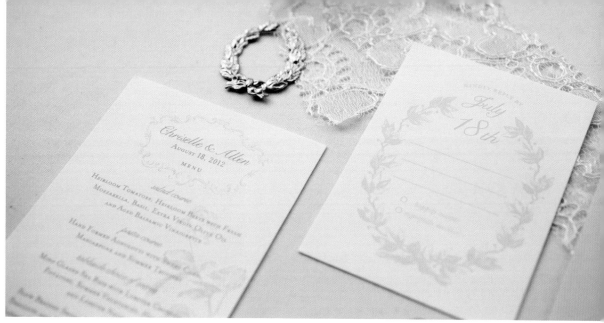

# CHRISELLE & ALLEN

## 克麗塞勒與艾倫婚禮平面設計

Design agency: Papermade Design
Designer: Elaine Chou
Photographer: Erin J. Saldana Photography
Client: Chriselle & Allen
Country: USA

設計機構："紙質設計"公司
設計師：伊萊恩·周
攝影師：愛琳 J. 薩爾達納攝影公司
委託客戶：克麗塞勒、艾倫
國家：美國

For this garden estate wedding the artists used vintage rose imagery along with a wreath illustration to describe the floral decor. To match the gold chinaware, they incorporated gold through the marble-pattern envelope liners and handwritten gold calligraphy on mint envelopes. Pale pink and taupe ribbons tied escort cards to vintage skeleton keys.

這場婚禮在花園中舉行，所以設計師選用復古風格的玫瑰圖案，搭配花環的圖形，來呼應婚禮現場的花卉裝飾。信封的內層有大理石花紋。為了能跟金色陶瓷餐具相配，設計師還特意為信封增加了金葉子造型的綁帶。薄荷色信封上的手寫體文字也是金色的。配套卡片採用淡粉色和灰褐色的絲帶，綁著一把復古風格的"萬能鑰匙"。

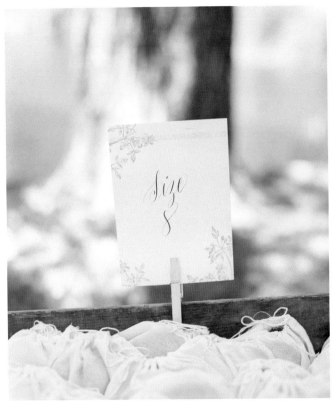

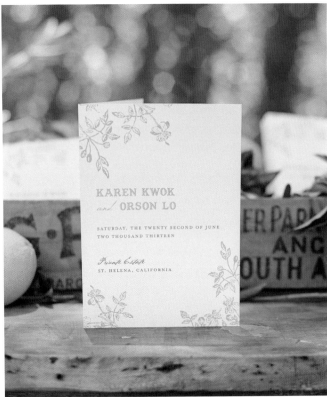

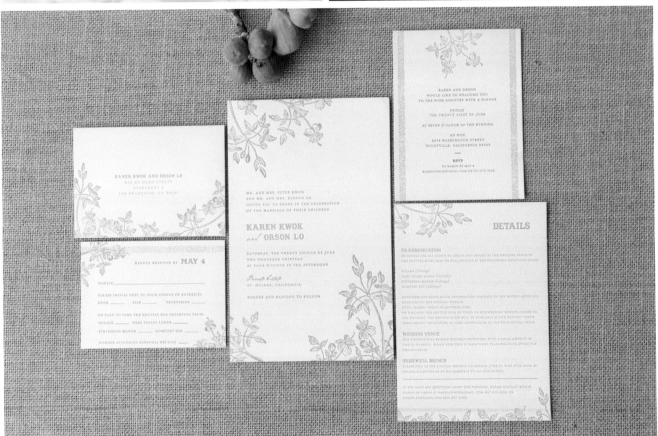

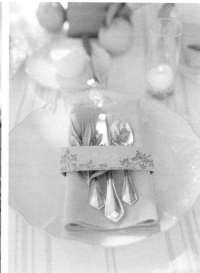

# KAREN & ORSON

## 凱倫與奧森婚禮平面設計

Design agency: Good on Paper
Designer: Lisa Jackson
Photographer: Lisa Lefkowitz
Client: Karen Kwok & Orson Lo
Country: USA

設計機構： "紙上好設計" 工作室
設計師：麗莎．傑克遜
攝影師：麗莎．傑克遜
委託客戶：凱倫．郭、奧森．羅
國家：美國

This wedding invitation suite embodied the theme of the wedding –
a fancy fun picnic with touches of French country farmhouse. For the
casual luxe, refined rustic style, the colour palette was fun and fresh
with bright red, salmon pink, apricot orange, and indigo blue.

這套婚禮請束設計呈現了這場婚禮的主題－法國鄉村農舍野餐。設
計上既要簡約淳樸又要精緻典雅。設計師選用了鮮紅色、橙紅色、
杏黃色和靛藍色，營造出整體清新活潑的色調。

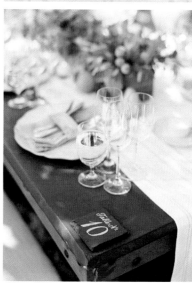

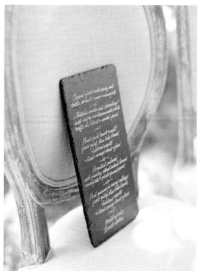

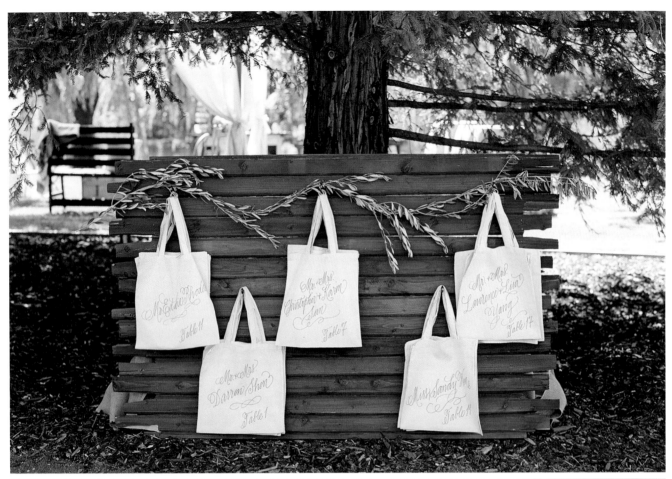

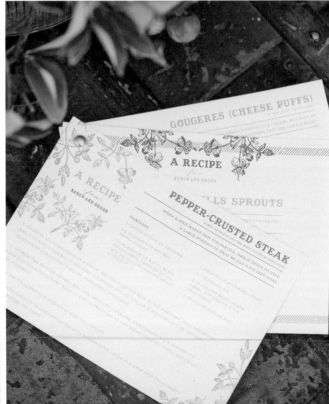

# TOMAS & TERESA

## 湯瑪斯與特麗莎婚禮平面設計

Design agency: Concreate Studio
Client: Tomas Massarenti & Teresa Palestini
Country: Italy

設計機構：康克裡特設計工作室
委託客戶：湯瑪斯‧馬薩倫蒂、特麗莎‧帕萊斯蒂尼
國家：義大利

Tomas (one of the two associate of Concreate Studio) got married
and for his wedding he wanted to realise an out-and-out brand
which pivots on the shape of the tree. In the logo design love is
represented through two hearts, which take shape among the
branches and the roots of the tree, symbol of life, growth and
communion. The theme is then recalled and developed in the
whole wedding's visual identity: in the invitations, in the booklets
of the Mass, in the menu and in the place cards, and finally in
the party favour (a bonsai). The paper had a big importance, too,
and the Favini Crush was chosen because of its strong natural
component.

新郎湯瑪斯是康克裡特設計工作室的合夥人之一，他希望婚禮
平面設計能夠具有凸顯的特點。整套設計圍繞一棵古樹的形象
展開。在LOGO標識的設計中，兩個心形代表愛情，與老樹枝
幹和根莖融為一體，樹木則象徵著生命、生長與共用。這一主
題在整套婚禮平面設計的視覺形象中都有所表現，包括請柬、
做彌撒的小冊子、功能表、座位卡及送給賓客的小禮物（盆栽
植物）等。紙張的選擇也很重要，設計師選用了范維尼公司的
CRUSH紙品，這種紙由純天然原材料製成。

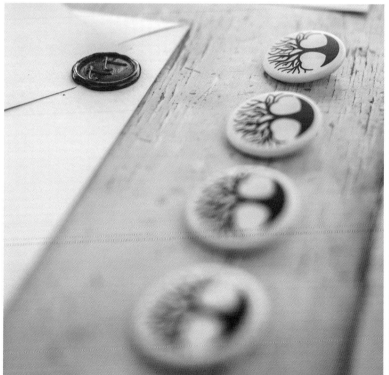

# DESERT POEMS

## "沙漠詩篇" 婚禮平面設計

Design agency: Brown Linen Design
Photographer: Erich McVey
Country: USA

設計機構：棕色亞麻設計工作室
攝影師：埃裡希・麥克威
國家：美國

This concept combined with the rich desert surroundings of Bend, Oregon became the inspiration for this suite. Using handmade Spanish Arpa paper, the organic, handwritten calligraphy was just the right pairing to create this majestic display of understated elegance.

"沙漠詩篇" 的設計理念，結合了俄勒岡州本德市豐富的沙漠環境，形成了這套婚禮平面設計。隨性的手寫體文字印在西班牙手工製作的阿爾帕紙（Arpa）上，正適合這套卡片低調、典雅的風格。

# BELLE SUITE 貝爾婚禮平面設計

Designer: Olive & Emerald
Photographer: Lisa Mallory Photography
Client: Lekai Ranch
Country: USA

設計機構：奧利弗 & 埃默拉爾德設計工作室
攝影師：麗莎．馬婁裡攝影公司
委託客戶：勒凱．蘭奇
國家：美國

The Belle Suite concept was to have the 'down-home charm' of a Southern wedding, but with a California twist. Family tradition, preppy patterns, and monograms inspired the stationery and the colour palette of pale pink, and French and navy blues helped keep things fresh for the wine country wedding.

貝爾婚禮套卡的設計理念是想要營造一種南部婚禮的親切鄉土感，同時要具備加利福尼亞風情。這套平面設計包括色調的選擇（淡粉色），借鑒了新人的家族傳統、學院風的圖案以及新人名字首字母組成的圖案。法國藍和海軍藍的使用讓這場在葡萄酒之鄉舉行的婚禮顯得清新自然。

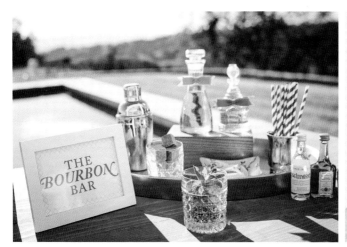

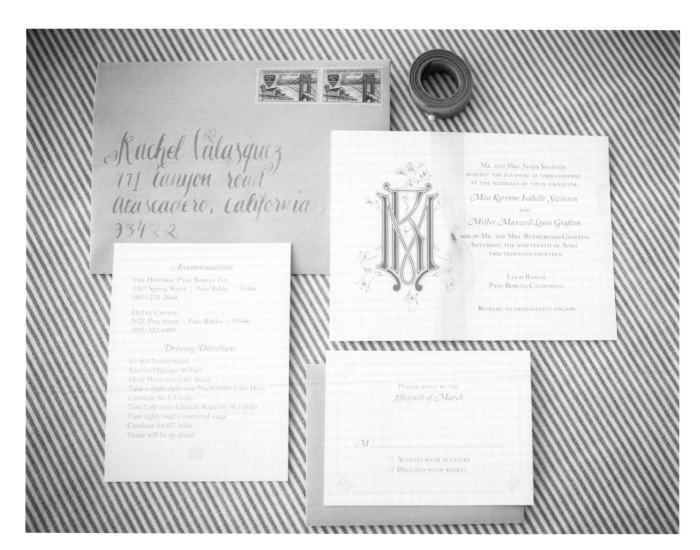

Rachel Valasquez
777 Canyon road
Atascadero, California,
93422

**Accommodations**

THE HISTORIC PASO ROBLES INN
1103 Spring Street | Paso Robles | 93446
(805) 238-2660

HOTEL CHEVAL
1021 Pine Street | Paso Robles | 93446
(805) 522-6999

**Driving Directions**

Us 101 North/South
Exit for Highway 46 East
Head West onto 24th Street
Take a slight right onto Nacimiento Lake Drive
Continue for 1.4 miles
Turn Left onto Adelaida Road for 10.3 miles
Turn right, road is restricted usage
Continue for 0.7 miles
Venue will be up ahead

MR. AND MRS. JAMES SWINTON
REQUEST THE PLEASURE OF YOUR COMPANY
AT THE MARRIAGE OF THEIR DAUGHTER
*Miss Korinne Isabelle Swinton*
AND
*Mister Maxwell Louis Grafton*
SON OF MR. AND MRS. RUTHERFORD GRAFTON
SATURDAY, THE NINETEENTH OF APRIL,
TWO THOUSAND FOURTEEN

LEKAI RANCH
PASO ROBLES, CALIFORNIA

REVELRY TO IMMEDIATELY FOLLOW

PLEASE REPLY BY THE
*fifteenth of March*

M

○ ACCEPTS WITH PLEASURE
○ DECLINES WITH REGRET

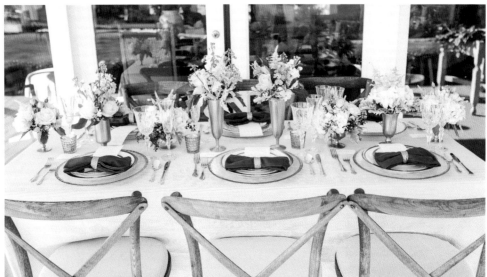

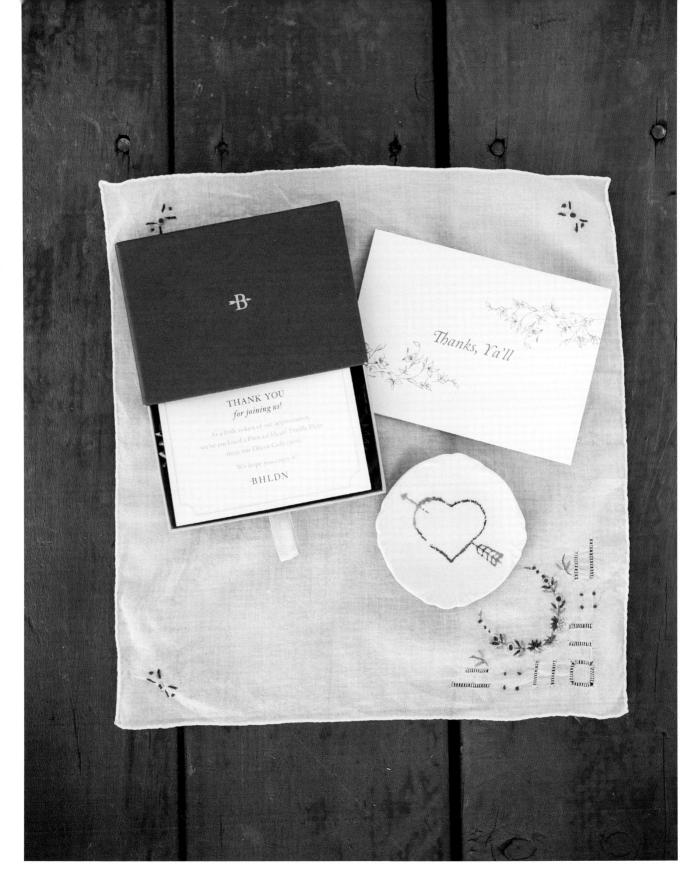

# RUSTIC WOOD SUITE 木紋婚禮平面設計

Design agency: caratterino 設計機構：卡拉特里諾設計工作室
Designer: Ara Marsili 設計師：阿拉・瑪律西利
Photographer: Cinzia Bruschini 攝影師：欽齊亞・布魯斯奇尼
Country: Italy 國家：義大利

This wedding invitation was created for a couple who married in an Italian farmhouse, under the trees. So the artist decided to use wooden sheets, printed in nature and leaves theme, and natural recycled paper, joined by a rice-paper wrap and rustic thread.

這是在一間義大利農莊中舉行的 "樹下婚禮"。所以設計師決定在請束套卡的設計中採用木板，上面印製了大自然和樹葉的主題元素。此外還用了天然再生紙。包裝採用米紙和粗糙的線繩。

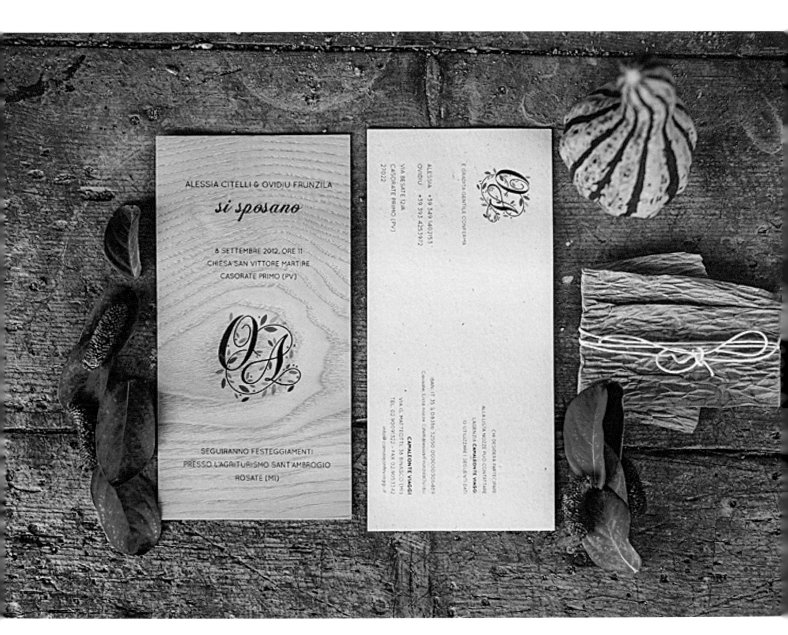

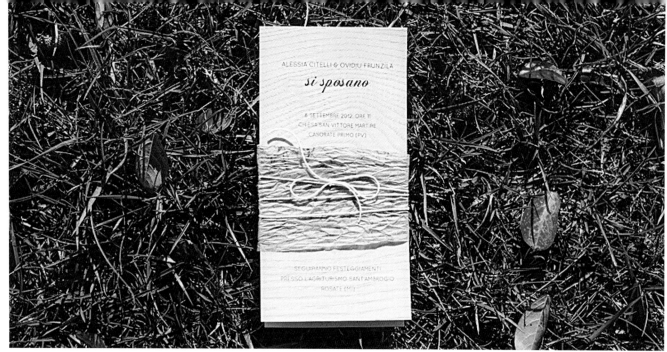

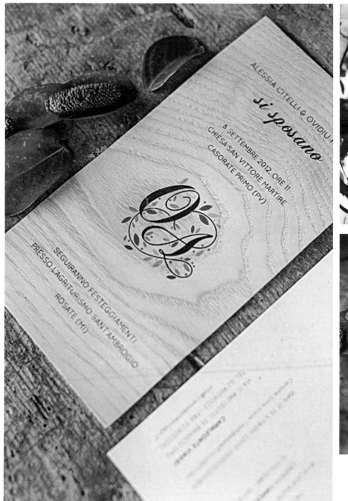

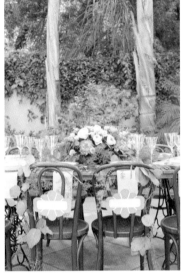

# GILDED GARDEN 鍍金花園婚禮平面設計

Design agency: Gourmet Invitations
Designer: Tifany Wunschl
Photographer: Twah Dougherty at Style Art Life
Client: Styled Editorial shoot
Country: USA

設計機構："美味請柬" 設計工作室
設計師：蒂芙尼·溫莎
攝影師：塔瓦·多爾蒂（藝術風格攝影公司）
委託客戶：風尚攝影活動
國家：美國

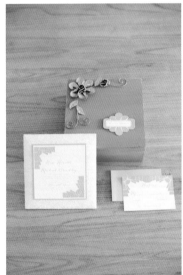

An eclectic mix of Bohemian and Art Deco with textures of a gilded garden. Shabby Chic boxes were adorned with metal flowers. The invitation was a flower lace pad with gold Art Deco overlays.

這套平面設計結合了波西米亞風格、裝飾藝術風格（Art Deco）和鍍金花園的質感。新懷舊風格的小盒子採用金屬雕花來裝飾。請柬是一套卡片，有蕾絲花朵的圖案和裝飾藝術風格的金色鑲邊。

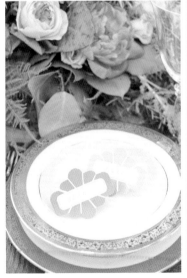

# RUSTIC GARDEN WEDDING 古樸花園婚禮平面設計

Design agency: Jen Simpson Design
Designer: Jen Simpson
Photographer: Ashley Bee Photography
Country: USA

設計機構：珍‧辛普森設計工作室
設計師：珍‧辛普森
攝影師：艾希莉‧比攝影公司
國家：美國

This invitation is perfect for a rustic garden wedding filled with burlap, twine and lush flowers. The script font adds a touch of whimsy to complete the look. It is packaged perfectly with bakers twine and a tag that you can customise with your website information.

這場婚禮在一座古樸的花園中舉行，花園裡有茂盛的花卉，使用的材料有粗麻布和麻線。這套平面設計非常適合這場婚禮的風格。手寫體字母讓卡片看起來非常別致。卡片的包裝採用綁麵包用的麻線和一張小標籤，上面可以寫上不同的資訊。

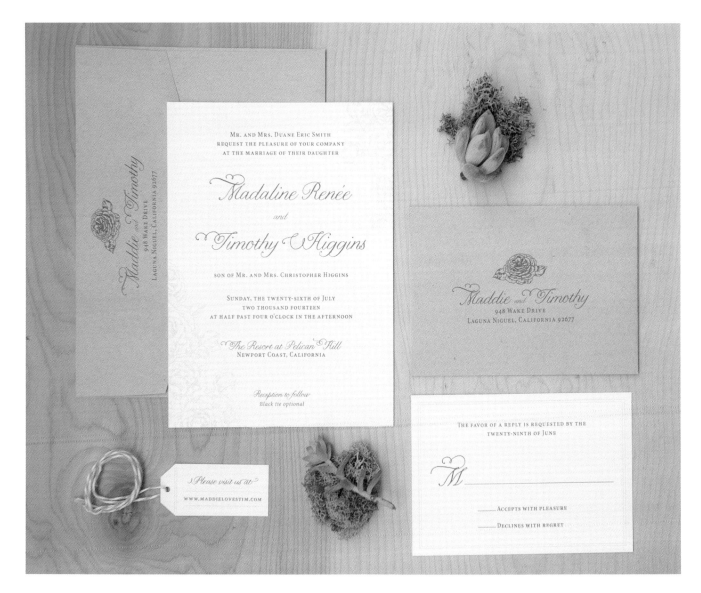

# SUMMER HARVEST SUITE

**"夏日豐收" 主題婚禮平面設計**

Designer: Lisa Mishima
Photography: Lisa Mishima & Emily Scannell
Client  Lisa Mishima & Aaron Fiske
Country: USA

設計師：麗莎‧三島
攝影師：麗莎‧三島、艾米麗‧斯卡內爾
委託客戶：麗莎‧三島、亞倫‧菲斯克
國家：美國

The concept of this wedding was to bring family and friends together with food. All of the design elements related to the celebration of food: growing, harvesting, cooking, and eating. A San Francisco specific food wheel was the focus of the invite and a cookbook was designed with guests' favourite summer recipes.

這場婚禮的主旨是讓親朋好友齊聚一堂及共享美味。所以，所有的設計項目都與食物有關：生長、豐收、烹飪、飲食。請柬的設計圍繞三藩市風格的 "食物輪" 圖形展開。此外，還附有一本迷你烹飪書，裡面有賓客最愛的夏季食譜。

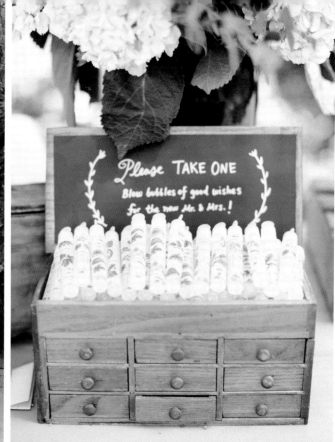

Please TAKE ONE
Blow bubbles of good wishes
for the new Mr. & Mrs.!

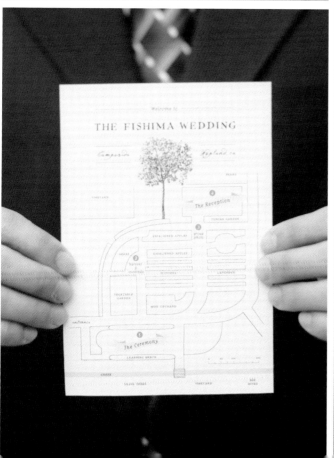

Welcome to
THE FISHIMA WEDDING

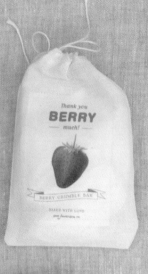

Thank you
**BERRY**
much!

BERRY CRUMBLE BAR

BAKED WITH LOVE
www.fishima.com

BEET

**JUNE 6** 2013

## Lisa & Aaron

*invite you to celebrate
their ∞ union*

*in*

**MARRIAGE**

*Thursday*
**June 6th 2013**

*Five o'clock in the evening*
*Campovida*
*13601 Old River Rd*
*Hopland, CA*

**JUNE 6** 2013

Schedule
Accomodations
Directions

Get all the details
at
**FISHIMA.COM**

>>>>> the <<<<<
# FISHIMA
COOKBOOK

*A collection
of everyone's favorite
summer recipes*

∞

SHARE YOUR FAVORITE

## SUMMER RECIPE

Help us compile our wedding cookbook!
Please use the attached card and mail
with your RSVP.

It's
## THYME
*for a feast!*

THYMUS VULGARIS

FISHIMA SEED CO.
www.fishima.com

## LETTUCE
*entertain you!*

LACTUCA SATIVA

FISHIMA SEED CO.
www.fishima.com

*Let's dance
to the*
## BEET

BETA VULGARIS

FISHIMA SEED CO.
www.fishima.com

>>>>> **MENU** <<<<<

FIRST COURSE
**Heirloom Garden Beet Salad**
Garden Harvested Arugula,
Spring Onion & Candied Walnuts

**Sheep's Milk Ricotta Gnocchi**
Sweet Garden Pea Puree
& Parmesan Crisps

SECOND COURSE
**Fresh Mozzarella & Sweet Cherry
Tomato "Panzanella"**
Garden Harvested Herbs & Lettuce
Stone Oak Tomato & Croutons

**Traditional Italian Heritage
Porchetta**
White Corn Polenta, Porcini Mushroom
& Garden Fennel Frond

**Dessert Bar**
Cakes, cookies, petites candy, ice cream
and more!

PURE NEW ∞ FISHIMA

**JUNE 6** 2013

**5:00PM**
**The Ceremony**
Officiated by Sang Park

**5:30PM**
**Harvest & Cocktail Hour**
Join the newlyweds and gather fresh herbs and
veggies for the feast

**7:00PM**
**Group Photo**
Please gather by the Tuscan Garden for one
big group photo!

*followed by*
**The Reception**
Enjoy dinner and dessert in the Tuscan Garden
Cutting of the cake
First dance
Dance the night away!
( MUSIC BY THE SPEAKEASIES )

Welcome to
## THE FISHIMA WEDDING

Campovida                    Hopland CA

The Reception

The Ceremony

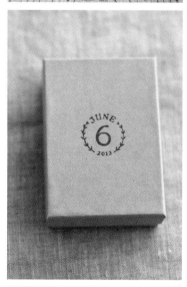

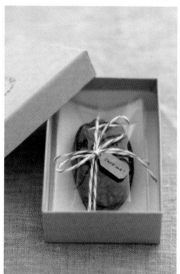

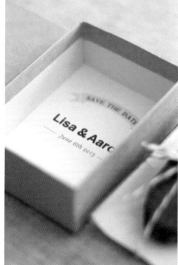

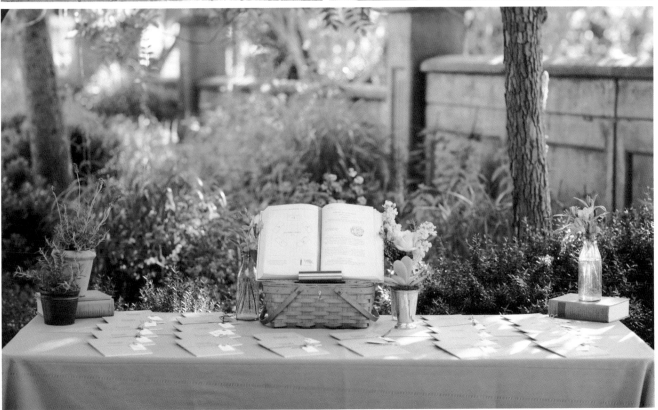

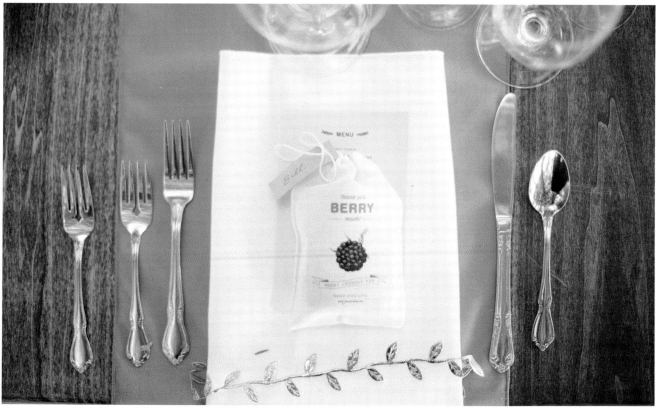

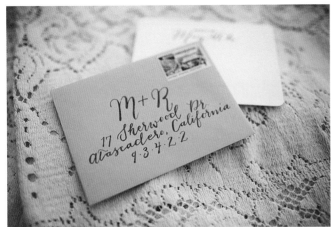

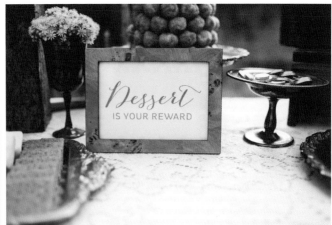

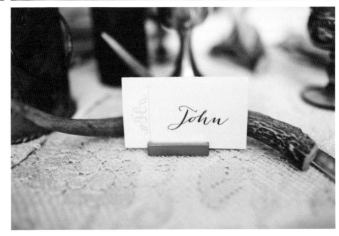

# MARIAN SUITE 瑪利安婚禮平面設計

Design agency: Olive & Emerald
Photographer: Sarah Kathleen Photography
Client: Sarah Kathleen Photography
Country: USA

設計機構：奧利弗 & 埃默拉爾德設計工作室
攝影師：薩拉・凱思林攝影公司
委託客戶：薩拉・凱思林攝影公司
國家：美國

The Marian Suite uses mixed-media – namely paper, leather, wood and gold – to tell the story of Robin Hood as part of the 'Ever After' photography series by Sarah Kathleen Photography. Iconic foxes and playful middle-aged flourishes help add some fun to the variety of materials.

瑪利安婚禮套卡的設計採用了多種媒材，包括紙張、皮革、木材和金色，敘述了兩位新人的故事。這是薩拉・凱思林攝影公司 "從此以後" 系列攝影的一部分。狐狸圖形和中世紀風格的花紋為這套卡片增添了趣味感。

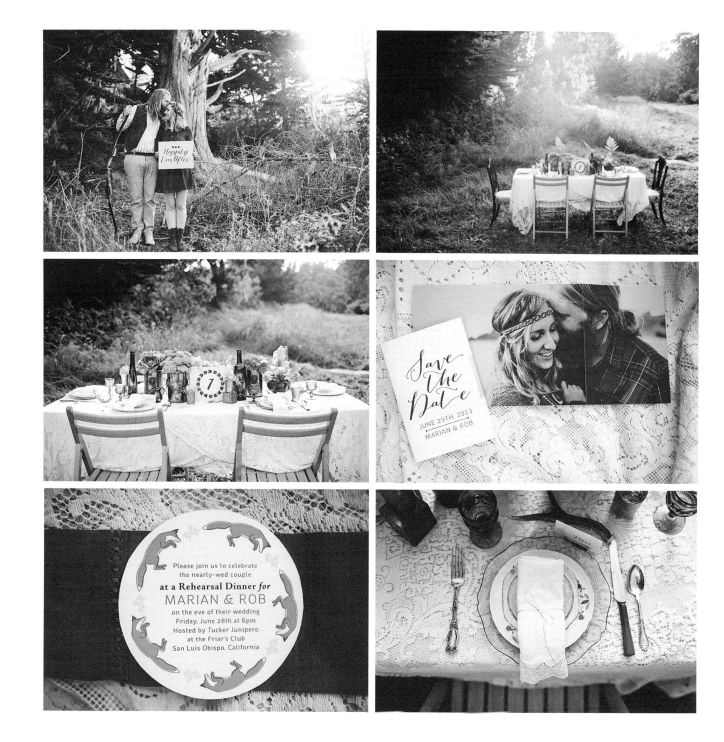

Save the Date
JUNE 29TH, 2013
MARIAN & ROB

Please join us to celebrate
the nearly-wed couple
at a Rehearsal Dinner for
MARIAN & ROB
on the eve of their wedding
Friday, June 28th at 6pm
Hosted by Tucker Junipero
at the Friar's Club
San Luis Obispo, California

# MARSHALL SUITE 馬歇爾婚禮平面設計

Design agency: Olive & Emerald
Photographer: Bret Cole Photography
Client: Bret Cole Workshops
Country: USA

設計機構：奧利弗 & 埃默拉爾德設計工作室
攝影師：佈雷特·科爾攝影公司
委託客戶：佈雷特·科爾工作室
國家：美國

Soft letterpress and hand-tinted watercolour make the paper goods feel luxurious. The Marshall Suite was designed to evoke the more sophisticated, elegant side of a coastal wedding by leaving iconic images of seashells and yachts out of the visual language.

柔和的印刷體文字和手工著色的水彩讓這套卡片看起來高雅奢華。馬歇爾婚禮套卡是為一場海濱婚禮設計的，旨在營造一種考究、典雅的氛圍。設計師使用了貝殼和帆船的形象作為視覺語言。

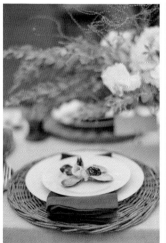

# MARTA & RAMON 瑪爾塔與雷蒙婚禮平面設計

Designer: Carlos Robledo Puertas
Photographer: Carlos Robledo Puertas
Client: Marta Robledo & Ramon Lopez
Country: Spain

設計師：卡洛斯‧羅夫萊多‧普埃爾塔斯
攝影師：卡洛斯‧羅夫萊多‧普埃爾塔斯
委託客戶：瑪爾塔‧羅夫萊多、雷蒙‧洛佩斯
國家：西班牙

When your sister is getting married, you find yourself with one of the hardest briefing ever. This was the artist's gift on his sister's wedding; printed on both letterpress and digital and hand mounted by the whole family. The design was meant to show the traditional part of the wedding but with a DIY touch. The fabric makes every single invitation unique.

當你的妹妹結婚時，你會發現你很難去平靜客觀地設計。這套卡片就是設計師送給他妹妹的結婚禮物，既有凸版印刷，也有數碼列印，最後由全家人手工裝裱製作完成。這套設計旨在傳達出傳統的婚禮卡片感覺，同時帶一點 DIY 元素。每套請柬使用不同的布料包裝，獨一無二。

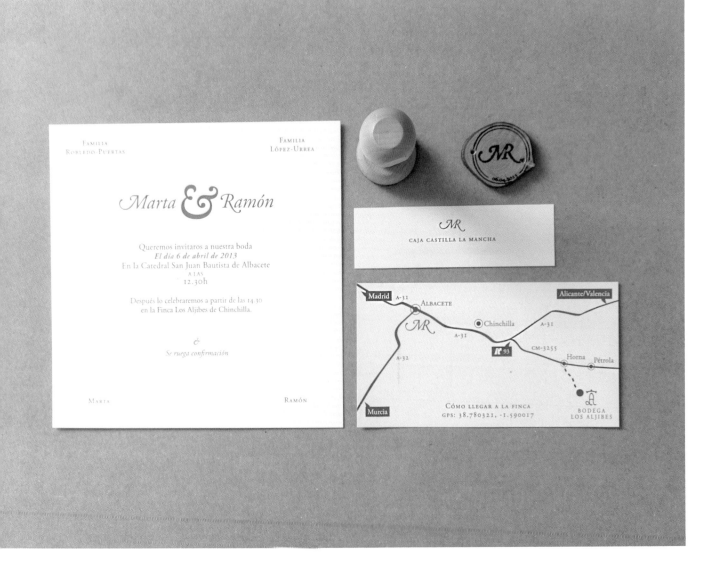

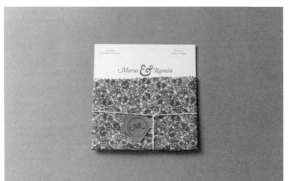
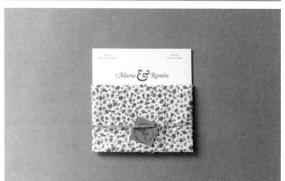
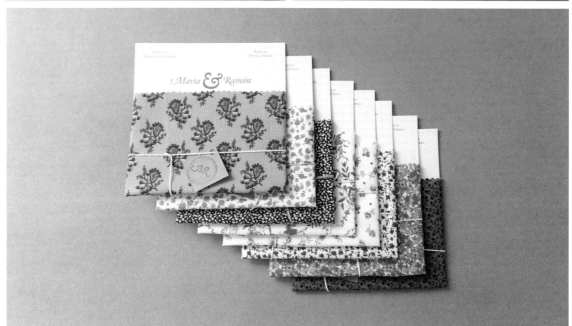
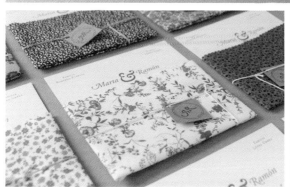
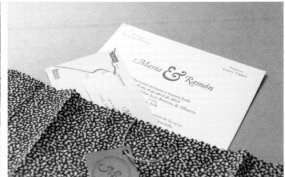

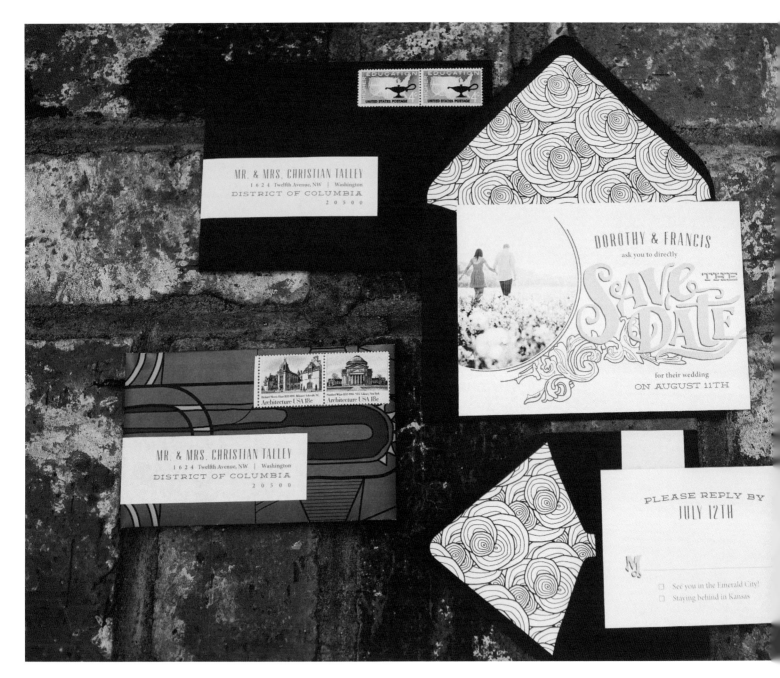

# OSWALD SUITE 奧斯瓦德婚禮平面設計

Design agency: Olive & Emerald
Photographer: Sarah Kathleen Photography
Client: Sarah Kathleen Photography
Country: USA

設計機構：奧利弗 & 埃默拉爾德設計工作室
攝影師：薩拉 · 凱思林攝影公司
委託客戶：薩拉 · 凱思林攝影公司
國家：美國

Inspired by the fictional land itself, the monochromatic colour palette of black, white and iconic emerald help tie the all the playful patterns of the Oswald Suite together to highlight the story of The Wizard of Oz as part of the 'Ever After' photography series by Sarah Kathleen Photography.

這套婚禮平面設計的靈感來自《綠野仙蹤》故事當中的環境。以單一的翠綠色為主色調，此外還用到黑色和白色，讓整套卡片呈現出統一的風格。這是薩拉 · 凱思林攝影公司"從此以後"系列攝影的一部分。

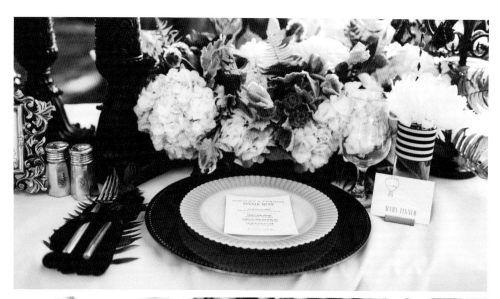

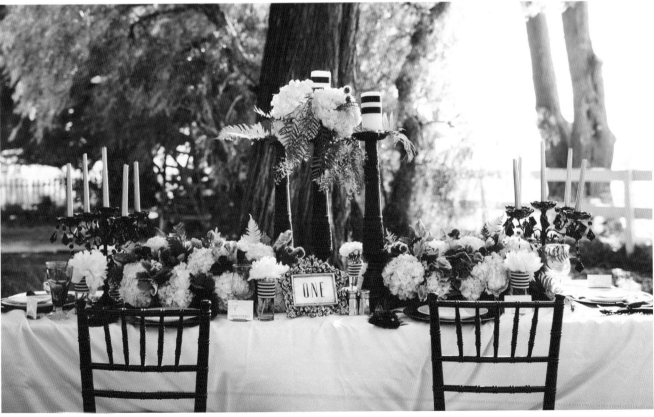

You are happily invited
to join in celebrating

THE MARRIAGE OF

Dorothy Judith
Baum & Francis
Oswald Gale

on Sunday, the 11th of August
two thousand thirteen

FLYING CABALLOS
RANCH

San Luis Obispo, California

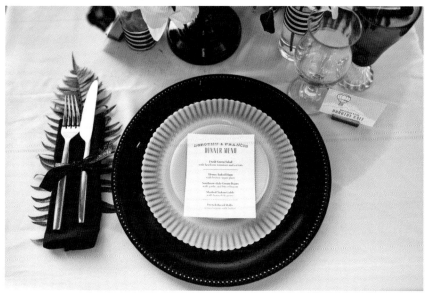

MISSUS
DOROTHY GALE

# RUSTIC KRAFT 古樸牛皮紙婚禮平面設計

Design agency: Jen Simpson Design
Designer: Jen Simpson
Photographer: Ashley Bee Photography
Country: USA

設計機構：珍‧辛普森設計工作室
設計師：珍‧辛普森
攝影師：艾希莉‧比攝影公司
國家：美國

This invitation set features beautiful hand-lettered fonts highlighted with fun, hand-drawn, organic scrolls and banners; printed on kraft card stock to give it a complete rustic feel.

這一系列請柬套卡以手寫字體為特色，字母設計的非常漂亮。此外，還用卷軸橫幅的形式作為裝飾和點綴。採用牛皮紙卡片印刷，營造出古樸典雅的感覺。

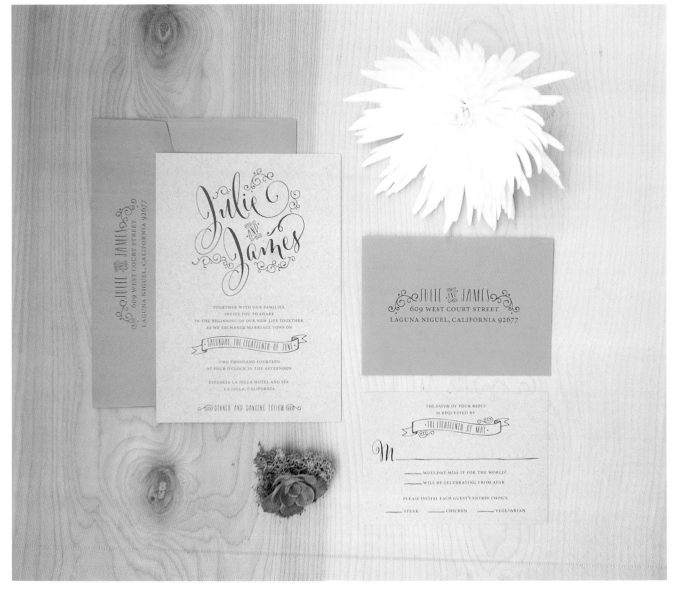

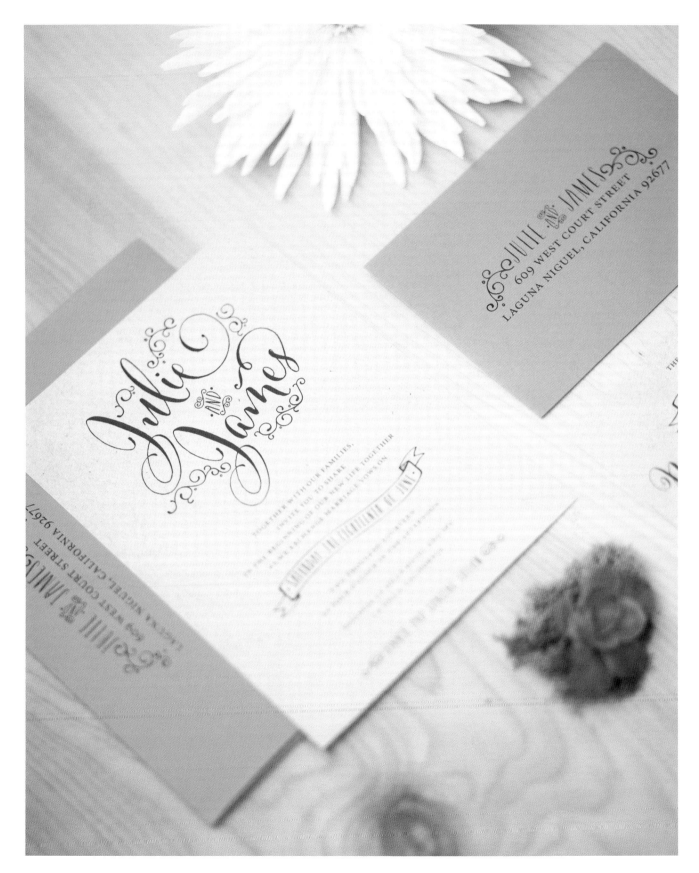

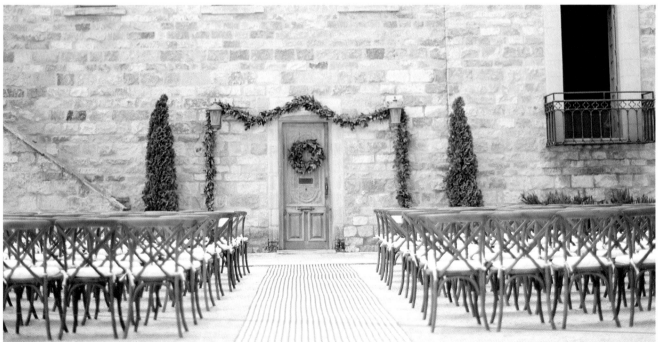

# SUMMER & BRYAN

## 薩默與布萊恩婚禮平面設計

Design agency: MaeMae Paperie
Photographer: JenHuangPhoto
Client: Summer & Bryan
Country: USA

設計機構：梅梅紙質設計工作室
攝影師：黃珍攝影工作室
委託客戶：薩默、布萊恩
國家：美國

Stationery for a gorgeous wedding that took place at Sunstone Villa. The colour palette is dominated by fresh green, as a symbol of life and vitality, representing a vigorous starting point for a new journey in the life of the newlyweds. Inspired by strips, animals and plants, the patterns are simple yet fun and chic.

這是在 "太陽石" 別墅舉辦的一場盛大婚禮。設計的主題顏色為清新而自然的綠色，象徵著生命與活力，這對甜蜜的新婚大婦也將踏上一段嶄新的人生旅程。條紋、動物和植物等圖案元素使整個設計看起來簡潔、時尚又不乏趣味性。

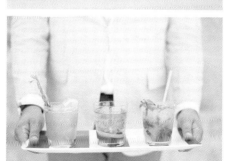

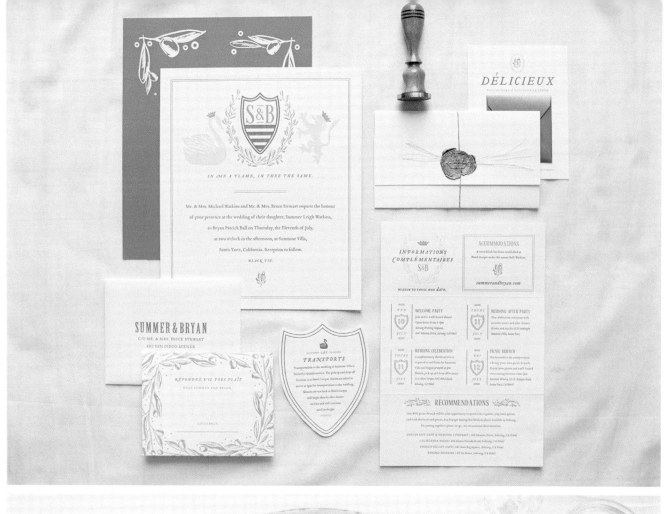

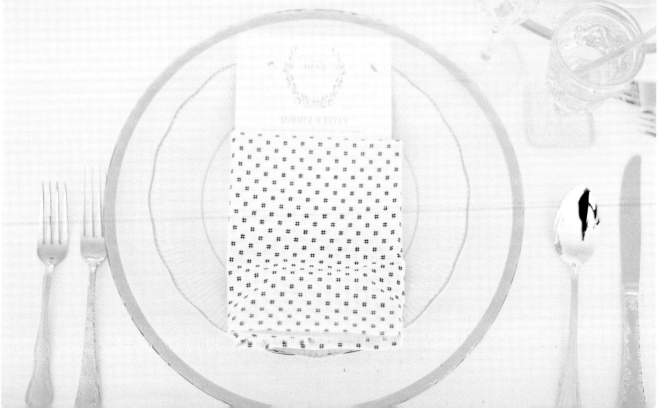

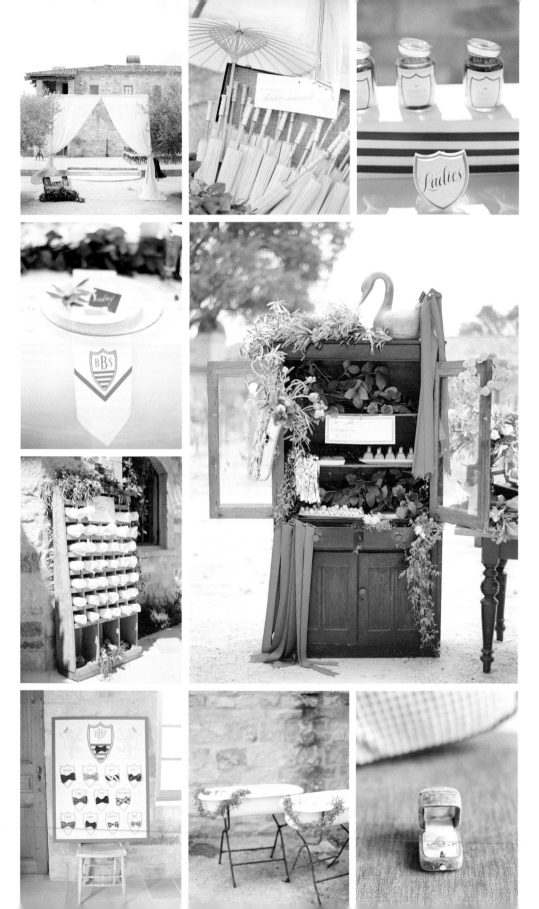

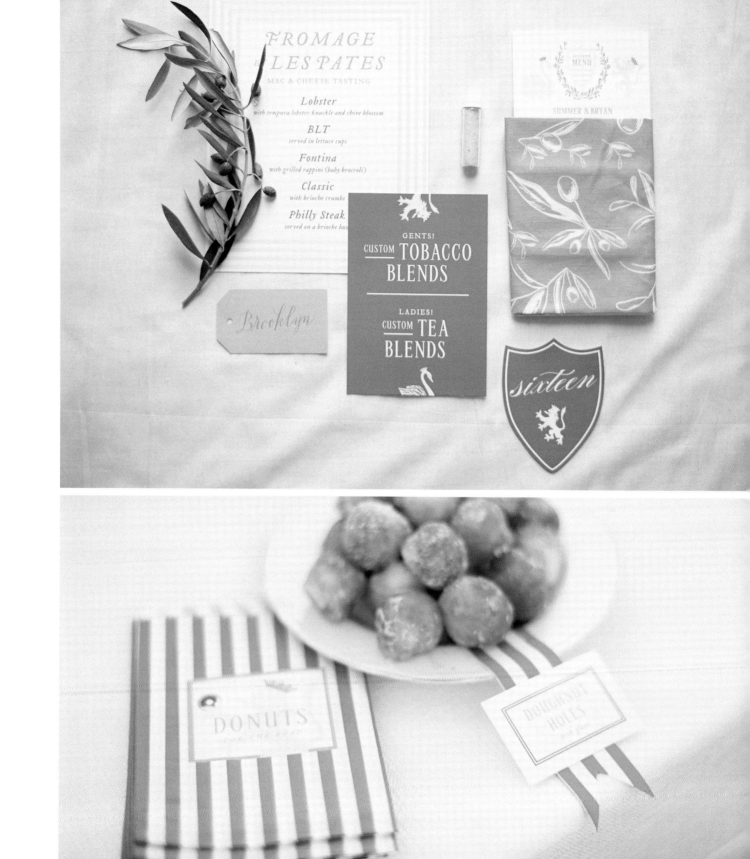

FROMAGE
LES PATES
MAC & CHEESE TASTING

Lobster
with tempura lobster knuckle and chive blossom

BLT
served in lettuce cups

Fontina
with grilled rappini (baby broccoli)

Classic
with brioche crumbs

Philly Steak
served on a brioche bun

Brooklyn

GENTS!
CUSTOM TOBACCO
BLENDS

LADIES!
CUSTOM TEA
BLENDS

sixteen

DINNER MENU

SUMMER & BRYAN

DONUTS
FOR THE ROAD

DOUGHNUT
HOLES
with glaze

# CASSIANA & L. FELIPE

## 凱西安娜與費利佩婚禮平面設計

Designer: Felipe Luize
Photographer: Rogério Freitas Memory
Client: The Bride
Country: Brazil

設計師：費利佩‧路易茲
攝影師：羅德里奧‧弗雷塔斯攝影公司
委託客戶：新娘
國家：巴西

Do your own wedding graphic design is not an easy task, mainly because the bride is your major client! After the wedding, the new couple were going to leave their hometown, so the artist (the groom) tried to create a brand that would carry this significance. It was important to involve the guests. That's why they took a lot of care with all the graphic details. Came to light the idea of a tree that has its leaves carried by the wind. Not only with all the meanings that a tree carries, the focus is on the movement of the leaves that's caused by the wind.

為自己的婚禮做平面設計可不是件容易的事，主要是因為新娘是你的委託客戶！本案就是如此。婚禮過後這對新人就要離開家鄉，設計師（新郎）希望能在設計中傳達出這一點。另外，設計還應該表現出對賓客的用心，在這方面，細節上的設計頗費心血。設計師採用了樹木的設計理念。除了利用樹木所具備的象徵意義之外，主要用意是「樹葉隨風飄遠」象徵著新婚夫婦離家遠行。

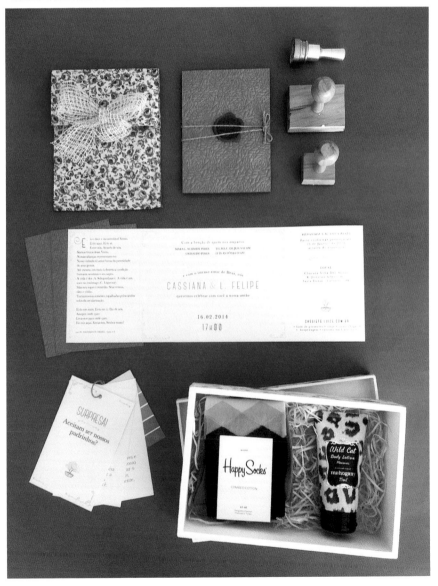

Quer um prato maior?

# VINTAGE COUNTRY GARDEN 復古鄉村花園婚禮平面設計

Designer: Elise Rayment
Photographer: Robin Fowley
Country: UK

設計師：伊麗絲·雷蒙
攝影師：羅賓·弗雷
國家：英國

Having a love of screen printing from her art school days the artist was keen to use this printing process for her wedding invitations. The design ideas came from her flowers and venue. She wanted a nostalgic country garden feel with a modern take. As the groom was wearing navy and the bride had a cream dress, she picked a navy and cream colour plan stock from GFSmith with embossing on one side, to give some texture. She screen printed using three colours which varied depending on the navy or cream stock. It was quite time-consuming but she loved the effect and layering of colours. She tied the invite, RSVP and information booklet together with twine and used matching colour plan embossed envelopes. She also screen printed the table plan, menus, order of service and thank-you cards. It consumed most of her time for several weeks but she loved the final result!

這場婚禮的新娘是來自蘇格蘭的平面設計師，在學校時就特別喜歡絲網印刷，所以自然而然地在自己的婚禮請柬上採用了這一技術。設計理念來自新娘捧花和婚禮地點。設計師想要營造一種懷舊的鄉村花園的氛，同時也要具備現代感。婚禮上，新郎穿海軍藍的西裝，而新娘穿乳白色的婚紗，所以平面設計選擇了海軍藍和乳白色作為主色調。卡片一端採用壓印技術，使其更有質感。絲網印刷使用了三種顏色，在海軍藍和乳白色的基調上有所變化。印刷過程由設計師親自操作，非常耗時，但是她喜歡這種層次豐富的色彩效果。請柬、回覆卡和小冊子用麻線綁在一起，裝在有凹凸效果的信封裡，信封也是相同的色調。座位表、菜單、流程卡和感謝卡也都是設計師自己進行絲網印刷的，花費數周時間，但她對最終的作品很滿意！

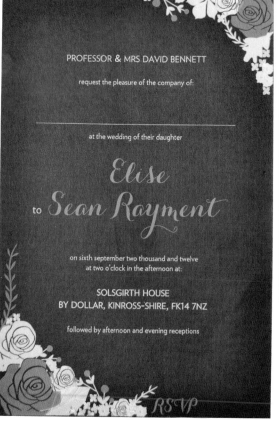

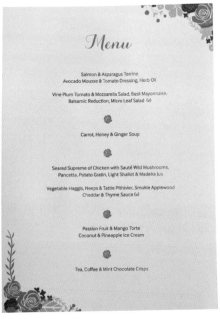

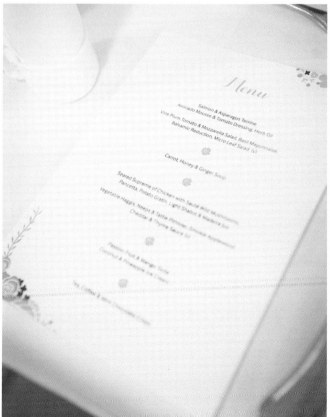

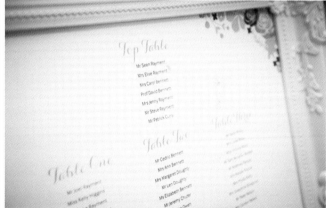

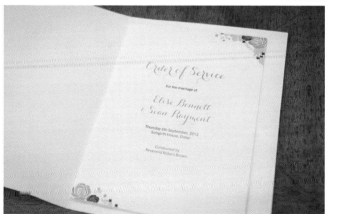

# ANISA & MICHELE  阿妮薩與蜜雪兒婚禮平面設計

Designer: Giorgia Smiraglia
Photographer: Giorgia Smiraglia
Client: Anisa Gjika & Michele Strippoli
Country: Italy

設計師：喬琪亞·斯密拉哥利亞
攝影師：喬琪亞·斯密拉哥利亞
委託客戶：阿妮薩·琪卡、蜜雪兒·斯特黎波里
國家：義大利

Inspired by the countryside environment, this wedding suite sets the perfect tone for Anisa and Michele's wedding day. The young couple were very clear about the mood: they wanted a rustic-yet-elegant wedding atmosphere that represented their wedding and their passion: the music. For this reason, their logo evolved out by the design of musical notes. Continuously inspired by music, the decorative elements were designed to recall a staff. This informed the rest of the design including invitations, table cards, menus, the wedding table plan and the party favour parchments. The colour palette was inspired by the location; in fact the party was to be held in a grassy garden full of daisies. All the materials were printed on a recycled uncoated paper, and the result was a rustic effect that coordinates well with the atmosphere of the countryside.

這套平面設計的靈感來自這場婚禮舉辦地的鄉村環境，整套設計為阿妮薩與蜜雪兒的婚禮奠定了完美的基調。這對年輕的新婚夫婦非常清楚他們想要平面設計營造何種氛圍：古樸而典雅，能夠表現出他們的摯愛－音樂。為此，LOGO 標識的設計借鑒了音符的形象。其他裝飾元素的設計也沿用了音樂的主題，處處都跟五線譜有關，包括請柬、桌號牌、菜單、桌椅的擺設佈局及羊皮紙包裝的小禮品等。色調的選擇是由婚宴場地決定的（這場婚禮在滿是雛菊的草坪上舉行）。所有卡片都採用再生非塗布紙印刷，成功營造出古樸典雅的氛圍，與婚禮的鄉村環境相得益彰。

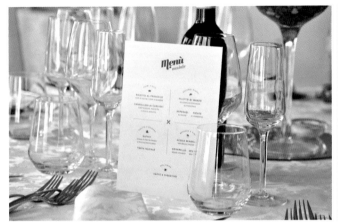

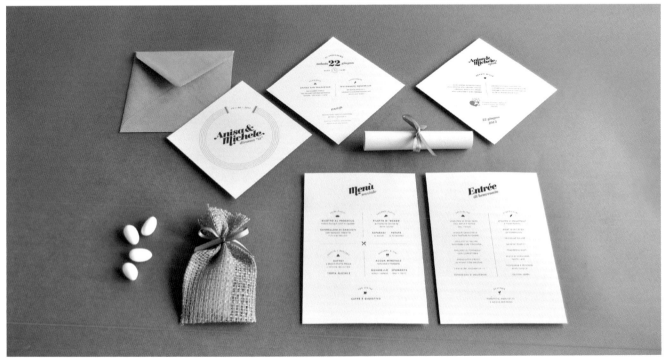

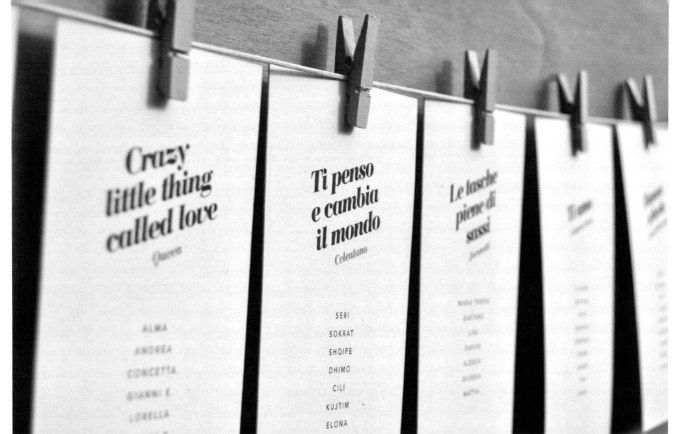

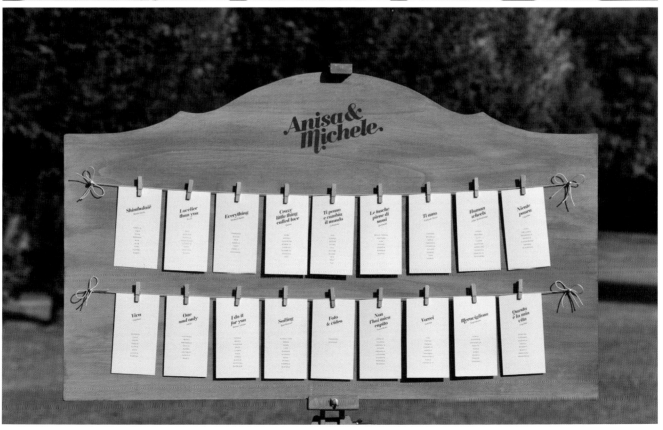

# MARTINA & FERNANDO

**瑪蒂娜與費爾南多婚禮平面設計**

Design agency: LEFTRARU
Designer: Lautaro Pelayez
Photographer: Lautaro Pelayez
Client: Martina Pelayez & Fernando Kampfer
Country: Argentina

設計機構：萊夫紮茹設計工作室
設計師：勞塔羅‧帕雷伊斯
攝影師：勞塔羅‧帕雷伊斯
委託客戶：瑪蒂娜‧帕雷伊斯、費爾南多‧肯普法
國家：阿根廷

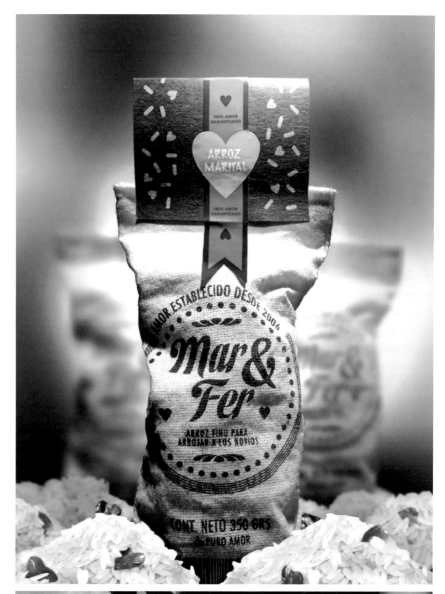

The clients wanted their invitations to be functional at their wedding so that they could be used by their guests throughout the celebration. Taking this into account, the designer created these invitations resembling a sack of rice, which connotation had to do with the amount of love that this product contained. The rice would be used to be thrown to the newlyweds as soon as the ceremony came to an end. Also, the sack had a card inside, with all the necessary information for the guests to attend the party. Efficiently, the invitation was a great success since all guests used it to bless and bother the newly married couple.

這對新人希望他們的婚禮請柬實用性強，讓賓客能在婚禮的過程中用到。從這點出發，設計師打造了這套新穎又具特色的一小袋大米，象徵著這對新人滿滿的愛。小布袋裡面裝的大米用在典禮結束的時候撒到新人身上。袋子裡面還有一張卡片，上面有賓客參加婚禮所需的各種資訊。這套設計非常成功，賓客用它來向新人表達祝福，浪漫而有趣。

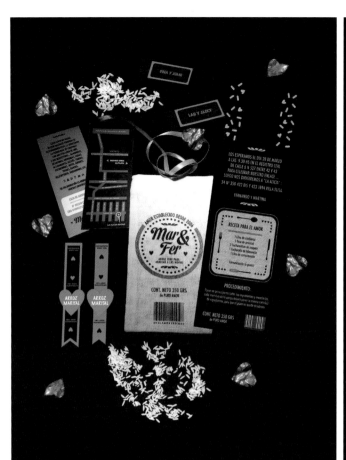

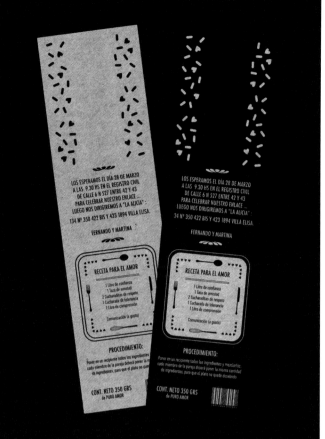

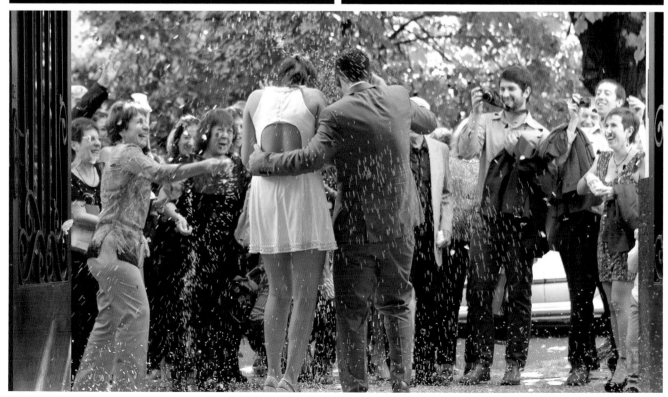

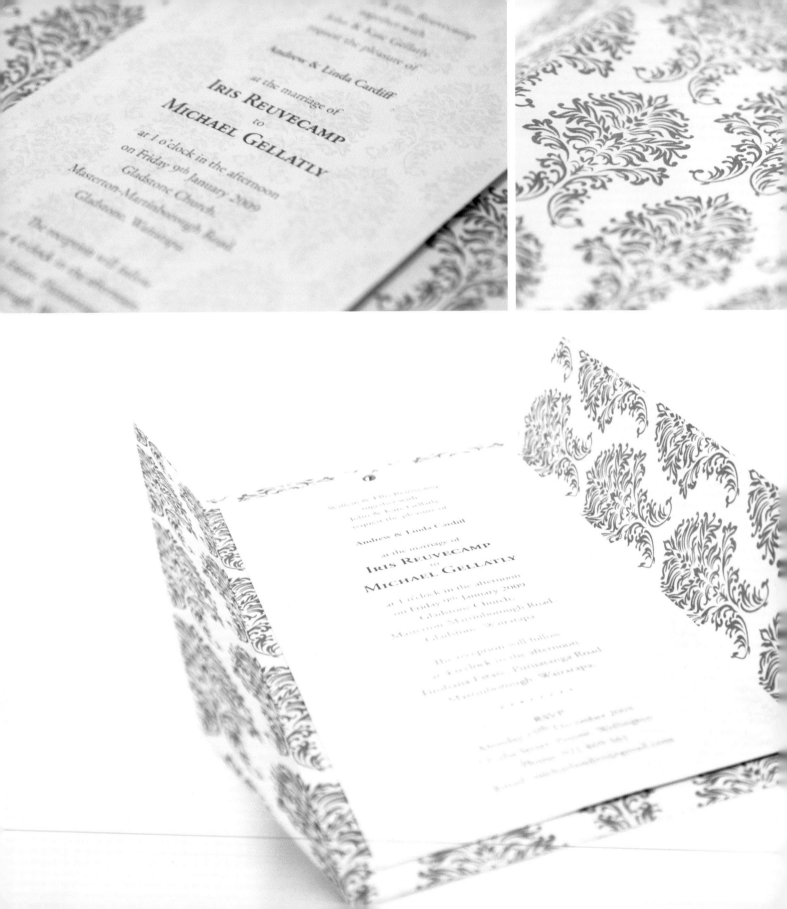

# IRIS & MICHAEL

## 愛麗思與邁克爾婚禮平面設計

Designer: Michiel Reuvecamp
Photographer: Michiel Reuvecamp
Client: Iris & Michael Gellatly
Country: New Zealand

設計師：米希爾．羅夫坎普
攝影師：米希爾．羅夫坎普
委託客戶：愛麗思．格拉特利、邁克爾．格拉特利
國家：新西蘭

For the Gellatly Wedding, stationary and accessories were developed along a specific theme. This request included the incorporation of a pattern and colour theme to reflect the floral arrangements. The wedding invites were supported by service cards, menus, table numbers and placeholders.

這套婚禮平面設計圍繞著婚禮的主題而展開，包括圖案和主題色都與婚禮現場佈置的鮮花相匹配。這套婚禮套卡包括：服務卡、菜單、桌號和預留位置卡。

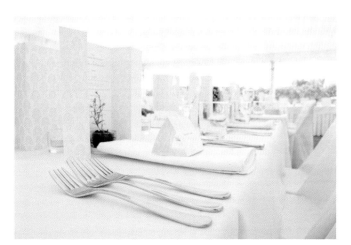

# ALEC & DOMI 亞力克與多米婚禮平面設計

Design agency: Las Chulas
Designer: Violeta Herbstein & Natalia Mendes Borralho
Photographer: Marina Jakobs
Client: Domi & Alec
Country: Argentina

設計機構：拉斯·舒拉斯設計工作室
設計師：維奧萊塔·赫伯斯坦、娜塔莉亞·門德斯·包拉羅
攝影師：馬里納·雅各斯
委託客戶：多米·亞力克
國家：阿根廷

For Alec and Domi's wedding, the artists decided to combine two main concepts: the elegance of such an event with the rustic countryside, due to that their beautiful farm in Manzanares was the chosen location for the celebration. All the typography and miscellany in the artworks were handmade specially for the occasion. Inside a vellum paper envelope, came the invitation with the map on the reverse, a card regarding the information for the wedding gifts, and an ID tag specially made to be hung in the car's rear-view mirror. This way, the guests were easily identified at the entrance. Personalised coasters were also printed, so they would be used during the celebration as well as take-away souvenirs. Letterpress was the printing method chosen for this project, using two colour inks, on a special thick warm white paper.

設計師為這對新人的婚禮平面設計選擇了兩大主題：時尚典雅與鄉村田園風（這場婚禮選在曼薩納雷斯的美麗農場中舉行）。作品中的所有元素都是手工製作完成的，凸顯淳樸的特色，以便與婚禮舉辦地的環境相符。信封的材質是仿羊皮紙，裡面裝著請柬，請柬背面有行程地圖。此外還有關於婚宴禮品的資訊卡以及一張小小的身份資訊卡，用來懸掛在汽車後視鏡上。當車輛一開到門口，主人就能認出是哪位賓客光臨。另外，還印刷了一批個性化杯墊，除了在婚禮現場使用之外，也作為送給賓客的小紀念品。這套設計選擇凸版印刷工藝，採用兩種色彩的油墨，在較厚的白色紙張上，給人的感覺很溫暖。

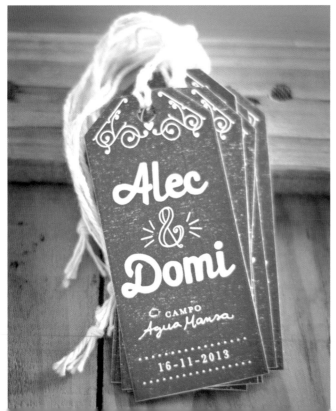

# BARN YARD BOGGIE 農場小豬婚禮平面設計

Design agency: Kalo Make Art
Designer: Kalo
Photographer: Kalo
Client: Kalo
Country: China

設計機構：卡洛藝術創作工作室
設計師：卡洛
攝影師：卡洛
委託客戶：卡洛
國家：中國

This wedding invitation suite was designed by Kalo and her husband, Daniel, for their barn yard boggie wedding in the summer. They both love animals and dream of having their own farm one day. Among all animals, pig is their favourite! The day they got engaged, Daniel gave Kalo two pig toys which were incorporated onto the wedding invitation design. The main wedding invitation was printed in a purple hot foil and the kraft paper piggy tags were cut out with a die cut machine. As a handmade lover, Kalo attached each piggy tag together with a piece of burlap and wrapped around the invitation set and she calligraphed all the guests' names to add a personal touch. To keep their friends entertained, they created several games that guests could play throughout the day. They came up with the idea of a 'Barnyard Bingo', an activity card to play during the dinner and Kalo even designed a Kid's Activity Book to keep the children busy!

這套婚禮平面設計由設計師卡洛和她的丈夫丹尼爾共同完成。兩人都喜歡動物，並夢想著有一天能擁有他們自己的農場。在所有動物中，豬是他們的最愛。訂婚那天，丹尼爾送給卡洛兩隻小豬玩偶，他們將其應用到婚禮的平面設計中。婚禮請柬呈紫色，印在熱箔片上。牛皮紙的小豬標籤由衝壓式裁切機制作完成。作為一名手工製作愛好者，卡洛親手將每個小豬標籤用一塊粗麻布綁在請柬上，並親手書寫了所有賓客的名字以示尊敬。為了讓朋友們玩得盡興，新婚夫婦還設計了幾種遊戲供賓客在婚禮當天娛樂。他們想出來一種名為"農場賓戈"的卡片遊戲，能在晚宴中玩。卡洛甚至設計一本《兒童遊戲手冊》，保證孩子們絕不會無聊！

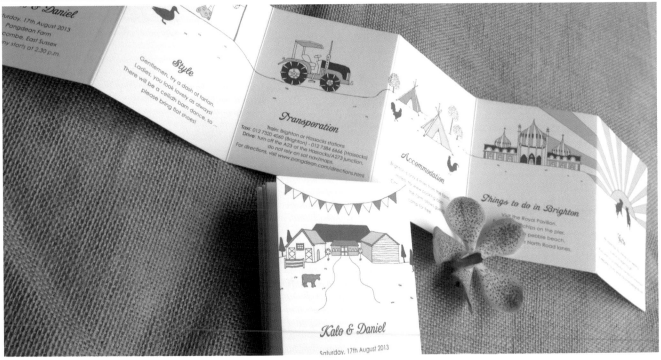

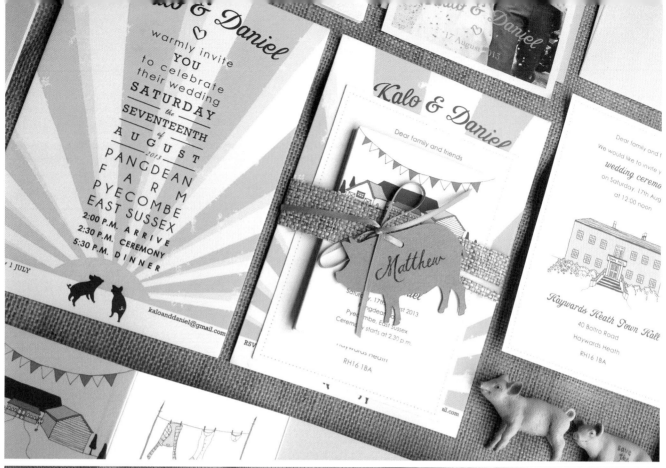

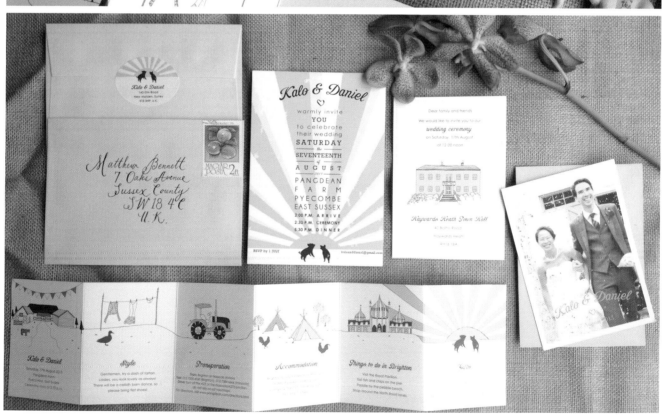

# ALEXANDRA & CHRISTOPHER

亞歷山卓與克里斯多夫婚禮平面設計

Design agency: Pretty in Print
Designer: Ann Gancarczyk
Photographer: Ann Gancarczyk
Country: Germany

設計機構："漂亮印刷"設計工作室
設計師：安・甘卡爾齊克
攝影師：安・甘卡爾齊克
國家：德國

Geometric shapes and flowing swashes work in perfect harmony together in these lovely rustic designs. The artist chose handwritten fonts and drew the heart and flag elements to give this collection its quirky organic style. The green and teal make a great colour combination. The design is a bit vintage, a bit modern and definitely unique.

幾何的形狀和流暢的線條完美結合，形成了這套淳樸而別致的婚禮套卡。設計師選擇了手寫體字母，並手繪了心形和旗幟等平面元素，讓這套設計顯得親切而獨特。綠色和青色的組合形成完美的色彩搭配。整套設計有些復古又有些現代，而且絕對獨一無二。

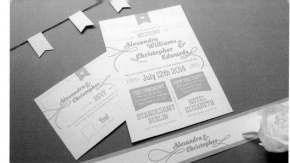

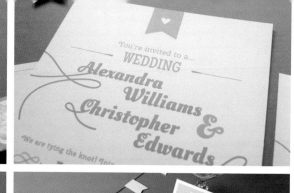

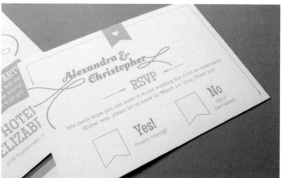

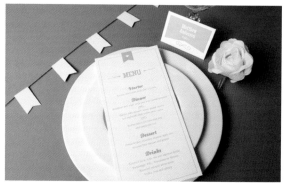

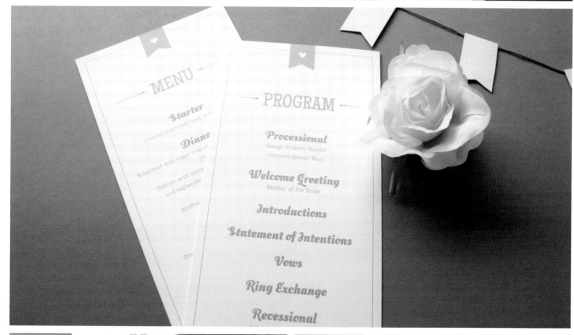

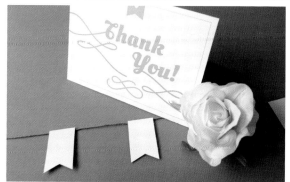

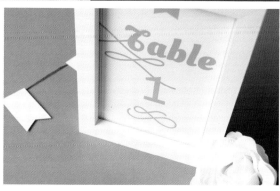

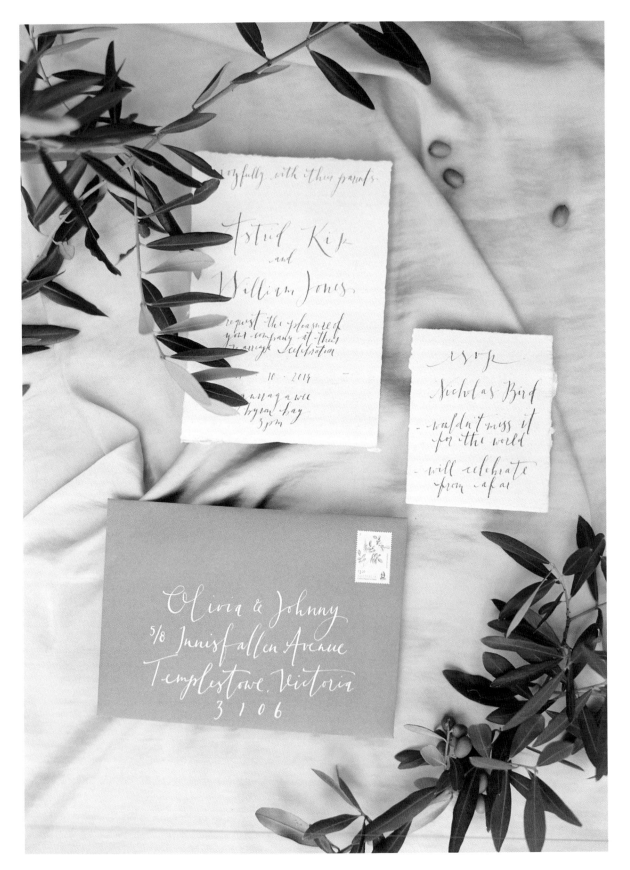

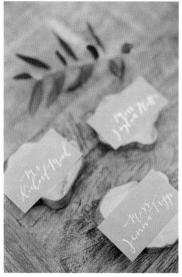
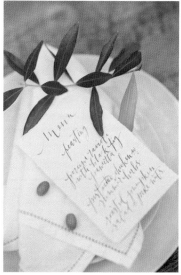

# NEW ZEALAND WEDDING

## 新西蘭婚禮平面設計

Design agency: Cotton Blossom
Photographer: JenHuangPhoto
Country: New Zealand

設計機構："木棉花開"設計工作室
攝影師：黃珍攝影工作室
國家：新西蘭

Wedding stationery designed in a vintage style. The combination of grey and white reveals the new couple's aspiration for nature. Hand making, script, and torn-edge paper all highlighted a great integration with nature, corresponding to the natural surroundings of the wedding.

這是一套古典的設計，微妙的灰與白之間，透露的是這對甜蜜的新婚夫婦追尋古樸自然的心境。手工製作、手寫字體和簡單的撕邊紙都能夠完美地與大自然相融合。讓我們一起感受這場在大自然間舉辦甜美氣氛的婚禮吧！

**PORTADA**

**CARAS INTERNAS**

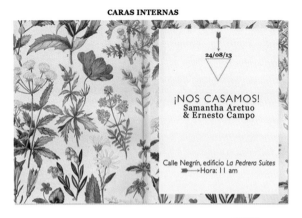

¡NOS CASAMOS!
Samantha Aretuo
& Ernesto Campo

Calle Negrín, edificio *La Pedrera Suites*
Hora: 11 am

24/08/13

**CONTRAPORTADA**

**EXTRAS**

**SOBRE**

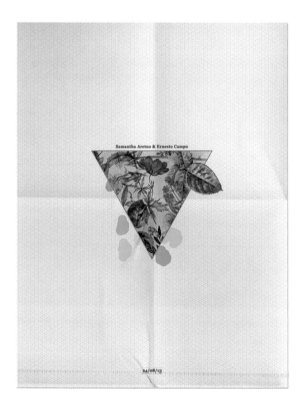

Samantha Aretuo & Ernesto Campo

24/08/13

# SAMMY & ERNESTO

**薩米與歐內斯托婚禮平面設計**

Design agency: Valentina Alvarado
Designer: Valentina Alvarado Matos
Client: Sammy & Ernesto
Country: Venezuela

設計機構：瓦倫蒂娜‧阿爾瓦拉多設計工作室
設計師：瓦倫蒂娜‧阿爾瓦拉多‧馬托斯
委託客戶：薩米、歐內斯托
國家：委內瑞拉

Wedding poster/invitation for the artist's friend Sammy. Sammy likes plants and flowers, and at the same time she is a fashion lover. Therefore, the artist created a suite with the theme of mysterious flowers, combined with some fashion patterns, completing a strongly personalised stationery design.

新娘薩米是這位設計師的朋友。薩米很喜歡各種植物和花卉，同時她又是個熱愛時尚的女孩子。所以設計師設計了這套以神秘花卉為主題的圖案，並融合了一些象徵著時尚的圖形設計。這是一套個人色彩濃郁的設計。

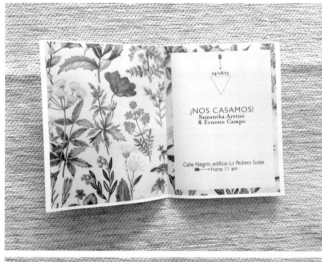

# FLORAL CITRUS SUITE 柑橘花婚禮平面設計

Design agency: BerinMade    設計機構：貝林設計工作室
Designer: Erin Hung    設計師：艾琳‧洪
Photographer: BerinMade    攝影師：貝林設計工作室
Country: UK    國家：英國

This brilliantly coloured suite is great for a colour-loving bride. Eye-popping, mouth-watering florals frame the design with large, loose-petalled florals. A cheeky butterfly hovers and you almost smell the heady scent of the English garden in full-bloom! The designs feature modern, block lettering in flashes of bright pinks and yellows.

這套色彩明媚的卡片十分適合鍾愛顏色的新娘。卡片上的花卉圖案非常生動，花瓣歷歷可數，不僅吸引眼球，而且甚至讓人產生食慾，垂涎欲滴！一隻美麗的蝴蝶在花朵上方盤旋，你幾乎可以聞到英式花園裡百花綻放的芬芳。這套設計採用現代的印刷體字母，文字的顏色是亮麗的粉色和黃色。

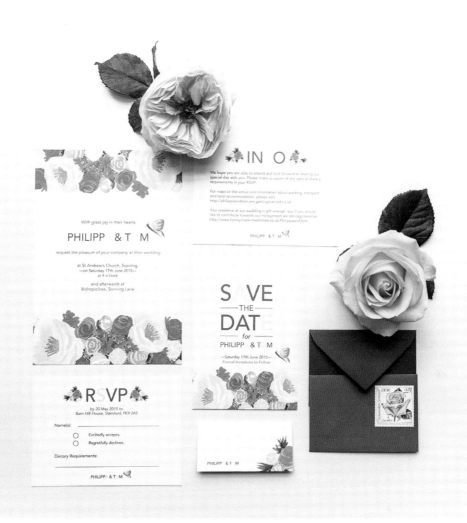

IN O

We hope you are able to attend and look forward to sharing our
special day with you. Please make us aware of any special dietary
requirements in your RSVP.

For maps to the venue and information about parking, transport
and local accommodation, please visit
http://philippandtom.are.gettingmarried.co.uk

Your presence at our wedding is gift enough, but if you would
like to contribute towards our honeymoon we are registered at
http://www.honeymoon-memories.co.uk/PhilippandTom

PHILIPP & T M

With great joy in their hearts

PHILIPP & T M

request the pleasure of your company at their wedding

at St Andrew's Church, Sonning
—on Saturday 17th June 2015—
at 4 o'clock

and afterwards at
Bishopsclose, Sonning Lane

S VE
THE
DAT
for
PHILIPP & T M

—Saturday 17th June 2015—
Formal Invitations to Follow

R SVP

by 20 May 2015 to
Barn Hill House, Stamford, PE9 2AE

Name(s):

○ Excitedly accepts.
○ Regretfully declines.

Dietary Requirements:

PHILIPP & T M

PHILIPP & T M

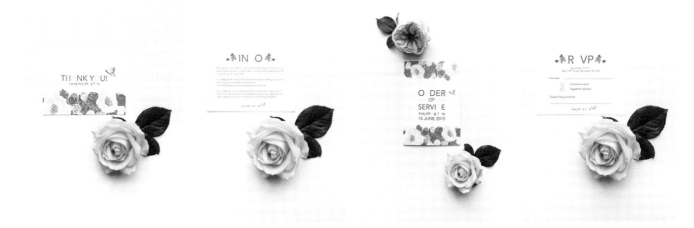

TH NKY U!

IN O

R VP

O DER
OF
SERVI E
PHILIPP & T M
15 JUNE 2015

# JENNIFER & ZACHARY 珍妮佛與紮卡裡婚禮平面設計

Design agency: Jolly Edition
Photographer: Sarah Mooney
Client: Jennifer & Zachary
Country: USA

設計機構：喬利設計工作室
攝影師：薩拉·穆尼
委託客戶：珍妮佛、紮卡裡
國家：美國

Californian college sweethearts Jennifer and Zachary stayed true to their roots when planning their vineyard wedding with a relaxed, casual and elegant feel. With such a fun set of requirements Jolly Edition were able to create a versatile look to excite their guests with a unique, lasting first impression.

珍妮佛和紮卡裡在加利福尼亞求學時相戀，兩位新人在籌畫他們的葡萄園婚禮時希望把這段愛情故事表現出來，同時要營造輕鬆而又高雅的氛圍。在這些要求的基礎上，喬利設計工作室打造了這套萬能的平面設計，能夠給婚禮的賓客留下獨特、持久的第一印象。

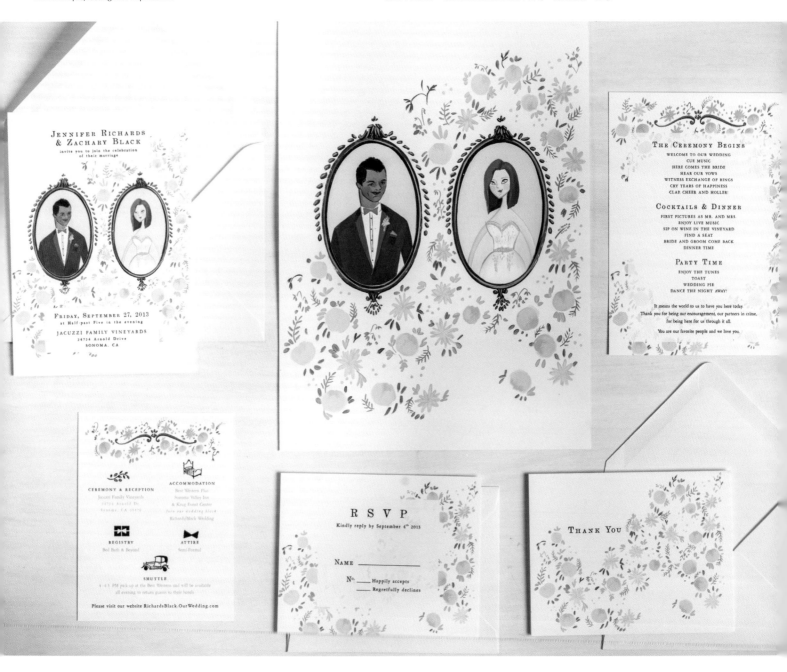

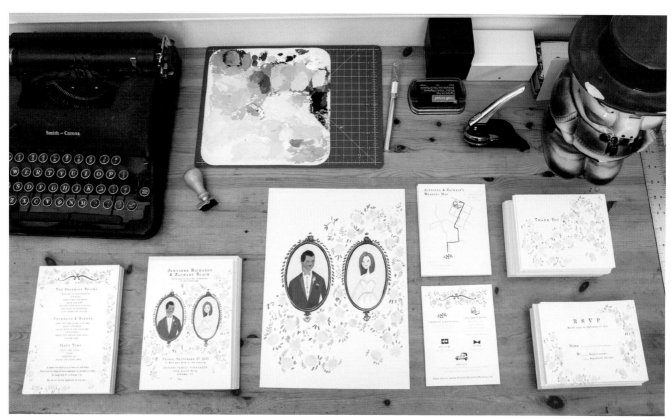

# WHIMSICAL WONDERS
## 奇幻風格婚禮平面設計

Design agency: Beet & Path
Designer: Kay Kent
Photographer: Beth & Ty
Client: Lynzie & Andrew
Country: Canada

設計機構："甜菜與小路"設計工作室
設計師：凱‧肯特
攝影師：貝絲‧泰
委託客戶：琳奇‧安德魯
國家：加拿大

Whimsical wedding invitations for a Toronto couple Lynzie and Andrew, inspired by travel, vintage touches, and far away love.

本案是一對來自多倫多的新人琳奇和安德魯而設計的奇幻風格的婚禮平面作品。設計靈感來自"旅行"、"復古風"和"遙遠的愛"等。

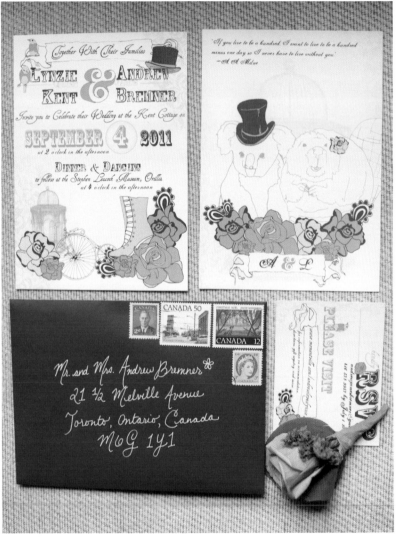

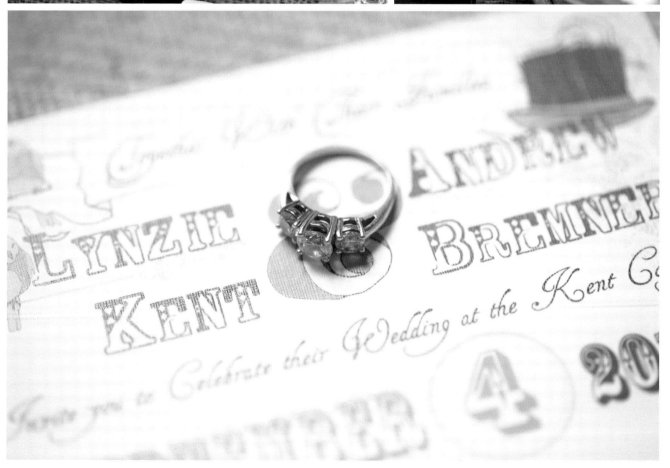

# NATSUKI & MATTHEW 夏樹與馬修婚禮平面設計

Design agency: Natsuki Otani Illustration
Designer: Natsuki Otani
Photographer: Nicola Norton
Client: Natsuki Otani
Country: UK

設計機構：大谷夏樹設計工作室
設計師：大谷夏樹
攝影師：尼古拉‧諾頓
委託客戶：大谷夏樹
國家：英國

Self-produced wedding project. Wedding stationery includes origami buttonholes, place name holders and place names. The names were designed in a fun font, and each was unique to the guest, using hand-drawn typography. The other design elements include dressing the venue and styling to an English country theme that combined warmth and intimacy with a light summer feeling. The theme continued with the choice of wild flowers in complimentary colour that continued into the catering and cake design. The gift bags were designed with hand-printed names and included branded handmade candles in the theme colours.

這是平面設計師大谷夏樹為自己的婚禮所做的設計，包括折紙手工品、座位名牌托和座位名牌。名牌上的文字採用一種趣味性的手寫字體，每位賓客各不相同。其他的設計內容還包括佈置婚禮現場。這場英式鄉村主題的婚禮顯得親切而溫暖，同時也帶點兒初夏的清新。這一婚禮主題也延續到花卉的選擇中，尤其是色彩的選擇，在婚宴酒席和蛋糕的設計中全都延續了相同的色調。小紙袋是贈送給賓客的禮品，上面的名字是手工印刷的，裡面是手工製作的蠟燭，也沿用主題色。

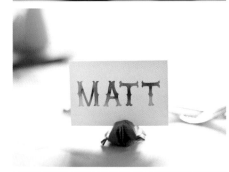
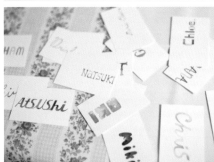

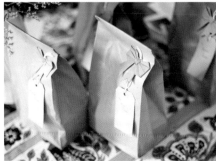

YOU ARE INVITED!

MATT & Natsuki's

Renewal of vows

A N D

Belated wedding PARTY

12.12.12 PM
SUNDAY
AT THE garden BARN
Little Bradley Suffolk CB9 7TG

# TEAL 鄉村婚禮平面設計

Designer: Dionysia Daskalaki
Photographer: Dionysia Daskalaki & Alexandra Argyri
Client: Konstantinos Chadios & Dionysia Daskalaki
Country: Greece

設計師：戴奧尼索斯・紮斯卡拉基
攝影師：戴奧尼索斯・紮斯卡拉基、亞歷山卓・阿基利
委託客戶：康斯坦丁諾斯・紮迪奧斯、戴奧尼索斯・紮斯卡拉基
國家：希臘

Teal is a custom-designed, hand-printed invitation suite created for a wedding that was held in the rural town of Messolonghi in western Greece. The design of the invitation as well as the other items such as favours and thank-you cards, complemented the wedding theme that emphasised the natural environment of the wedding venue; the cool and shady surroundings of the grove where the wedding chapel is located and the unique landscape of the Messolonghi lagoon where the wedding party was held. The still water surface, the traditional fishing boats, the characteristic wooden houses on the water and many more elements inspired by the iconography of the region were integrated in the design process and were depicted with silkscreen printing on natural materials such as recycled paper and cork. Bold, bright colours formed into triangular shapes complement the graphic composition giving the design a modern, summery twist.

這場婚禮的舉辦地是位於希臘西部的邁索隆吉翁小鎮的鄉村。這套量身訂製的請柬卡片由手工印刷製作完成。請柬以及其他卡片的設計（比如感謝卡，包括給賓客的禮物）都呼應了婚禮的場地和主題「回歸自然」。舉辦婚禮的小教堂外是一片小樹林，環境宜人。婚宴的場地位於邁索隆吉翁湖邊，景色優美。寧靜的水面、古老的漁船、水上小木屋等表現了當地特色的元素都納入到設計中，採用絲網印刷術印製在天然材料上，如再生紙和軟木塞等。大膽、明亮的色彩以三角形的形式出現，讓平面設計更加豐富，整套設計呈現出現代而又溫暖的感覺。

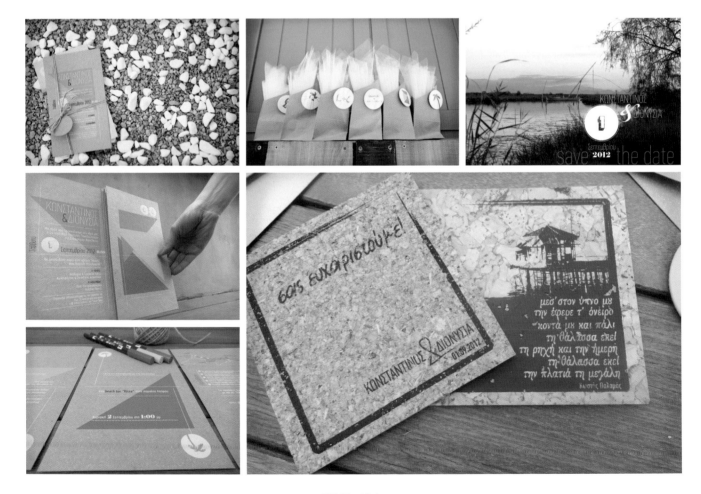

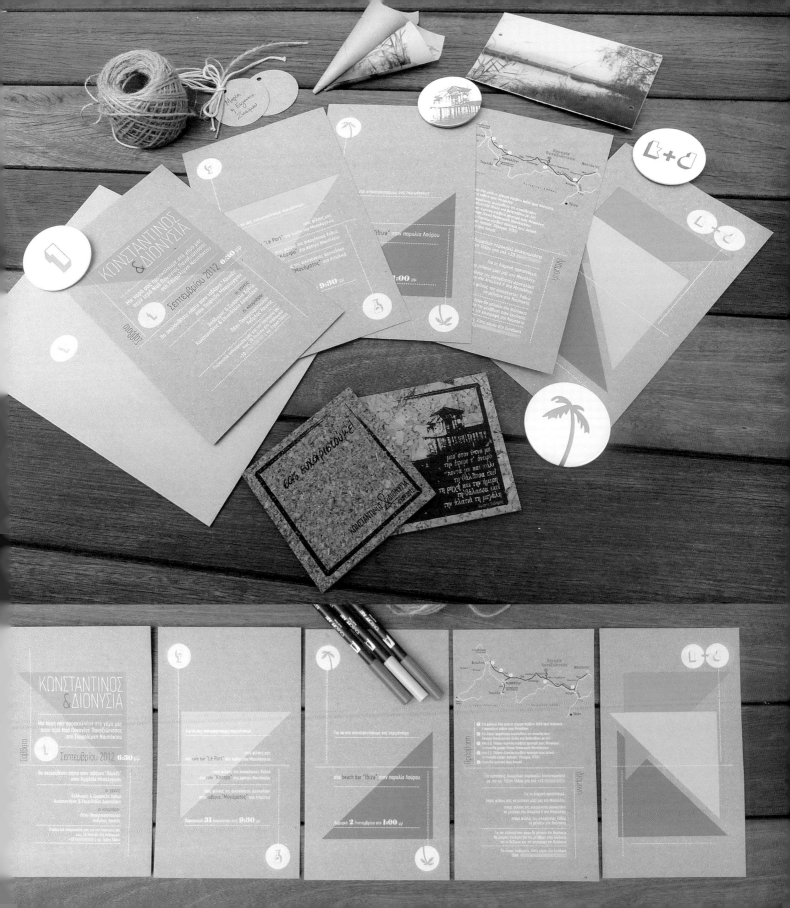

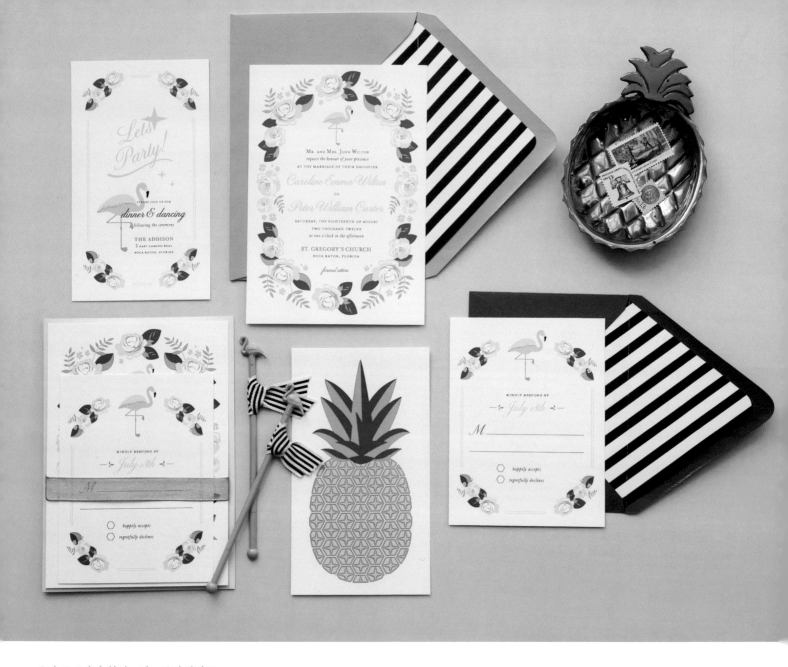

# CAROLINE & PETER 卡洛琳與彼得婚禮平面設計

Design agency: Papermade Design
Designer: Elaine Chou
Photographer: Erin J. Saldana Photography
Client: Caroline & Peter
Country: USA

設計機構："紙質設計"公司
設計師：伊萊恩‧周
攝影師：愛琳 J.薩爾達納攝影公司
委託客戶：卡洛琳、彼得
國家：美國

A charming wedding filled with pink blooms and flamingos! The artists illustrated a floral wreath with pink flamingos for this modern wedding. Bold pops of colours were incorporated through the dark green and peach envelopes with modern navy striped liners. A large pineapple added a statement to the back of the reception party card. With pink flamingo-stirs, this event was a recipe for fun.

這是一場以粉色花朵和火烈鳥為特色的浪漫婚禮。設計師利用粉色火烈鳥為設計元素，為這場現代的婚禮繪製了美麗的花環。信封配色大膽，採用墨綠色和桃紅色，內層採用海軍條紋，充滿現代感。婚宴卡片的背面設計了一個大鳳梨。在粉色火烈鳥的跳動中，這場婚禮趣味十足。

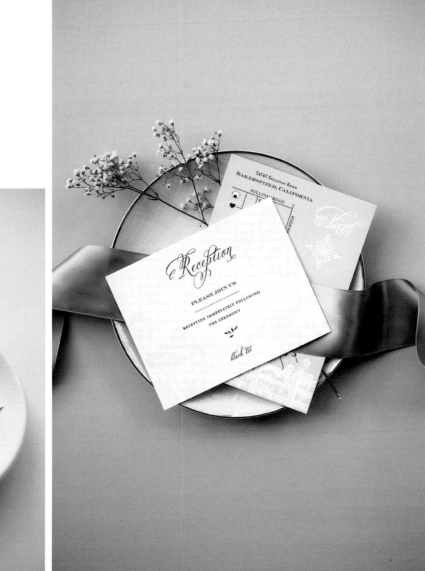

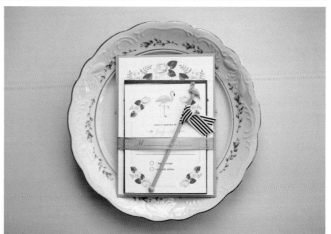

# KATE SPADE-INSPIRED WEDDING 凱特・絲蓓風格婚禮平面設計

Design agency: Llorente Design
Designer: Christine Llorente
Photographer: Chelsey Boatwright Photography
Client: Style Me Pretty
Country: USA

設計機構：洛倫特設計工作室
設計師：克裡斯汀・洛倫特
攝影師：切爾西・波特萊特攝影公司
委託客戶："拍出漂亮的我"工作室
國家：美國

Kate Spade has always been a major source of inspiration when the artist creates wedding invitations. This brand truly complements her style and everything she wishes to aspire too. This modern and bold paper suite features a save-the-date, invitation, RSVP, complete with lined envelopes.

著名時尚品牌凱特・絲蓓一直是這位設計師創作婚禮平面設計時的靈感之源。這個品牌非常符合她的設計風格，包含了她所喜愛的一切元素。這套現代、大膽的婚禮平面設計包括日期卡、請束和回覆卡等，並有帶內襯的信封。

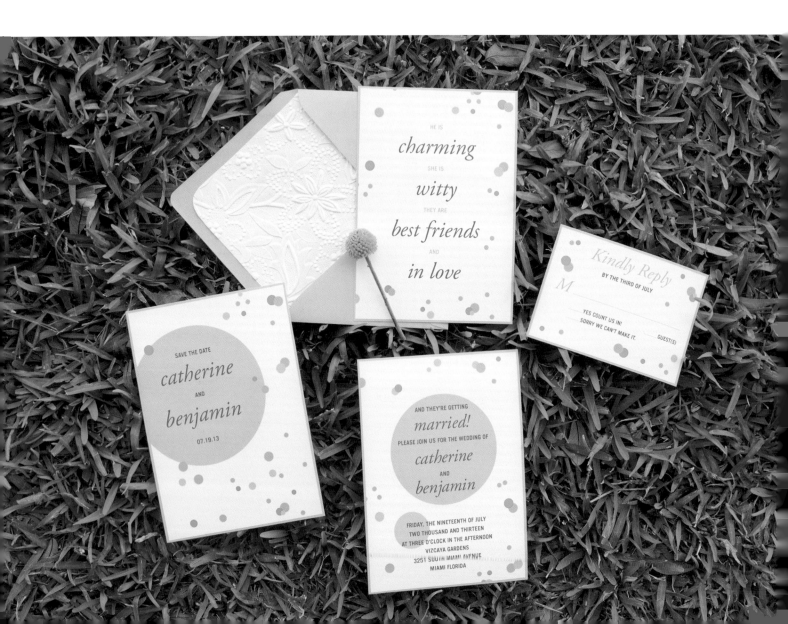

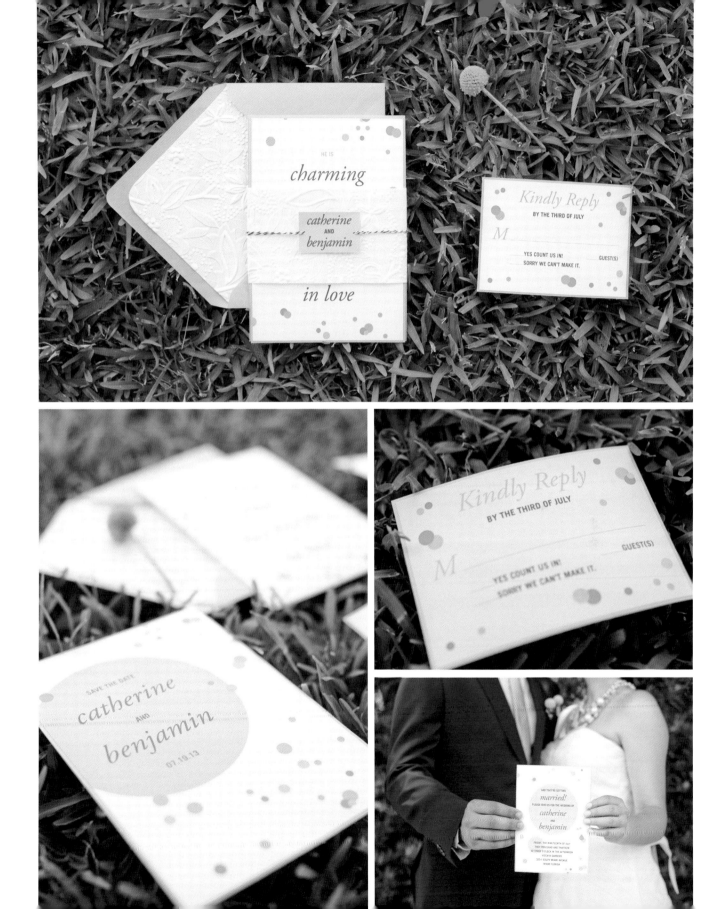

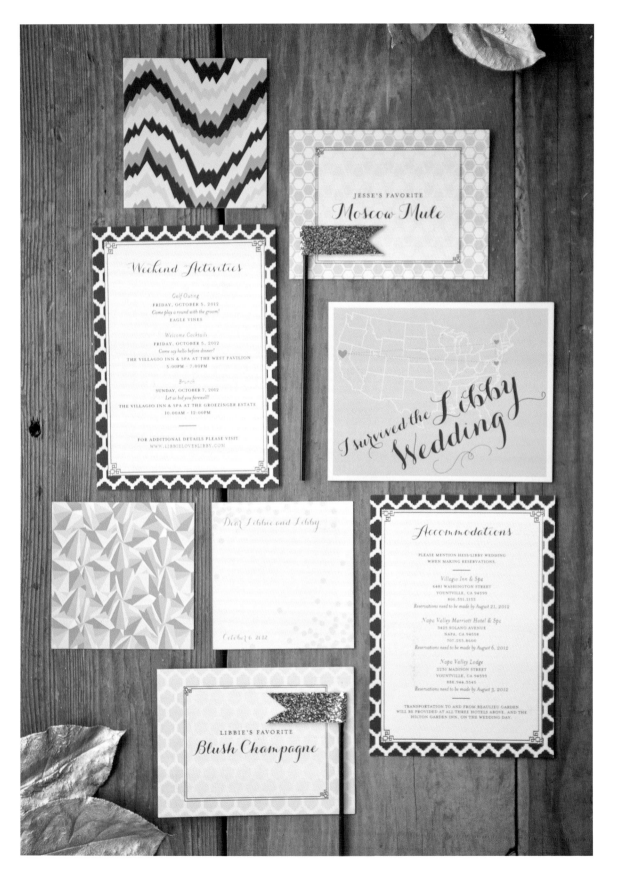

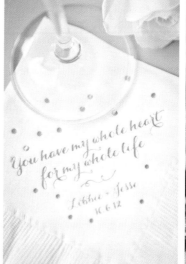

# LIBBIE & JESSE

## 莉比與傑西婚禮平面設計

Design agency: Good on Paper
Designer: Lisa Jackson
Photographer: Gary Ashley
Client: Libbie Hess & Jesse Libby
Country: USA

設計機構：＂紙上好設計＂工作室
設計師：麗莎·傑克遜
攝影師：加里·阿什利
委託客戶：莉比·赫斯、傑西·利比
國家：美國

This wedding invitation suite had gold foil letterpress printed pieces mixed with pretty paper and various patterns in classy black, gold, and blush colours. Every piece, from the save-the-date cards, the signature cocktail cards, to the giant wall of fame for guests, was personalised with custom details.

這套婚禮平面設計使用凸版印刷和燙金工藝，搭配復古風格的各種圖案，顏色有黑色、金色和粉紅。其中每一件的設計，從日期卡和雞尾酒卡片，到給賓客準備的巨型簽名牆，都是為這對新人量身打造的。

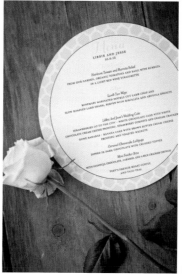

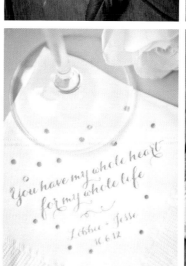
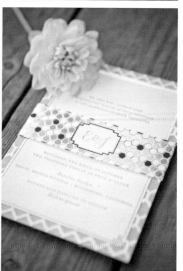

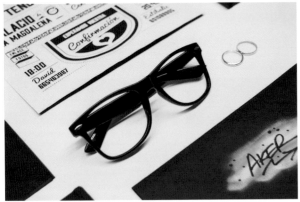

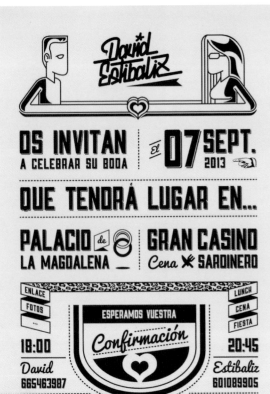

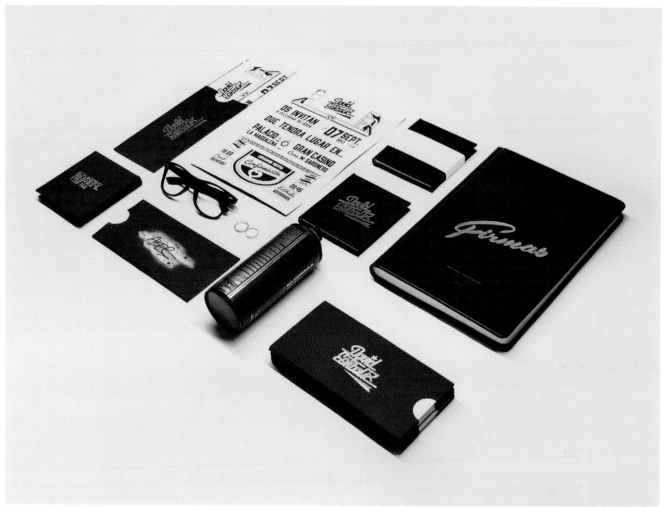

# D&E WEDDING

## D&E 婚禮平面設計

Design agency: mubien
Designer: David Mubien
Photographer: David Mubien
Client: David Mubien
Country: Spain

設計機構：穆必恩設計工作室
設計師：大衛・穆必恩
攝影師：大衛・穆必恩
委託客戶：大衛・穆必恩
國家：西班牙

Neon yellow, graffiti and design are the ingredients. An unusual handmade invitation wearing a gold hot stamping logo and customised with spray lines with the name of each guest. The detail is a notebook made with high-quality materials and a guest book with leather cover and dry etching and gold.

螢光黃和塗鴉藝術是這套設計的主要元素。這是一套不同尋常的婚禮平面設計，純手工製作，是西班牙設計師大衛・穆必恩為自己的婚禮而做的設計。金色的LOGO標識採用燙金工藝，而所有賓客的名字採用噴印完成。此外，還有一本筆記本，由高檔材料製作而成，以及皮革封面的賓客留言簿，採用干刻蝕技術和燙金工藝。

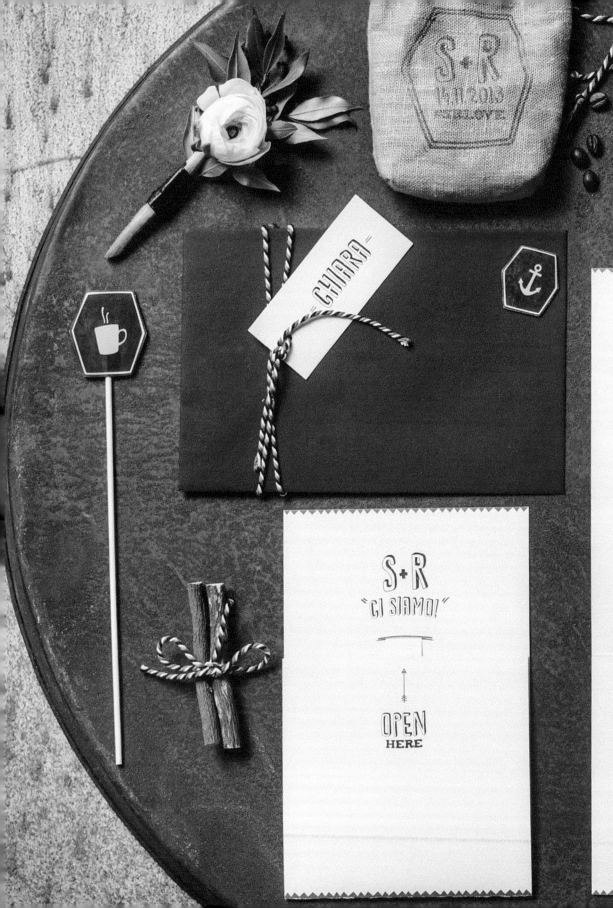

# WHOLE LOVE SUITE 同性之愛主題平面設計

Design agency: CUTandPASTE-lab
Team: SAY YEP
Photographer: giuli&giordi
Country: Italy

設計機構：剪貼設計工作室
設計團隊："同意吧！"設計工作室
攝影師：g&g 工作室
國家：義大利

For a winter same sex styled shoot was chosen a warm and hip atmosphere, with the aim of making people feel welcome and at ease. The stationery designed reflected this urban, fun and masculine vibe and was the trait d'union through all the details that came together in the shoot.

為一次冬季"同性之愛"主題攝影活動而做的平面設計。設計師選擇了時尚而溫暖的調子，目的是讓人感到舒適、自在。整套設計表現了都市風格和男性特徵，兼具趣味性，是將整套攝影中所有的細節串聯起來的紐帶。

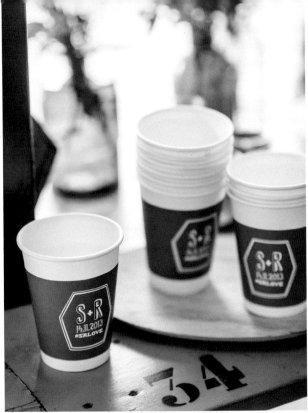

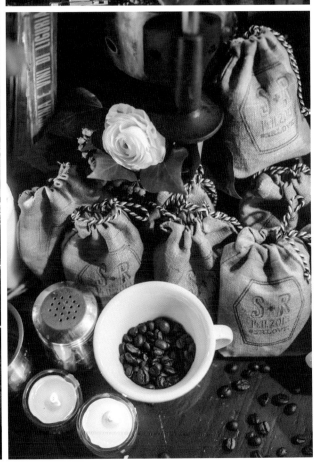

# LASER-ETCHED BRUSHED ALUMINIUM INVITATIONS 鐳射蝕刻磨砂鋁婚禮平面設計

Design agency: Gourmet Invitations
Designer: Tifany Wunschl
Photographer: Twah Dougherty at Style Art Life
Client: Erin Braun
Country: USA

設計機構："美味請柬"設計工作室
設計師：蒂芙尼·溫莎
攝影師：塔瓦·多爾蒂（藝術風格攝影公司）
委託客戶：愛琳·布勞恩
國家：美國

Brushed Aluminium acrylic invitations were laser-etched with the invitation wording. Digital printed White Linen inserts complemented the brushed aluminium. The invitations were mailed in a texture grey mailing box.

這套婚禮卡片採用壓克力磨砂鋁為材料，文字部分採用鐳射蝕刻技術，搭配白色亞麻布配飾，上面的文字採用數位列印。請柬裝在灰色的小盒子中寄出，極具質感。

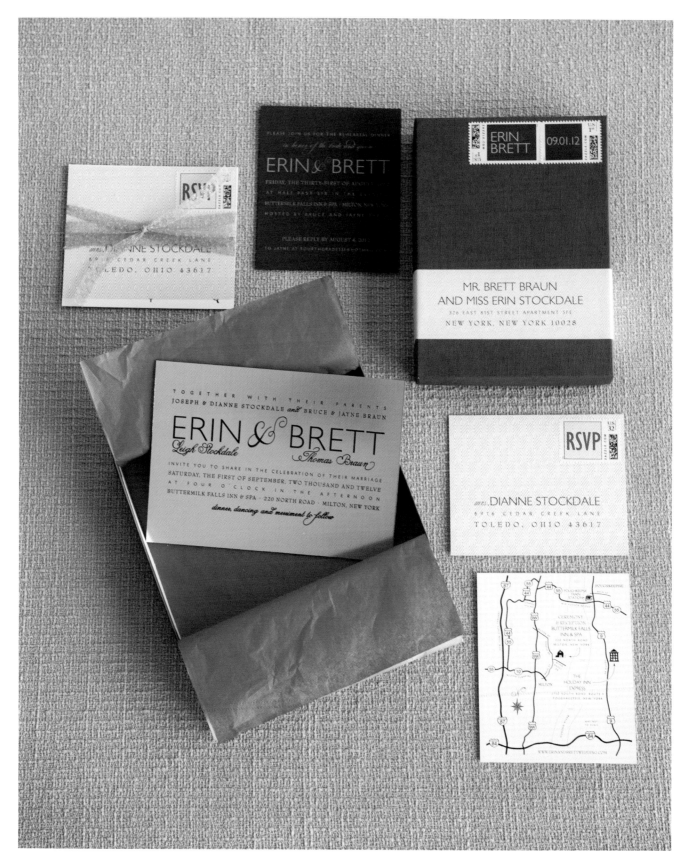

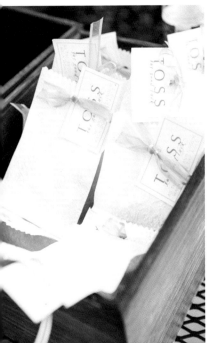

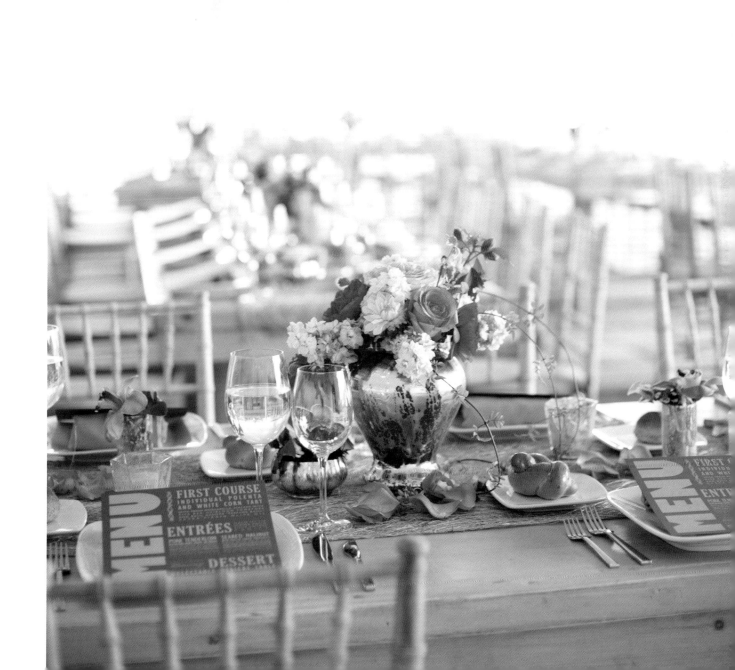

# POSTCARD SUITE

**明信片式婚禮平面設計**

Designer: Jono Garrett
Photographer: Jono Garrett
Client: Jono Garrett
Country: Germany

設計師：約諾‧加勒特
攝影師：約諾‧加勒特
委託客戶：約諾‧加勒特
國家：德國

Since the artist and his wife met, whenever either one of them was away from home they sent a postcard. About two years ago they left South Africa and moved to Germany, leaving their friends and families behind. They wanted their invitations to reflect something really honest about them, but also make the people receiving them feel important. They thought sending a pack of postcards documenting a timeline of their relationship (from songs they love to places they've travelled) to be the best solution. There was also the hope that, if they made them cool enough, they might end up framed as opposed to being stuck on the fridge.

這位設計師自從與妻子相識以來，不管是誰離家遠行，都會互相寄明信片。兩年前他們離開南非，遷居德國，遠離了親朋摯愛。他們希望他們的婚禮請柬能夠反映出他們這些情況，同時也要讓收到請柬的親朋好友感到有意義。他們決定用寄送一套明信片的方式來發放請柬，其中記錄了他們建立親密關係的發展歷程（從他們喜歡的歌曲到兩人旅行過的地方）。他們希望能夠用獨特而出色的設計讓這套卡片值得收藏，可以裝上相框永遠保存，而不是隨手放到冰箱上。

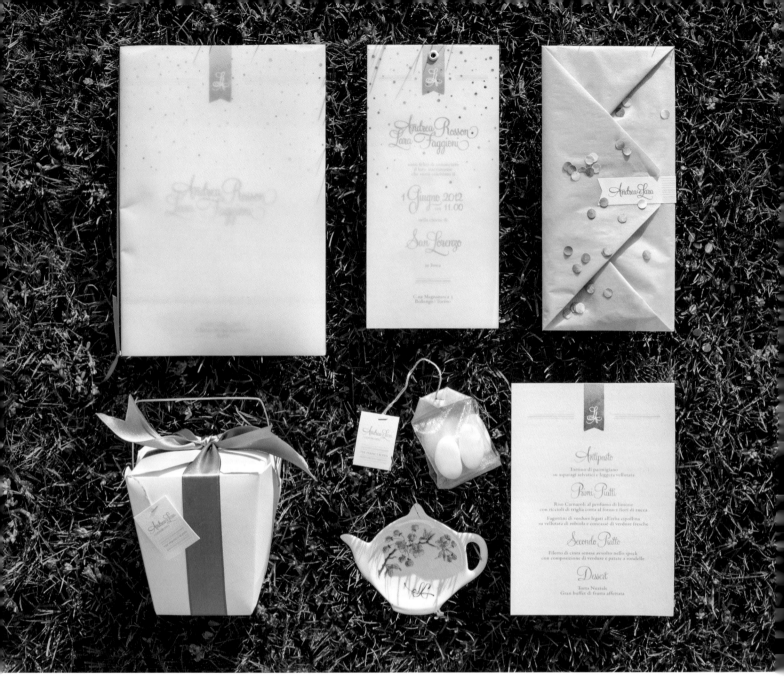

# JAPAN IN WATERCOLOUR SUITE 日式風情水彩婚禮平面設計

Design agency: CUTandPASTE-lab　　設計機構：剪貼設計工作室
Photographer: giuli&giordi　　攝影師：g&g 工作室
Client: Lara & Andrea　　委託客戶：拉臘、安德里亞
Country: Italy　　國家：義大利

By combining love for tea, flowers and all things Japanese, the suite created has became a perfect mix of vintage chic and fun with modern touches. The colour palette shifted from light peach to green and lavender and a watercolour treatment gave the right freshness to the stationery set.

這套設計結合了茶道、插花等各種日式元素，實現了復古與現代、趣味與時尚的完美結合。色彩從淡淡的桃紅色逐漸轉變為綠色和淡紫色。水彩的處理手法讓整套設計更加清新自然。

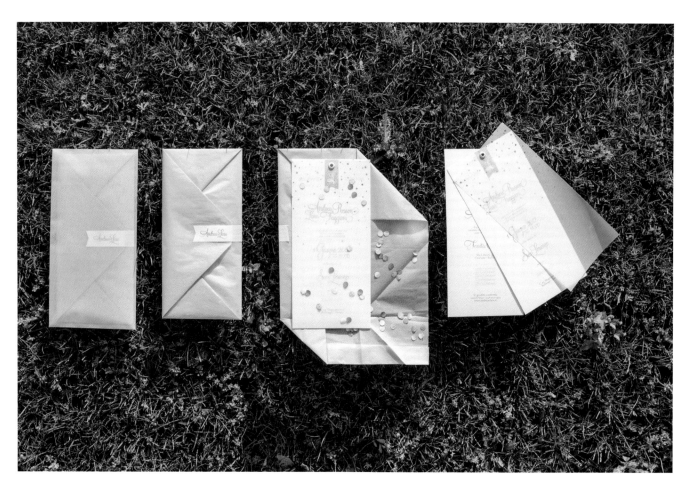

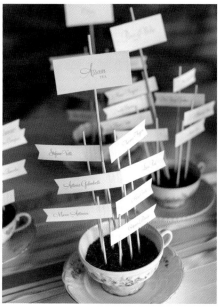
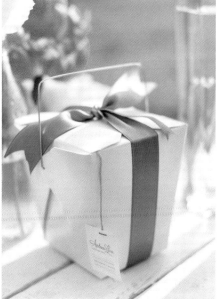
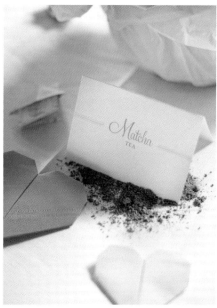

# GEOMETRIC SUITE 幾何婚禮平面設計

Design agency: October Ink
Designer: Jayne Swallow
Photographer: Ceebee Photography
Client: Flower Afternoon
Country: USA

設計機構："十月墨"設計工作室
設計師：傑恩·斯沃洛
攝影師：西碧攝影公司
委託客戶："午後鮮花"工作室
國家：美國

This invitation came to be through an inspiration shoot curated by Flower Afternoon. The designers wanted the spring event to be unique highlighting geometric shapes and neon punches of colour. They achieved that in their invitation suite by including a geometric motif in the monogram, die cut, and pattern.

這套請柬套卡是為"午後鮮花"工作室策劃的一次春季攝影活動而設計的。設計師採用了獨特的幾何結構和醒目的霓虹色。交織字母組合圖案、卡片的裁切以及圖案等的設計中都延續了幾何的主題。

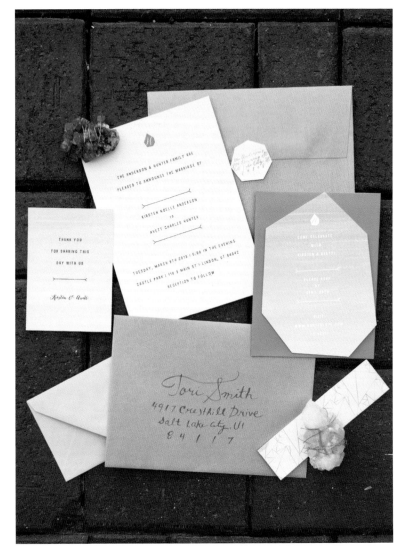

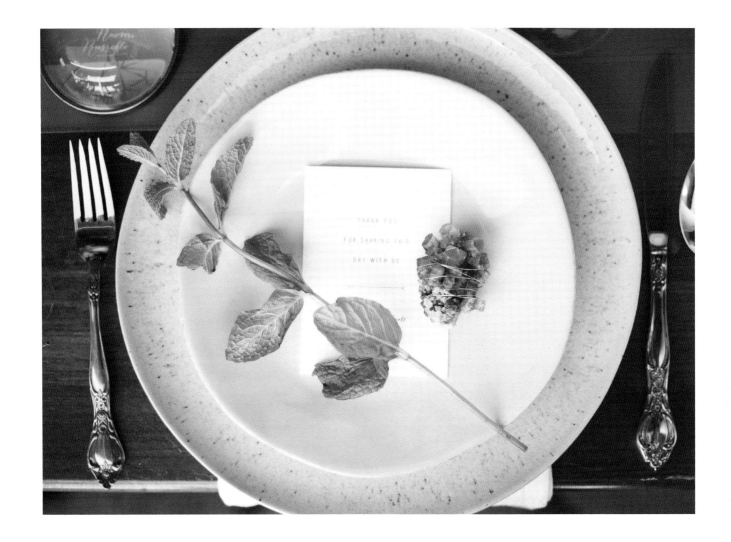

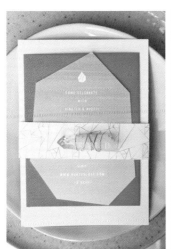

# ALEX & ALICIA 亞曆克斯與艾麗西婭婚禮平面設計

Design agency: August Studios
Designer: Joel Derksen
Photographer: Joel Derksen
Client: Alex & Alicia
Country: Canada

設計機構：八月設計工作室
設計師：喬爾·德克森
攝影師：喬爾·德克森
委託客戶：亞曆克斯、艾麗西婭
國家：加拿大

Alex and Alicia wanted their wedding invite to feel authentic to who they are. August Studios began with symbolic imagery that characterised their years together. The artists developed graphics inspired by vintage concert posters, tracing a path from where they met to their wedding. Recipients also get a card of cut-outs, featuring the couple and their daily props.

亞曆克斯和艾麗西婭想讓他們的婚禮請柬表現出他們的特點。設計師從一系列象徵符號著手，這些符號象徵了他們在一起的幾年中的點點滴滴。這套平面設計的靈感來自復古風格的音樂會宣傳海報，記錄了兩人從相識到結合的歷程。賓客還會收到一張立體挖空卡，上面有新婚夫婦的卡通形象。

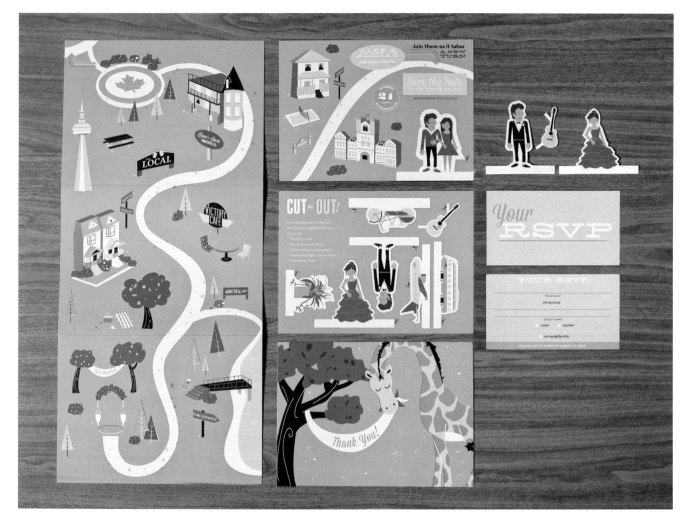

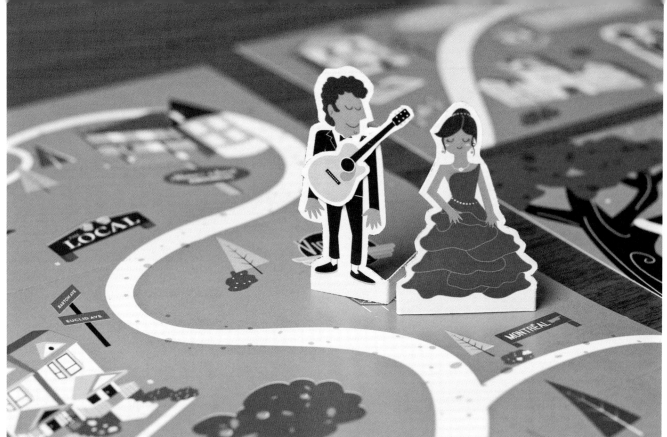

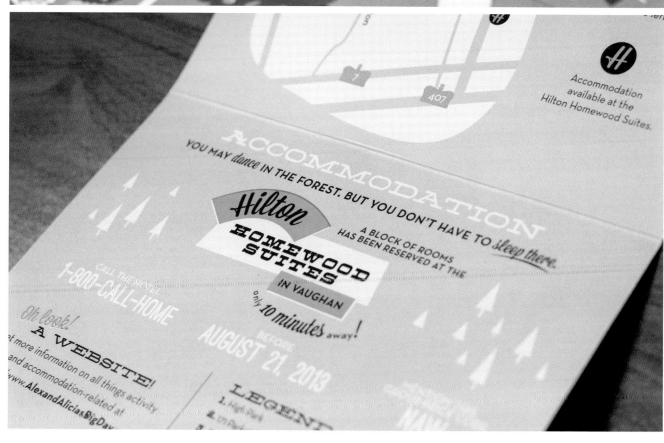

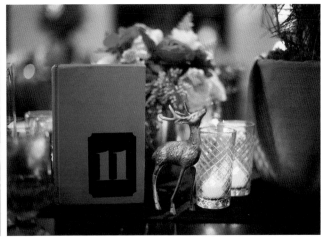

# JAIME & MELINDA

### 傑米與梅琳達婚禮平面設計

Design agency: Bash, Please
Designer: Paige Appel,
Kelly Harris & Melinda Davila
Illustration: Melinda Davila
Photographer: The Weaver House
Client: Jaime & Melinda Davila
Country: USA

設計機構：＂請重擊＂設計工作室
設計師：佩奇‧阿佩爾、凱利‧哈裡斯
‧梅琳達‧達維拉
插畫設計：梅琳達‧達維拉
攝影師：＂紡織屋＂工作室
委託客戶：傑米‧達維拉、梅琳達‧達維拉
國家：美國

Jaime and Melinda collaborated with Paige and Kelly of Bash, Please to plan and design their wedding at Vibiana in Los Angeles, California on March 9, 2013. Combining distinct graphic design, personal hand illustration, and a carefully selected palette, they aimed to give the day an elegant yet whimsical visual style and express their identity as a couple.

新人傑米和梅琳達與＂請重擊＂設計工作室的兩位設計師佩奇和凱利合作，共同籌畫並設計了他們在 2013 年 3 月 9 日於加州洛杉磯維比安納大教堂所舉行的婚禮。透過獨特的平面設計、個性化的手繪插畫和精心搭配的色彩，這對新人希望讓婚禮呈現出典雅大方而又新穎奇異的視覺效果，凸顯兩人是一對夫婦的身份。

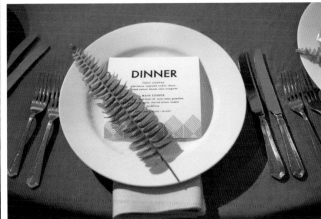

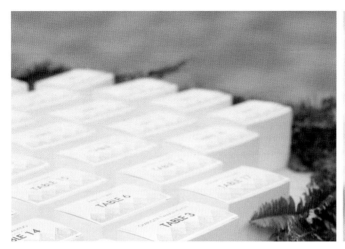

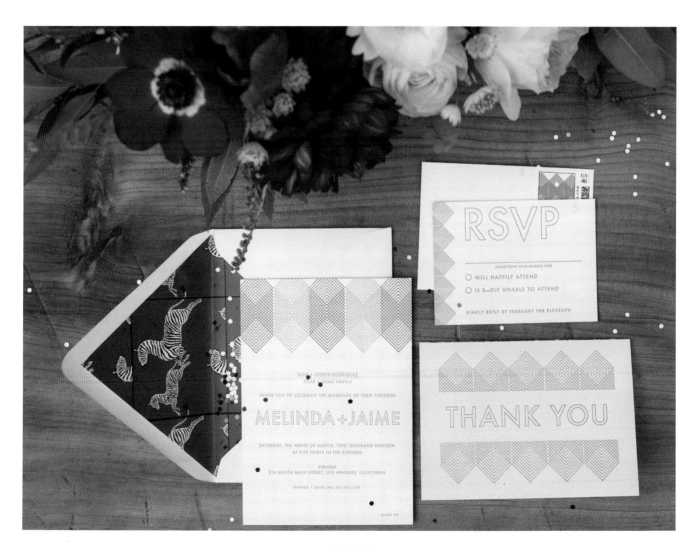

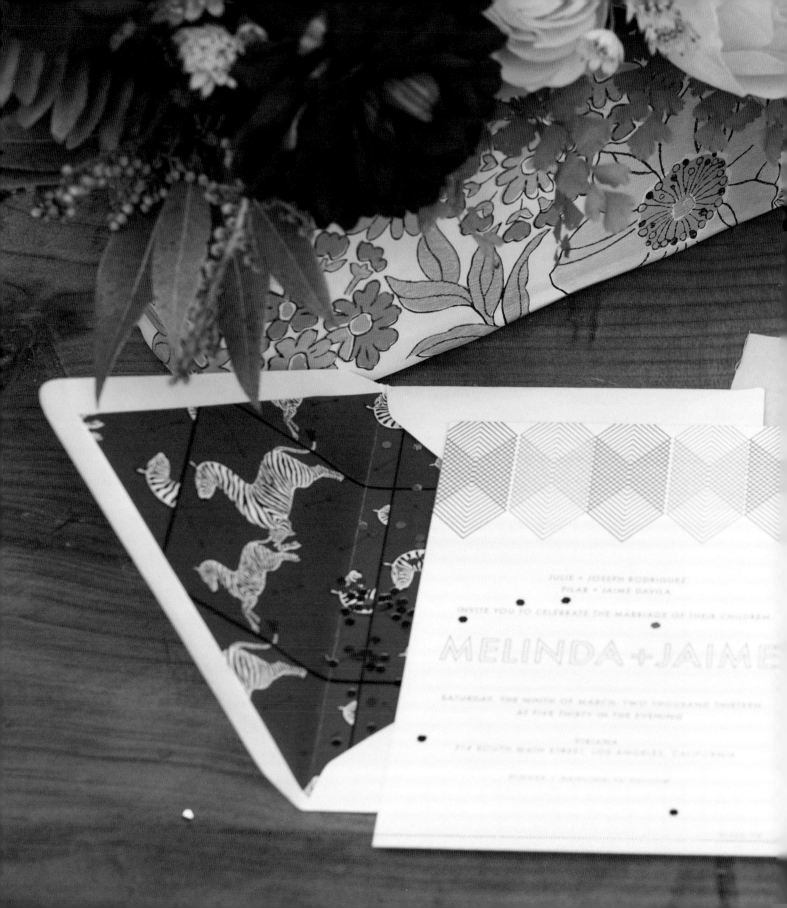

# LETTERPRESSED WEDDING INVITATIONS 凸版印刷婚禮平面設計

Designer: michele wong kung fong
Country: USA

設計師：蜜雪兒‧王
國家：美國

This letterpressed wedding invitation visually blends the couple's Eastern descent and upbringing with their Westernised lifestyle. The visual quality and structural proportions of the couple's Chinese last name 王 (Wang and Wong) informed the design of this wedding invitation. While Wang is the Pinyin romanisation of the Chinese surname, Wong is the Cantonese romanisation of that same Chinese character. A customized typeface was initially created based on the Chinese character and later applied to create a typographic pattern (used on the coaster) that captured the sought-after Eastern-Western essence. This pattern inspired a series of patterns that could be applied to other parts of the invitation design system. The pattern on the RSVP card hinted at checkboxes while the 'words of wisdom' coaster played off of the graphic representation of 'hugs and kisses' and the invitation and direction cards used and/or deconstructed the Chinese character itself. The invitation, direction, RSVP, and thank-you cards were letterpressed using metallic grey ink on #110 uncoated Lettra paper and the coasters were letterpressed on #220 uncoated Lettra paper.

這套凸版印刷的婚禮卡片從視覺上融合了這對新人東方血統和西方化的生活方式。因為兩位新人都姓王，所以設計借鑒了"王"字的視覺形象和筆劃比例。設計師以此漢字為基礎創造了一種字體，並以此字體設計了一種印刷圖案（應用在杯墊上），呈現出中西合璧的精髓。從這一圖案衍生出一系列的圖案，應用在這套設計的其他部分。回覆卡上的圖案類似複選框，印有"智慧箴言"的杯墊則用平面元素表現了擁抱和親吻，而請柬和路線卡都利用並解構了"王"字。請柬、路線卡、回覆卡和感謝卡都用凸版印刷，採用銀灰色油墨，紙張使用110號Lettra 非塗布紙。杯墊也是凸版印刷，採用220號Lettra 非塗布紙。

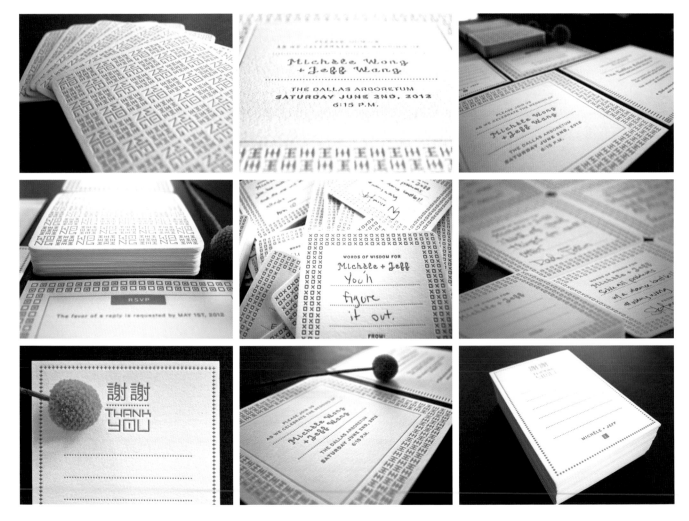

WORDS OF WISDOM FOR
*Michèle + Jeff*

_____
_____
_____

FROM:

謝謝
THANK YOU

_____
_____
_____
_____

MICHÈLE + JEFF

RSVP

The favor of a reply is requested by MAY 1ST, 2012

☐ ACCEPT(S) WITH PLEASURE
☐ DECLINE(S) WITH REGRETS

PLEASE JOIN US
AS WE CELEBRATE THE WEDDING OF

*Michèle Wong
+ Jeff Wang*

THE DALLAS ARBORETUM
SATURDAY JUNE 2ND, 2012
6:15 P.M.

THE CEREMONY AND RECEPTION
WILL BE HELD AT

*The Dallas Arboretum*
8525 GARLAND ROAD, DALLAS, TX

The ceremony will take place in
THE JONSSON COLOR GARDEN

The reception will immediately follow
IN ROSINE HALL

+ Find out more about the wedding at +
www.wangwongwedding.com

# MODERN FAIRYTALE SUITE 現代童話婚禮平面設計

Design agency: CUTandPASTE-lab
Photographer: Les Amis Photo
Client: Chiara & Danilo
Country: Italy

設計機構：剪貼設計工作室
攝影師：朋友攝影工作室
委託客戶：齊亞拉、達尼洛
國家：義大利

The project's style was inspired by the medieval location desired for the great event and so, for this wedding, it could not have chosen a more regal colour than red combined with black and grey. Invitation gave the start to the creativity becoming a sort of small book with capital letters and a modern and clean castle icon.

這場婚禮計畫在中世紀風格的老式環境中舉行，這就決定了平面設計的風格。沒有比紅色更能表現這種隆重、奢華的顏色了，搭配黑色和灰色，莊重典雅。請柬的設計給其他部分帶來靈感，由此衍生出一整套設計，匯成一本小冊子。信封上是大寫字母和現代而簡潔的城堡形象。

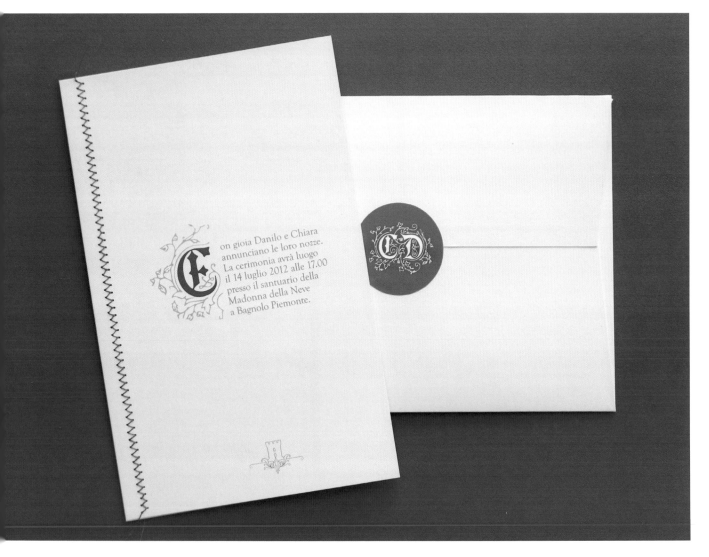

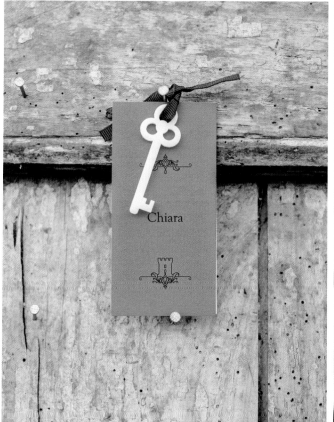

# WEDDING TABLE GIFTS 婚禮禮品平面設計

Designer: Jono Garrett, Shaun Botes, Simone Rossum,
Paul Hinch, Dustin Slabber, Dietrich Mengel, Jessica Webster,
Nikki Taylor, Heiko Gunter & Olja Ilyushchanka
Photographer: Jono Garrett
Country: Germany

設計師：約諾‧加勒特、肖恩‧包提斯、西蒙‧羅蘇姆、保羅‧欣奇、
達斯汀‧斯萊波爾、迪特裡希、門格爾、潔西嘉、韋伯斯特、
尼基‧泰勒、海科‧甘特、奧利婭‧伊利斯坎卡
攝影師：約諾‧加勒特
國家：德國

The new couple asked a few of their really talented friends and family to illustrate something that would be glazed onto plates and used as table gifts for their wedding. The plates were handmade for them, and a limited run of seven of each design was produced. Among them are illustrations by illustrators, designers, fine artists and one by the groom's father-in-law, a retired architect.

這對新人邀請了多位擁有藝術才華的親朋好友來為他們繪製一些插畫，然後印製在盤子上，作為婚禮上送給賓客的禮物。盤子是純手工製作完成，每款設計只限量製作 7 個。這些插畫的創作者有插畫師、設計師和藝術家，其中一幅是由設計師（新郎）退休的建築師岳父創作的。

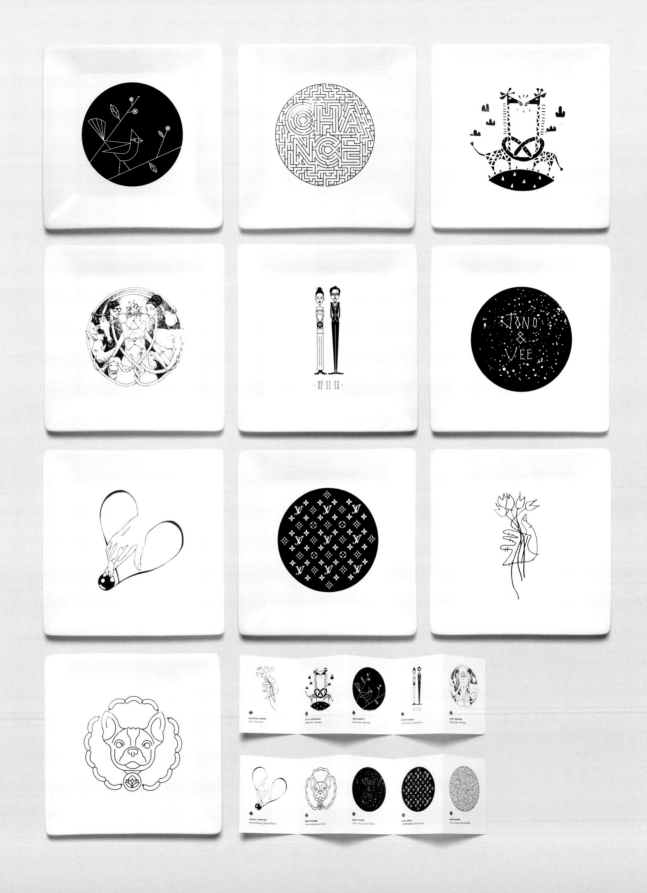

# MARILISA & FRANCESCO

**瑪芮麗莎與法蘭西斯科婚禮平面設計**

Design agency: Graficheria
Designer: Stefania Servidio & Alessandro Ingrosso
Client: Marilisa & Francesco
Country: Italy

設計機構：格拉菲什利亞設計工作室
設計師：斯特凡尼婭、塞維迪奧、亞歷山大·因羅梭
委託客戶：瑪芮麗莎、法蘭西斯科
國家：義大利

Marilisa and Francesco, friends of the designers, asked them to design their wedding invitations and the full identity of the event. The artists chose a sweet and minimalist design customising two icons on the typical food of the city where the new couple were born: Bari and Terni. They designed invitations, website, pins and the tableau marriage.

這對新人是設計師的朋友，設計內容包括婚禮套卡的設計以及整場婚禮的視覺形象設計。設計師選擇了甜美清新的極簡主義風格，用兩位新人的出生地「巴里和特爾尼」最著名的食物創造了兩個卡通形象。這套設計包括婚禮請柬、網站、日曆以及各種小物件。

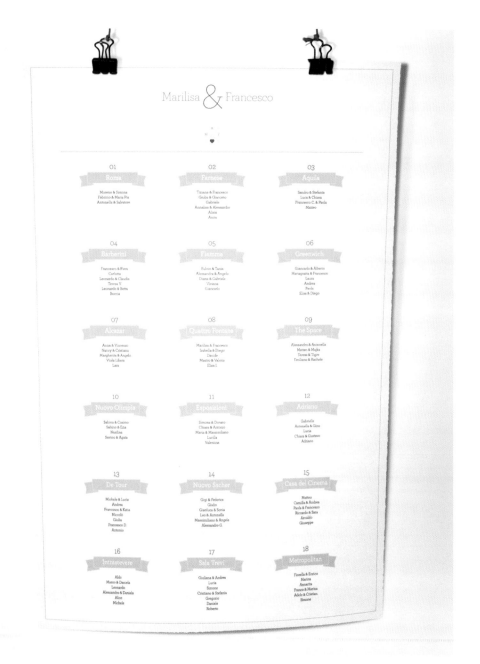

Marilisa & Francesco

*sono felici di invitarti al loro matrimonio
e di festeggiare insieme a te, a partire dalle ore 20.00, da Eataly*

*Air Terminal Ostiense · Piazzale XII Ottobre 1492, Roma*

RSVP

Gennaio · 2013

| L | M | M | G | V | S | D |
|---|---|---|---|---|---|---|
|   | 1 | 2 | 3 | 4 | **5** | 6 |
| 7 | 8 | 9 | 10 | 11 | 12 | 13 |
| 14 | 15 | 16 | 17 | 18 | 19 | 20 |
| 21 | 22 | 23 | 24 | 25 | 26 | 27 |
| 28 | 29 | 30 | 31 |   |   |   |

ORE **18.00**

del PIAZZA
CAMPIDOGLIO

SALA ROSSA

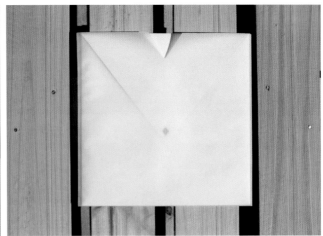

# MILA & BERNARDO

## 米拉與伯納多婚禮平面設計

Designer: Pedro Paulino
Client: Mila & Bernardo
Country: Brazil

設計師：佩德羅‧保利諾
委託客戶：米拉、伯納多
國家：巴西

Mila and Bernardo are good old friends. They came to the artist with the idea of doing different wedding invitation, fleeing the traditional super models they see around. The colours permeate between light tones, reflecting the decorative palette of the beautiful spot where the ceremony took place, a former farmhouse with large and green garden illuminated by the blue sky. Pieces were worked out highlighting the most important information. The triangular shapes, like diamond and the bottom flap of the envelope, symbolised the stoning of this union, taking into consideration a great friendship and complicity between them. Like they say in Brazil: O amor é lindo! (Love is beautiful!)

米拉和伯納多是老朋友了。他們找到設計師佩德羅，想要設計一款不一樣的婚禮請柬，要有一種巴西傳統超級名模的感覺。整套設計色彩淡雅，呼應了婚禮舉辦場地的裝飾色調。這場婚禮的舉辦地原來是個農舍，藍天白雲、綠樹環繞、環境宜人。整套卡片呈現出統一的風格，涵蓋了婚禮的重要資訊。信封三角形的造型象徵了兩人的結合牢不可破，也表現了兩人深厚的友誼。正如巴西的那句名言所說：「愛情是美麗的！」建立在友誼之上的愛情更顯動人！

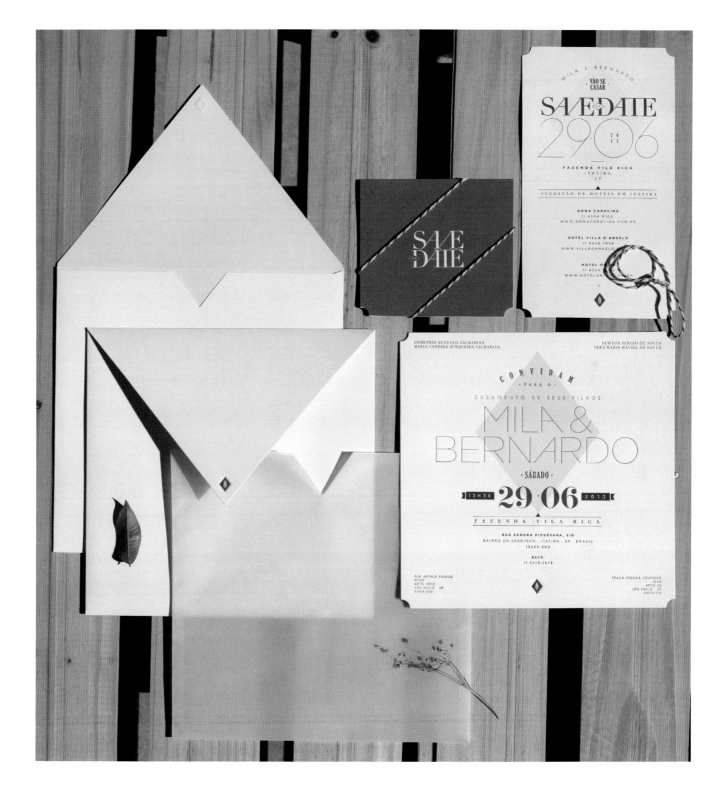

# LUCK, LOVE & SUCCESS

## "幸運、愛情與成功" 婚禮平面設計

Design agency: K.GREBE
Designer: Karoline Grebe
Photographer: Karoline Grebe
Client: Benedikt Stehle & Meltem Kilic Stehle
Country: Germany

設計機構：格雷貝設計工作室
設計師：卡羅利尼．格雷貝
攝影師：卡羅利尼．格雷貝
委託客戶：貝內迪克特．史泰來、梅爾泰姆．克勒齊．史泰來
國家：德國

Luck (star), love (heart) and success (diamond); three wishes for the couple, which can be found throughout the whole paper items and especially in the wedding monogram. The invitation is a zig-zag-fold. First you see a picture of the couple, then the invitation text. The information unfolds step by step in two languages: German and Turkish. The cans are filled with prosecco and gave to the guests as a gift, a wonderful reminiscence of this beautiful day.

幸運（星星）、愛情（心）與成功（鑽石）是對這對新人的三個祝願，貫穿了整套設計，尤其是在兩人名字首字母組成的圖案中。請柬是一張多層折疊卡，首先會看到新人的照片，然後是請柬正文。隨著卡片展開，更多資訊逐漸以兩種語言呈現：德語和土耳其語。易開罐裡裝的是全球知名的義大利普洛塞克葡萄酒，是送給賓客的禮物，美酒的芳香會讓這美麗的一天更加難忘。

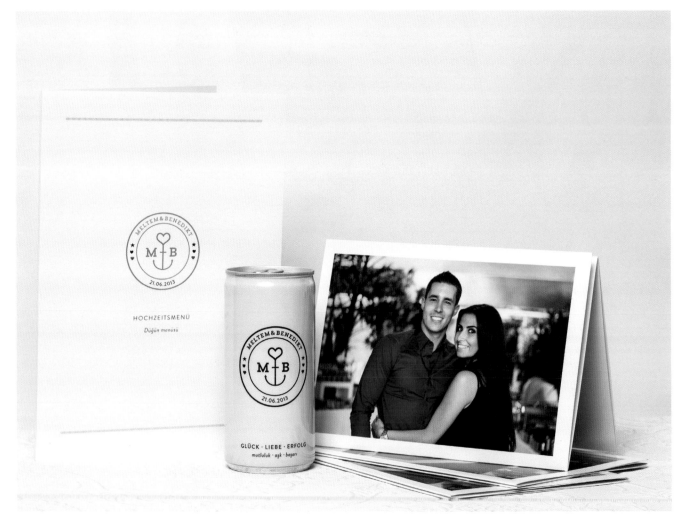

SAVE THE DATE FOR THE WEDDING OF

*Düğün için bu tarihi kaydedin*

# MELTEM KILIC
## &
# BENEDIKT STEHLE

FREITAG / 21. JUNI 2013 / IN MÜNCHEN

*Cuma / 21. Haziran 2013 / Münih*

★ ♥ ◇

GLÜCK · LIEBE · ERFOLG

*mutluluk · aşk · başarı*

GLÜCK · LIEBE · ERFOLG

*mutluluk · ask · basarı*

### HOCHZEITSPARTY MIT DJ2A
### IM BOTANIKUM MÜNCHEN, THEATERHAUS
### 18.30 UHR

FELDMOCHINGER STRASSE 75, 80993 MÜNCHEN

*Aus Erfahrungen von anderen großen Partys wissen wir, dass die Kinder der Gäste eine quirlige Bereicherung sind, aber auch mit zunehmender Dauer immer mehr Aufmerksamkeit verlangen. Wir möchten Euch bei unserer Hochzeit – richtig egoistisch – ganz für uns haben und bitten Euch daher, Eure Kids ausnahmsweise zu Hause zu lassen.*

*Büyük partilerin deneyimlerinden biliyoruz ki, davetlilerin cocuklari artan süreyle giderek fazla ilgi istiyorlar. Biz- tam bir bencillik yaparak- sizleri tamamen bizim için istiyoruz ve bu sebepten dolayı sizlerden cocuklarınızı evde bırakmanızı rica ediyoruz.*

Design: Karoline Grebe, www.karoline-grebe.com, design@karoline-grebe.com

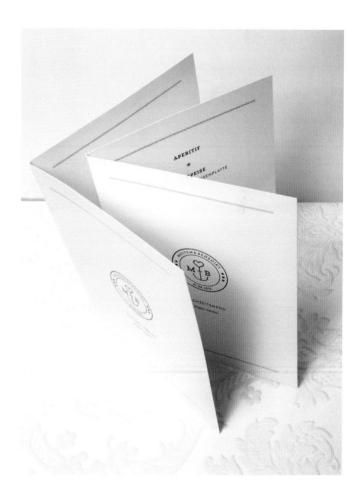

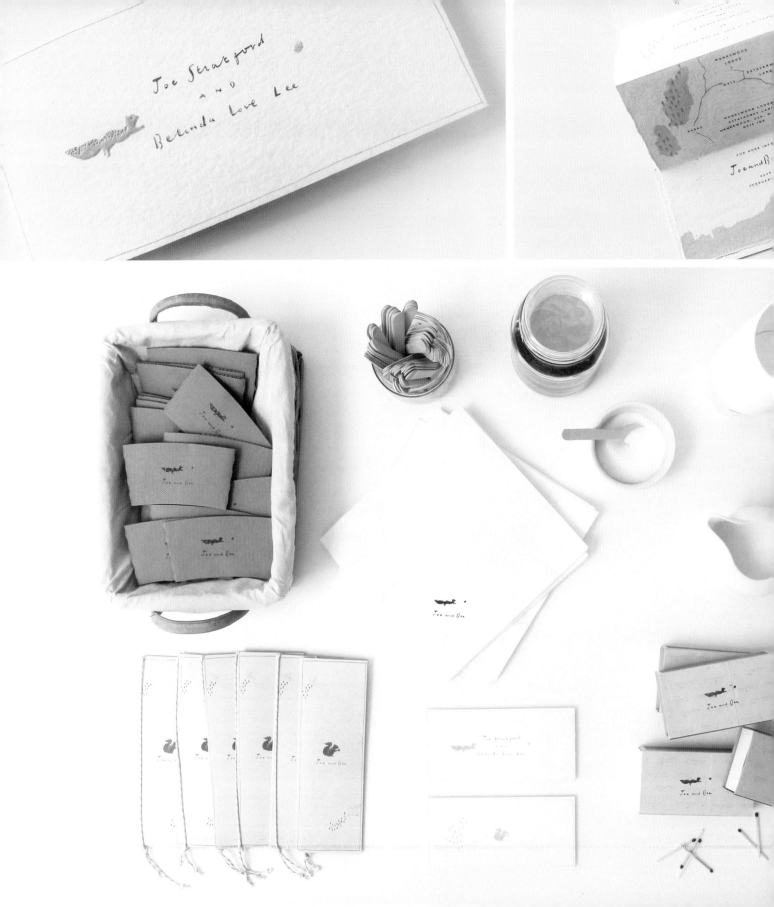

# JOE & BEE
## 喬與比婚禮平面設計

..............................................

Design agency: Belinda Love Lee
Photographer: Belinda Love Lee
Client: Joe Stratford & Belinda Love Lee
Country: UK

設計機構：比琳達設計工作室
攝影師：比琳達設計工作室
委託客戶：喬，斯特拉特福德、比琳達設計工作室
國家：英國

This wedding suite was designed for the artist and her husband.
They wanted it to represent them without being overly floral/girly/
wedding-y. Thus the simplistic, minimal, illustrative qualities came
most true to them. They also aimed to keep it multi-functional: the
invites were designed with a rip-off reminder, and the programmes
with a napkin to dry the eyes and confetti to celebrate! The invitations
are printed on embossed 320 gsm textured cotton paper, with the
inside fold printed on eco-friendly recycled texture paper. The
programmes are printed on a variety of 130 gsm coloured paper.
Calligraphy and illustrations are done by hand.

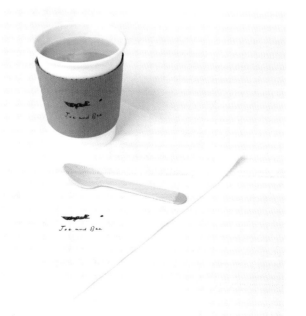

這套平面設計是設計師為自己和丈夫量身訂製的。他們希望用設計
來表現出真實的自己，而不要過於花俏、過於少女情懷、過於像婚
禮平面設計。因此，他們選擇了極簡主義的風格。另外，兩人還希
望這套設計能夠具有多種功能，比如：請束上有防盜提示，流程卡
附有紙巾（拭去感動的淚水）和五彩紙花（歡慶新人的結合）。請
束卡片採用有凹凸效果 320 磅的織紋棉紙，折疊內層採用環保的再
生織紋紙。流程卡採用各種類型 130 磅的彩色紙張。文字和插畫全
部手繪完成。

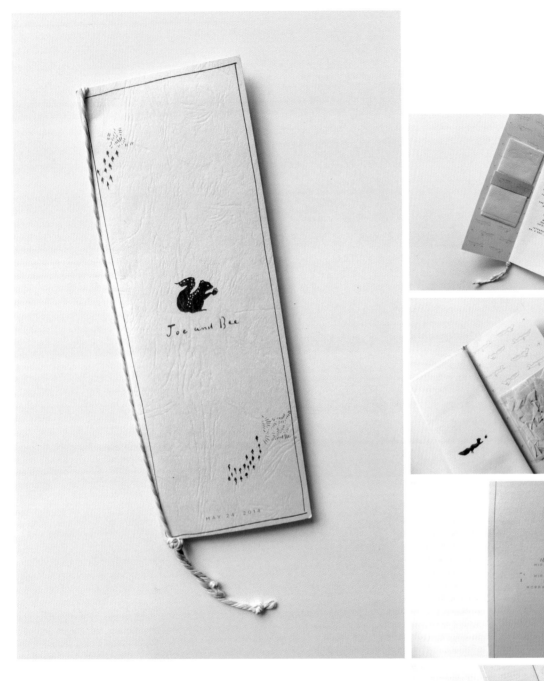

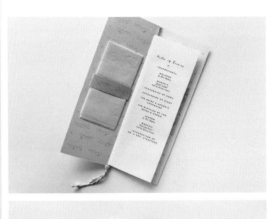

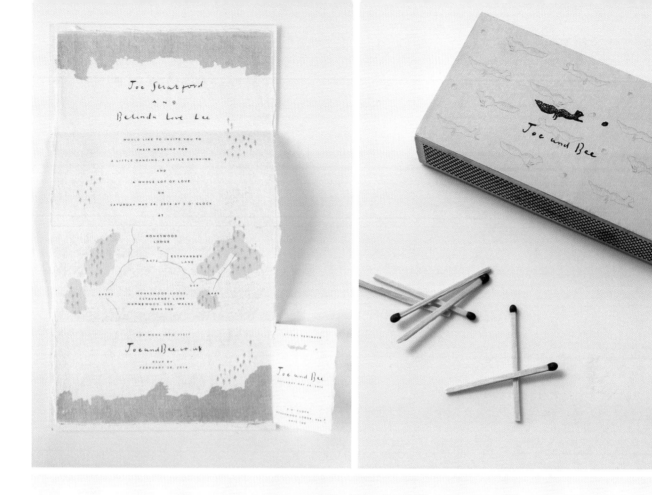

JoeandBee.co.uk

# ILENIA & MARCO 伊萊尼婭與瑪律科婚禮平面設計

Design agency: Mara Colombo
Photographer: Mara Colombo
Client: Ilenia Carcano
Country: Italy

設計機構：瑪拉．可倫坡設計工作室
攝影師：瑪拉．可倫坡設計工作室
委託客戶：伊萊尼婭．卡卡諾
國家：義大利

Ilenia and Marco are a wonderful and witty couple. For their wedding invitation cards, they love to bring a smile to their guests with an illustration that shows them wearing ceremony dresses. The illustration had been used for the main invitation card and for the T-shirt and badges as a gift to give to the guests at the party. The bride and groom wanted to keep something of the traditional Italian invitation cards, thus the designers printed all the invitations and the cover of Mass booklet, on a 100% cotton paper in letterpress using a neutral colour.

伊萊尼婭和瑪律科是一對幽默詼諧的夫婦，他們希望婚禮請柬套卡能展現出兩人身著婚紗和禮服的卡通形象，讓賓客看到後莞爾一笑。卡通形象除了用在請柬上之外，還應用在 T 恤衫和胸牌上，作為贈送給賓客的禮物。新娘和新郎想要呈現出義大利傳統婚禮請柬的特點，因此，所有卡片以及小冊子都採用 100% 的棉紙，凸版印刷，色彩為中性色。

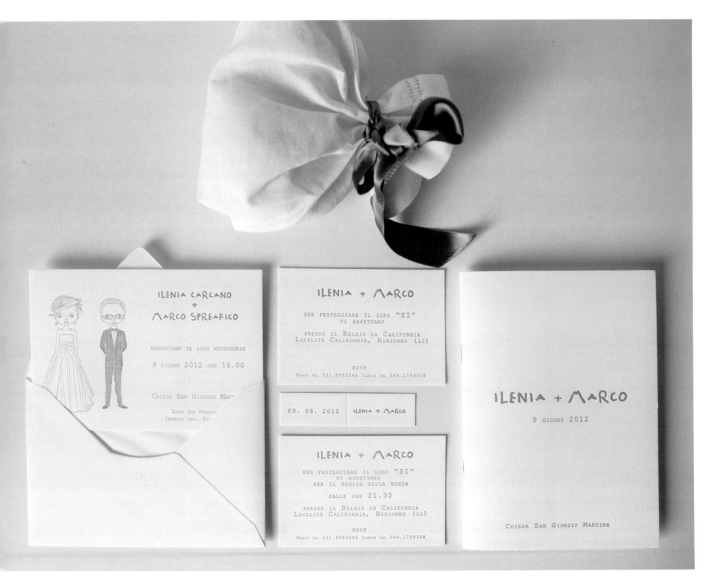

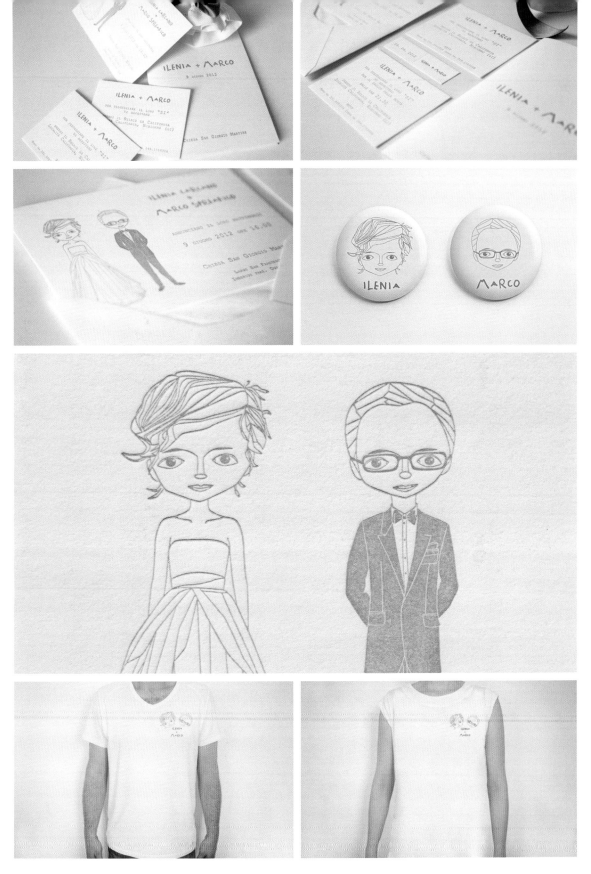

# LAURA & MATT 蘿拉與馬特婚禮平面設計

Design agency: Jolly Edition
Photographer: Sarah Mooney
Client: Laura & Matt
Country: USA

設計機構：喬利設計工作室
攝影師：薩拉‧穆尼
委託客戶：蘿拉、馬特
國家：美國

Laura and Matt met on Valentine's day through mutual friends. Matt was the bass guitarist in a band Laura had been invited to see with friends in Washington D.C. They got talking and eventually found time to bond through their mutual love of music and even found their song on their first date.

蘿拉和馬特是通過他們共同的朋友在情人節相識的。那天，蘿拉受邀與朋友一起去華盛頓看一場樂隊演出，馬特是樂隊裡的低聲部吉他手。他們聊天後，發現兩人都熱愛音樂且志同道合。兩人第一次約會時甚至發現他們最愛的是同一首歌。

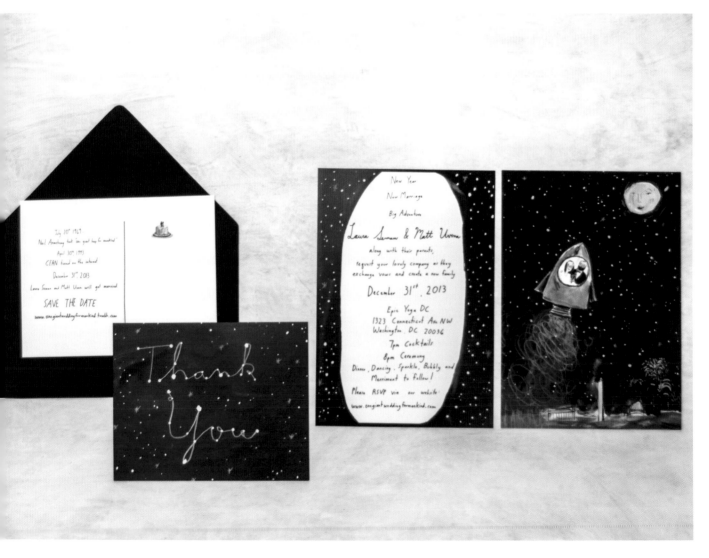

# SAN FRANCISCO WEDDING

## 舊金山婚禮平面設計

Design agency: Kristina Micotti Illustration
Designer: Kristina Micotti
Photographer: Daniel Kim
Client: Andrew Alderette & Kristina Micotti
Country: USA

設計機構：克莉絲蒂娜‧米科蒂設計工作室
設計師：克莉絲蒂娜‧米科蒂
攝影師：丹尼爾‧金姆
委託客戶：安德魯‧阿爾德萊特、克莉絲蒂娜‧米科蒂
國家：美國

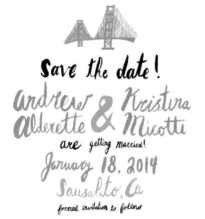

Kristina's invitation combines the unique elements of hand type coupled with her illustration of San Francisco's Golden Gate Bridge resulting in a bold yet refreshingly simplistic design.

設計師克莉絲蒂娜為自己的婚禮而做的平面設計，結合了各種獨特的手繪元素，包括她繪製的舊金山金門大橋的形象，整套設計大膽、簡約、清新。

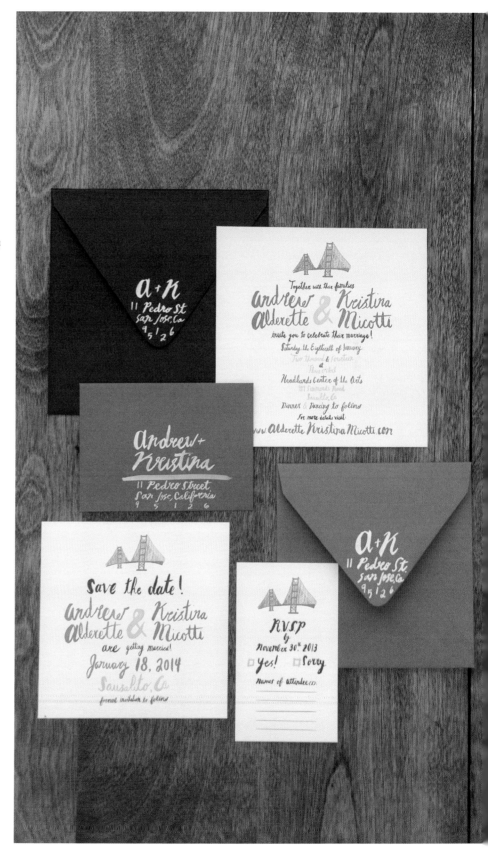

Together with their parents,
Antonio Santos † & Melinda Del Mundo,
Lucio Tiu † & Lily Tiu

# PAOLO & CRISTINE

*joyfully invite you to share in their happiness
as they unite in marriage.*

## MAY 25, 2014 · 3:30PM

Sanctuario de San Jose, Duke cor. Buffalo Street,
Greenhills East Subd., Mandaluyong City

### SANTOS – T

To guide us in c
Ambassador Chen Hsi Tsan
Mr. Manuel Santos
Mr. Antonio Tan
Mr. Benjamin del Mundo Jr.
Mr. Guillermo Flores III
Mr. Adrian Guanzon

Bes
Jose Maria Rufino, Jr. &

Maid c
Isai

Groomsmen
Robert Jay Sumulong
Catalino Hilario, Jr.
Marcus Erlano

To light our path    To cloth
Carlos Lim    Niño Fer
Joni Lim    Vittoria Fr

Coin & Ring Bearer    Flow
Jamil Eryx Santos    Mariae R
Reese

這是為保羅和克莉絲蒂娜的婚禮所做的幾套平面設計方案。這對新人將他們喜愛的色彩和元素寄給設計師，要求以此為基礎來設計，設計師運用這些元素和對稱的手法創作了這些設計方案。
選用的字體非常簡單，以免整體設計顯得過於繁複。新人最終選中的是紙風車那套請束。第一張卡片印製出來後，設計師也非常喜愛，並一直將其納入自己的作品集之中。

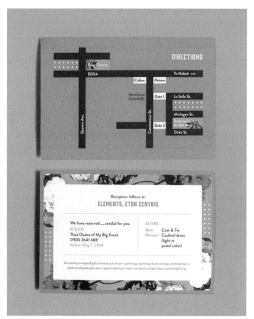

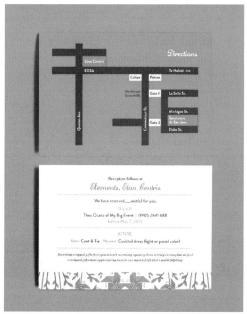

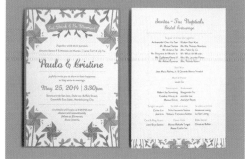

# PAOLO & CRISTINE

## 保羅與克莉絲蒂娜婚禮平面設計

Designer and Ilustrator: Raxenne Maniquiz
Client: Paolo Santos & Cristine Santos
Country: The Philippines

設計師 / 插畫設計：雷克珊．馬尼基茨
委託客戶：保羅．桑托斯、克莉絲蒂娜．桑托斯
國家：菲律賓

These are the wedding invite options made for Paolo and Cristine. They sent to the artist their colours and mood board to work from. The artist loved playing with the elements and creating symmetry. Simple fonts were used to balance everything out. The one they chose to produce was the pinwheel invite. The artist loved how the first one turned out, so she still included it in her portfolio.

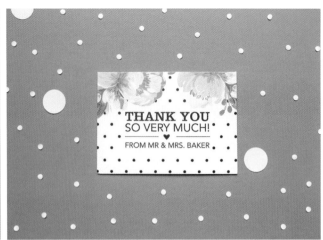

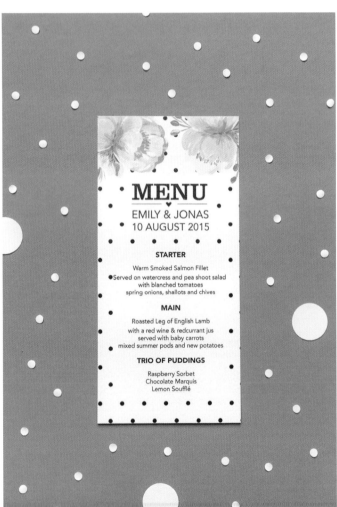

# POLKA PEONY SUITE

## 波點牡丹婚禮平面設計

---

Design agency: BerinMade 　　設計機構：貝林設計工作室
Designer: Erin Hung 　　　　　設計師：艾琳・洪
Photographer: BerinMade 　　攝影師：貝林設計工作室
Country: UK 　　　　　　　　國家：英國

A quirky pairing of the simple polka dot and the shapely peony. Often the flower of choice for a bustling bouquet, the billowy, hand-painted peony makes an appearance in this suite as a dramatic headliner. The text is presented in effortless black typography, aligned in a clean-cut block. This design is perfect for the girly and fashion-forward bride.

簡單的波點搭配美麗的牡丹花，取得了出人意料的效果。牡丹花是製作花束的常用花卉。設計師手繪了大朵的牡丹花，成為這套卡片中最搶眼的設計元素。文字採用黑色印刷格式呈現，整齊、簡單又清晰。這套設計非常適合有著少女情懷又時尚前衛的新娘。

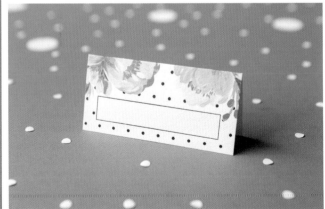

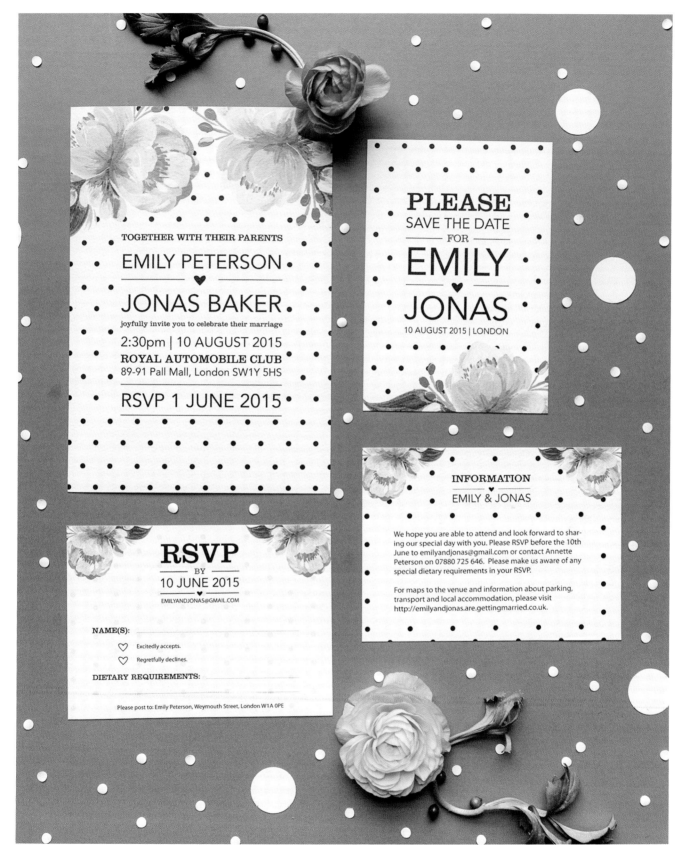

TOGETHER WITH THEIR PARENTS

EMILY PETERSON
♥
JONAS BAKER

joyfully invite you to celebrate their marriage

2:30pm | 10 AUGUST 2015
ROYAL AUTOMOBILE CLUB
89-91 Pall Mall, London SW1Y 5HS

RSVP 1 JUNE 2015

PLEASE
SAVE THE DATE
FOR
EMILY
♥
JONAS
10 AUGUST 2015 | LONDON

INFORMATION
♥
EMILY & JONAS

We hope you are able to attend and look forward to sharing our special day with you. Please RSVP before the 10th June to emilyandjonas@gmail.com or contact Annette Peterson on 07880 725 646. Please make us aware of any special dietary requirements in your RSVP.

For maps to the venue and information about parking, transport and local accommodation, please visit http://emilyandjonas.are.gettingmarried.co.uk.

RSVP
BY
10 JUNE 2015
EMILYANDJONAS@GMAIL.COM

NAME(S): _____

♡ Excitedly accepts.

♡ Regretfully declines.

DIETARY REQUIREMENTS: _____
_____

Please post to: Emily Peterson, Weymouth Street, London W1A 0PE

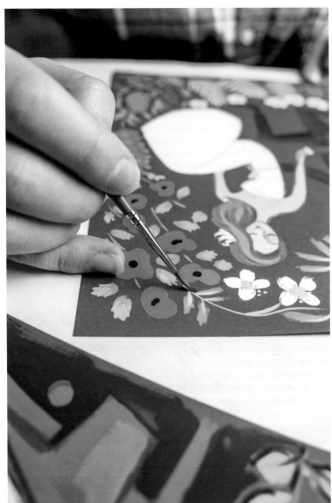

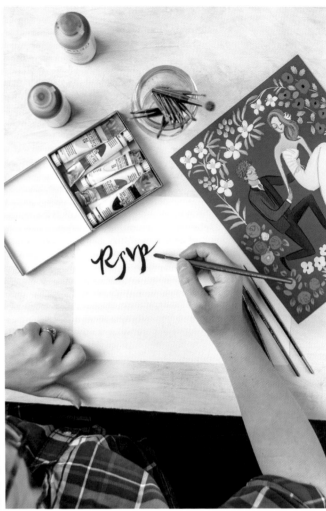

# ANNA & DENIS 安娜與丹尼斯婚禮平面設計

Design agency: Jolly Edition
Photographer: Sarah Mooney
Client: Anna & Denis
Country: USA

設計機構：喬利設計工作室
攝影師：薩拉・穆尼
委託客戶：安娜、鄧尼斯
國家：美國

After meeting at college in Minnesota these two singers quickly became inseparable and asked Jolly Edition to create stationery to adorn their wonderfully eclectic Matisse/Picasso-inspired wedding.

安娜和丹尼斯都是歌手，兩人在明尼蘇達州上大學時相識，並迅速發展為密不可分的戀人。他們邀請喬利設計工作室創造一套婚禮平面設計，要與他們婚禮的風格相稱。這場婚禮兼收並蓄地融合了馬蒂斯和畢卡索的藝術風格。

RSVP

PLEASE RESPOND BY FEBRUARY 4, 2014

NAME(S): _____

JOYFULLY ACCEPTS / REGRETFULLY DECLINES

NO. ATTENDING: _____

ACCOMMODATION INFORMATION CAN BE FOUND AT
sites.google.com/site/AnnaandDenisWedding

TOGETHER WITH THEIR FAMILIES,

*Anna Newman*

AND

*Denis Griffis*

INVITE YOU TO COME CELEBRATE
THEIR MARRIAGE!

THE FESTIVITIES WILL BEGIN
**SUNDAY, MAY 4, 2014**
FOUR-THIRTY IN THE AFTERNOON
AND WILL CONTINUE INTO THE EVENING
WITH VICTUALS AND REVELRY

BRING YOUR WASSAIL BOWLS TO THE
**DUBLIN ARTS CENTER**
7125 RIVERSIDE DRIVE
DUBLIN, OH 43016

sites.google.com/site/AnnaandDenisWedding

# Index
索 引

Jono Garrett

"Jono Garrett, Shaun Botes, Simone Rossum,

Paul Hinch, Dustin Slabber, Dietrich Mengel, Jessica

Webster, Nikki Taylor, Heiko Gunter & Olja Ilyushchanka"

K.GREBE

Kalo Make Art

Kristina Micotti Illustration

Las Chulas

Lauraland Design

LEFTRARU

Legacy Loft

Lisa Mishima

Llorente Design

MaeMae Paperie

Mara Colombo

Michael De Pippo

michele wong kung fong

Michiel Reuvecamp

Monsieur + Madame

mubien

murmuration.ua

Natsuki Otani Illustration

October Ink

Olive & Emerald

Paperfinger & JenHuangArt

Papermade Design

Pedro Paulino

Pretty in Print

Raminta Vas

Raxenne Maniquiz

Studio Kohl

Suze Studio Design

Valentina Alvarado

國家圖書館出版品預行編目(CIP)資料

婚禮平面設計 / 夏洛特.弗斯戴克作. --
新北市：北星圖書, 2017.03
　　　面；　公分
ISBN 978-986-6399-49-7(平裝)

1.平面設計 2.婚禮

964　　　　105022539

# 婚禮平面設計

| | |
|---|---|
| 作　　　者 | 夏洛特·弗斯戴克 |
| 發 行 人 | 陳偉祥 |
| 出版發行 | 北星圖書事業股份有限公司 |
| 地　　　址 | 新北市永和區中正路458號B1 |
| 電　　　話 | 886-2-29229000 |
| 傳　　　真 | 886-2-29229041 |
| 網　　　址 | www.nsbooks.com.tw |
| E-MAIL | nsbook@nsbooks.com.tw |
| 劃撥帳戶 | 北星文化事業有限公司 |
| 劃撥帳號 | 50042987 |
| 製版印刷 | 皇甫彩藝印刷股份有限公司 |
| 出版時間 | 2017 年 3 月 |

| | |
|---|---|
| 書　　　號 | ISBN 978-986-6399-49-7 |
| 定　　　價 | 850 元 |

如有缺頁或裝訂錯誤，請寄回更換
本書由遼寧科學技術出版社授權出版